CLASSICAL PAINTING ATELIER

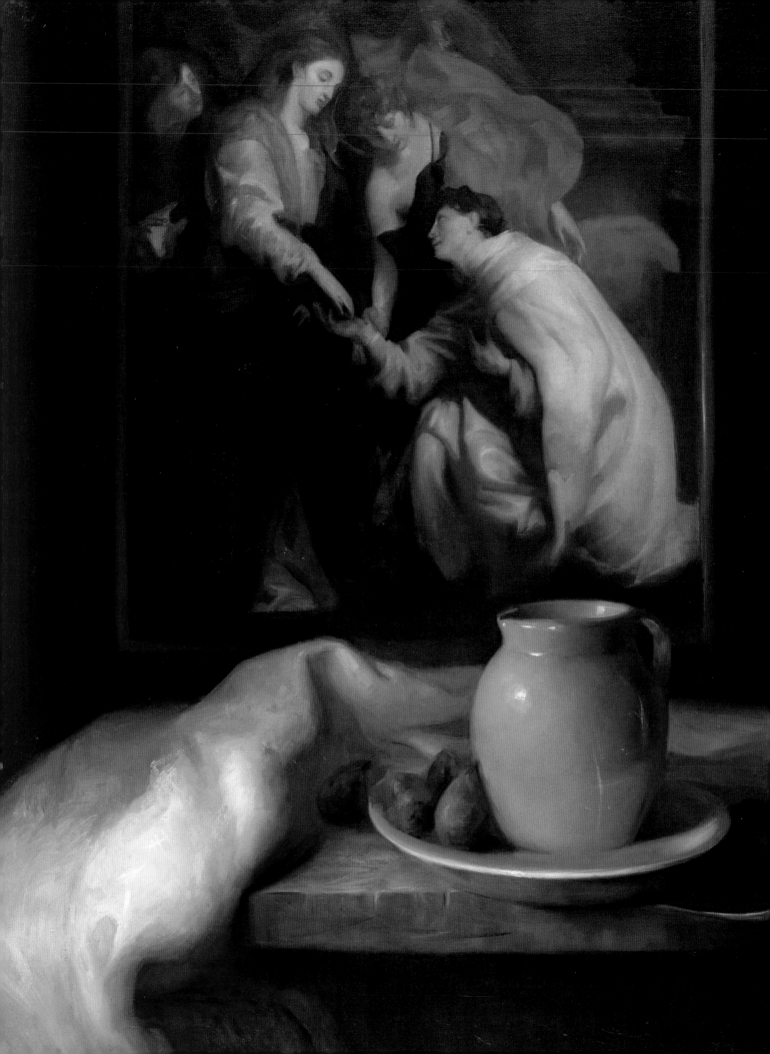

CLASSICAL PAINTING ATELIER

A Contemporary Guide to Traditional Studio Practice

JULIETTE ARISTIDES

WATSON-GUPTILL PUBLICATIONS / NEW YORK

Previous Spread: Juliette Aristides, *The Spanish Pitcher,* 2007, oil on linen, 24 x 36 inches, collection of David and Lisa Joseph

First published in 2008 by
Watson-Guptill Publications,
Nielsen Business Media, a division of The Nielsen Company
770 Broadway, New York, NY 10003
www.watsonguptill.com

Library of Congress Cataloging-in-Publication Data

Aristides, Juliette.
 Classical painting atelier : a contemporary guide to traditional studio practice / Juliette Aristides.
 p. cm.
 Includes bibliographical references and index.
 ISBN 978-0-8230-0658-8 (hardcover)
 1. Painting—Technique. 2. Painting—Study and teaching. I. Title.
 ND1500.A64 2008
 751—dc22

 2007023000

Executive Editor: Candace Raney
Editor: Alison Hagge
Designer: Christopher Cannon and Eric Baker, Eric Baker Design Associates
Production Manger: Alyn Evans

ISBN-13: 978-0-8230-0658-8
ISBN-10: 0-8230-0658-1
Printed in China
First Printing, 2008
1 2 3 4 5 6 7 8 / 15 14 13 12 11 10 09 08

To my children, Natalia, Jason, and Simon

Acknowledgments

I extend my sincere gratitude to all the people who contributed to the publication of this book. A special thank you to Candace Raney for believing in this project and for the support of the Gage Academy of Art's director, Pamela Belyea, and artistic director, Gary Faigin. My deepest appreciation to Fred and Sherry Ross from the Art Renewal Center (www.artrenewal.com) for your invaluable assistance, including providing permission to reproduce paintings from your impressive collection and for providing many historical works of art. I am particularly grateful to editorial goddesses Sarah Jardine Howard and Alison Hagge for keeping me on track. My appreciation to students, artists, and models who contributed to this publication, especially Michael John Angel and photographer Richard Nicol. I am indebted to Dino Aristides, my husband, for your invaluable assistance and your research into the design systems of ancient Greece. I extend my utmost thanks to Eduardo Fernandez and art historian Carol Hendricks for your research into the lives of the artists. Many thanks to the Marlborough Gallery, Forum Gallery, Arcadia Gallery, and to two great Seattle collectors, Allan Kollar and Susan Winoker, for your contributions to this book. I would like to recognize the support of art lovers Wendy Chung and Alyce Hoggan for your belief in my work. I am obliged to Fred and Sara Harwin and Robert Gamblin for the stimulating discussions on color and the patient answers to my questions. I am thankful for the contribution by Peter Malarkey on sound painting techniques. My gratitude for the sacrifices of my teachers: Bruce Kasper, Myron Barnstone, Wade Shuman, Dale Redpath, Syd Wicker, Carlos Madrid, the instructors at PAFA, and, with special affection, Jacob Collins. With much gratitude, I would like to thank Susan Bari Price; your support as a friend was as instrumental as your contributions to the design of this book. Passed on but not forgotten, Ida Bendhiem, my grandmother, whose art inspired me from my earliest days. Most important, I would like to thank my parents for the years of encouragement.

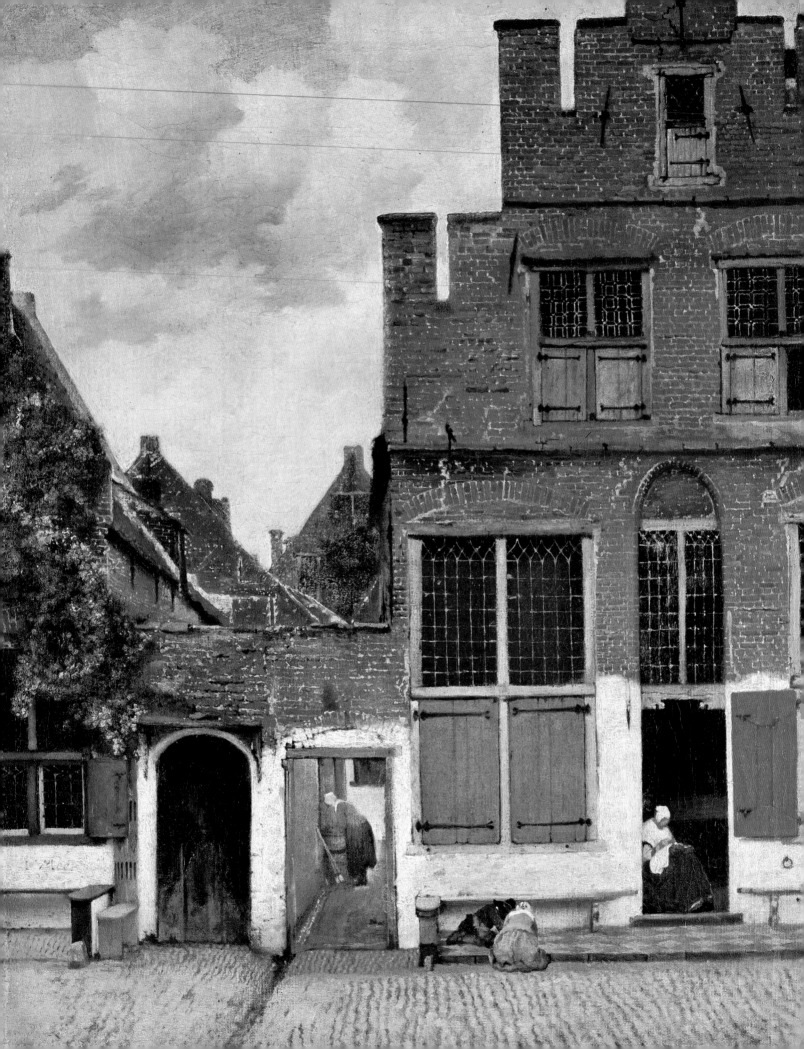

CONTENTS

ix **FOREWORD**
Fred Ross, Chairman, Art Renewal Center

xi **INTRODUCTION**

PART ONE: THE ARTIST'S STUDIO

1 **CHAPTER ONE: HISTORICAL AND CONTEMPORARY STUDIO PRACTICES**
An Overview of Atelier Training

PART TWO: TIMELESS PRINCIPLES

19 **CHAPTER TWO: COMPOSITION**
Design Systems of the Masters

53 **CHAPTER THREE: VALUE**
The Power of Limits

75 **CHAPTER FOUR: COLOR**
The Full Palette

PART THREE: TIMELESS PRACTICES

109 **CHAPTER FIVE: THE PAINTER'S PROCESS**
Methods and Inspiration

133 **CHAPTER SIX: PAINTING FROM LIFE**
The Muse

PART FOUR: MASTERWORKS

161 **CHAPTER SEVEN: STILL-LIFE PAINTING**
Nature Tamed

183 **CHAPTER EIGHT: PORTRAIT PAINTING**
An Intimate Likeness

209 **CHAPTER NINE: FIGURE PAINTING**
The Body Divine

238 *Appendix*

239 *Bibliography*

240 *Index*

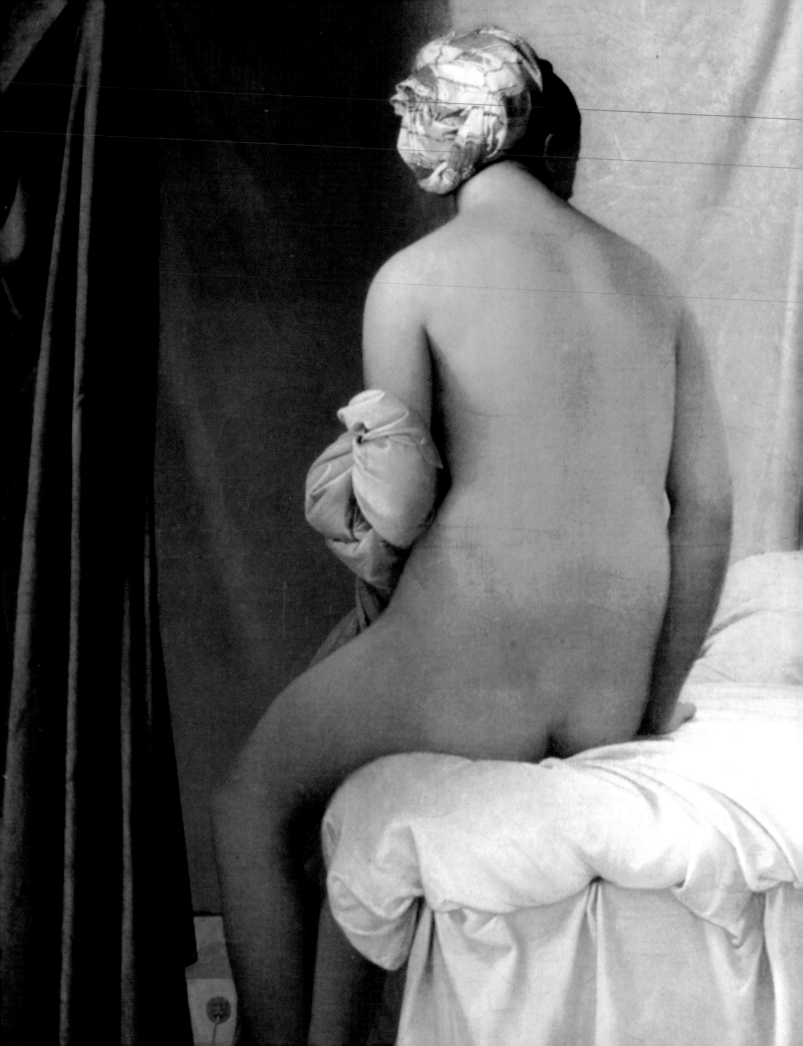

FOREWORD

The atelier approach to art education has its roots in the guilds of the early Renaissance. For more than five hundred years, master artists transmitted a system of knowledge to their students. This tradition reached its zenith in the second half of the nineteenth century, when ateliers prepared thousands of accomplished artists to paint in dozens of different styles on countless subjects. Skill-based teaching in the nineteenth century was centered on observation of nature, sound artistic principles, and universal themes. Aspiring artists obtained the technical ability, personal commitment, and philosophical views needed to create great art. The impact of Enlightenment thinking, with its respect for human rights and equality before the law, allowed art to expose the evils of slavery and child labor as well as to promote women's rights and other social issues. This new democratic way of thinking, in conjunction with unparalleled classical training, ignited the greatest period of creativity that the fine arts had ever seen.

With a shift in the aesthetics of art-world politics, affected in part by the horrors of World War I and World War II, cynicism, novelty, shock, and rebellion became the fashionable staples of art in the early twentieth century. Art that could be produced rapidly and yet be considered valuable became a dream come true. Modern art, although it may have had claim to a few artists with a sincere desire to experiment and rebel, soon became lost, for without standards or any need to communicate through universal themes, it was easily controlled by those who stood to make vast fortunes from this "new" quickly made art. Art became "art about art" not art about life.

Against all odds and facing ridicule, a handful of artists who were still academically trained managed to preserve the core technical knowledge of Western art and to continue the process of teaching another generation. There is now a growing movement of artists demanding to be taught the classical methods. They are part of a new Renaissance that has brought the atelier method full circle and back into the art world of today. In the ateliers of the twenty-first century, artists have once again lit the torch of inspiration with the desire to reunite the powers of masterly painting and humanistic subject matter. As long as humanity is permitted to compare and decide for itself what constitutes art, truth, beauty, and a commitment to excellence will prevail.

FRED ROSS
Chairman, Art Renewal Center

Opposite: Jean-Auguste-Dominique Ingres, *Bathing Woman*, 1806, oil on canvas, 57 1/2 x 38 1/4 inches, Louvre, Paris, France, courtesy of Art Renewal Center

Previous Spread: Jan Vermeer, *The Little Street of Delft*, circa 1657–1658, oil on canvas, 21 3/8 x 17 3/8 inches, Rijksmuseum, Amsterdam, The Netherlands

Photo Credit: Erich Lessing / Art Resource, New York, New York

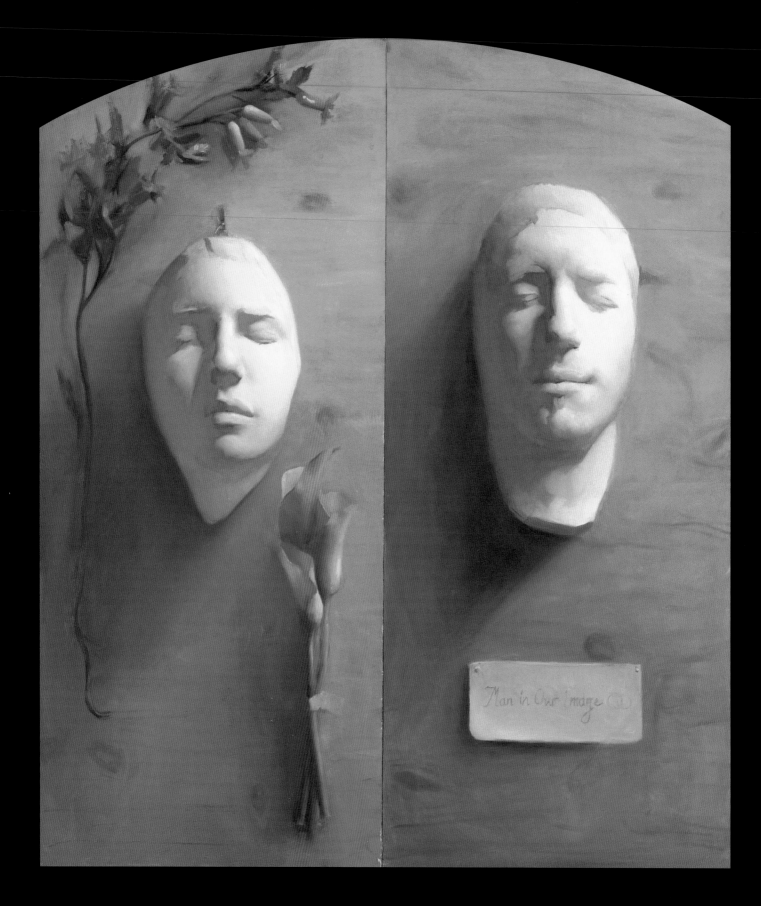

Man in Our Image

INTRODUCTION

"Beauty is unbearable, drives us to despair, offering us for a minute the glimpse of an eternity we should like to stretch out over the whole of time." — ALBERT CAMUS (from *Notebooks, 1935–1951*)

About fifteen years ago, I was a passenger on a road trip. It was raining and I passed the time by watching the water bead up and stream down the window. The combination of the gray sky, the warm car, and the long trip made me drowsy. Just as I was falling asleep, I noted that this was just one of innumerable moments in my life that I would never remember.

Over the course of my life, most of the daily experiences—countless meals, great conversations, and long walks—have been erased by the passing of time. They are gone. And while I failed to realize it in the car that day, it is not only the daily business of most of our lives that slips by unremembered; given enough time, we ourselves will slip away into the vastness of history.

Joseph Conrad wrote that part of the aim of art is to snatch a moment from the remorseless rush of time and to reveal that rescued fragment to others. Capturing and holding up a sliver of life's truth and emotion creates solidarity among all who share it. That nondescript moment right before I fell asleep in the car became a distinct memory because I distilled it through examination. Likewise, isolating and transcribing an occurrence or thought along with its emotional tenor can transform an indistinguishable fragment of human life into a powerful conveyer of the human experience.

Human life is not made up of neutral moments simply waiting to be interpreted or transformed into art. Rather, each moment is a slice or microcosm of the worldview of the artist. The larger context of an individual's life, beliefs, environment, temperament, and upbringing form the base from which he approaches every encounter and formulates every artistic expression. These worldviews, moreover, are not just private beliefs; they are inherently tied to

Opposite: Juliette Aristides, *Image*, 2005, oil on panel, 28 x 26 inches

Based on a portion of *The Book of Genesis*, this trompe l'oeil painting explores the necessity of having a multiplicity of personalities, races, and genders to more fully reflect divinity.

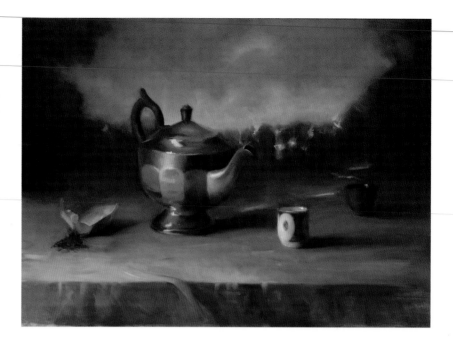

Juliette Aristides, *Silver Teapot,* 2007, oil on panel, 16 x 22¹/₂ inches

This painting is from a series involving a limited palette and the interchange between value gradations filling empty space and objects from significant family members who have passed on.

the beliefs of the greater or larger culture. Like fractal geometry, the smaller shapes are unavoidably imprinted with the shape of the whole.

In previous eras, artistic production was colored by the subtext that human beings, as children of God, have divine origins and that our existence is not transitory but eternal. This belief provided not only hope for the future, but a deep assurance of the intrinsic significance and value of a human life. Artists reflected this vision of reality in their artwork, which enabled them to glimpse beauty in the face of tragedy and to portray monumental views of human life. This is why Sandro Botticelli could paint his ethereal goddesses, revealing a reality only hinted at in the world as the black plague ravaged Europe.

The postmodern skeptic, faced with an unflinchingly pragmatic and scientific worldview, has no hope of an eternal future. Humanity, crawling out of the primordial soup, living briefly, and, returning to the mud, wrestles with a cosmic insignificance that is reflected in the art of our time. Beautiful figure paintings look hopelessly naïve and outmoded in many art circles precisely because they no longer represent the predominating beliefs of the artistic and intellectual elite—the end of man is not glory but dust. Thus the art of the modern epoch has been largely nonrepresentational, characterized by a marred, earthbound, fragmented view of the human being. Beauty, eternity, and truth seem to have faded into a bygone era.

While people share much with other living creatures, the desire for beauty, the capacity for self-reflection, and the longing for eternity are distinctively human qualities. On some subconscious level we need beauty, despite its perceived

lack of function. If we were to give a horse a diamond ring, it would assess it only on the basis of its utility, essentially asking the question, "Can I eat it?" In contrast, the human being has the elevated option to ask not only "Is it useful?" but "Is it beautiful?" The enormity of human suffering in the world does not render this question, or the desire to ask it, trivial. Rather, it affirms an appreciation of aesthetics as fundamental to our nature.

Artists help us see the surprising beauty that breaks into our daily lives by celebrating that which might otherwise pass by unnoticed. Artists are in a unique position to leave an intimate record of human life, as they give us the opportunity to see not only through their eyes but also through their thoughts and emotions. One could say that the greater the art, the more clearly we experience this communion of souls. Artists remind us that despite the pain and ugliness in the world, something deeper exists—a beauty that peeks through the drudgery of life, whispering that there is more just beneath the surface. We see a landscape filled with longing and loss or a figure filled with love and empathy. These images enable us to long and love with the creators.

Nature shows us one kind of beauty, such as the way the light falls through the tree canopy, speckling the forest floor where I now sit and write. Occasionally, an unusually insightful individual is able to capture this kind of beauty in art. This is why Mozart's *Requiem Mass* still moves people to tears in packed orchestra halls or why people are willing to wait in line for hours to see an exhibition of works by Vermeer. Despite all appearances and talk to the contrary, we crave art that captures truth and remains powerfully and beautifully relevant long past the time of its creation. This sort of art is not just pretty or made up of the hollow aesthetic beauty that changes with the eye of the beholder. It is not sentimental, for sentiment is fleeting. The sort of art that lives eternally is that which captures astonishing, spine-chilling, breathtaking beauty that heightens our senses and floods us with transforming thought and emotion. In this work, we hear a whisper from another world saying, "It's all real." The ache to last means you were meant to last; the longing for beauty calls to you because beauty marks a reality that actually exists.

The contemporary artists in this book lived parallel to the rages of modern and postmodern art; they saw the same grimy buses pass by, the same soggy newspapers and cigarette butts in the gutter, the same horrors on the news, but they saw in these things an alternate reality of meaning—one that they communicate in their work. The topics they choose to express are not always comfortable to look at, but, through the artists' vision, they are infused with pity, compassion, and insight that express a kind of beauty that transcends even the thorniest subject matter. The art portrayed in this book shows the courageous path followed by visionaries who are strangers in their own times, looking ahead to a land not yet found to capture a hope that, through beauty, can fight its way back into our world.

PART ONE

The Artist's Studio

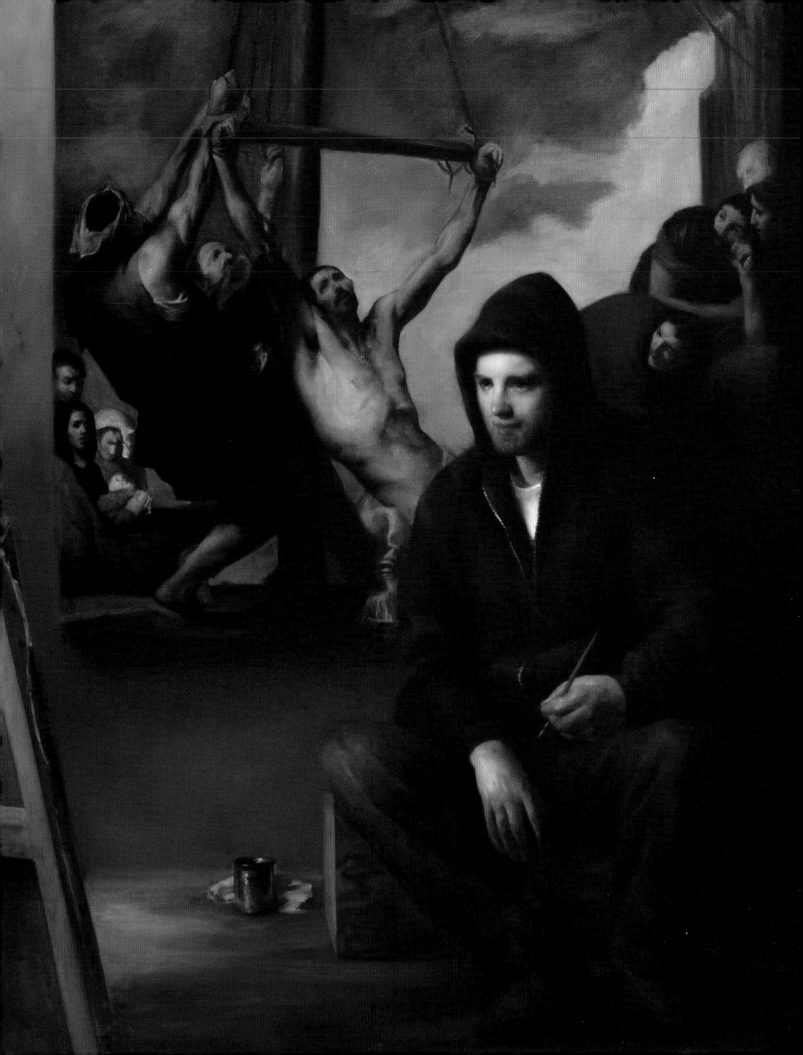

HISTORICAL AND CONTEMPORARY STUDIO PRACTICES

An Overview of Atelier Training

"You, therefore, who with lofty spirit are fired with this ambition, and are about to enter the profession [of painting], begin by decking yourselves with this attire: Enthusiasm, Reverence, Obedience, and Constancy. And begin to submit yourself to the direction of a master of instruction as early as you can; and do not leave the master until you have to." — CENNINO D'ANDREA CENNINI (from *Il Libro dell'Arte*)

Learning to paint is a demanding process that requires nuanced instruction on the part of the educator and careful observation along with persistent practice on the part of the student. Few art manuals from the distant past exist, in part because artistic training was never acquired through reading but by direct apprenticeship under a master. This text is not an exhaustive technical manual, because so much of the application of principles is personalized and open to interpretation. Therefore, rather than providing a thorough guide for a specific set of skills, this book offers a foundational overview of atelier training. It contains a roadmap for the aspiring artist's course of study, showing a way to navigate the confusing world of art education and its application to the creation of masterworks.

Let's begin by examining the atelier approach—how it differs from the other educational opportunities available to contemporary artists as well as how the atelier curriculum naturally builds upon itself during the course of a developing artist's period of study. For a more in-depth historical perspective on how the contemporary atelier model fits within a broader context of the master-student relationship that thrived in past eras, please refer to my previous book, *Classical Drawing Atelier.*

Contemporary Atelier Training

If you were to visit my atelier, after climbing four flights of stairs and walking down a long hallway, you would reach a studio designated for the monastic study of fine arts. Jars of pigments rest on a shelf, as in an old apothecary. Dozens of brushes stand in jars and palettes hang crooked on nails in the wall. Casts, books, and paint rags are scattered on bookshelves and tables, and the smell of oil paint and turpentine permeates the air. An entire year's worth of

Opposite: Juliette Aristides, *The Artist,* 2007, oil on canvas, 48 x 36 inches

The model, a student of mine, reminded me of a modern-day Francisco de Zurbarán. This painting focuses on the influences and inspirations of the artist. I painted a small self-portrait in the lower left of the Ribera picture behind the student. (The full, original image is shown on page 33.)

Previous Spread: Antonio López García, *Main Street* (detail), 1974–1981, oil on canvas, 35 5/8 x 36 7/8 inches

Photo Credit: Image copyright © 2006 Artists Rights Society (ARS), New York / VEGAP, Madrid

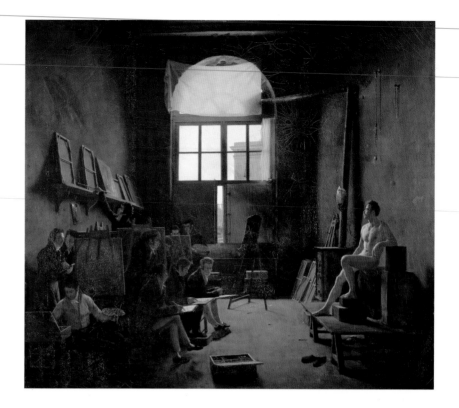

paintings created by students is hung, salon style, on the walls. If you arrive when one of our figure models is on a break, you will hear students talking shop while others work at their easels or pore over a book containing images of old master paintings.

This environment is much like the art studios of the past, with the palpable intensity generated by a group of people struggling to achieve excellence. Many of the students gathered in my atelier have made great sacrifices to study art. Some have left their small-town homes and relocated to an urban center to pursue their training, just as I once did.

In past eras, young, budding artists often left home with little more than an aptitude for drawing and a sense that they could do more with it. While a student might have been the best artist in his small town, every apprentice who arrived at the master's studio started at the bottom. New students in nineteenth-century ateliers faced the possibility of exhausting poverty, cruel hazing, and fierce competition. Classrooms were crowded and positions around the model were highly coveted. Neophytes worked from engravings and casts and were not allowed to draw from the model until they could prove their talent.

In art studios of the past, it was not enough to be good; you had to be the best. Those who succeeded were catapulted into superstardom. Unrelenting compe-

tition, fear of failure, and the lure of possible rewards made for an extremely high-pressure environment that threatened to turn creativity into pride, bitterness, and disappointment. In both historical studios and contemporary ateliers, the students who succeed are among those who have the humility to learn their craft, enough ego to withstand criticism, and the ambition to persist against all odds. It takes perseverance to temper the tumultuous passion of youthful idealism and transform it into the deeper love and skill that mark the mature artist. The atelier model of training is designed to ensure that the artist develops the character and skill set needed to succeed in the art world. Eugène Delacroix said, "The cultivation of a true eye and a sure touch, the art of carrying a picture on from the first sketch to the finish, and many other matters, all of the first importance, require unremitting study and a lifetime of practice. Very few artists, and here I speak of those who really deserve the name, fail to become aware as they reach the middle or decline of their careers, that time is too short to learn all they lack, or to begin over again a bad or unfinished education."

Michael Klein, *A Day in the Life,* 2005, oil on linen, 30 x 40 inches

Cast halls such as this can found in many art schools that have a focus on and history of traditional drawing and painting practices.

Contemporary art students in both art schools and university art departments are often confronted with a dizzying array of artistic choices but given little or no guidance on how to achieve mastery in their chosen field. These students are encouraged to develop a personal style, which, like creativity, is at its best when it is the unconscious byproduct of a sincere attempt to do the best possible work. C.S. Lewis encapsulated the sentiment when he said, "No man who values originality will ever be original. But try to tell the truth as you see it, try to do any bit of work as well as it can be done for the work's sake, and what men call originality will come unsought."

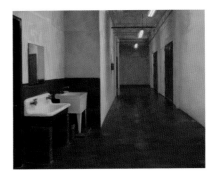

Kate Lehman, *Water Street Hallway,* 2002, oil on canvas, 15 x 19 ⁵/₈ inches

Kate painted this hallway leading to the original Water Street Studio, where she studied. The austere hallway leading to this atelier belies the warmth and camaraderie that she found behind the door.

Artists of the past sheltered students from premature concerns and devised a progression of study that was designed to impart mastery of the skills necessary to be successful in the studio. The exercises that formed the artist's education provided a secure foundation of knowledge upon which the artist could lay the building blocks of his artistic future. For centuries, would-be artists have struggled to find the secrets that accounted for the compelling perfection found in work of the old masters—their unique visual insights and the longevity of the work. However, in spite of the monumental effort expended to find the holy grail of the masters, the biggest secret of all is practice. To unlock the secrets of the old masters one must apply and reapply and continually refine the primary principles of art until they become second nature.

Atelier training features an apprenticeship-like course of study in which students receive intensive mentoring from an artist. This teacher is committed to giving the students all the tools necessary for life as a painter. Every aspect of the program is conducive to ensuring the students' progress. For example, even the act of showing up each day, all day, cultivates the perseverance necessary for the student's success as a professional artist who does not wait for inspiration to strike but has the self-discipline and motivation to work, rain or shine.

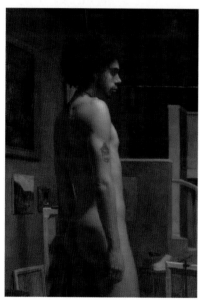

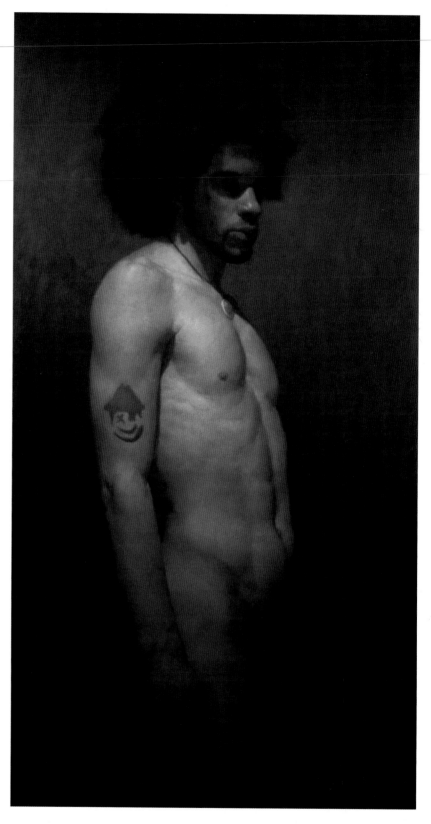

Clockwise from Top Left: Michael Klein, *69th Street Studio,* 2005, graphite on paper, 14 x 11 inches; Carl Dobsky, *Study of a Man,* 2005, oil on canvas, 36 x 20 inches; Michael Klein, *69th Street Studio,* 2005, oil on linen, 18 x 14 inches

These paintings, created in the Jacob Collins Studio, were done from the model in the life room. Both artists portrayed the model differently, according to their artistic aims. One focused specifically on the figure; the other incorporated the studio environment.

In an atelier program the master artist gives each student new information only as he is able to apply it, and theory is always linked to practice. The rest of this chapter outlines the basic progression of atelier exercises as they build in complexity, giving students the chance to master one skill before moving on to another.

Drawing

Drawing is the foundation, or as Jean-Auguste-Dominique Ingres said, "the probity," of art. It should be the art student's chief concern during the initial stages of his education, whether he is working to become a painter, printmaker, sculptor, animator, architect, or designer. Such topics as proportion, design, gesture, composition, value, and form all fall under the domain of drawing. In fact, most skills related to painting can be studied via drawing, with the exception of paint handling and color. For this reason, drawing is frequently taught before painting.

There are two distinct ways of seeing—functional and artistic. Functional seeing, which is our normal mode of vision, is related primarily to survival. It is concerned with such questions as "If I sit down on that shape will I fall or be supported?" "Does that spot of shade mean there is a dip in the ground, or is it a hole?" and "Is that person friendly or hostile?" Conversely, artistic seeing is purely aesthetic, concerned with shape, color, value, edges, and other elements apart from functionality. Through disciplined practice at drawing the artist learns to record in an abstract, objective manner the things around him. Once the artist has mastered the skill of drawing, he can distort nature, inflecting it and transforming it to suit his aesthetic and emotional purposes.

The most direct way for a student to obtain mastery in art is to understand its foundational principles, which are primarily found in the discipline of drawing. Some of the topics included under the umbrella heading of drawing are design, composition, perspective, anatomy, value, form, and proportion. Like the proverbial tortoise and hare, the student who diligently acquires a solid foundation in drawing will find his efforts rewarded in the long run. For students wishing to improve their drawing skills, my book *Classical Drawing Atelier* provides an overview of the classical aesthetic as well a detailed guide to the drawing curriculum I use in my atelier classroom.

Monochromatic Painting

Once a student has achieved a certain level of mastery with drawing, he can begin to experiment with paint. Often students struggle with a disheartening setback in ability when moving from a skill in which they have attained expertise to a new set of problems in uncharted territory. An individual may be a competent draftsman but finds himself clumsy when attempting a synonymous action with paint and brushes on canvas. Remember, it takes time to build up new skills.

Daniel Monda, cast drawing of *Male Greek Torso,* 2007, charcoal on paper, 17 1/2 x 11 inches, courtesy of the Aristides Classical Atelier

Studying the monumentality of form found in classical sculpture allows students to begin to see similar elements in the life room. This extended cast drawing assignment allowed Daniel to push his drawing abilities and take as much time as was necessary to improve his work.

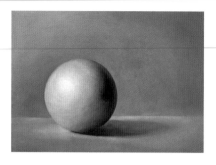

John Rizzotto, *Sphere #2*, 2003, oil on canvas, 5 x 7 inches, courtesy of the Aristides Classical Atelier

John painted this sphere multiple times and with different tonal arrangements until he understood it completely. The seamless gradations and perfect shape make this an excellent, but difficult, assignment to do well; any inaccuracies are immediately apparent.

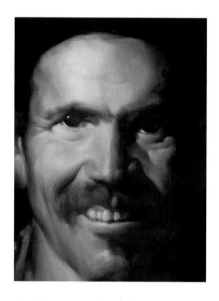

Maria Olano, monochromatic master copy painting of a detail of Diego Velázquez's *Triumph of Bacchus*, 2007, oil on panel, 14 x 12 inches, courtesy of the Aristides Classical Atelier

The grisaille master copy gave Maria an opportunity to experiment with re-creating Velázquez's paint handling and ability to capture lively expressions.

In my atelier curriculum, painting in black and white, or with the addition of another color (such as a raw or burnt umber), is referred to as monochromatic painting. This practice helps the student transition from drawing to painting, as it presents familiar principles, such as composition, value, and form, but introduces a new medium. The student learns how to create a painting—from constructing the support to massing in the underpainting to finishing the overpainting—as well as various painting techniques.

Every atelier structures its curriculum slightly differently. Some begin by having students paint a sphere in black and white. This simple monochromatic exercise is designed to help the student learn how to turn form in paint and create the illusion of the third dimension. The perfect geometric solid clearly reveals any problems in rendering and helps isolate the areas the student needs to develop further. Understanding the anatomy of chiaroscuro well enough to transform a circle into a sphere forms a benchmark of knowledge necessary for solving more complex problems. From here the student can turn his attention to monochromatic master copy paintings, cast paintings, still-life paintings, and figure paintings—often in precisely that sequence.

Historically, the practice of master copying was a central component in the methods of training painters; it started at the very beginning of a student's training and often lasted long after the individual had reached mastery. Eugène Delacroix noted in his journals that his idol, Peter Paul Rubens, was more than fifty years old when he was sent on his mission to the King of Spain. Yet while there he spent his free time copying the superb Italian originals. This practice of copying was the source of Rubens's immense knowledge. "Copying," Delacroix wrote, "herein lay the education of most of the great masters. They first learned their master's style as an apprentice is taught how to make a knife, without seeking to show their own originality. Afterwards, they copied everything they could lay hands on among the works of past or contemporary artists." By copying engravings, drawings, paintings, and sculptures (the last of which are essentially three-dimensional masterworks), the student would learn proficiency in a particular medium as well as the cultivation of an artistic aesthetic. This exercise was practiced in each era by artists desiring to extend the range of their abilities through emulation of their precursors. The hope is that by following in a master's footsteps the student artist will gain some of the same aesthetic sensibility, the same ability to solve problems, and ideally the same technical ability as his predecessor. Just as a child imitates a parent, mimicking them to learn such things as life skills and socialization, the student painter follows those he admires and is led into a world that he can only begin to imagine.

Through master copying, an artist forms a link with history and can study under any master he chooses. Historically, artists traveled great distances, often going to great lengths and making many sacrifices, to study masterworks.

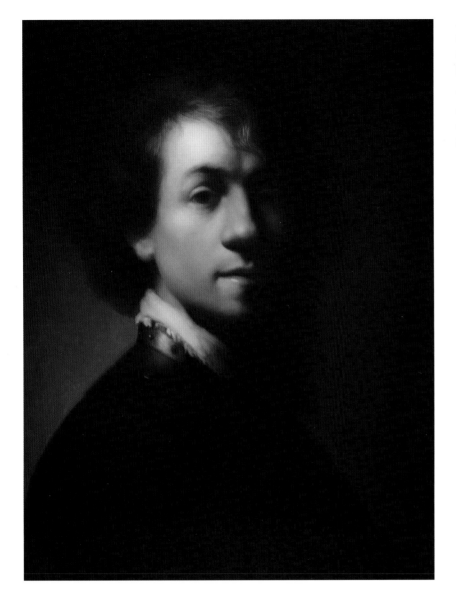

Joshua Langstaff, master copy painting of Rembrandt van Rijn's *Self-Portrait in a Gorget,* 2006, oil on panel, 14 x 11 inches, courtesy of the Aristides Classical Atelier

This master copy painting helped Joshua understanding that the power of Rembrandt's work relies on his manipulation of value and his handling of form.

Students could always be found at their easels in museums, in front of their favorite art heroes looking for inspiration and advice. Although nothing compares with studying directly from an original painting, today students have the benefit of being able to reference high-quality reproductions in books as well.

In my program, we have various methods of doing master copies and for a number of purposes. The first type of master copy we do in paint is a black-and-white poster study. The poster study is a simplified interpretation of a work of art. It provides an opportunity to study one particular aspect of that work, such as its value distribution and composition. Creating a poster study helps the student distill a complex image into its most essential components. By limiting the painting to just a few values, the student learns an economy of means, which is the hallmark of mastery. Once he learns to construct a harmonious

Matthew Grabelsky, cast drawing of the *Laocöon*, 2004, oil on canvas, 51 1/4 x 31 1/2 inches, courtesy of the Angel Academy of Art

Cast painting forms the bridge between drawing and painting. This exercise allowed Matthew to tackle the same issues of proportion, form, and design in paint that he had resolved in charcoal.

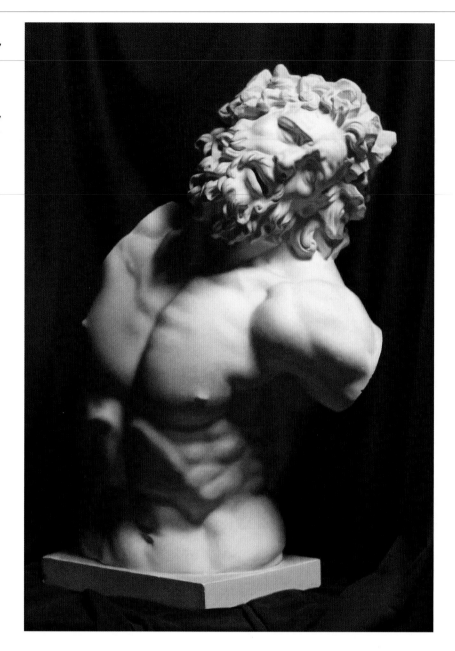

value composition, the student can then add any number of smaller elements without a loss of unity. This skill will serve him well when he arrives at the point of studying the figure, as he will be able to see past details on the model, knowing how to simplify to the greatest effect.

Once a student is able to confidently and effectively do a poster study of his chosen masterwork, he creates a finished monochromatic master copy painting. By pushing a painting to completion, the student is able to examine every facet of the masterwork and learn to re-create a compelling image. This method helps the student reconstruct a master's technique and interpret it for our times using the materials available today. Ultimately, the goal is not to learn to make

old master paintings but to gain their knowledge. This practice is very rewarding, resulting in a student having a copy of something that he loves as well as enabling him to be surrounded by the work of his teachers and mentors.

The next concept that I introduce during the monochromatic painting phase is cast painting. At its essence, this involves copying sculptures from antiquity. Historically, students drew plaster casts of famous sculptures as a way of studying design systems and light hitting form, with the ultimate goal being to develop a strong aesthetic and reliable working methods. In contemporary atelier training, students not only draw the casts but also paint them, with both a monochromatic palette and (later) a limited color palette. This practice of cast painting forms yet another bridge between drawing and painting. By working from a stationary white object, often a figure, the student becomes prepared for greater challenges in still life and figure work.

After the student has successfully completed the value sphere, master copy, and cast painting exercises, he can move to more complex still-life arrangements. These will give him practice at arranging a composition, creating atmosphere, and (if the original master copy painting is in color) translating color into value. The better a student can get at identifying the value of a color, the easier it will be for him to paint objects that depend on correct value for verisimilitude. This exercise challenges the student to balance a complex composition, while simultaneously creating art that powerfully projects from a distance. This exercise also provides an opportunity for the student to develop a more personal mode of expression with his increased range of mood and subject matter.

As a final exercise during the monochromatic stage, the student creates a painting from life using white and just one color. The heart of beautiful figure painting lies in its combination of beauty of proportion and sensitivity of

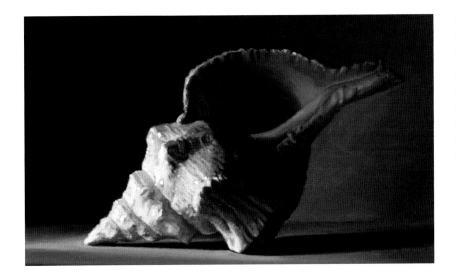

John Rizzotto, *Horse Conch*, 2004, oil on canvas, 11 x 14 inches, courtesy of the Aristides Classical Atelier

Painting a still-life object in grisaille gave John the opportunity to apply his understanding of chiaroscuro, gained while doing figure and cast work, to more personal imagery. This shell applies all the principles of the sphere exercise (shown on page 6) to a more complicated object.

expression. The challenge of painting is learning how to see the whole and the parts simultaneously. This exercise underscores the need to be able to render the small forms in the foot, for example, while not losing sight of the foot's correct value range in relation to the head. Painting a figure from life represents one of the most complex challenges for the artist. Subdividing the process into individual elements and consciously devoting one's best efforts to each part helps ensure a successful conclusion.

Warm-and-Cool Studies

An atelier student spends a significant amount of time working essentially in black and white. As a result, the transition from working in monochrome to working in color can be intimidating. The brief intermediate stage of working in a simple palette with only a few colors, representing the shift in temperature from warm to cool, incrementally introduces critical concepts in color, pointing the way to full-color painting.

The most beautiful paintings can be tonal, relying more on value than color for their charm. With this kind of painting the artist's palette is limited, sometimes to no more than five colors. To make a successful tonal painting, often the artist concentrates on subtle shifts between warm and cool tones to create an effect. Despite the lack of dramatic color shifts, these paintings can feel complete, owing to their perfect balance of value and temperature.

Jura Bedić, *Golden Onions*, 2006, oil on canvas, 19 ⁵/₈ x 23 ⁵/₈ inches

Jura, who trained at the Florence Academy, created this compelling image by balancing a strong triangular composition with subtle shifts in warm and cool colors.

It has been said that painting with a limited palette is more difficult than painting with a full palette. This is true if one is trying to get the actual color that one sees. However, most color is both evasive and relative, and creating a successful painting often ends up being more about finding the correct series of relationships than finding one perfect note. When using a very limited palette, the artist cannot get the exact color found in life, but he can begin to understand how much of the illusion of life is in the undulations between warm and cool tones. It is always surprising to see how much variety of color can be created—even by using an extremely limited palette of two colors plus black and white. The painting can feel correct even if the artist has not used colors found in life but has translated the relative relationships accurately.

Some of the atelier exercises involving temperature parallel their monochromatic counterparts. However, the fact that the student is using a color palette, albeit a limited one, brings new challenges, allowing him to adjust his skills to an increased range of expression. For instance, doing a color painting of a white cast allows the student to begin to see temperature changes in addition to value changes. An artist must have strong observational skills to see and paint a white object in color. In my program, we do our first warm-and-cool study with two colors, which forces the student to translate what he is seeing.

The study of temperature helps the student become a conductor of color, balancing and harmonizing multiple individual elements into a cohesive, and greater, whole. By focusing on one characteristic of color, warm and cool, the artist begins to understand which aspects of color are responsible for achieving what end. Two colors work as well as thirty to illustrate the principle of color intensity and neutrality and how a limited range of color can appear to be extended by juxtaposing warm and cool notes. This simple palette, if handled well, can convey a remarkable sense of naturalism and light within a harmonious color landscape or environment.

Another lesson conveyed by the warm-and-cool practice is how to translate a complex visual reality into an effective artistic one. The limitations of the artist's tools to capture light hitting the surface of forms within a real atmosphere require trickery on the part of the artist. The difficulty of transcription is pinpointed and addressed in exercises such as these by offering a solution that helps the student overcome these limitations.

Color

The final stage of the atelier student's training is to work in full color. Because color is highly personal, it is the least teachable of all the aspects of painting. In past centuries, artists had limited access to highly chromatic pigments, as these were only created in the industrial era and later through the advent of modern chemistry. In addition, historical aesthetic preferences favored tone over color. Having determined specific goals for their work, artists devised

Larine Chung, *Milk Jug*, 2007, oil on canvas, 8 x 10 inches, courtesy of the Aristides Classical Atelier

Larine did a series of one-day paintings in ultramarine blue, burnt sienna, and white, to understand how to manipulate tone and temperature, two fundamental elements of color.

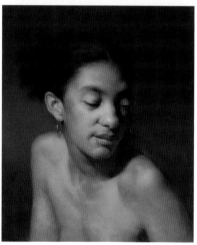

Top: Tenaya Sims, *Pigeon in Profile*, 2006, oil on panel, 14 1/2 x 11 inches, courtesy of the Aristides Classical Atelier

Tenaya carefully manipulated the edgework and bunched the warm, bright light to the very edges of the figure, imparting a sensitivity of spirit to his painting from the life room.

Above: Joshua Langstaff, *Pigeon*, 2006, oil on panel, 14 1/2 x 12 1/2 inches, courtesy of the Aristides Classical Atelier

This painting shows another view of the same model. The differences between these two images highlight the fact that much of artistic creation lies not in the subject, but in the mind, temperament, and vision of the artist.

conventions that enabled a systematic approach to painting. While at first such a practice might seem confining to an artist today, these limitations actually gave artists of the past freedom to consistently create admirable paintings because they were not continually rethinking their working methods.

Today artists do not have the luxury of simply adopting the current norm because we live in an era when no single aesthetic dominates the discussion. We have more palette systems, more paint mediums, more methods of paint application, and a wider spectrum of colors than an artist could possibly use. In such a confusing environment, it is logical to start with a simple, time-tested foundation, adding variety as one's need and comfort level increase.

The atelier student who is ready to make the leap from theory to practice does various color theory exercises and quick studies. These rapid studies can be done from an interior, a still life, a portrait or a life model, or from a landscape. However, perhaps the most accessible starting place is from the master copy. Creating simplified master copy paintings is an especially valuable color exercise as it allows one to learn from the best colorists throughout art history. The exact purpose of a master copy can be tailored to the goals of the individual or of the educational program. Students can do a very literal copy, stroke for stroke; an interpretive copy; or a simple sketch. In my program students do color poster studies (which are quick interpretations) and then fully finished master copies, which give them experience in color mixing, color composition, and application. It is such a rewarding process that artists of the past used to continue this practice throughout their careers.

For the purposes of a color exercise the student directs his efforts only toward the master's use and range of hue, temperature, intensity, and value. By blocking in big, simple planes of local color as it forms light and shadow shapes, rather than seeking nuanced shading and hues, the student can create a powerful interpretation of the masterwork. By learning to mix color and apply it to the same effect as the master artist, the student gains an intimate understanding of one particular palette and how to use it. When he is ultimately ready to paint from life, the student's comfort level will be elevated as he can choose to adopt a palette similar to the one analyzed in the master copy.

The finished master copy helps reveal how to achieve a perfect resolution, combining excellent technique with insight into the unique self-expression of the master. The student is forced to think through numerous issues, including subtle glazes, edgework, and surface finish, as he brings a complex work to a fully realized completion. Ideally, this experience will greatly improve the student's original work.

Still-life painting was not historically taught in schools, principally because it was low in the hierarchy of subject matter. However, the monumental figurative

painting commissions of the past are gone, and public tastes have changed, enabling many artists today to make a living and express themselves through still life. Contemporary ateliers use still-life painting instead of narrative works to focus on composition and color.

Initially, when studying the still life in my atelier, the student begins with one-day studies to practice getting started and to help gain an expertise with the material. The transition from temperature painting to full-color work, as well as the shift from single objects to full composition, can be daunting. I've found that without the intermediate stage of doing one-day studies students can take a week to try to set up a perfect arrangement before beginning. Doing one painting a day offers the chance for experimentation. After a student has done a dozen or so works, he begins to set up a composition and a solid working method easily. He also starts determining what subject matter resonates with him more than others.

At the heart of the atelier curriculum, which is designed around the training of figure painters, is the work in the life room. Creating of figure and portrait paintings builds upon all the skills that a student develops during his initial years of training. By the time an artist is ready to tackle a full-color figure painting, he is confident in his drawing skills and understands the subtle value shifts and value composition required for successful figure painting. He has also studied the structure and gesture of the figure and mastered measuring, proportion, and anatomy. When all these skills come together the student is ready to bring his experience to bear when working from life.

As with many of the earlier painting stages, color poster studies play a crucial role when the student works from life in full color. This quick painting of the model, normally done in one sitting, provides a simplified way of conceiving the color of the figure in its environment, its relation to the background, the ground plane, and any other elements, such as drapery. This practice gives the artist a chance to try out an idea and see if it will work without a vast investment of time and resources. Interestingly, some of these quick studies capture the energy and spontaneity of the model in a manner that is difficult to get in a longer, more developed painting, and at times these small studies are used to inform a more extended painting.

The next practice is one of pushing an idea into a finished painting. Different ateliers go about this in various ways, which will be discussed in more detail later. This practice normally involves some kind of drawing, an underpainting (even if it is just a thin tonal wash), and an overpainting. Creating a finished work forces the student to resolve whatever problems arise. He cannot hide sloppy, indecisive work with flashy, sketchy paint handling, which disguises inaccuracies. Although the results can, at times, be awkward, the practice will result in a more competent, well-trained artist who will be unhindered by the lack of knowledge about how to finish a painting and therefore can attempt

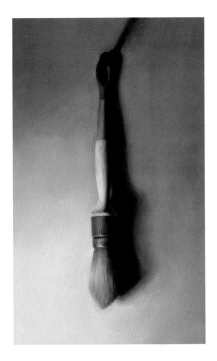

Yumiko H. Dorsey, *Brush,* 2006, oil on panel, 12 x 9 inches, courtesy of the Aristides Classical Atelier

Yumiko created this trompe l'oeil painting using a predominantly cool palette with just a few color accents to move our eye throughout the image.

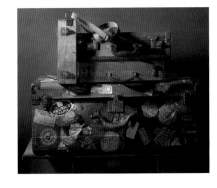

Nicholas Raynolds, *Trunk and Cases,* 2005, oil on linen, 30 x 36 inches

Nicholas juxtaposed the three-dimensional structure of the cases with the two-dimensional stamps while simultaneously introducing the thematic element of journeys.

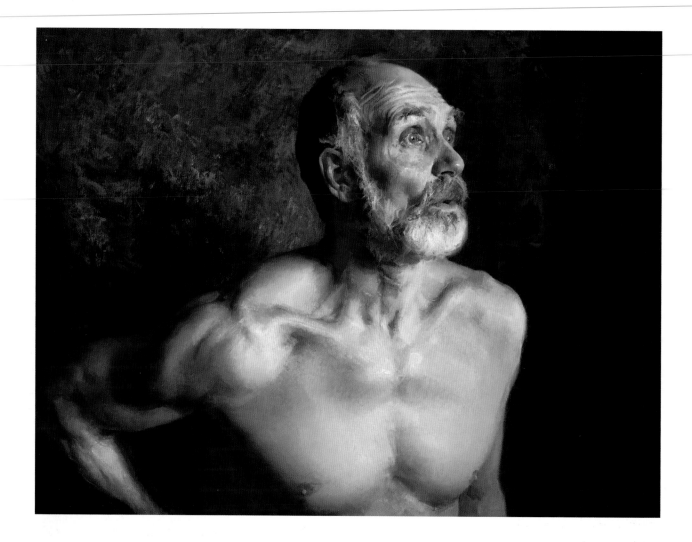

Michele Mitchell, *Moving toward the Light*, 1993, oil on canvas, 36 x 42 inches, collection of the artist

Michele created this painting when she was a student at Atelier Lack, inspiring me to apply to study there the following year. She built up the compact, overlapping forms with layer upon layer of broken color, lending vitality to the surface of the painting and drawing attention to the quality of the light itself.

bold things. Often the small forms that are discovered in the later stages of the creation of the painting will inform the beginning stages of the next work once the student gets more adept and quicker at proceeding. So after a few years of training the artist is capable not only of quick and adroit brushwork but also of accuracy and subtlety in his execution of his mature work.

The reader should now have a general overview of the atelier curriculum. All of the exercises—from year one to the completion of the program—are designed to help the student solve problems from many different perspectives. The studio side of the program is also balanced with theoretical considerations found in lectures and classes in color theory, perspective, anatomy, and art history. The end result is that the artist is fully equipped to embark on a career as a painter.

A Note About the Structure of This Book

Chapter One outlines the education one receives with an atelier curriculum; however, in reality, the progression of training is often layered, the sequences blurred. In an actual program, the student may spend half a day on figure drawing or painting and the other half on studio work. Someone might find himself drawing part of the time and painting the rest, or doing valued-based work in one area and color in others. This type of education is customized according to the goals and strengths of the individual.

Lessons are included at the end of the first six chapters of this book. These lessons roughly correspond to the sequence in which a student might encounter them in an atelier environment. By completing these exercises, the reader will be able to more fully digest the concepts they are reading about, translating them from theory into practice. Also, a discussion about materials and archival practices, written by a painting conservator, appears on pages 128–131.

Part four, the masterworks chapters, showcases significant historical and contemporary paintings and explores the ways in which these master artists employ key artistic principles discussed in earlier sections of the book. Through asking a series of questions about each piece, we learn about the conscious and unconscious decision-making process of each artist and how this process affects both the creation of the work and its perception

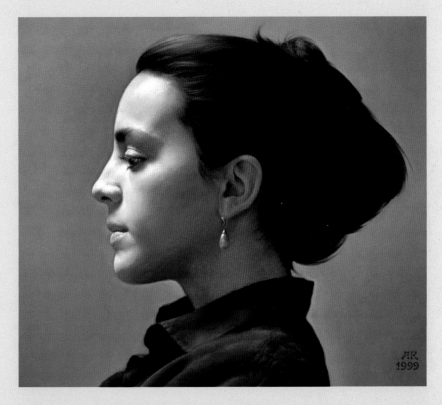

by us, the viewer. We can better understand these methods as we study the application of universal principles such as composition, value, and color in relation to masterworks.

One of the most powerful tools at the student's disposal is studying works in which the elements and principles of art are used in perfect harmony. Therefore, the images in the masterworks chapters make excellent choices for the master copy assignment. Looking carefully at this work, the student will be able to draw back the curtain of illusion and study the

mechanics that culminate in a powerful emotional experience. The more adept one's eye becomes at decoding this language, the greater one's ability will be to use these elements, and the greater one's enjoyment will be when looking at a work of art.

Anthony Ryder, *Justine,* 1999, oil on linen, 12 x 14 inches

Ryder, a former student of the Art Students League of New York and Ted Seth Jacobs, combined his exquisite drawing skills with a love of form and color in this image.

Timeless Principles

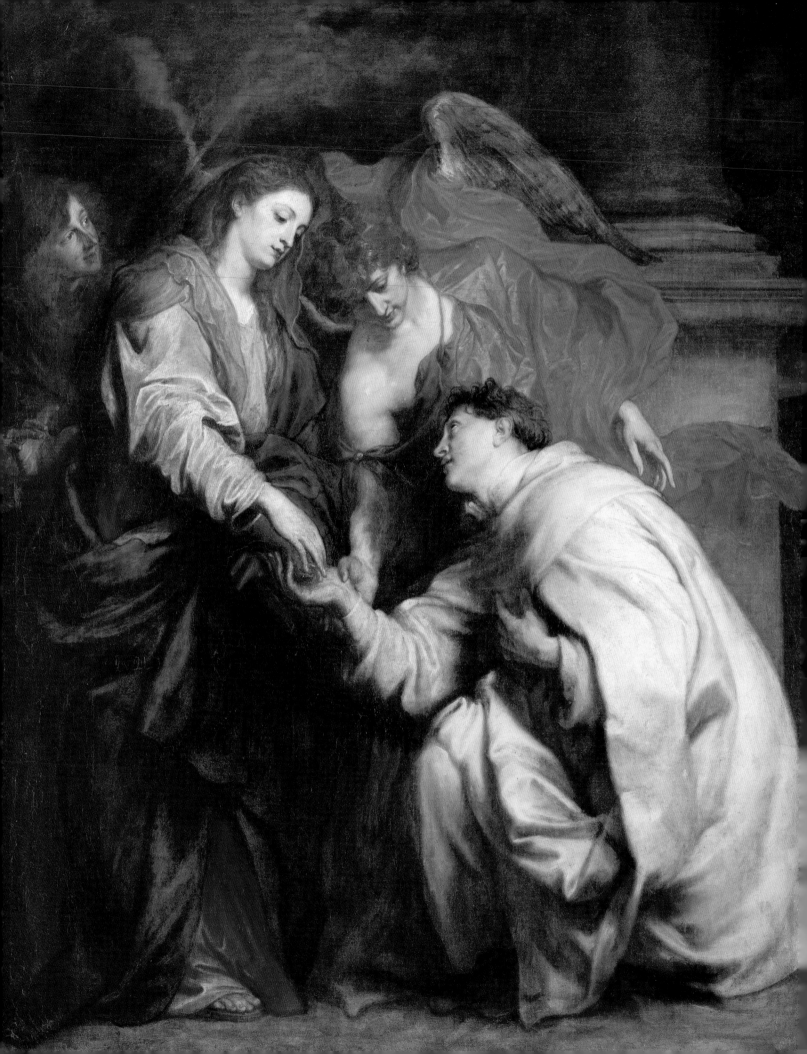

COMPOSITION

Design Systems of the Masters

"I am every day more and more convinced of the truth of Pythagoras's saying that Nature is sure to act consistently, and with a constant Analogy in all her operations: From whence I conclude, that the same Numbers, by means of which the agreement of sounds affects our ears with delight, are the very same which please our eyes and mind. We shall therefore borrow all our rules for the finishing of our proportions from the musicians." — LEON BATTISTA ALBERTI (from *The Ten Books of Architecture*, Book IX, Chapter V)

Composition is an essential element of master paintings. In his book *On Painting*, architect, artist, and mathematician Leon Battista Alberti ranked composition as the second most important element of painting (with drawing being first and color third). Master painters agreed with Alberti and accordingly put much thought and effort into the design of their pictures. As a result, these artists created consistently masterful works. Today, composition is perhaps the least studied and most underrated area in art. This may come as no surprise, for the contemporary classical realist painter has had to reconstruct the skills of representation that were lost in the century and a half of modernism. So much time and effort has been spent rediscovering the painting traditions of the past—including mastering materials and grasping and applying techniques—that pictorial composition seemed like a problem that could wait until another day.

That day has now arrived. Some of today's painters can render figures and objects as well as the master painters of the past; however, these painters do not consistently produce masterful compositions, largely because they rely solely on their intuition to group figures, objects, and spaces within the frame. Artistic intuition and sensitivity to order are vital elements that contribute to the style of an artist, yet these elements alone are not enough if one is to achieve a consistent level of compositional mastery.

Design rules must be actively sought out, learned, and applied. There are rules for drawing, there are rules for color, and there are rules for composition. In fact, the rules or limits of any discipline actually help define it and give the participant in that discipline freedom to create and express himself. Jacques Villion (the brother of Marcel Duchamp) put it well when he said, "In the artistic chaos of these last years, when the absolute liberation of the individual instinct has

Opposite: Anthony Van Dyck, *Mystic Engagement of the Beatified Hermann Joseph with the Virgin Mary*, 1630, oil on canvas, Kunsthistorisches Museum Vienna, Vienna, Austria

Historically, master artists, such as Van Dyck, were well versed in how to use the rules of composition to maximum advantage. In this painting our eyes travel along the dominant diagonal, from upper left to lower right. Notice how the direction of the gaze, from the Madonna to the saint, reinforces that primary movement. An ellipse, which is implied by the arch formed by the upper part of the Madonna's arm and the outstretched hand of the angel, keeps our interest in the center of the painting.

Photo Credit: Erich Lessing / Art Resource, New York, New York

Previous Spread: William Bouguereau, *The First Mourning* (detail), 1888, oil on canvas, 79 7/8 x 99 1/8 inches, Museo Nacional de Bellas Artes, Buenos Aires, Argentina, courtesy of Art Renewal Center

brought it to the point of frenzy, an attempt to identify the harmonic disciplines that have, secretly, in every period, served as foundations for painting may well seem folly. Yet the framework of art is its most secret and its deepest poetry." The time has come for the modern master painter to begin to reconstruct the skills and unearth the lost traditions of this secret framework.

We can learn about design systems simply by turning to several passages in art history. The design systems of the past were based on an extensive and profound study of nature. Early peoples saw order in nature, which manifested itself in easily identifiable patterns, such as the Earth's rotation forming the succession of day and night, the passage of seasons, and the cycles of life. They also saw

order in the knowledge of geometry, which at the most rudimentary level can be defined as a study of idealized forms that are hinted at in nature. It is easy to see the obvious pattern repetitions found in the macrocosm of nature, but more difficult to see the order that exists on a much smaller scale.

Great minds are marked by curiosity, retaining their childlike inquisitiveness as they age, taking nothing for granted. While the rest of us settle into a kind of wakeful sleep, they remain alert and questioning. This curiosity can sometimes result in great discoveries. Think of Archimedes who, as the water overflowed when he got into the tub, shouted "eureka" as in a flash he understood the principle of how water displacement could determine the volume of an object. There are many other famous stories. If Newton's apple fell on my head, all I would find would be a lump; he discovered gravity. Similarly, the history of composition has interesting tales of great minds looking for hidden patterns and order and finding it where the rest of us just see chaos.

Pythagoras Discovers Harmonic Proportions

Compositional schemes and their accompanying philosophies have come in different forms over the centuries, as artists have looked for new ways to arrange figures and objects within a given space. (In the chapters on value and color we discuss alternate means to govern the eye, such as the use of tone, rhythm, gradation, visual weight, and balance, but there are far more methods for composition than we have space to discuss. Excellent books that fully describe alternate systems include those written by Henry Rankin Poore and Rudolf Arnheim.) Yet none has dominated the art worlds of the past so much (and none is as little known today) as the composition schemes based on harmonic proportion. This particular field of design owes its discovery to Pythagoras.

Pythagoras, the ancient Greek mathematician and philosopher, was an unlikely ally for artists, architects, and musicians. Legend has it that in 500 B.C.E. Pythagoras was walking by a blacksmith's shop when he noticed that each of the sounds emanating from the hammers hitting the anvil was different. He went into the shop to investigate and discovered that the different sounds were caused by the various sizes and weights of the hammers. This led to his discovery that number (e.g., the size and weight of the hammer) creates a physical effect in space and time (in this case, a sound).

To use another example, consider the xylophone. It has eight different-sized panels that correspond to the musical scale that we know as do-re-mi-fa-sol-la-ti-do. The larger panels, when struck, make a lower sound than the smaller panels, which make a higher sound. Now imagine a universe where there is no difference in sound based on striking the different sizes and weights of the panels of the xylophone; that would be a world where number would make no difference and would have no meaning. In our universe, however, number matters.

Odd Nerdrum, *Three Namegivers*, 1990, oil on canvas, 81 1/2 x 89 inches, courtesy of Forum Gallery

Nerdrum's painting is an essay in contrasts as he creates tension and resolution with line, value, and color. He juxtaposes diagonal lines with horizontal ones, volumetric form with flat shapes, and saturated color with neutrality. Together these elements keep our eyes continually moving through the picture.

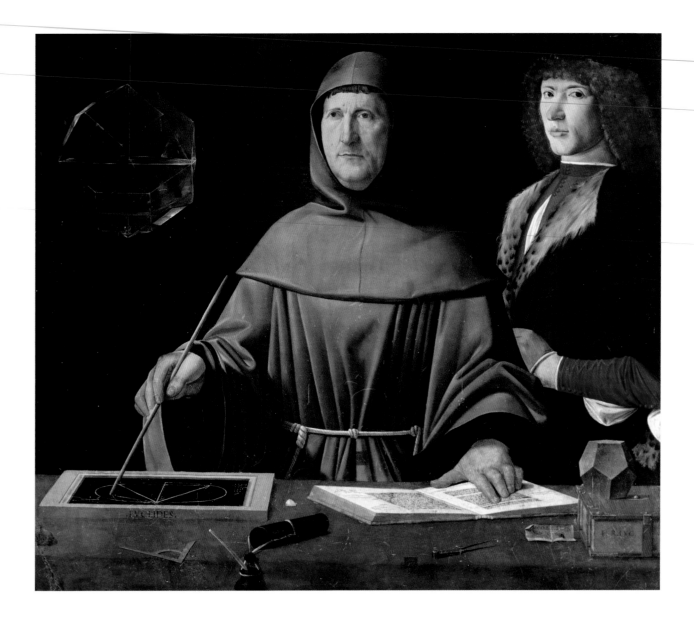

Jacopo de' Barbari, *Fra Luc Pacioli,* 1495, oil on panel, 39 x 47¼ inches, Museo Nazionale di Capodimonte, Naples, Italy

Pacioli, a Franciscan friar and mathematician credited as the father of accounting, wrote a book called *The Divine Proportion,* with illustrations by Leonardo da Vinci. Pacioli also translated some of the writings of his teacher, Piero della Francesca.

Photo Credit: Erich Lessing / Art Resource, New York, New York

Pythagoras wanted to further investigate this mysterious connection between number and physical reality as it is manifested through sound. To do so, he conducted experiments with musical strings of differing lengths. Pythagoras found that, like the hammers, the shorter strings (or smaller numbers) produced higher-pitched sounds while the longer stringers (or larger numbers) produced lower-pitched sounds. He then made a startling discovery. First, he struck the string. Then, while it was vibrating, he lightly touched his finger along the string. In most places, this deadened the sound. Yet in a few certain places a remarkable physical phenomenon occurred—the clear and pleasing ringing of a musical tone. These new tones were created at the one-half, two-thirds, and three-quarters divisions of the string when measuring the string from right to left. When measuring the string from left to right, however, these tones are created at the one-quarter, one-third, and one-half divisions.

These pleasing tones are called "harmonics" or "musical root harmonies." They are the audible result of the string taking on a new physical form, called a "sinusoidal wave" (better known as a "sine wave"), when it is pressed at the one-half, two-thirds, and three-quarters division points. We now refer to these key positions along the string as the "octave," the "perfect fifth," and the "perfect fourth," respectively. Furthermore, Pythagoras noticed that these divisions were not strange, irrational, or uncommon numbers. Rather, they were simple whole-number ratios consisting of the numbers one, two, three, and four. The harmonic ratios of the vibrating string show us that certain intervals in vibrations create a pleasing, or "harmonic," physical effect to our ears, while other ratios produce an effect that is not pleasing our ears. Not only does size or number matter, but now ratio matters as well.

Pythagoras then realized that the sound produced by an open vibrating string and the sound produced by the one-half division of the string were almost identical in tone but were different in pitch. In other words, the sounds were simultaneously the same and different. Furthermore, Pythagoras realized that the relationship of the sound of the open (untouched) vibrating string and the sound of its one-half division produced a beginning-to-end, or full-circle, phenomenon or sensation to the human mind. This one-half division is of course the octave, and what Pythagoras experienced was the central characteristic of harmony—sameness and difference. Harmony occurs when the parts and the whole relate to each other in a certain way, depending on the circumstance.

Plato wrote about Pythagoras's discovery and the concept of harmony in *The Timaeus.* This concept of harmony through ratios and proportion was given much importance and study in ancient Greece, and, accordingly, they had a whole field of science, called "mediation," devoted to this subject. In his book *Sacred Geometry,* Robert Lawlor discusses with great insight the Greek science of mediation.

Pythagoras next set out to find the intervals of sound between the first note (the tonic) and the last note (the octave). In doing this, he uncovered one of nature's greatest mysteries: the musical scale. (Pythagoras did indeed discover, not invent, the musical scale.)

In short, order and beauty in sound are determined by the musical root harmonies, which in turn are the result of a natural phenomenon that occurs when certain physical intervals of vibrations are produced. These intervals of vibrations (or notes) that create pleasurable sounds are measured by ratios. The string does not create its own order; instead, it provides us with an example of an existing subtle universal or cosmic order that is hard to see on a small scale but that is profoundly felt.

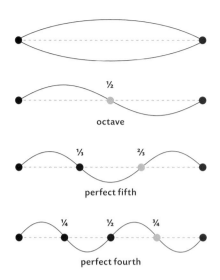

The sine waves pictured here illustrate the geometry that occurs when the vibrating string is lightly touched at the one-half, two-thirds, and three-quarters ratios of the string, creating the octave, perfect fifth, and perfect fourth, respectively.

Plato's ideal world and Aristotle's earthly world
are suggested in this monumental painting, as
Plato points up while Aristotle points down.
Surrounding the two Greek philosophers are
other important contemporary scientists,
mathematicians, and astrologers. This painting
was commissioned by Pope Julius II and shows
the Renaissance fascination with the classical
world. Notice the detail. Pythagoras is shown
explaining musical harmony; the board held by
his pupil features a diagram of the harmonic
musical ratios.

Artist Unknown, *Mars and Venus*, circa first
century B.C.E.–C.E. 79, fresco, Museo Archeologico
Nazionale, Naples, Italy

This deliberate composition is locked firmly
into the diagonals of the square. Those angles
are reiterated by the staff held by Venus and
the arrow held by Cupid. Interestingly, the
lyrical contour lines found in ancient frescos
can later be seen in the work of such artists as
Raphael and Ingres.

*Photo Credit: Scala / Art Resource, New York,
New York*

From the Greeks to the Renaissance and Beyond

Vibrations in sound are picked up by our ears, and we instinctively find the
sounds made by some of those vibrations to be more pleasing than others.
Curiously, the same ratios that are pleasing to our ears provide pleasing intervals
to our eyes. Throughout history—from ancient Greece, through the Renaissance,
and up through the first half of the nineteenth century—master artists have
used the harmonic ratios discovered by Pythagoras to divide up their pictorial
space, mirroring the universal patterns found in the intervals of sound and
proportions of nature.

As mentioned earlier, Plato was the first to write about Pythagoras's harmonic
ratios and its accompanying philosophy in his book *The Timaeus*. After Plato,
came Vitruvius, a first-century Roman architect with a love of ancient Greek
culture. Vitruvius is credited as being the first to record the design principles
discovered by the ancients in his *Ten Books on Architecture*, dedicated to Caesar
in about 27 B.C.E. Vitruvius wrote about the harmonic ratios as based in Greek
music theory, as found within the design of man, and as used in art and archi-
tecture. After Vitruvius came Boethius, a fifth-century philosopher who wrote
about Pythagoras's harmonic ratios.

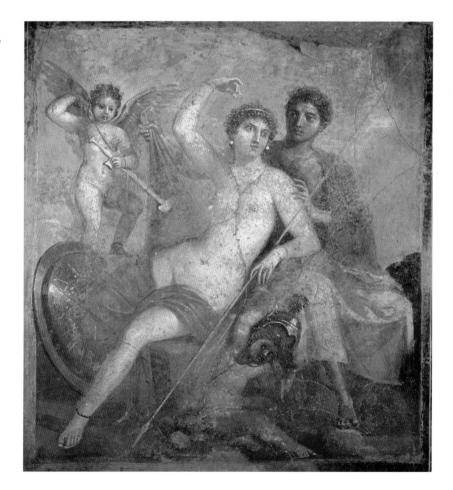

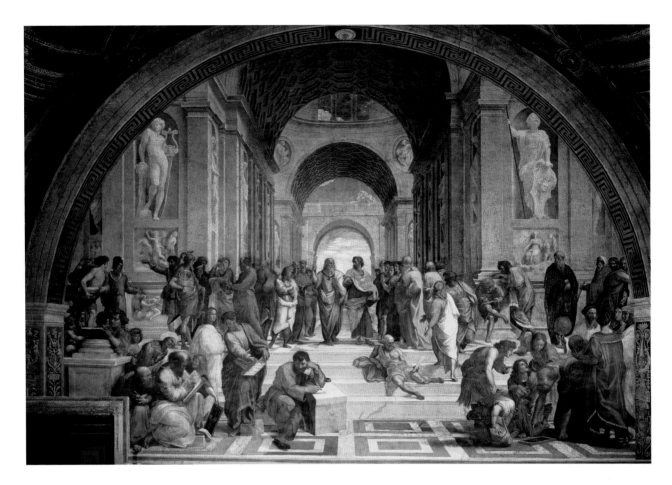

After Boethius came Leon Battista Alberti. The quintessential Renaissance man, Alberti rediscovered, examined, and expanded knowledge of these ancient design principles in his own *Ten Books on Architecture*. Alberti wrote in great detail about the use of the harmonic ratios in design. He refered to the ratios using the language of musical terms as well as of numbers. He defined harmony and outlined the philosophy behind the harmonic ratios exactly as they were defined and outlined by Pythagoras and Plato almost two thousand years before him. He provided numeric examples of how to divide space harmonically based on the size of the frame or platform to be used. He outlined divisions based on small, middle, and large platforms. According to Renaissance scholars, copies of Alberti's *Ten Books on Architecture* widely circulated among Renaissance artists, thanks in large part to the then-recent invention of the printing press. Alberti was so influential that many of his artistic contemporaries embraced the exact letter of his text, including his writings on the harmonic ratios.

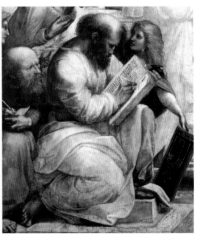

An example of Alberti's influence on the Renaissance mind can be found in a letter written around 1535 by Francesco Giorgio, a Franciscan monk known for his expertise on proportion. In the letter, Giorgio details the design plans for a new church, San Francesco della Vigna in Venice, which he specifically describes

as being based on the harmonic ratios and their accompanying Pythagorean-Platonic philosophy. Giorgio's design was approved by a group of three people—a humanist, an architect, and a painter. The painter was none other than Titian. (For those who wish to study this letter, it can be found reproduced in Rudolph Wittkower's *Architectural Principles in the Age of Humanism.*)

For Renaissance artists, the time was right to take hold of the harmonic ratios as a basis for composition. In contrast to medieval artists, who embraced elaborate design, Renaissance artists were looking for an uncomplicated way to organize their compositions as well as a sophisticated, powerful philosophy; the concept of harmonic ratios provided both. This was indeed a win-win situation for the Renaissance mind. And most major artists in the centuries that followed—from Nicholas Poussin and Peter Paul Rubens up through Jacques-Louis David and Jean-Auguste-Dominique Ingres—continued to be fascinated by these systems of the ancients.

Design Systems in Theory and Practice

The history of composition, like the history of many subjects, is murky. Details are difficult to come by, and analysis of composition in art takes much time, persistence, and specialized knowledge across several disciplines. Jay Hambidge, in his book *The Elements of Dynamic Symmetry,* says, "The recovery of these design principles by analysis is difficult, requiring special talent and training, considerable mathematical ability, much patience, and sound aesthetic judgment." This may indeed be a reason why very little has been written on the subject of design principles of past master paintings. Charles Bouleau's book *The Painter's Secret Geometry* is perhaps one of the greatest books written on the use of geometry in art. While these books are certainly worth exploring, one can begin to understand composition simply by studying two different approaches—the armature of the rectangle and root rectangles.

THE ARMATURE OF THE RECTANGLE

Master artists of the past used geometric tools such as dividers, calipers, straightedges, and compasses to divide the picture plane in the process of composing their paintings. These, along with books on the instruments of geometry, were the standard tools of the artist's trade. While these tools helped the artist compose paintings, master artists also used the diagonals of the rectangle to divide and subdivide the picture plane. As a result, they relied on known geometric principles to determine certain harmonic divisions.

The combination of the rectangle and its diagonals provide a simple means of determining harmonic divisions, for when fourteen diagonal lines are super-imposed upon a rectangle, a compositional grid is formed; the intersections of these diagonal lines determine the location of the harmonic divisions. Bouleau referred to this grid as the "Armature of the Rectangle." This armature provides the limits of composition, and within these limits, compositions can be varied

endlessly. The importance of the armature of the rectangle is paramount to an artist. Its meaning should be understood and its construction should be memorized and practiced until it becomes second nature. This is the musical scale of composition.

Let us now construct this armature of the rectangle:

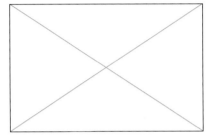

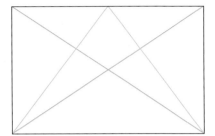

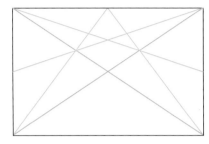

1. Start with a rectangle of any proportions, including a square. Draw two long diagonals connecting the opposing corners of the rectangle. The intersection of the diagonals provides the one-half division of the rectangle from both the vertical and horizontal perspective.

2. Draw two diagonals from the midpoint of the top down to the corners of the rectangle. The intersections of these diagonals with the main diagonals divide the picture plane at the one-third division, both vertically and horizontally (as well as the two-thirds division vertically).

3. Draw two diagonals from the top corners of the rectangle to the midpoint of their opposing sides. The intersection of these diagonals divides the picture plane at the one-quarter division vertically, and at the one-half division horizontally. Notice that the intersection of these diagonals with the rectangle's main diagonals also produces the one-third and two-thirds vertical divisions of the picture plane.

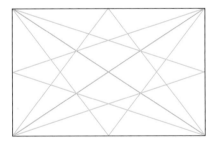

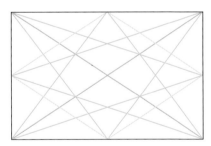

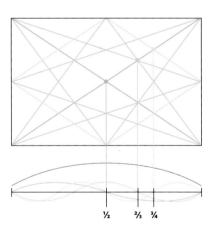

4. Thus far all of the diagonals have originated from the top side of the rectangle. Repeat steps 2 and 3 from the remaining three sides. The rectangle should now look like this. Notice that the intersections of the diagonals, with the exception of a few, produce the harmonic divisions from all sides. This armature structure should begin to make sense.

5. Draw a line from the midpoint of the top to the midpoint of each side; repeat from the midpoint of the bottom. The harmonic armature of the rectangle is now complete.

6. This is the musical scale of composition.

This armature can be used to create an endless variety of compositions, from simple to complex, all while retaining a system of order found within nature. Let's examine the manner in which Diego Velázquez utilized the armature of the rectangle to create the masterpiece *Las Meninas*.

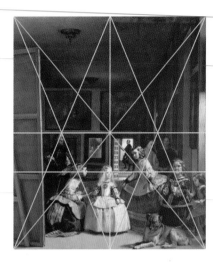

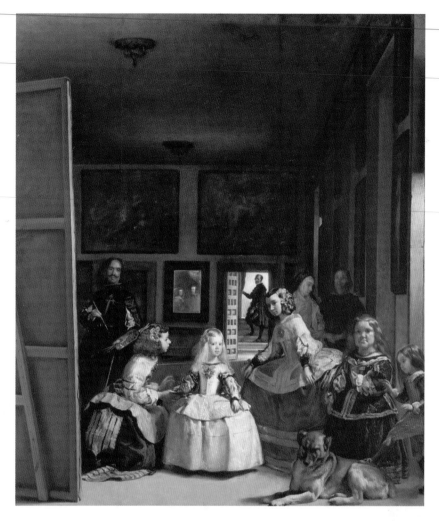

Diego Velázquez, *Las Meninas*, 1656, oil on canvas, 125 1/8 x 108 5/8 inches, Prado, Madrid, Spain, courtesy of Art Renewal Center

Famous for its groundbreaking design elements, Velázquez's painting shows us a room as seen by the king and queen of Spain (who are reflected in the mirror) as they sit for their portrait. Notice how, by including the open door in the background, the artist has created an exit point for the eye, yet he brings us back by the glance of the man within the door frame.

Diego Velázquez was a master geometrician. He had an extensive library of geometry books, ranging from Euclid's *Elements* to Vitruvius's *Ten Books on Architecture* to Palladio's *Four Books on Architecture*. Velázquez also had a wide assortment of geometry tools, which he used for his compositions. Velázquez had a great spontaneity about his work, yet his essential composition was very much based on his knowledge of harmonic design principles.

In *Las Meninas*, Velázquez contained all the figures within the horizontal one-half division of the picture plane; the artist's own head and the frame of the mirror are precisely at that division line. The vertical one-half division runs along the edge of the open door in the background and also frames the right side of the central girl. The horizontal two-thirds division runs through the eyes of the two girls on the left side of the painting and also touches the bottom of the chin and top of the head of the two figures on the far right side of the canvas.

Velázquez made use of both major diagonals. The diagonal that runs from lower right to upper left frames the angle of one of the main girls—her body

and arm literally rest upon the line. This diagonal also sets the top-corner placement of the massive canvas within the painting itself. The diagonal that runs from lower left to upper right sets the angle of the girl on the far left and also runs through the face of the figure in the mirror. In addition, the diagonal that runs from the lower middle to the upper left encloses the figure of the artist himself, while the adjoining diagonal, which runs from the lower middle to the upper right, sets the angle of the woman in the background. Many artists have been influenced by Velázquez's compositions. John Singer Sargent based his remarkable *The Daughters of Edward Darley Boit* on *Las Meninas.*

I have found very little written about the use of the harmonic divisions in master compositions. However, upon direct analysis of master compositions, I have

Titian, *Bacchus and Ariadne,* 1522–1523, oil on canvas, 68 7/8 x 74 3/4 inches, National Gallery, London, England, courtesy of Art Renewal Center

Titian created an intense, balanced distribution of color across the surface of his canvas. Despite having limited access to intense pigments, Titian created prismatic colors with his masterful use of glazing. This is also a fantastic image to analyze using the armature of the rectangle.

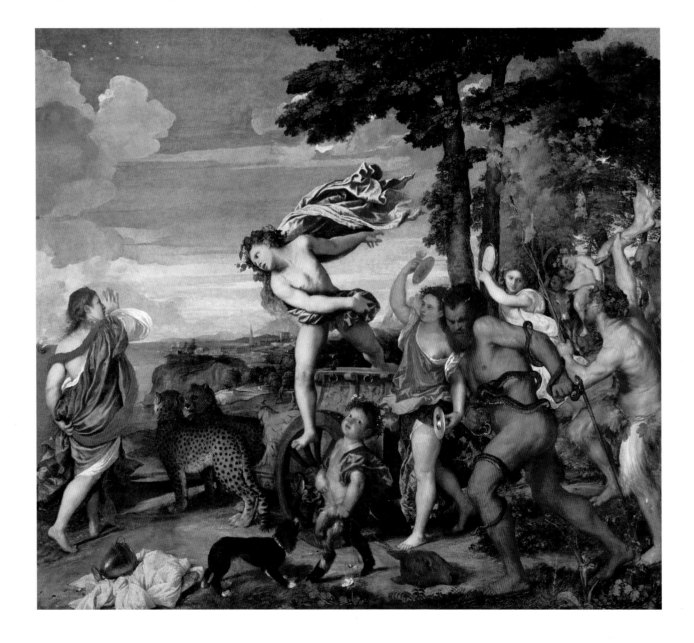

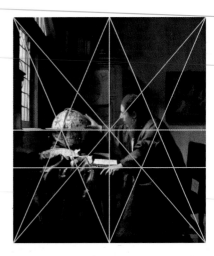

Opposite: Johannes Vermeer, *The Astronomer,* 1668, oil on canvas, 19 ⅝ x 17 ⅝ inches, Louvre, Paris, France, courtesy of Art Renewal Center

This exceptionally designed interior captures the quiet sobriety of a scholarly life. The angles of the astronomer's body, the hand touching the globe, and the head all follow major diagonal lines. The horizontal one-half and two-thirds dividing lines also play prominent roles. In addition, the astronomer's arms form an ellipse that embraces the celestial globe and tabletop; while repeating diagonals echo the direction of the light itself.

found that the master painters who used these harmonic divisions used them in a variety of ways. One of the most common techniques was to frame subjects or objects at certain harmonic divisions. Another common technique was to run a harmonic division through the eye or eyes of their figure(s). And yet a third common technique was to rest or place figures along the diagonals of the rectangle.

The divisions were used in other ways as well, but perhaps the greatest lesson for today's artist in learning how to use the harmonic divisions is to study the compositions of the past master artists. Titian's *Bacchus and Ariadne* utilizes the armature of the rectangle, as does Vermeer's *The Astronomer.* Study these images and then try to find other examples on your own. Take a master painting, overlay the harmonic armature, and see if the artist used it; if so, then articulate how it was used. This is a trial-and-error approach that takes much patience, yet the reward is unlocking some of the secrets of past master composition.

After you have made a few successful studies, then try some compositions yourself. Start simple; make a composition with just a few divisions. As you become more familiar with the armature, you can try more complex compositions. Then you can overlay circles, ellipses, golden ratio forms, oblique lines, and other design patterns. You have the musical scale of composition; you are now only limited by your imagination.

The circle and the square composition is based on the design of a circle inscribed within a square, and it was used often by master artists and architects. Its origin dates back to the ancient Greeks and it was first recorded by Vitruvius. This pictorial device was derived from the philosophy of reconciliation between a finite world (represented by the square) and an infinite world (represented by the circle). *The Deposition,* shown on the following page, utilized this convention. Raphael angled and crowded the outside figures to form a circular design within a square frame. He then used the two main diagonals of the square to rest the head of the central woman and to run up the arm and position the angle of the man in the red shirt, respectively.

Next, Raphael made use of the harmonic divisions as given by the armature of the rectangle. The horizontal one-fourth division sets the upper horizon of the figures and runs though the eyes of the central man. The horizontal one-third division runs through the eyes of the central woman. The horizontal two-thirds division sets the lower horizon of the Christ figure. The vertical one-third division coupled with the vertical one-half division frames the central woman on the left and the woman on the right respectively, while the vertical one-half division goes through the central male figure's leg and bisects the picture plane. The vertical three-fourths division, coupled with the vertical one-half division, frames the central man. Using the circle and the square design coupled with the harmony of the musical ratios, Raphael created plastic music that dazzles us many years later.

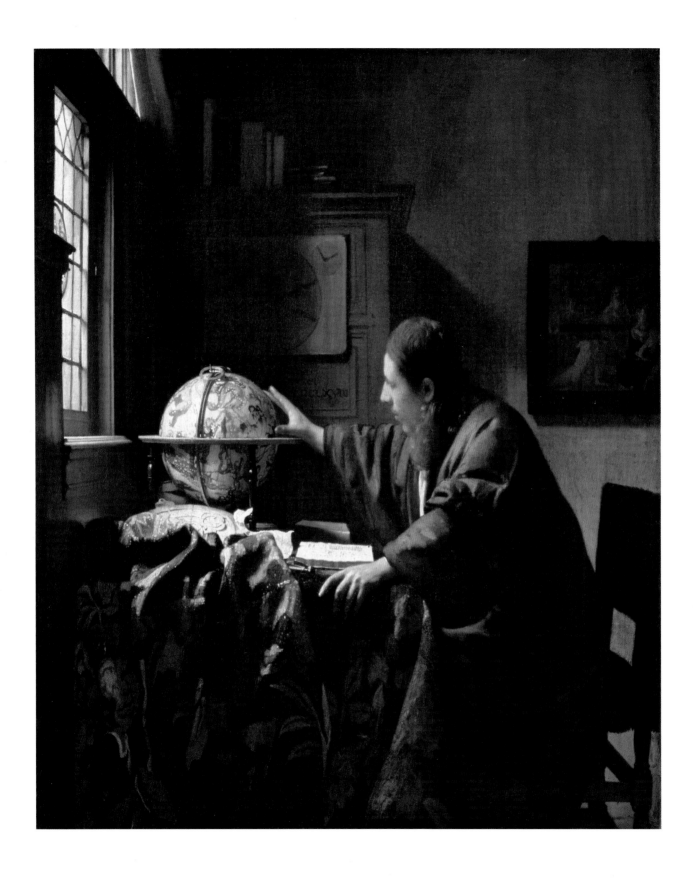

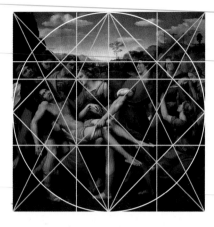

Raphael, *The Deposition*, 1507, oil on panel, Galleria Borghese, Rome, Italy, courtesy of Art Renewal Center

Raphael's painting is based on the circle and the square design coupled with the harmony of the musical ratios; combined, these create a stunning piece of visual music.

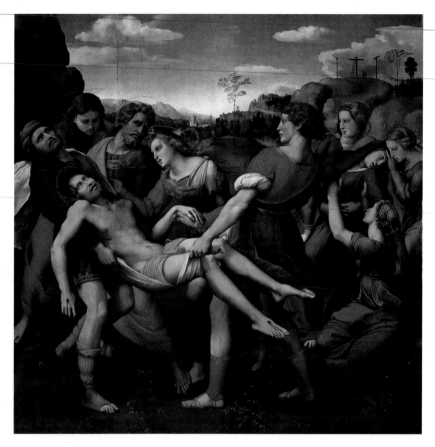

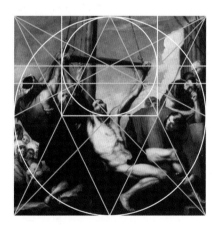

Jusepe de Ribera, *The Martyrdom of Saint Philip*, 1639, oil on canvas, 92 1/8 x 92 1/8 inches, Prado, Madrid, Spain

This powerful composition utilizes two circle in a square compositions, one contained within the other.

Photo Credit: The Bridgeman Art Library

Similarly, Ribera used the circle and square composition and the armature of the rectangle for *The Martyrdom of Saint Philip*. Notice how he crowded his figures in a circular pattern within a square frame. He then employed the diagonals of the armature of the rectangle by using the two main diagonals— through the face of the main figure in one direction, and through the left arm of the figure in the opposite direction. Also, the two diagonals that start in the bottom center and run to the upper corners frame the outside figures. In looking at the musical ratios, we can see that Ribera rests the head of the central figure on the horizontal one-half division. The horizon of the figures is set at the horizontal two-thirds division, with the exception of one figure on the far right who is contained within the three-fourths division, which also runs through the horizontal wooden beam. I recommend to my students to take a sheet of acetate and a pen and draw these lines themselves.

Ribera pushed the circle and square composition idea even further by creating a second, smaller circle within a second, smaller square. The baseline of the smaller square rests on the horizontal one-half division line of the larger one; its left edge rests at the vertical one-fourth line of the larger square and its right edge rests at the vertical three-fourths line. What is fascinating about this second formation is that the smaller circle encompasses the arc formed by the arms of the saint being martyred—making a deliberate statement, considering the symbolism of the circle.

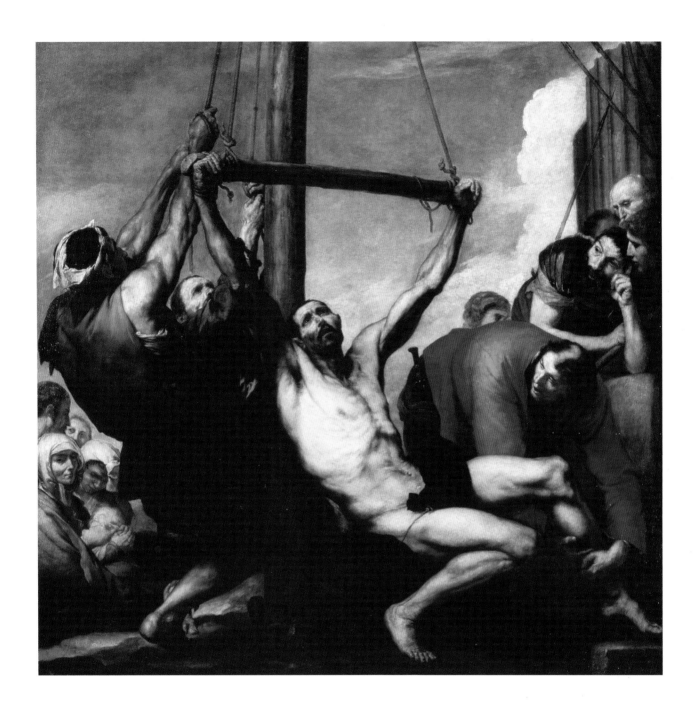

Many Renaissance artists took this idea one step further and embraced the circular canvas, commonly known as a tondo. The circle itself connoted Heavenly space and so was appropriate for religious subjects, such as the Madonna and child. Many of these paintings employed the armature of the rectangle within the circular configuration of the canvas. This is one of the many strengths of the armature of the rectangle system: It interweaves the subjects with the shape of the canvas and can take on many forms, depending on the goals of the artist.

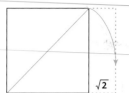

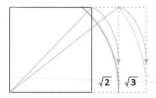

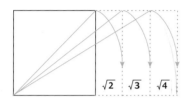

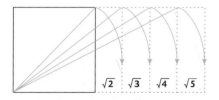

Root rectangles are created by taking the measurement of the diagonal of a square or rectangle and using that measurement to define the width/baseline of a new rectangle. Shown here (from top to bottom) are root 2, root 3, root 4, and root 5 rectangles.

ROOT RECTANGLES

Another powerful system of composition that is used in art is called the "root rectangle" system. Root rectangles are rectangles whose dimensions are based on the ratio of the square root of the numbers 2, 3, 4, and 5 to 1. In other words, a root 2 rectangle is a rectangle whose height is approximately 1.41 (the square root of 2) times bigger than its width. (If the rectangle is oriented horizontally, as in the examples shown here, then its width will be the larger of the two numbers, but the ratio will remain the same.) Similarly, a root 3 rectangle is a rectangle whose height is approximately 1.73 (the square root of 3) times bigger than its width; a root 4 rectangle consists of two attached squares, since the square root of 4 is 2; and a root 5 rectangle is a rectangle whose height is approximately 2.23 (the square root of 5) times bigger than its width.

To create a root 2 rectangle, first use a ruler to draw a square. Then draw the diagonal of the square from the lower-left to the upper-right corner, marking the length of the diagonal on the ruler. Swing the ruler down from the upper-right corner to the baseline of the square. (The easiest and most common method is to use a compass; however, rulers and strings are often more practical for measuring the diagonal and swinging it down.) The mark that measured the length of the diagonal of the square will define the lower-right corner of the root 2 rectangle. Connect the remaining lines accordingly.

Use the same system to create a root 3 rectangle, this time measuring the diagonal of the root 2 rectangle. Swing the compass down to the baseline, use the mark to define a new lower-right corner, and connect the remaining lines.

To create a root 4 rectangle, either draw two adjacent squares or measure the diagonal of a root 3 rectangle, swing the compass down from the upper-right corner to the baseline to define the new lower-right corner, and connect the remaining lines. And finally, to create a root 5 rectangle, measure the diagonal of a root 4 rectangle, swing the compass down to the baseline to define the new lower-right corner, and connect the remaining lines.

Now that you have created the root rectangles, the next step is to draw the divisional lines (armature). Follow the process on the opposite page. However, please notice that the dividing lines of each root rectangle look very different, as we will see on the following pages.

You now have the armature of the root rectangle based on 90-degree intersecting lines. There are several points to consider with this armature: The intersecting lines form harmonic divisions; the vertical lines demarcate smaller (but proportionally identical) versions of the whole rectangle; and the 90-degree intersecting lines can be used to divide the picture plane into geometric proportions.

The discovery of the root rectangles is unknown, but it is likely that its origin is based on the Pythagorean discovery of the square root of 2. The square root of 2 is the length of the diagonal of the square, and its discovery shook up the fundamental belief of the Pythagorean society that everything in the universe can be explained using whole number ratios or rational numbers. The square root of 2 is not a whole number ratio. It is in fact a ratio of geometric form that cannot be expressed with numbers. It is an irrational number. The discovery of the square root of 2 (and the concept of irrationality of number) created such a controversy that legend has it that the Pythagorean Hippasus, who made the discovery, was later drowned for revealing its irrationality to outsiders. Against this historical backdrop, one must begin investigating who first used the root rectangles and how they were used as a compositional system in art.

Jay Hambidge wrote extensively on this subject in his unique and superb book *The Elements of Dynamic Symmetry*. Hambidge, who studied ancient Greek design, identifies the use of root rectangles in the composition of Greek art forms during ancient times. While Hambidge's rediscovery and expansion of the root rectangle system are brilliant, he makes no mention as to the root rectangle's connection to the harmonic ratios. He may have been unaware that a relationship exists between the two. Likewise, Bouleau, who discusses the harmonic armature of the rectangle in *The Painter's Secret Geometry*, makes no reference to Hambidge's root rectangles, and Bouleau wrote his book more than forty years after Hambidge's book. Nonetheless, upon careful study of the divisional lines of the root rectangles, we can show that these lines create the same unique harmonic divisions found in the armature of any other rectangle.

Given that these two methods produce the same harmonic divisions, what differentiates one system of composition from the other? In my opinion there are multiple answers. The root rectangle diagonals provide a greater range of divisions when used as a framework on which to build additional schemes. The 90-degree intersection has geometric proportioning, generating many smaller versions of the main rectangle, which can also grow in a gnomonic rhythm. The second point is more subtle and lies within the incommensurability of the root rectangles.

The secret of the root rectangles is that the measurement of the height and width are numerically incommensurable. In other words, there is no unit of measurement that can be used to measure both the height and the width. Imagine a square made up of sticks where all the sticks are the same size. Now using that same-size stick, try to create the diagonal of the square. It cannot be done. No matter what size stick you use as a standard, you can never create the square and its diagonal with that stick. The two lengths are incommensurable; they cannot be compared to each other with a single certain unit of measurement.

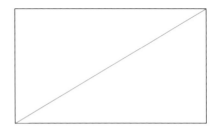

1. Start with a rectangle of any proportions, including a square. (This example features a root 3 rectangle.) Draw one main diagonal of the rectangle, connecting two of the corners.

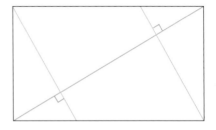

2. Starting from one of the two remaining corners, draw a second diagonal that intersects the main diagonal at 90 degrees. (The end point of this diagonal will not be at the opposing corner.) Repeat this step with the remaining, fourth corner.

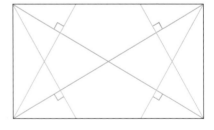

3. Draw the second main diagonal and its two smaller adjacent diagonals. Your rectangle now has four 90-degree intersecting points. The two smaller Xs also become the main diagonals of two smaller root 3 rectangles.

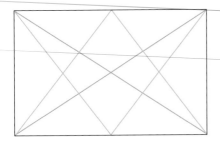

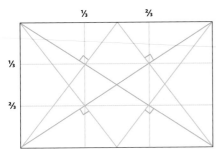

⅓　　⅔

⅓

⅔

√2　　√2

Top: Here is the straight armature of the root 2 rectangle, with the main diagonals and the secondary diagonals indicated. **Middle:** Notice how the crossing of the main diagonals with the secondary diagonals creates four 90-degree angles; these angles (which are sometimes called the "eyes of the rectangle") correspond in this case with the one-third and two-third vertical and horizontal dividing lines. **Bottom:** The secondary diagonals also become the main diagonals of two smaller root 2 rectangles.

Opposite: Peter Paul Rubens, *Venus, Cupid, Bacchus, and Ceres*, 1613, oil on canvas, Staatliche Kunstsammlungen, Kassel, Germany

In addition to using the harmonic divisions established by the root 2 rectangle, Rubens adds a dynamic sense of movement by contrasting the twist of the back of one figure with the turn of the front of another, a common and very effective historical artistic device.

Photo Credit: Lauros / Giraudon / The Bridgeman Art Library

Now imagine a rectangle whose height is the same height as a square, and whose width is the same length as the diagonal of the square. One now has a rectangle where the height and width are incommensurable. There is no unit of measurement that can measure both the height and the width. Because of this incommensurability of form, the mind is continually challenged to measure the relationship between the height, width, and diagonal of the picture plane. This reconciliation of opposing forces creates a balance. This aids in generating a dynamic substructure in the sense that the mind is subtly, continually challenged to understand the design.

A basic tenet of good design is that should define a space that can easily be navigated, yet it should be varied enough to sustain our interest. That is why most of our manmade designs are based on straight lines; the mind can easily measure the relationship of the parts. Imagine how unnerving it would be to continually confront a circular television set, a wave-shaped sign, or an erratically polygonal door frame. Thus, it may be that root rectangles produce just the right amount of balance for the mind to give it the challenge or dynamic feel it enjoys. The mind needs to be able to measure space just as the ear needs to understand a tune. When viewing space, the mind also needs a certain degree of challenge, just as the ear wants to be surprised when listening to music.

Root rectangles are a versatile and powerful platform for composition in painting. In fact, I feel that the root rectangles coupled with harmonic armature lines is perhaps one of the best compositional systems because of its versatility in the sense that its diagonals form both harmonic divisions and diverse parts that work well together. Ironically, during the Renaissance period, root rectangles were not widely used in art because Alberti and Palladio did not like the fact that they were based on incommensurability of ratio. However, both Alberti and Palladio did indeed write about the root 2 rectangle in their respective books on architecture, and some of the master painters of the Renaissance and later master painters did in fact use root rectangles in their compositions. And, as we shall see, they used them well. Let us look at Peter Paul Rubens's *Venus, Cupid, Bacchus, and Ceres*, Caravaggio's *Madonna of the Pilgrims*, and Titian's *The Assumption of the Virgin*, which are based on root 2, root 3, and root 4 rectangles, respectively. An in-depth analysis of the use of a root 5 rectangle in Leonardo da Vinci's *The Annunciation* can be found in the first book in this series, *Classical Drawing Atelier*.

Peter Paul Rubens used the irrational-based dimensions of the root 2 rectangle to maximum effect for the composition of his *Venus, Cupid, Bacchus, and Ceres*. Rubens positioned the main focal point of the painting (the head of Venus) in the upper-left corner of the painting. Her chin rests precisely at the 90-degree intersection of the main diagonal of the armature of the rectangle and the main diagonal of the rectangle on the left created by dividing that larger

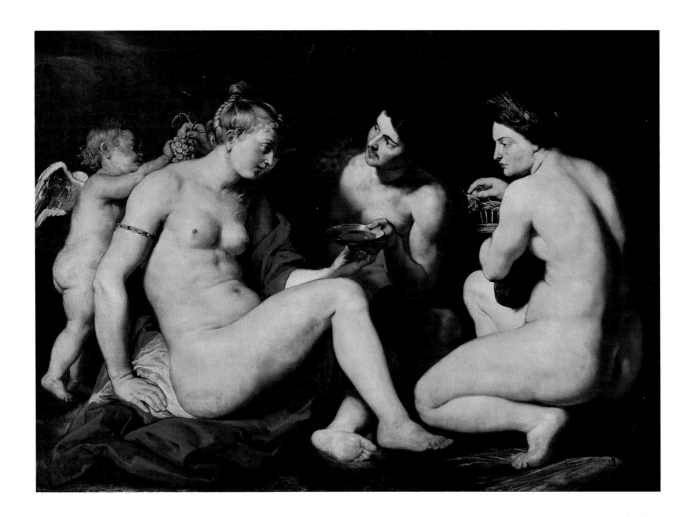

rectangle in half vertically. (Notice how her head follows both diagonals.) This 90-degree intersection positions the angle of her head at the horizontal one-third division of the picture plane. Furthermore, if one were to overlay a logarithmic spiral based on the square root of 2, the center of the spiral would fall on this 90-degree intersection.

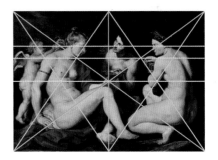

Rubens also made use of the other harmonic divisions. The vertical and horizontal one-half divisions of the painting lead to the hands and cup in the center of the painting, while the line marking the horizontal one-quarter division cuts through the eyes of the figures. The heads on the right half of the painting are defined by the upper-right 90-degree intersection of the main diagonal of the armature of the rectangle and the main diagonal of the rectangle on the right created by dividing that larger rectangle in half vertically.

Finally, the short diagonals that create the 90-degree intersections described previously start from the lower corners and end along the perimeter of the rectangle in the middle of the painting, dividing the space into two smaller root 2 rectangles. Here we can see a correlation with the vibrating string—one

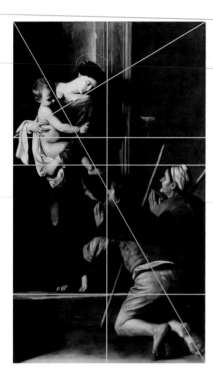

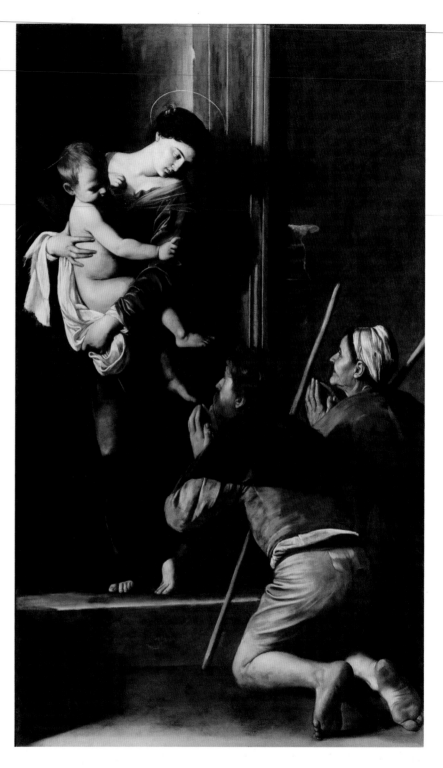

Caravaggio, *Madonna of the Pilgrims*, 1603–1605, oil on canvas, 102¹⁄₄ x 59 inches, San Agostino, Rome, Italy, courtesy of Art Renewal Center

The mother and child, who are physically self-contained through a tender embrace, form an emotional connection with the pilgrims through their gazes. Caravaggio was criticized for using common people and street thugs as models in his paintings and for capturing authentic expressions of their hard lives, such as the ragged clothes and filthy feet of the peasants.

that is only found within the root rectangles. The 90-degree intersection of the main diagonal of the armature of the rectangle and the secondary diagonal of the root 2 rectangle produces a one-half division of the picture plane, which produces a 2 to 1 space of smaller rectangles that have the same dimension as the whole. Like the musical string that creates 2 to 1 vibrations from a one-half division of the string, so too does the root 2 rectangle. This is musical rhythm; simultaneous existence of sameness and difference, sameness of design, difference of scale.

Caravaggio used the irrational-based dimensions of the root 3 rectangle for his composition of *Madonna of the Pilgrims.* He positioned the main focal point of the painting (the heads of the Madonna and baby Jesus) in the upper-left corner of the painting, roughly at the 90-degree intersection of the main diagonal of the larger root 3 rectangle and the main diagonal of the smaller root 3 rectangle. Notice how the head of the baby Jesus is positioned on the rectangle's main diagonal, and the head of the Madonna is positioned on the reciprocal diagonal.

This reciprocal diagonal is next used to create a reciprocal division, which positions the arm of the baby Jesus. This reciprocal division does two things. First, it divides the painting into exact thirds. (Again, this correlates with the vibrating string in that the 90-degree intersection of those two main diagonals produces a one-third division of the picture plane, which produces a 3 to 1 space of smaller rectangles that have the same proportions as the whole. Like the musical string that creates 3 to 1 vibrations from a one-third division of the string, so too does the root 3 rectangle. This creates a rhythm.) Second, the rectangle produced by this reciprocal division creates another root 3 rectangle, which is smaller in size. We can now see that Caravaggio enclosed the main focus of the painting in a rectangle that has the same proportions as the whole picture plane yet is different in scale—smaller, and in a manner that produces a rhythmic division.

Caravaggio's composition manifests harmony in that it produced a visual experience of sameness and difference. If one were to overlay on this painting a logarithmic spiral based on the square root of 3, the center of the spiral (which is the focal point of the painting) would fall on this 90-degree intersection.

Caravaggio composed the remainder of the painting in a square. Composing a painting within the square of a rectangle was common among master artists, for all rectangular designs are born from the square. Here the diagonals are drawn within the square. The ledge upon which the Madonna is standing is set at the horizontal two-thirds division, while the face of the male pilgrim is centered at the vertical halfway mark. This is musical rhythm; the image contains a simultaneous existence of sameness and difference, sameness of design and difference of scale. And this is Caravaggio's music.

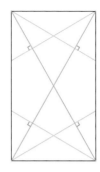

Left: With the root 3 rectangle, the 90-degree angles created by the crossing of the main diagonals with the secondary diagonals correspond with the one-fourth and three-fourths vertical and horizontal dividing lines. **Right:** As with all root rectangles, the secondary diagonals of the large rectangle also become the main diagonals of smaller root 3 rectangles.

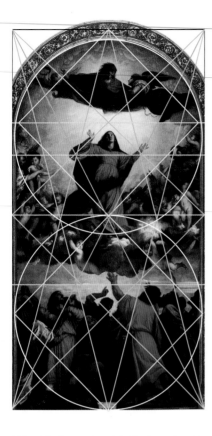

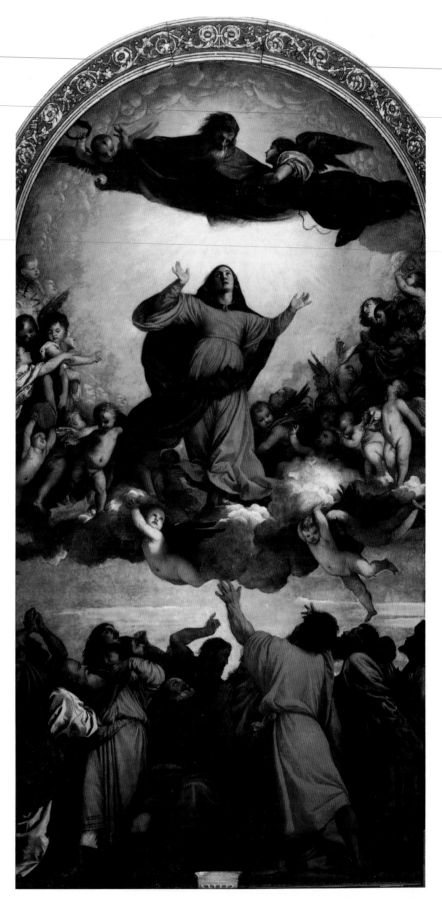

Titian, *The Assumption of the Virgin*, 1516–1518, 271 3/8 x 141 5/8 inches, Santa Maria Gloriosa dei Frari, Venice, Italy, courtesy of Art Renewal Center

This painting is a powerful example of how isolation can be used to enhance a principal focal point. Here the Madonna gains monumentality by being separated from the surrounding figures, whereas the multiple figures that both encircle her and border her below are read by the viewer as a large, single shape.

In his painting *The Assumption of the Virgin,* Titian framed his masterpiece based on the proportion of the root 4 rectangle, which is in fact two adjoining squares. Contained within these two squares are two overlapping circles. The bottom circle is inscribed within the bottom square of the painting, while the upper circle is inscribed slightly lower than the top square so as to overlap the bottom circle. The overlapping of the circles represents an intersection between Heaven and Earth. The center of the bottom circle falls exactly on the horizontal three-fourths division of the painting, while the center of the top circle is located on the nose of the Virgin, somewhere between the horizontal one-fourth and horizontal one-third divisions. Notice the two angels pushing up on the clouds from the base of the heavenly circle.

In addition to utilizing these two circles, Titian used harmonic division to punctuate his composition. He framed the lower (earthly) figures at the horizontal two-thirds division. He contained the Virgin within the middle third of the picture. He then set the upper division between the Virgin and God at the horizontal one-quarter mark.

Titian also used the diagonals of the rectangle as they fan out from all four corners of the picture plane. These diagonals provide the principal lines for the main figures to follow and give the composition a turbulent and dynamic movement. To strengthen and balance this movement, Titian inscribed two vertical isosceles triangles—a larger one and a smaller one—within the picture plane. The larger one starts at the top of the painting. It contains God's head and travels down through the one-third division of the Virgin's arms to the bottom corners of the painting. The smaller one is formed by the three orange figures, with the bottom of the Virgin's leg as the top of the triangle. The vertical isosceles triangle is perhaps one of the strongest and most balanced of geometrical designs. Triangles are symbols of great strength and balance because they can contain pure symmetry and can sustain much force before their geometry changes.

It is interesting to note that Titian created an atmospheric perspective by using a cool blue sky set within mostly warm colors. This painting was considered Titian's finest at the time. Its composition is based on the strength, balance, and unity of circles, squares, diagonals, triangles, and harmonic ratios. It is a visual creation based on a philosophy of ancient Greek music theory and natural design. Titian's result is both powerful and elegant.

Today there is a revived interest in the classical tradition of compositional design as well as in the methods and techniques for applying these principles in a contemporary vein. Just as Renaissance artists thought that the artists of antiquity were like gods among men, Renaissance artists appear in a similar light to many contemporary artists. We marvel and wonder at their accomplishments. By studying the language of design that they (as well as some

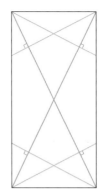 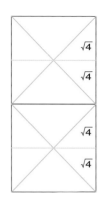

Left: The larger the root rectangle gets, the farther from the middle the "eyes of the rectangle" become. Right: The root 4 rectangle can be broken down into either four smaller root 4 rectangles or two squares.

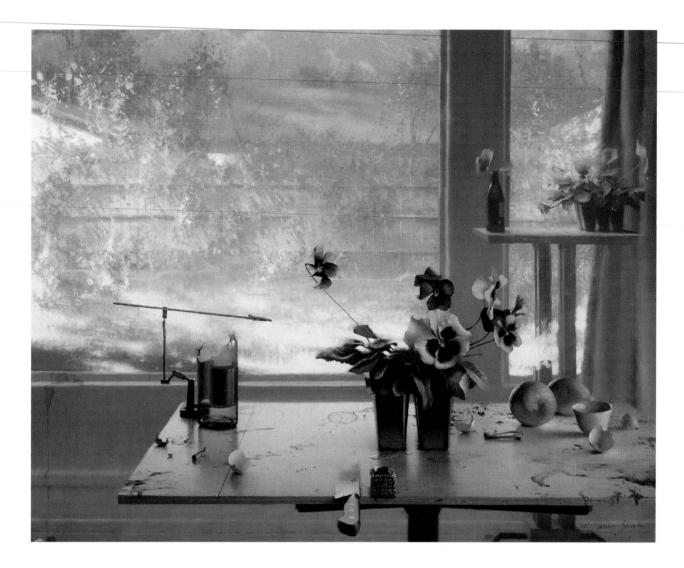

Above: Daniel Sprick, *Pansies and Landscape*, 2003, oil on panel, 24 x 40 inches

All the major events in this painting fall on simple harmonic divisions of the rectangle.

Opposite: Edgar Degas, *The Collector of Prints*, 1866, oil on canvas, 20 7/8 x 15 3/4 inches, The Metropolitan Museum of Art, New York, New York, H. O. Havermeyer Collection, bequest of Mrs. H. O. Havermeyer, 1929

The frame in the background divides the picture in half vertically, while the horizontal space is precisely subdivided into three quarters.

Photo Credit: Image copyright © The Metropolitan Museum of Art / Art Resource, New York, New York

master artists who followed them) used we gain an insight into the minds of the artists who performed the amazing creative feats of the past and learn how to apply them in our own creative endeavors in the future—furthering, without repeating, a great tradition.

In summary, I would recommend that artists today study the compositions of past master paintings. Analyze as many as possible to try and determine the overall composition—circular, elliptical, diagonal, vertical, and so forth. Then look where the principle lines, figures, and divisions are located. See if the artist made use of the major and/or minor diagonals. Overlay the armature of the rectangle on a master painting and see whether or not the musical divisions were used, and if so, how? By becoming a detective and researching the various ways master artists designed their paintings, you will start to adapt some of these timeless principles into your own work. This knowledge, coupled with your own artistic sensitivity for order, balance, and dynamism, will enhance the composition in your own work as well as heighten your ability to analyze the work of others.

MONOCHROMATIC MASTER COPY PAINTING

The value poster study allows artists to explore tonal relationships. Larine covered the panel quickly with opaque paint, working from background to foreground to create a context for the small, light shapes.

In the atelier curriculum the monochromatic master copy painting exercise represents the key bridge between drawing and painting. Solving problems in black and white helps the student confront the difficulties inherent to paint handling without simultaneously worrying about color. Value carries a lion's share of the weight in creating a successful painting. This exercise allows students to focus their full attention on the distribution and modulation of values, which helps them get a full understanding of tonal composition. In his notebooks, Leonardo da Vinci described the importance of establishing dominant light and shadow tones, which are then used as a basis of comparison to all other notes. Everything is useful to learn from such a great mind—from how he accented and diffused his edges to where he positioned tonal shapes within the rectangle.

In addition, this exercise introduces one method of constructing a painting from beginning to end, which will be useful for all of the student's future endeavors.

Gathering Your Materials

In preparation for creating your monochromatic master copy painting, assemble the following materials:

- Oil paint*
- Brushes
- Canvas or panel
- Odorless mineral spirits
- Medium
- Paint rag
- Palette

Larine blocked in a few measured reference points and created a free-hand tonal drawing before squaring the image for transfer to the panel.

The transferred drawing can be unintentionally erased by mineral spirits or subsequent paint layers, so Larine traced her drawing with a thin line of oil paint, which she allowed to dry overnight.

· Palette knife

Note: Larine used titanium white, ivory black, raw umber, and burnt sienna for this exercise.

Selecting Your Master Painting

The first consideration in this lesson is to choose a master-work that you admire and that suits your artistic aims. Larine picked Leonardo da Vinci's *Lady with an Ermine* because she was battling to keep an extended value range and a delineated tonal statement in her paintings. In this instance, the original features a very limited palette and is essentially a monochromatic work. However, you don't need to be limited to black-and-white images when selecting your masterwork; you can choose any color image to translate into black and white.

Setting Up Your Painting

After deciding on a masterwork, it is necessary to find a high-quality reproduction of the piece, unless you are going to work from the original. Reproductions can be found in museum stores, on the Internet, or in books. If you are working from a photocopy, make a color print (even if the original work is black and white, as a color copy will provide better tonality). It is helpful if your painting and the copy are identical in size for easy comparisons.

Set up your easel and place your reproduction next to your canvas or panel, so you can look back and forth with ease. Instead of using straight black, Larine chose to use a mixture comprising equal parts of raw umber and burnt sienna for her monochromatic palette, adding white to

Larine washed in a layer of burnt sienna with some mineral spirits to create a thin transparent underpainting.

On top of this tonal guide she applied a more opaque and heavier layer of oil paint using a mixture of raw umber, burnt sienna, and white.

lighten and black to darken it. She mixed each of the values 1 through 9 and made enough to fill empty paint tubes so that she had an adequate supply of the same mixture to use for the whole painting.

Creating Your Master Copy Painting

Familiarize yourself with the original by making a freehand sketch and a value poster study. To transfer the image to your canvas you can trace it or draw it freehand.

Now begin the underpainting. Larine used a burnt umber wash to establish the overall value relationships. Even in this early stage, your image should convey the same feeling and should look like a washed-out version of the original masterwork.

The final step is the overpainting, which involves using more opaque paint. Start in the darkest areas, then gradually and faithfully turn the form by carefully observing the lighter shapes. Your goal at this stage is to copy the original work as closely as possible. Step back and look at the painting from a distance from time to time. This will help you see inaccuracies and correctly judge the values.

Opposite: To create the final layers Larine gave her full attention to each area, working from darks to lights and attempting to finish the painting with one pass of paint.

Larine Chung, copy after Leonardo da Vinci's *Lady with an Ermine*, 2007, oil on panel, 21 x 15 inches, courtesy of the Aristides Classical Atelier

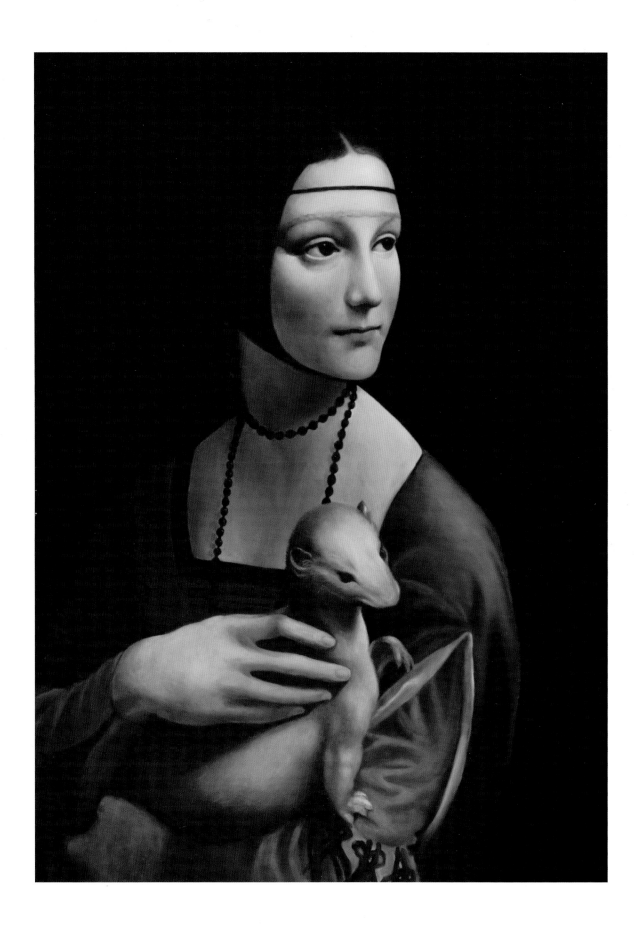

MONOCHROMATIC CAST PAINTING

Using the sight size method, John blocked in the big measurements directly on his canvas.

Casts are made from noteworthy sculptures, in this case one created during the Italian Renaissance. They provide a role model for how a complex reality was transformed into art. As with the master copy assignment, studying someone's artistic productions allows us to visualize how this alteration occurs and to strive toward it ourselves. The goal of learning to paint a sculpture, reducing a complex three-dimensional object onto a two-dimensional surface while re-creating the illusion of depth and volume, helps us distill and master essential principles. The cast, usually depicting a full figure, or parts of the human form, provides an entranceway into painting without the difficulties associated with working from life—as the cast is a completely stationary, uniformly colored object seen under consistent lighting conditions.

Gathering Your Materials

In preparation for creating your monochromatic cast painting, assemble the following materials:

- Oil paint*
- Brushes
- Canvas or panel
- Odorless mineral spirits
- Medium
- Paint rag
- Palette
- Palette knife
- Cast
- Drapery (optional)
- Plumb line

*Note: John used titanium white, ivory black, and raw umber for this exercise.

Setting Up Your Painting

For this exercise, John set up his working area in order to do the sight size method. This means that he placed the cast next to his canvas and then stood back a distance approximately equal to three times the height of the object

John aimed to create an accurate drawing by massing in the large dark and light shapes of the cast. He drew the forms from the inside out, loosely blocking in the shadow shapes as he progressed.

John started thinking about the figure-to-ground relationships, indicating the beginnings of the background tone against the figure.

so that he could easily see both the cast and canvas without turning his head or looking up and down. As he was developing the painting, John continually used his plumb line to take and compare measurements directly from the cast and the painting. He stood back to look and make comparisons and then walked up to his canvas to paint. Although you can opt for another approach (such as comparative and relational measuring) for this assignment, the sight size method facilitates self-correction. When using the sight size method, however, it is crucial that the setup remain unchanged throughout the session or else it will be impossible to achieve accurate measurements.

If you choose to use drapery, secure it behind the cast and gather it in a pleasing manner. Direct a light source, such as a window or lamp, in a visually pleasing manner on the cast and drapery. Pay careful attention to such things as the tone of the background, the value of the ground plane, and the shapes of the shadows that are cast upon the background or ground. All these elements will affect the atmosphere and mood of the finished painting.

Creating Your Cast Painting

Create and transfer a drawing of the cast to your canvas, using whatever method is comfortable for you. You may also want to create value and color poster studies. John's method of painting is very direct, meaning he does not involve himself with creating a lot of preliminary work, such as value and color poster studies. He is less interested in drawing than in moving around spots of value. Therefore, he chose to mark the top and bottom of the cast within the rectangle of his canvas, locking in the overall proportion of the piece. Then, using a brush and working directly on the canvas, he ghosted in the big measurements. However you choose to begin the process, continue developing the work on your canvas by drawing the forms from the inside outward, blocking in the shadow shapes as you go along.

Once the background and shadow shapes were firmly in place, the light shapes were framed, which made it easy for John to assess the accuracy of these large masses.

John worked the smaller shapes into the context of the big form and paid special attention to creating three-dimensional, illusionist aspects of volume.

Next, block in the shadows and the drapery in the background. This process isolates the lights and allows you to evaluate the accuracy of your work based on shapes. By opting not to concentrate on line, you will create a painting that more closely resembles what you actually see: a world of big tonal masses. After placing the overall tones in the shadows and surrounding environment, turn your attention to modeling the big forms of the lights. The core shadow sets the stage for modeling forms by directing your attention to the division between the darks and the lights. This small area is where you concentrate your tonal gradations to create the three-dimensional, illusionist aspect of the work.

Next, work in the smaller forms within the context of the big shapes. These are generally placed from dark to light. By building up the tiny shapes, you will create a feeling of particularly observed reality and bestow volume and solidity to the structure. Finally, examine the edges of

your forms. Some edges should be so soft that they are lost entirely, dissolving into adjacent forms; others should be strong and sharp, leading the eye to their crisp delineation; there should be every variation in between. Soft, broad shadows, vigilantly modeled turning form, a full range of values from white to black, and a variety of kinds of edgework all contribute to creating a sense of theme and variation. A finished painting that contains these elements is exciting to look at, capturing the viewer's eye and leading it all through the picture.

Opposite: By capturing such things as the light washing over the surface of the sculpture and the gently modulated halftones along with cracks and dents in the sculpture, John attained both breadth of vision and sensitivity to small forms carefully observed from nature.

Michael John Angel, copy after Verocchio's *David*, 2004, oil on canvas, 19 5/8 x 17 3/4 inches, courtesy of the Angel Academy of Art

CHAPTER THREE

VALUE

The Power of Limits

"Even in front of nature one must compose." — EDGAR DEGAS (from *Shop Talk of Edgar Degas* by R. H. Ives Gammell)

The subject of value composition is of primary concern for the artist and forms one of the core principles underlying great art. The term "value"refers to the range of black and white tones that provides the substructure of color. To understand this concept, just imagine a scene photographed in black and white. When we study the work of great masters, we can see a fluent pictorial language that they applied to create value compositions. The masters' handling of value becomes like a type of natural law, similar to gravity or entropy, in a mini-universe. Consistently applied value systems create a backdrop that contributes to the depiction of a believable atmosphere. Degas used to say that if he let himself follow his own taste in the matter, he would never have done anything but black and white. "But what can you do," he would ask with a gesture of resignation, "when everyone is clamoring for color?"

Light itself is the prerequisite for value and indeed is a requirement for just about everything. It is worth taking a moment to contemplate the subject of light—as it has been said that its portrayal is the chief subject of art. From the moment that God hit the switch in the universe and created light there existed chiaroscuro, the distribution of darkness and light. The pattern and organization of value is found in nature and predates the existence of the Earth by eons. The glorious photographs captured by cameras on the Hubble telescope record the phenomena, such as giant nebulas and galaxies, found in the vast expanse of darkened space.

Light and dark are omnipresent, and not only in physical ways. In metaphysical terms, chiaroscuro is descriptive of the human condition, with its communal and individual wrestling between good and evil. The distribution of light is one of the most foundational characteristics and is the subtext of our life on planet Earth.

Opposite: Daniel Sprick, *Still Life and Mirror,* 2004, oil on panel, 28 x 26 inches

Sprick's sensitive handling of tone and edges create visual hierarchy as well as the illusion of depth and atmosphere. Notice how the edges of the objects become increasingly clear as they move closer to the viewer—such as the soft haziness of the picture frame against the wall as compared with the sharp edge of the drapery around the table.

Above: Michael Nagle, *The Apostate (Portrait of the Artist Rembrandt Lockwood)*, 2007, oil on canvas, 40 1/8 x 40 1/8 inches

This image is based on a daguerreotype by Matthew Brady. Nagel reduced the image to three simple block shapes and the portrait of Lockwood. The subject is used to gently poke fun and warn artists about the dangers of their profession. Rembrandt Lockwood was a gifted academic artist who never developed his own visual personality and eventually abandoned painting to become a successful architect of church buildings.

Opposite: Diego Velázquez, *The Waterseller of Seville*, 1623, oil on canvas, 42 x 31 7/8 inches, Wellington Museum, London, England, courtesy of Art Renewal Center

The artistic device of compacting the value range (either lighter or darker, depending on the image) to create visual hierarchy can be clearly seen this painting. Compare the boy on the left, who is represented with a full value range, with the man drinking in the back, who is depicted with a compressed tonal range.

Likewise, in a microcosm, dark forms the bedrock of our artistic production. In fact, the portrayal of light and shadow is itself one of the driving forces behind most successful works of art—infinitely greater than the most carefully rendered inventory of objects. Contemplation of the subject of light as the subtext of the artist's work can add another dimension of meaning and enjoyment to the experience of art.

The presupposition underlying this chapter is that the student must take three important steps before he can make progress. First, his mind must be trained to know what to look for. Second, his vision must be honed so that he sees these things in life. And third, his hand must be trained so that he can execute his ideas as he envisions them. In other words, the ability of the artist's mind to understand a subject precedes his ability to execute what he sees. Thus the first goal of an educator is to hone vision through bestowing an understanding of artistic principles. Because of the inevitable gap between understanding and ability, especially during the early years of training, a beginning artist often experiences a frustrating sense of never quite creating a perfect actuality of his intention. It is akin to learning how to speak a foreign language: The mind knows what it wants to say, but the words do not always follow accordingly. The promising side of this frustration is that it thwarts complacency, as the artist always desires to do better.

The Limitation and Compensation of Art

Artists have always wrestled with the problems inherent in reproducing the complex and infinitely varied appearance of nature while having limited means to accomplish this end. Pythagoras said that nature is sure to act consistently in the form of an analogy. Art could be said to continuously function in the form of pictorial analogies. Artists simply do not have the range of nature, so we must distill, exaggerate, and diminish what exists in the natural world to convey a full sense of reality. For example, we apply transparent paint to canvas to give the illusion of a vaporous shadow. By having a thorough understanding of our pictorial language, the artist can manipulate his limited means to imply enormous variety.

A number of elements truncate artists' ability to replicate nature using traditional painting materials. For example, paint can capture the darks found in nature but cannot come close to portraying a light source, such as the sun or even a candle. The range of a person's sight extends indefinitely as long as he keeps moving his head. However, even the biggest canvas will not give the impression of limitless space. Also, life presents us with three dimensions. Objects have actual weight and volume—all while existing in space with real atmosphere. The artist has to give the impression of three dimensions while only having two at his disposal. Paints, brushes, and canvas are the only tools we have to give the illusion of the myriad textures and surfaces in nature, such as light bouncing off pale skin or the sheen of polished metal.

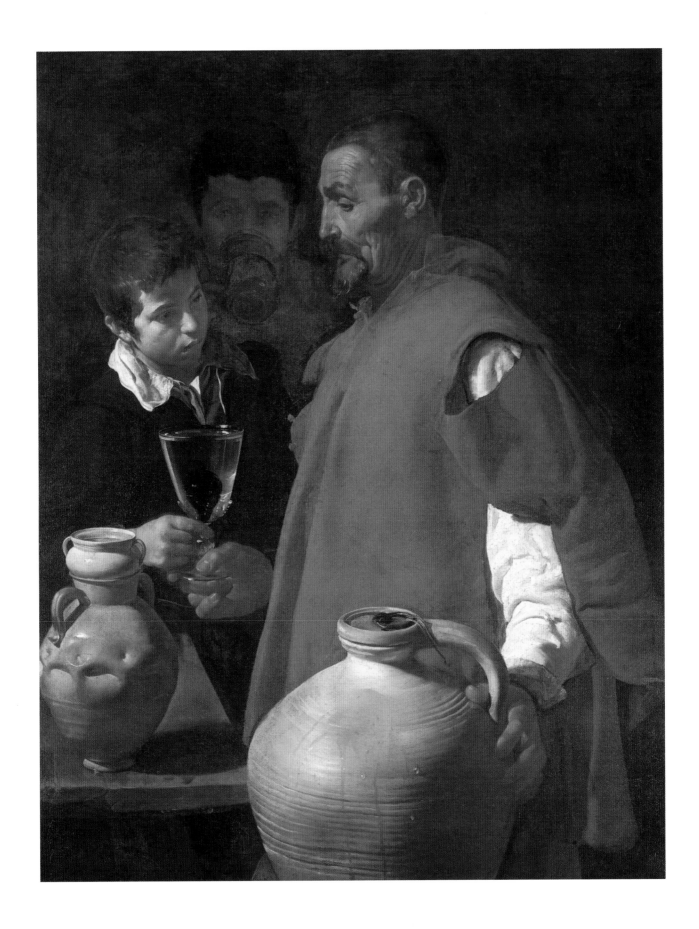

Eugène Carrière, *Maternity*, oil on canvas, Musée des Beaux-Arts, Reims, France

Carrière used contrasting values to arrest the eye at the spot where the mother kisses her child.

Photo Credit: Bridgeman-Giraudon / Art Resource, New York, New York

So does the artist have *any* advantage over nature? Is the artist's job to copy what has already been expressed by nature but with limited means? No, the artist has intelligence and will—a clear advantage—and his job is most certainly not simply to copy. Nature has an external face, but not an internal one. Such things as trees, coffee mugs, and clouds do not have an emotional, spiritual, and intellectual component. Painting is an expression of the soul. The artist has the ability to reorganize and order this world to covey the internal aspect of life.

Nature often presents us with conflicting and confusing information. The job of the artist is not to repeat or transcribe what he sees, but to interpret it. By ordering nature and making sense out of it, he can present to the world a clearly distilled statement about life. Tolstoy described this phenomenon in his book *What Is Art?* by articulating two different ways of narrating an event. He said to imagine two people talking about their day. One comes home and essentially reiterates the events. The other recounts the events but gives emphasis

to his story by editing and exaggerating elements to convey the experience, presenting to the listener not only the words but also the emotions. One is functional communication; the other is storytelling as an art. In the visual arts a technician copies, but an artist transforms. Degas described something similar when he said that he lies in his art to tell the truth. Given limited means at his disposal, the artist condenses and embellishes upon life.

The Qualities of Value

Value plays four essential roles in creating a successful painting: It allows an image to be read from a distance, it creates mood and tone, it forms a powerful composition, and it provides the illusion of volume. All of these elements can be used together to create compelling images.

THE STRENGTH OF VALUE PATTERN

Value is responsible for the propulsion of the image to the viewer. It dictates how easily the painting can be read from a distance, which is instrumental to creating a sense of power and structure. I remember walking through the

Michele Mitchell, *The Call*, 1992, oil on canvas, 36 x 48 inches

The light coming from the direction of the turning head brings to mind Caravaggio's *The Calling of Saint Matthew.* The L-shaped darkness on the left side of the picture is balanced by the inverted L shape of light on the right side.

Right: Michael Grimaldi, *Portrait of Ainat,* 2003, tempera and oil on panel, 10 1/2 x 8 inches, private collection

The wash of light coming from the upper left to lower right illuminates a figure who is turning her back on the light. A repeating rhythm of light and dark moves our eye through the picture.

Opposite: William Merritt Chase, *Portrait of Louis Betts,* oil on canvas, 16 x 10 inches, courtesy of A.J. Kollar Fine Paintings

This painting is a fascinating essay in chiaroscuro. The head and neck are locked into a single rectangle, which is set in front of a series of light and dark shapes transparently washed into the background. The principal shape of light, the collar, also has the only truly sharp edge in the painting.

National Portrait Gallery in London years ago. I had been there for several hours and was tired. I was walking quickly on my way out of the building when I saw a doorway leading into another gallery. At the very end of that large room was a small painting. It arrested me completely. When I went nearer I saw it was a beautiful Jules Bastien-Lepage portrait—as pleasing up close as it was from a distance. That is the power of value. It can stop a tired person from a great distance and pull him inexplicably toward a work of art. This concept is linked to the idea of value pattern. The idea of how the image reads apart from its representation can be referred to as value pattern.

Even the most articulated rendering is composed of a series of two-dimensional graphic shapes that form an underlying tonal pattern. This is not just true for painting but also for such things as woodblock prints, posters, commercial illustration, textile design, and Persian carpets—all of which all rely on abstract,

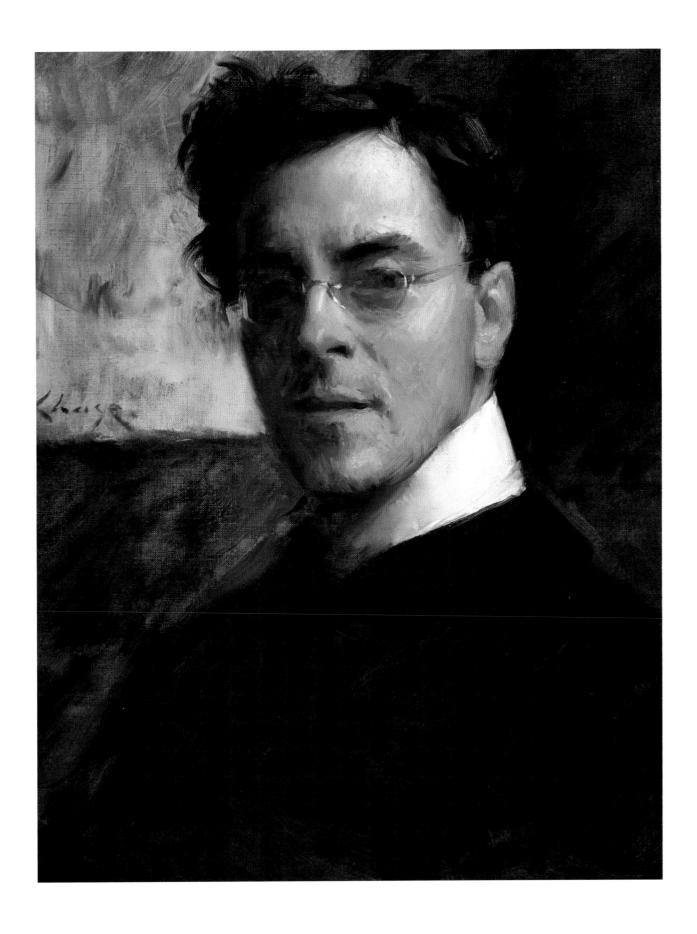

Jacob Collins, *Michael*, 1997, oil on canvas, 22 x 25 inches, private collection, courtesy of the John Pence Gallery

This low-key image has its principal focal point in the light areas of the form. The open form of the figure melds into the background, drawing the viewer's eye away from the contours and into the center of the face. Notice how the cool light contrasts with the warm shadows.

simple compositional elements to create a commanding image. This type of pattern is purely ornamental and is not descriptive of a light source or a form. This distribution of value patterning has a charm all its own, and some cultures have never moved beyond this two-dimensional consideration. One could think of the geometric paintings on Greek pottery and Islamic tiles as examples. The cut paper exercise found on page 70 is designed to help the artist focus on this issue.

MOOD AND TONE

The second function of value is to create mood and tone, which form the emotional base note of a work of art. The overall tenor in a painting is often what catches our attention. It has been said that much of what we understand from a conversation is transmitted by the tone of the person's voice and the accompanying body language, not the actual words and their content. Actually,

if we are to believe the studies, the words form the smallest percentage of the information we take in. Much the same thing could be said about painting. The abstract qualities of a work of art convey much of the work's artistic and emotional qualities; the content itself is less important. For example, one could look at a painting of the Last Judgment by a technically competent artist and not be moved. Yet one could feel true spiritual humility and sensitivity emanating from a painting of a newspaper and a pewter jug, if that work was created by an artist like William Nicholson.

Each work of art has its own value landscape, and the artists of certain movements favored one value scheme more than another. Artists intentionally limit and control their value scheme to convey certain effects. The Impressionists favored a high-key palette that concentrated on the light end of the value spectrum, which is a perfect vehicle for showcasing the beauty of color. Because the Impressionists celebrated color, not tonality, they truncated the value range to allow the viewer to focus on subtle shifts of temperature and hue. In contrast, Luminists pushed their darkest notes to the edge of their canvas to allow a flamelike effect of values. Baroque artists were attracted to dramatic shifts of value from the whole value

Childe Hassam, *Isle of Shoals,* 1890, oil on canvas, 16 1/2 x 22 1/4 inches, courtesy of A.J. Kollar Fine Paintings

In the true spirit of Impressionism Hassam kept a high-key value scheme, celebrating light and subtle shifts of color and creating harmony through the interplay of warm light set against cool shadows. The darkness of the rocks is the only strong value accent in the piece.

spectrum, which heightened the drama of their works of art. Seventeenth-century Dutch genre artists favored more unaffected and subtle shifts of light to give the impression of natural lighting conditions found in their interiors, as seen in Vermeer's *The Astronomer* on page 31. The value range an artist embraces depends on personal taste, the time in which he lives, and his artistic goals.

COMPOSITION

Color gets the credit, but value actually does much of the work when it comes to composition. When beginning artists are building up their skill levels in painting, they frequently spend so much energy mastering their materials that composition is sometimes a far-off goal. However, sensitivity to composition cannot be encouraged too soon in an artist's development, as it forms the understructure to every artistic endeavor. Even the great masters did not paint every aspect of their work flawlessly. For example, occasionally you see a hand or foot that is hastily executed and strangely proportioned, but the composition is so outstanding that the general effect is monumental. An adequately painted but well-designed image will outlast a well-painted but haphazardly designed picture.

Above: Carlos Madrid, *Contact,* 2004, oil on linen, 28 x 40 inches

An essay in contrast, this image features stark blocks of value, that are offset by gentle gradations of value in the foreground.

Opposite: William Nicholson, *Tall Pewter Jug,* 1933–1939, oil on panel, 18 x 15 1/2 inches, courtesy of Paul Kasmin Gallery

Nicholson created balance and variety by intermingling almost equal divisions of dark and light. The small, jagged highlight stands apart and captures our attention.

Photo Credit: Image copyright © Elizabeth Banks. Image reproduced by kind permission of Mr. J.E.B Hill England.

Edward Minoff, *October, Through the Fog*, 2006, oil on canvas, 8 x 20 inches

The long horizontal format is a perfect choice for this seascape, reinforcing the hypnotic lengths of water and the peaceful nature of the sky. The dark notes found in the diagonal shore and waves add dynamism and depth, moving our eye through the picture.

Value directs the eye, and in a painting, the area of principal contrast arrests the eye. When I was a student, my teacher used the mantra "The place where the lightest light and the darkest dark meet is the principal focal point in a work of art." It seems like a simple proposition. However, many things can distract one from adhering to good value composition. For example, if you stare too long into the shadow, the shadow will get too light; if you stare too long into the light, your light will get too dark. Focusing on one area creates an inversion in the value patterns. When you glance at a scene in nature, the value patterns have coherence and strength. These patterns diminish the longer one looks at them. The clarity gets lost in a muddle of tones.

Another idea for helping organize values in your painting, which is discussed in Leonardo da Vinci's notebooks, is to locate the lightest light and darkest dark and compare every other value to these. In that way you will be able to keep all of the values in proper relation to one another. The trick and beauty of a masterpiece is its simplicity. Ironically, it is much more difficult to create a simple value composition than a cluttered one. A concise, elegant tonal composition is wonderfully satisfying.

Edges, color, and placement also help dictate focal points, yet value must always be considered in relation to these concepts. If your principal focal point is somewhere other than the area of principal contrast, it risks being overshadowed. An example would be a night scene with a full moon shining brightly in a dark sky, but the intended subject is on the ground in a dark corner. The subject becomes the moon regardless of the artist's intention. The close value range of the subject is sending the viewer a message that it is not intended to take center stage.

When considered in relation to value, edges can also indicate the primacy of an area. A sharp edge catches the eye more than a soft one. The range of edges can parallel the idea of a value step scale, with a perfectly delineated edge on one side of the scale, becoming more diffused until it is totally lost at the other end. By manipulating the degree of rigidity or faintness found in the contour lines, the artist directs the eye.

Color offers another way to send a message to a viewer. A minority entry of any kind sends a powerful message to the viewer. The difference is enough to draw our full attention—like a sharp sound in a quiet library. In value, this can be illustrated by the expanse of darkness in our night landscape—the small moon is like a flame of light that attracts our eyes. In color, this principle can be illustrated by a vast green field punctuated by a small red barn—the barn becomes the subject because its color is the dominant difference. The small anomaly has greater weight compositionally. Color uses the range of sameness and difference to direct the eye through the picture and add variety and to balance a composition.

Transparency and opacity also help to guide the eye. The transparent shadows fall away; the opaque lights move toward the viewer. Diminishing information in the shadow also helps the viewer's eye hover longer in the area where there is more form. The eye naturally moves out of the twilight and into the light. Consciousness will help you build a sensitivity to these issues. They are easy to learn, but they are actually surprisingly difficult to consistently apply because they are often not what we see.

Using values to guide the eye to areas of the painting, not letting it stop or become diverted on its way through the picture, is the key to creating great art.

Derek James, *Asbury Plaza,* 2003, oil on canvas, 60 x 120 inches

Value is more indispensable than color for a sighted person trying to function in the world. You could find your way home in a world of grays, but imagine what it would be like to navigate in a world that had color but where objects had no volume and space had no depth.

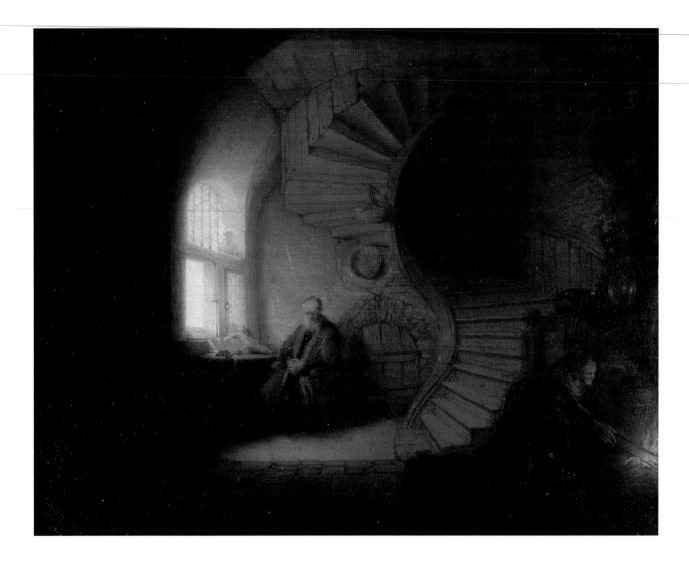

Above: Rembrandt van Rijn, *Philosopher in Medi-tation,* 1632, oil on panel, 11 x 13 ³/₈ inches, Louvre, Paris, France, courtesy of Art Renewal Center

The light is coming from left to right, along a Baroque diagonal. This directionality has positive connotations of divine illumination. Notice how Rembrandt subdued the fire in the right-hand corner to avoid the possibility of having two focal points.

Opposite: Jan Vermeer, *Woman in Red Hat,* circa 1666–1667, oil on canvas, 9 ¹/₈ x 7 ¹/₈ inches, National Gallery of Art, Washington, D.C., Andrew W. Mellon Collection, courtesy of Art Renewal Center

Vermeer used extended gradations of tone within a narrow value range to describe form within darkness.

Vermeer's *Woman in Red Hat* is a beautiful example of this. Notice how he manipulates color, value, and edgework to create an interesting and harmonious piece. The viewer's eye flows through the painting much as it does in nature itself—effortlessly. The features of the woman's face are understated, as the tones dissolve into one another. The hat, background, shadowed face, cloths, and chair all interlock with the darkness. Out of this unity emerges a bright triangle of light that draws our attention to the mouth, collar, and blue drapery leading to down to the hand. The red of her hat forms the strongest color note and zigzags to the top left edge of the picture. Every aspect of space, from the lion carved into the knob of the chair to the tapestry in the background, rests in a quiet hierarchy—each value and color perfectly in its place.

THE ILLUSION OF VOLUME

The last essential aspect of value is its role in creating the illusion of the third dimension. My first book in this series, *Classical Drawing Atelier,* dedicates a whole chapter to this subject and there are many other books that cover this

topic in depth. However, the main principles can be outlined quickly. (But learning to apply the methodology takes much time.) By understanding how light hits form, the artist can mirror what happens in life and re-create the impression of volume and weight. The principles of form are quite simple. The surface of every form shifts, to a greater or lesser degree, according to its relationship to a light source. This modulation of planes is responsible for a continual undulation of color and value. Focusing and rendering these tiny shifts in surface topography (caused by light raking across the surface of the form) creates a three-dimensional relief of the surface. It is helpful to keep the values in the lights bunched up toward the light end of the spectrum, keep the values in the shadows close together, and give full range to the halftones, which are largely responsible for creating a feeling of girth.

By locating the line of the core shadow, which is the line of demarcation between the shadow and the light, the artist can describe the idiosyncrasies and essential

character of the subject. This identification of the core shadow line serves to
separate an object into two sides—a light side and a shadow side. By grouping like
tones within each of these two sides in close proximity to each other, the artist
provides an important unity and flow to the light and the shadow. This flow of
light gives solidity to the forms and strength to the painting.

Artists in the past, such as Raphael, took the unbroken flow of light literally;
you can see one uninterrupted flow of light starting at the head and going
down to the feet. Later artists such as Caravaggio broke this rule and allowed
such things as cast shadows to cross the forms. (Regardless, even in Caravaggio's
work each isolated area of light respects this rule.) Some contemporary artists
also push this rule with success, as can be seen in paintings with very strong
reflected light. Steven Assael's *D,* which is shown on page 205, is an excellent
example. The painting has its own internal logic and its volumetric form is
strong enough to create visual clues about the hierarchy of light.

Once an artist understands the dynamic of form he is able to apply it in end-
lessly varied and complex ways without thinking about the process. When I
learned to drive a stick shift car I had to think about each action as I did it:
First push the clutch; then change the gear; then step on the gas without letting
the car stall. I had trouble believing that I would ever get to a place where the
action would become unconscious and I could focus just on the road and the
thoughts in my own head. For a person learning to turn form, the feeling is
similar. Once the artist masters the skills, they become an automatic extension
of his will, unconsciously falling into the rules of the universe they create.

Exploring Value in Two Dimensions

Above: Larine Chung, *Hand of David*, 2007, paper, 9 x 12 inches, courtesy of the Aristedes Classical Atelier

Larine had an added dimension of difficulty with this exercise, as the background and foreground were the same tone. She solved this problem by introducing a thin horizon line and a cast shadow, which helped define the space, leaving the viewer's imagination to fill in the blanks.

Right: Norma Crampton Bergquist, *Still Life in Four Values*, 2006, paper, 7 5/8 x 8 3/8 inches, courtesy of the Aristedes Classical Atelier

Norma's elegant solution to this exercise uses just four tones with no halftones to re-create a still life. It illustrates that a simple foundation of large value patterns can carry the majority of the success of an image. Notice how your eye fills in the gaps in ambiguous areas, such as where the side of the bowl dissolves into its shadow.

Limiting a painting to a few values can give it strength. This exercise provides a powerful value foundation by helping you see a still-life grouping as a series of abstract shapes rather than as outlines of objects. The problem of simplifying these objects can be solved in multiple ways. Coming up with a successful image means choosing one idea and developing it consistently. If you are not satisfied with your initial work, try a few alternate solutions.

To do this exercise, you will need a graphite pencil, white drawing paper, glue, scissors, and toned paper in black, dark gray, light gray, and white. First, set up a still life and light it, paying careful attention to the shapes of the lights and shadows. (These shapes should be fairly simple.) Then

draw the still life carefully onto a piece of paper, trying not to think about it as a grouping of individual items but as four values (black, dark gray, light gray, and white). Looking at the still life through a sheet of red Plexiglas or in a black mirror will help you simplify the tones into four values. If you don't have those tools, squinting will be adequate. Next, trace each of the value shapes in your drawing onto the appropriate toned paper. Cut out each of those shapes and glue them on to white paper. Essentially you are fitting puzzle pieces of toned paper together to make a "drawing." The relationship of these shapes will allow you to accurately "draw" the still life. If the shapes are accurately represented, the result should look like your still-life setup.

Experimenting with Value Range

Still life provides an excellent subject for testing value theories. One exercise that we use in the atelier to familiarize students with various value scenarios is to execute a number of paintings of the same setup using different value relationships. For example, if white is represented by value number 1 and black number 9, the overall tonal scheme of the first painting might be a high-key image, hovering between 1 and 6, with maybe one darker note. The second might be a middle-key painting and have an almost equal distribution of chiaroscuro and require the full value step scale. The third painting might be on the dark side, a low-key image, perhaps ranging from 6 to 9, with lighter tones forming only accents.

To do this exercise, you will need oil paint (titanium white and ivory black mixed into nine value steps), brushes, a canvas or panel, a palette, and a palette knife. It is helpful to make a value-step scale that shows the nine values squares, as these offer easy comparison of values. If you intend to make a number of monochromatic paintings, it is helpful to premix tubes of all nine values; this cuts down on the setup time.

The practical difference between each of these scenarios is what happens with lost edges and areas of pronounced form. In each instance different parts of the image project toward or recede from the viewer. The dissolving of forms into one another creates the illusion of atmosphere and reality. It is sometimes called "open form painting," which means that the objects are integrated into the atmosphere (in contrast to "closed form painting," where the outline separates each object). In the light-value setup, the light areas of each form meld into one another, leaving the darkest note, which could be a shadow area in highest relief. In a middle-value scenario, the halftones of the objects meld into the background, but the shadows and lights are illuminated by the surroundings. In a dark-value setup, the lights are in full relief, perhaps including the halftone, and the shadows get lost in the atmosphere.

..

Walker Hall, *Still Life Studies*, 2007, oil on canvas, each 5 x 8 inches, courtesy of the Aristides Classical Atelier

With these images Walker explored some of the effects that can be created just by alternating different value combinations. Notice the light figure on a dark ground, the dark figure on a light ground, and the light figure on a midtone ground.

LESSON THREE

VALUE-BASED STILL-LIFE PAINTING

David created several thumbnail sketches, exploring the composition and distribution of values among the still-life objects.

It is a great challenge to transform a visual phenomenon into a powerful artistic statement. The goal of this lesson is to expand upon the ideas embodied in two-dimensional value composition and create an original work that pushes value, edges, and turning form. You can choose to do this exercise monochromatically or with a limited range of pigments. Of course, the complexity of the assignment increases when you add color. In the example shown, David selected orange for the dominant hue, and the entire painting is awash in a warm glow. The color and value are integrated into a unified artistic statement, with the abstract qualities of light, tone, and color taking precedence over the cataloging of objects. In other words, the painting informs us about the artist's goals and sensibility rather than serving as a faithful document of the items he selected.

Gathering Your Materials

In preparation for creating your value-based still-life painting, assemble the following materials:

- Oil paint*
- Brushes
- Canvas or panel
- Odorless mineral spirits
- Medium
- Paint rag
- Palette
- Palette knife
- Still-life objects

Note: David used titanium white, ivory black, Naples yellow, yellow ocher, transparent earth orange, Indian red light, burnt umber, raw umber, king's blue, and ultramarine blue for this exercise.

Setting Up Your Painting

If you choose to carry out this exercise with a limited palette (rather than monochromatically), make sure to select your still-life objects carefully and allow only one chromatic note to dominate. David was attracted to the warm, relatively colorful brown eggs and arranged them so that the two eggs on the left would receive the brightest light. The reflective surface of the bowl created an opportunity to explore the light and dark notes within a relatively neutral chromatic range.

With a value-based painting it is important to carefully consider the distribution of the light. Generally, the higher the contrast and the more comprehensible it is to the viewer, the easier the object is to paint and the easier it is for a viewer to understand. Very subtle lighting, such as front-facing light or a high-key condition, often requires deft handling of color and temperature shifts to produce a successful painting; this can be challenging to achieve. Any kind of lighting can be beautiful; however, each scenario poses its own set of complications. David positioned a single light source just above the level of the countertop, creating a horizontal flow of light across the composition. This creates a more raking light than the classic form-revealing light, which is 45 degrees above the objects.

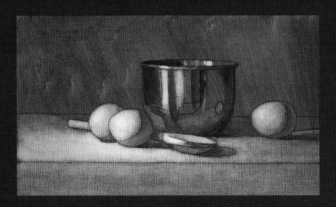

When he was ready to do the underpainting, David chose the wipeout technique, as it provides a unified tonal base that links the various elements with a harmonious layer of raw umber.

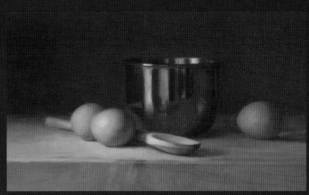

The succeeding paint layer celebrates the particular subtleties of form and color found in life. Because this painting has limited color, David placed great emphasis on the value and temperature changes.

Creating Your Value-based Still-Life Painting

Create a series of thumbnail studies to assess how the values will be distributed in your composition. These initial sketches will also allow you to determine the relative dimensions of your painting as well as its orientation (horizontal versus vertical). Use these sketches to plan your painting at its most structural level, apart from representational concerns.

Next, execute a small value poster study; this provides a more thorough realization of your ideas and gives you a trial run at the finished painting. If you are working with a limited color palette, create a small color poster study as well; this will permit you to explore potential pigments and color mixtures for your final painting.

A virtue inherent in dividing the painting process into stages is that it allows you to thoroughly understand and give your best effort to each aspect of the painting. For your final drawing, you can either work directly with charcoal on the surface of the canvas or you can do a drawing on paper and transfer it. If you are working on paper, the final image will need to be transferred to the canvas. Therefore, the image can either be the same size as the anticipated final painting or it can be enlarged to the final size. You can transfer the drawing to the primed canvas using a number of different materials, including graphite transfer paper, charcoal rubbed on the back of paper, or a thin layer of paint rolled out with an ink roller

on tracing paper. Then ink in the drawing lightly with a thin waterproof India gray or sepia-ink marking pen. Alternately you can take a fine brush and outline the drawing with oil paint. (David used a sepia-ink pen; if he had used black ink, the dark lines might have shown through the thinly painted areas of the canvas.)

Next, utilize the wipeout technique to achieve a value-oriented underpainting. David applied raw umber oil paint with a large, stiff bristle brush (without any odorless mineral spirits or medium) to lay in a uniform dark halftone value on the entire canvas. Then he worked quickly in a single sitting to wipe away the paint, using a soft rag to reveal the lighter areas of the composition. If necessary, moisten the cloth with a small amount of mineral spirits and rub to achieve the lightest lights. David reinstated the darkest values by applying raw umber oil paint with a brush.

When the underpainting has dried, complete the final overpainting using your selected palette. Apply the paint thinly in the shadows and build it up more thickly in the light areas.

David Dwyer, *Kitchen Scene,* 2007, oil on canvas, 8 x 13 inches, courtesy of the Aristides Classical Atelier

Photo Credit: All images by Richard Nicol

CHAPTER FOUR

COLOR

The Full Palette

"But the Leopard, he was the 'sclusivest sandiest-yellowish-brownest of them all—a grayish-yellowish catty-shaped kind of beast, and he matched the 'sclusively yellowish-grayish-brownish color of the High Veldt to one hair." — RUDYARD KIPLING (from *How the Leopard Got His Spots*)

In a room with no light there is no color. Why? In a nutshell, when light passes through a prism, or through drops of water (which act like a prism), it is separated into wavelengths. When these wavelengths hit an object, most of them are absorbed. The waves that are not absorbed reflect off the object, revealing themselves to our eyes as color. These colors make up the rainbow—red, orange, yellow, green, blue, indigo, and violet. It takes light to reveal color, so, in essence, color is light. The world illuminated by these light waves continually shifts in appearance depending on the light sources, adjacent colors, and reflected lights in the environment. These permutations create an extensive range of possible colors—approximately seven million—that the eye can perceive.

Because of the innumerable permutations possible within a small number of variables, color is the most difficult to articulate of all the aspects of painting. In addition, color use is highly dependent on personal taste and aims. Excellent color systems are available that teach accurate color mixing and enable the artist to match observed colors. However, creating a convincing painting requires more than just matching what one sees. It also requires color harmony, which allows the work of art to function as an integrated whole in a way that conforms to the purpose of the artist. In the end, even formulas to get the perfect color fail, because ultimately the right color is the one that works with the overall logic of the piece. In such a confusing environment, it is important to create a context for understanding color, beginning with a study of the commonalities among the various systems as a gateway to further study.

In past centuries, artists tended to use just a handful of colors and were taught to paint just like the masters with whom they studied. They learned to do much with little. Mastering a limited system gave these artists great artistic

Opposite: Edgar Degas, *The Painter Albert Melida,* **1864, oil on canvas, 17 3/8 x 13 inches, Musée Bonnat, Bayonne, France**

Degas created dynamic tension by juxtaposing the impassive expression of his brother-in-law Melida with a pulsating background. He tied the two together by carrying orange all through the image in such places as under the eyes and in the tie.

Photo Credit: Scala / Art Resource, New York, New York

Joseph Mallard William Turner, *The Burning of the Houses of Parliament*, 1834, oil on canvas, 36 x 48 inches, Philadelphia Museum of Art, Pennsylvania, courtesy of Art Renewal Center

The intensity of the flames is balanced by the bridge and the crowd. Turner uses color and dark accents to guide our eye in an S-shaped arabesque through the picture. The dark crowd forms an arc that connects with the bridge, which points into the fire; we are led full circle by the flare of the flames, which circles back to the crowd again.

freedom because it was feasible for them to understand their particular system completely and therefore to manipulate the pigments in ingenuous ways to accomplish all that they desired. Pliny the Elder wrote in C.E. 30 that the most renowned painters of ancient Greece often limited themselves to only four colors—even when more were available. Pliny said that work was better when resources were limited because ample resources tempt artists and patrons to value materials above genius.

Today, we have many more materials at our disposal, and we use color more emotionally and symbolically than did the artists in previous eras. In addition, copious information about the entire history of art is instantly available to us, making it problematic to impose limits. At the same time that we had an explosion of range and new materials we lost any sense of traditional training like that found in the earlier apprenticeships and academies. We are ever aware of the myriad methods, conflicting styles and theories, paint application techniques, color systems, and seemingly endless color choices available. Unfortunately, this abundance can create paralysis, and the palette can end up mastering the artist instead of the artist mastering the palette.

My own education in color has been centered on accomplishing two goals: first, to understand and mix colors accurately, and second, to find a reliable color system that easily gives me harmonious color mixtures. In my self-taught days, I wrestled every beautiful color into a pasty, chalky mess, just mixing haphazardly. Later, I began studying how colors worked in the color wheel and spent weeks mixing nuanced neutrals until the palette knife had blistered my hands. (Technically, the term "neutral" means an absence of color. White, black, and gray are neutrals. However, many artists, including myself, use the term to describe muted or low-intensity versions of a color.) I have used the open palette, color strings, limited palette, and half a dozen other methods of paint application and have capped it all off by experimenting with advice from other artists and exercises given in books. My enthusiasm to find the perfect color system has not completely abated; there is a beauty and logic to color that makes the subject very rewarding to study, even after so many years.

My search has taught me something that may seem obvious: It is the artist who makes the palette work. A great painter can transform any palette into an excellent painting; an inexperienced artist can have an extensive palette containing the very best colors and still turn the colors to mud. There is simply not one perfect way to make a painting. What makes a painting perfect is inextricably linked to the skills and goals of the artist. Every style and genre has its own brilliant practitioners.

Jacob Collins, *Great South Bay from Fire Island, Off Season,* 2004, oil on canvas, 30 x 54 inches, collection of Dr. and Mrs. Michael Mann, courtesy of Hirschl & Adler Modern

In the tradition of Lumanist art, light emanates from the center of the picture and radiates out, pushing the darkness toward the frame of the rectangle.

Color theory and its application can be one of the most daunting subjects to learn. I recommend that students of painting begin by experimenting with color mixing, which is described later in this chapter. After you understand color mixing, I recommend choosing one color system (or palette of colors), even arbitrarily, and practicing it until you know the combinations so well that they become automatic. I will provide some suggestions to get you started. This familiarity will give you the experiential knowledge necessary to master the language of color, a starting point that forms a frame of reference for study in other branches of the subject.

The leap from monochromatic work into work with a color palette can be a challenging experience for the beginning painter. Every time I teach a figure-painting class, I am struck by the difficulties that students encounter when trying to match the success they had working in grisaille. It is not unusual for someone to experience a noticeable loss of a mastered skill while trying to integrate new information. For example, a child might be a prolific crawler, getting around quickly and efficiently. However, when the child starts walking, he might experience a temporary loss of full mobility, falling backward or down as often as he is able to propel himself forward. Progress often initially feels like a regression. So too in art; it takes the same tenacity and determination to learn to paint in color that it took to learn to draw.

I vividly remember the frustration of not only being unable to paint the color and form that I wanted but even having trouble seeing the various broken colors that together gave the appearance of light hitting an object. It took both trust in the guidance of others and continued practice before I could see the nuanced color changes within seemingly obvious local color. As with learning to draw, the artist must make the shift from a utilitarian way of seeing to an artistic way of seeing. This will allow him to begin opening up the remarkable world of color.

Color Basics

Although discussions on color had occurred earlier, the first modern color theory for the artist is found in the scientific explorations of Sir Isaac Newton and his development of the color wheel. This model provides a useful simplification of color into families or hues for the artist. Although colors seen in life often bear little resemblance to Newton's seven prismatic hues, the study of color theory using simplified colors can arm the artist with a valuable understanding of how color works on his palette. Today color theorists have devised three-dimensional models to portray color space; these include not only hue but intensity and value gradations as well. These models are useful aids to help the student visualize the range of color. However, artists mix their paint on a flat surface; for this reason, I am limiting our discussions to the eminently practical color wheel.

Let us start with some rudimentary color information by studying the color wheel. An artist's traditional color wheel has twelve colors: three primary (red, yellow, blue), three secondary (orange, green, violet), and six tertiary (red-orange, yellow-orange, yellow-green, blue-green, blue-violet, red-violet). The outside ring of the color wheel represents the color at its highest point of saturation (intensity). Color as it appears directly out of the tube is the most saturated and therefore is placed on the outside of the ring, while the center point of the wheel represents a hue at its most neutral or unsaturated point, such as a gray.

Pure red, yellow, and blue cannot be created by the artist (although less saturated versions of these colors can), so these three colors are the bare minimum

Opposite: Antonio López García, *Main Street*, 1974–1981, oil on canvas, 35 5/8 x 36 7/8 inches

Nuanced shifts of neutral grays create an elusive color atmosphere often found in urban settings. Notice the tiny, continual interchanges of temperature and occasional accents of intense color notes from the entire spectrum that move through this piece.

Photo Credit: Image copyright © 2006 Artists Rights Society (ARS), New York / VEGAP, Madrid

Two opposing colors (red-orange and blue-green) gradually diminish in intensity as they move across the palette, reaching their least saturated (and most neutral) point in the center.

Jules Bastien-Lepage, *Gathering Potatoes,* 1879, oil on canvas, 71 x 77 inches, courtesy of Art Renewal Center

Small, intense color accents enliven the predominantly neutral palette. Notice how Bastien-Lepage reinforced his principal focal point by placing the lightest and darkest values on the central figure.

required to produce a range of hues. In other words, they are the "primary" ingredients of all the other colors found on the wheel. By mixing these primary colors together in varying amounts, the artist can create the secondary and tertiary colors. However, most colors found in life and in painting are various degrees of neutrals, which are created by mixing across the palette to colors on the opposite side of the color wheel.

Colors directly opposite one another on the wheel are called "complementary colors," which are jarring and discordant when placed next to one another at full intensity. Robert Gamblin, of the paint company that bears his name, said that the only true complements on the wheel are phthalo emerald and quinacridone red; he has combined these two hues to form a color called chromatic black. If the artist mixes colors directly across from one another—

let us say a yellow with a violet—the result is too severely gray a color, a neutral that could have been made by mixing with straight black. Colors adjacent to one another on the wheel are called "analogous colors." If the artist chooses to mix a color with another that is too close to it on the wheel, the effect is too harmonious to lessen its intensity. (A blue mixed with a blue-green, for example, will not significantly affect its chroma.) However, the artist can jump to the left or right of a complementary color to a color called a "split complement"; this pairing will be different enough to neutralize but similar enough to truly compliment.

Attributes of Color

One of the first questions that arises for a painter when he is sitting in front of a subject is, "What color is it?" This innocuous question is a small door that leads into a gigantic room. The answer for some objects, such as a bright red ball, might seem obvious. Well, it is red. However, if you try to find a corresponding tube of red paint to represent the ball, it will not take long to discover that it is difficult to re-create the red that you thought was so obvious. If I tint the color, for example, lightening it by adding white to the red to represent the lights and highlights, I find my ball getting cooler, because white cools as it lightens. If I make a shade, adding black to darken my red, I achieve a dead color that does not even begin to approach the full chromatic red in the shadows. It is only by shifting into a range of analogous colors, such as moving toward yellow and orange in the light areas and toward violet and brown in the shadows, that I can represent the impression of the depth and complexity found in reality. The underlying principle is to look for the color shifts that accompany value shifts. Artists can also create the illusion of shifts in the surface of a form without value changes, just by modulating color alone.

The colors on the outside of the wheel represent the hues at their highest point of saturation. The smaller dots extending inward show the nine value step scales of each hue.

If you attempt to paint something more complex than a red ball, such as the translucent skin of a fair child, what then? We do not even have vocabulary for colors like that, let alone a corresponding tube of paint. So, the first goal of the painter is to move past labeling a color and searching for a corresponding tube of paint. Rather, the artist must resist quick certainty and instead aim for a more accurate method of color identification—specifically, identifying attributes of the color such as value, hue, temperature, and chroma.

Each color has an underlying value, which falls somewhere between white and black. This value determines the color's tone. For example, a lemon in full sun will have a light value while a navy blue sweater will have a dark value. Years of working in black and white make most of my students very adept at translating color into value. A color also has a hue, meaning it falls into a family of colors such as those found in Newton's color wheel. For example, both a pear and a brown paper bag may fall generally under the category of yellow. Colors have temperature as well; colors in the red-orange range are "warm" while colors nearer to blue-violet are "cool." Even within the same hue family

Top: Kent Lovelace, *Senenque,* 2005, oil on copper, 12 x 14 inches

The close range of value and low color saturation in this image convey the twilight evening Lovelace painted; compare how a slight jump up the value step scale and a subtle shift of color turns the evening to morning in the next image.

Above: Kent Lovelace, *Guisto,* 2005, oil on copper, 16 x 18 inches

Evocative of early morning, this image uses the lighter end of the value step scale compared to the previous image. Lovelace's use of atmospheric perspective gives the impression of great distance.

there are changes in temperature. For example, a birch leaf that leans toward yellow would be warm, while evergreen needles with undertones of blue would be cool. Chroma, the final attribute of color, regulates the intensity of a color. For example, an orange hue may be at its most intense chroma in a tangerine and at its most neutral in a walnut.

When working in color, the artist sets up a series of comparisons among the characteristics of any given subject. For instance, in a still-life setup, the blue glass jar may be the most intense hue; the reflected light on the table may also be cool but not as strong a color note as the jug itself; and the gray tablecloth may be a blue hue but not as intensely cool as the reflected light or the jar. Asking questions about a color's value, hue, temperature, and chroma assists the artist in correctly identifying each precise color note to arrive at a harmonious series of relationships. Logic and order begin to permeate the picture, communicating essential visual information to the viewer. Accuracy only matters if it works in the general composition of the picture. By keeping overall color relationships in mind, the artist works toward believability. This process of identification can feel cumbersome at first but becomes both precise and natural when mastery is attained.

Color Mixing

Since paintings are rarely made using a color directly from the tube and are instead created from carefully managed neutrals, most of the color that appears in a work of art comes from combinations mixed by the artist. This is why an understanding of color mixing is so essential. As discussed in our earlier example of the red ball, preserving the intensity of a color while making it lighter or darker is a complex task that requires the artist to develop a functional understanding of color relationships. In studying color mixing, students learn how to match the colors they see as well as how to manipulate color intensity. As the artist becomes familiar with how to mix colors, he will also begin to see more clearly where some of the more subtle tubed colors, such as burnt umber or raw umber, fall within broader groupings of colors.

To become familiar with color mixing, I recommend putting a large sheet of glass on top of a sheet of paper upon which a circle representing the color wheel has been drawn. On the glass, place the most chromatic version of each of the twelve colors along the outside of the wheel in its appropriate spot. (I suggest using cadmium red, cadmium yellow light, and phthalo blue for your primaries and cadmium orange, phthalo green, and cobalt violet for your secondaries; then you can either mix the tertiaries yourself or buy tertiary colors such as alizarin crimson for red-violet, ultramarine blue for blue-violet, cobalt teal for blue-green, cadmium green light for yellow-green, cadmium yellow deep for yellow-orange, or cadmium red light for red-orange. Keep in mind that different brands of paint make different versions of these colors. Choose the version that seems most appropriate.) Then start mixing directly

across the color wheel. For example, if you've chosen to mix orange with green, place a daub of orange immediately inside the ring next to the straight orange paint, add just a tiny bit of green, and fully mix the two paints with a palette knife. Then, place another daub of orange at the next spot further inside the ring, add a bit more green to it than you did to the first mixture, and mix the two. Continue working in this way, gradually increasing the amount of green in each consecutive mixture until you get to a 50-50 mixture of green and orange in the center. Then work your way toward the green at the outside of the ring on the opposite side of the circle, gradually decreasing the amount of orange that you use as you go. You may be surprised by some of the outcomes; for example, the orange and green will at a certain point make a neutral yellow. Spend most of the time mixing split complementary colors and experimenting with other combinations rather than just working with

Thomas Eakins, *Sailing,* circa 1875, oil on canvas, 46 1/4 x 31 7/8 inches, private collection, courtesy of Art Renewal Center

If you cover the sail and lower half of this painting, the image is predominantly a cool blue. Do the reverse, exposing only the bottom of the image, and the dominance shifts to a warm brown. The intermixing between the two transitions our eye.

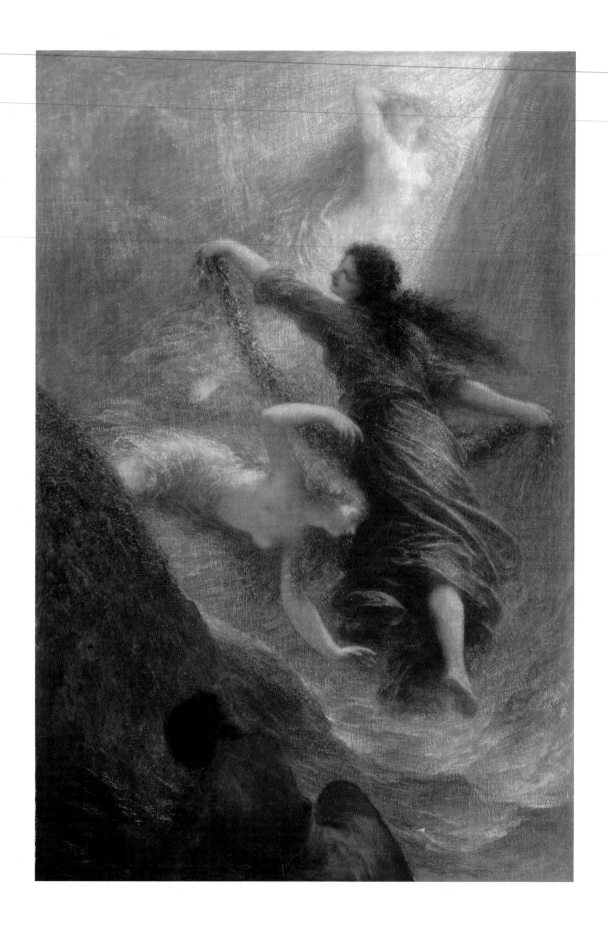

White ◄——— Orange ———► Black

Above: This orange color string features the local color as well as lighter and darker versions of the hue. Notice how the color reaches its maximum intensity midway through the step scale. The addition of white or black both changes its saturation and adjusts its value. This color string could have been used to paint such things as the drapery in the Fantin-Latour image on the opposite page.

Left: Umberto Boccioni, *Signora Virginia,* 1905, oil on canvas, Museo Civico, Milan, Italy

Boccioni created this painting before joining the Futurists. He applied Divisionism, a concept of optical color mixing similar to French Pointillism. This method juxtaposed colors that are laid in clean, short brushstrokes on the surface of the painting, allowing them to be blended by the eye, not the brush.

Photo Credit: Alinari / Art Resource, New York, New York

Opposite: Henri Fantin-Latour, *The Daughters of the Rhine or Rheingold,* circa 1876, oil on canvas

Primarily known as a still-life painter, Fantin-Latour actually had a large repertoire of subjects. Inspired by a Wagner opera, this image shows the three daughters of the Rhine enveloped in the soft edges of atmospheric perspective. Just a few warm color notes set the girls apart from the murky waters.

Photo Credit: Bildarchiv Preußischer Kulturbesitz / Art Resource New York, New York

complementary opposites. In this way, you will see the simple colors of the color wheel transform into marvelous variations and subtle neutrals as they move across the color wheel.

As Robert Henri said, "You can make hundreds of experiments on the glass of your palette, the memories of which will sink into you to come into service in cases of actual need when at the work of painting." The artist's palette represents his own version of a color wheel, with the artist's choice of colors forming the primary, secondary, tertiary colors, and so on. There is a mystical aura surrounding paints that clouds the artist's vision. But by using a methodical and scientific logic to understand the way color works, you will gain confidence to see clearly how to manipulate color.

Color Systems

How does an artist choose what colors to place on his palette? There is no one perfect palette that can be recommended to fit all situations, because color choices are too intertwined with the personal goals of each artist. Some artists consider form more primary than color, some love the emotional and symbolic use of color for its own sake, and some artists bathe their subjects in a warm, golden light versus a cool, milky one. In spite of these differences, commonalities exist. When comparing palettes you will see that they all have white and a red, yellow, and blue of varying intensities. There are rare exceptions, and they can be subtle. For example, in some limited palettes the only blue is actually black—the artist finds he does not need any cooler note; the grays produced read as blue on the canvas. On the other hand, the Impressionist palettes often did not include black at all. (They did not need such a wide range of value, and they disliked the deadened color made by black.) The warm/cool paintings

such as ones made for the warm-and-cool studies lesson are made only with white, burnt sienna (a yellow-orange), and ultramarine blue (a blue-violet); this selection functions as a very limited full-color palette. The ultimate goal for the artist is to have an efficient and balanced palette that provides as wide a range of color necessary to achieve the desired aims.

Noted color authority Faber Birren suggests a balanced palette with a minimum of seven colors to evenly cover the color wheel. With a five-color palette (the three primaries plus white and black) one can achieve a good range, but it is impossible to mix many brilliant secondary and tertiary hues. By their very nature, any admixtures of the three primaries will be less intense than the starting piles. The colors used for the color mixing exercise are very intense and not universally useful. If you are a figure painter, for instance, you may not need the very saturated blues and greens. A palette balanced with both intense and earth colors is more manageable for most paintings, but it needs to be augmented on a case-by-case basis. Birren's palette is versatile and gives a wide access to color space. Nevertheless, many artists prefer to change their palette each time they paint, depending on the subject. The seven colors Birren

suggests are a red-orange (such as cadmium red), a traditional red-violet (such as alizarin crimson), a clear yellow (such as cadmium yellow light), a turquoise blue (such as cobalt teal), a blue-violet (such as ultramarine blue), black, and white.

It is easier to create shades and more muted versions of colors, which are so important in painting, if the palette also includes some deeper colors that can be used to balance the chromatic ones. For creating muted versions of colors, Birren suggests adding to your seven base colors the following earth tones: an earth red (such as Venetian red here), a true brown (such as burnt umber), a muted yellow (such as yellow ocher), a neutral green (such as earth green), and a deep blue (such as cobalt). Notice how these additions give you essentially a warm and a cool variety of each hue as well as an intense and a neutral version. Keep in mind that these are just suggestions and are open to interpretation.

In the discussion of palettes that follows, notice how the palette listings compare and contrast to the balanced palette. Before the industrial era, artists generally used muted earth colors with the exception of some saturated ones, such as

Leonard Ochtman, *Morning Haze*, 1909, oil on canvas, 30 1/8 x 40 1/8 inches, Smithsonian American Art Museum, Washington, D.C., gift of William T. Evans

In this classic example of a high-key image, with a single, dark focal point, Ochtman perfectly captures the quiet, cold atmosphere of this winter landscape. He relies principally on the color shifts to convey his message.

Photo Credit: Smithsonian American Art Museum, Washington, D.C. / Art Resource, New York, New York

Right: Sofonisba Anguissola, *Self-Portrait Painting the Madonna*, 1556, oil on canvas, 26 x 22 1/2 inches, Łańcut Castle Museum, Łańcut, Poland

Notice how few colors Anguissola placed on her tiny, rectangular palette. This technique was not unique to this Renaissance master; other artists' self-portraits from this period show palettes that are restricted in size and in colors used. You might want to compare Anguissola's palette with Chardin's palette, as shown on page 128.

Photo Credit: Erich Lessing / Art Resource, New York, New York

Opposite: Anthony Velasquez, *The Artist's Assistant*, 2005, oil on canvas, 15 3/4 x 21 5/8 inches, courtesy of the Angel Academy of Art

Here are some of the tools of the artist's trade. Lapis lazuli, used to make the brilliant ultramarine pigment (presented here next to the mauler), came predominantly from mines in Afghanistan. Historically, it was one of the most expensive paints, second only to gold. Titian used ultramarine to depict the vibrant sky in *Bacchus and Ariadne,* shown on page 29.

vermilion (equivalent to our cadmium red), lapis lazuli (our ultramarine), and lead tin yellow (our cadmium yellow deep). Their limited palettes were suited to their artistic goals and formal interests; their color choices were not made because they did not have access to other materials or information. (For example, Leonardo da Vinci wrote in his notebooks that the shadows of light bodies will have a bluish cast. The Impressionists are often credited with the discovery of colored shadows. While da Vinci observed this phenomenon more than four hundred years earlier than the Impressionists, he chose not to paint them that way.) Additionally, limited palettes could be extended by their application on the painting surface. Some of the paintings done by Raphael, for instance, give no appearance of color limitations. The intensity and luminosity of these pure color glazes appear prismatic and jewel-like, almost garish by today's standards. Certainly they are more colorful than the work of Whistler, for example, who had access to a far greater range of color.

If we examine historical self-portraits of such artists as Sofonisba Anguissola and Jean-Baptiste-Siméon Chardin, for example, we can see the small range of

colors different artists used on their palettes, with perhaps a few color strings (premixed lines of colors) to extend the range. However, these few colors suited their purposes well. Many artists in the past, such as Michelangelo, liked big areas of local colors (meaning the color something is in normal light with more limited reflected color bouncing in). He favored form over color, and his artistic aims were accomplished with a limited palette. Nineteenth-century artist Thomas Couture said, "You will see that the art of drawing surpasses everything else, and that the qualities of color and light are only secondary to it." This statement could have been made by many artists who love form. The figurative artist concerned with creating an illusion of space and solid mass generally used limited colors systems, as he did not need highly chromatic colors to paint lifelike skin. In fact, Couture said that all you need for figure painting is Naples yellow, vermilion, flake white, and black. With these limited palettes the artist would make various admixtures of the colors to be used, effectively increasing the range of color choices.

Let's examine the palettes of a few portrait painters. Sir Henry Raeburn, the eighteenth-century Scottish portraitist, used such colors as white, black, vermilion, burnt sienna, raw sienna, and Prussian blue. Anthony Van Dyck recommended lead white, Naples yellow, yellow ocher, vermilion, ultramarine, Titian green, raw sienna, charcoal black, red lake, and the color now called Van Dyck brown. James NcNeill Whistler was famous for spending almost as much time mixing his palette as painting; he preferred a palette consisting of yellow ocher, raw sienna, raw umber, vermilion, Venetian red, Indian red, cobalt blue, and mineral blue. American painter Gilbert Stuart used yellow ocher, Prussian blue, vermilion, alizarin crimson, burnt umber, and ivory black.

By the second half of the nineteenth century some artists had moved away from prioritizing the illusionist qualities of art. These artists often dispensed

Juliette Aristides, *Jeremy,* 2004, oil on canvas, 36 x 24 inches

Impressionistic color relies less on the general, or local, color of an object and more on natural light, which contains all the colors of the rainbow. This image incorporates unmixed dots of pure color, which are unified by value and placed close together on the canvas. These dots mix on the viewer's retina and are more vibrant than large, simple areas of color.

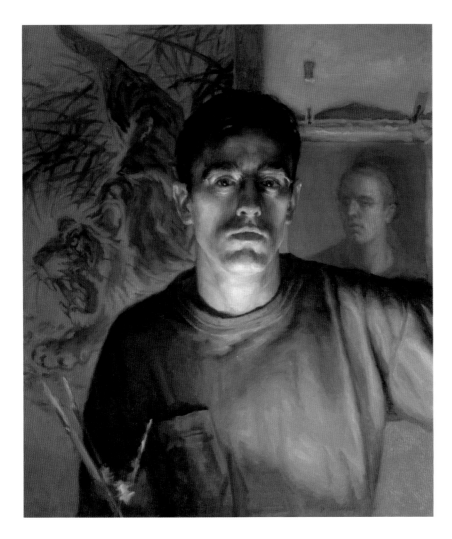

Dan Thompson, *Nightmares,* 2001, oil on canvas, 30 x 24 inches

Thompson's paintings reflect his deep love of color, often with interesting and varied lighting conditions. A good example of simultaneous contrast, the red rectangle in the lower right-hand corner becomes even more chromatic when surrounded by the green shirt; it pulsates, drawing our eyes to that area of the picture.

with traditional methods and pictorial concerns in favor of capturing the shifting colors seen in nature or even representing the beauty of color for its own sake. Although some artists, such as Vermeer, focused on shifting dots of color, it was the Impressionists who pushed the envelope and opened up a world of vibrating color that was closed to art before this point. They became fascinated with fleeting effects of broken (layered, multifaceted) color. This helped give great interest to the paint surface, with dazzling spots of broken color coming closer than ever before to the wide range of colors found in life. The Impressionists were able to achieve what they did in part because of the discovery of mineral colors like the cadmiums, which greatly increased the range of chromatic colors available to the oil painter.

The earliest paint colors were dug from the earth; later they came from minerals that were fired in furnaces; now they are made in laboratories and named after their chemical compounds. Today's artist has such colors as phthalo blue, naphthol red, Hansa yellow, and quinacridone orange. These

Geoff Laurence, *Papillon de Nuit,* 2003, oil on canvas, 30 x 20 inches

The Renaissance masters had a great influence on Laurence's work, including his indirect painting techniques and palette.

colors are even more intense and transparent than those of the past, and unlike cadmiums they do not become more muted when mixed with white, rather, they keep the intensity of the color while getting lighter. These colors are excellent for glazing and keeping the local tone of a highly saturated hue. However, they are more difficult to manage when re-creating the subtle colors in the life model.

Color systems (which are also called "palette systems") tend to have a few goals, such as providing the artist with the widest range of color space with the fewest means, creating harmonious color (unity within variety) in a work of art, and guiding the viewer's eye through the piece. Generally speaking, there are two types of palettes—the closed palette and the open palette. I notice with my students that what is on the palette directly affects what is on the painting, so it is important to choose your color system and master it thoroughly.

CLOSED PALETTE

In the first system, the closed palette, the artist places the colors directly from the tube onto his palette and then creates a range of mixed colors (usually using a palette knife) prior to beginning the painting. The artist often specifically prepares this type of palette for each painting rather than using a palette with the same colors again and again. The artist Michael John Angel compared the closed palette to a finely tuned instrument, saying, "It is not at all fanciful to compare the palette to a musical instrument and, like an instrument, the palette must be tuned, or put in order, before any work can be done."

The benefit of a closed palette is that premixed neutrals offer an easy way to manage color. This can be particularly beneficial for the beginning artist. However, many artists shy away from permanently using a closed palette because they are time-consuming to set up and because sometimes too rigid a premixed palette can result in predictable, uniform color that does not appear well observed or as interesting as the color found in life.

Color strings are a method of palette organization that helps the artist get consistent color by premixing shades and tints of a particular hue or transition steps from one hue to another. Most artists of the past used this method. Color strings are considered to be a variant of the closed palette and are especially useful when an artist is painting a single object or figure. For instance, if I am painting a large green drapery, I may wish to mix up piles of paint representing shades and tints of the local color. Color strings can also be created to reflect a color shift, such as a line of color going from yellow-green to blue-violet. By having a string of my color(s), I can confidently paint the drapery without rethinking the color while I am modeling form.

Color strings are generally favored by artists who consider form a principal concern rather than by artists who are focused on creating impressionistic

lighting effects and trying to catch color vibrations. Color strings offer a very formal and effective solution for some painters. Artists of the past commonly created various admixtures and shades and tints of colors. This type of organization enabled them to become very efficient. For example, at one point in his life, Sir Joshua Reynolds is said to have painted a portrait every few days. His accuracy and speed were attributable to the fact that he was not continually solving the same color problems.

OPEN PALETTE

An open palette is a system in which all the colors are placed onto the palette directly from the tube and mixed freely with a brush as the painting progresses. Most contemporary artists use this system or some variation thereof. If an artist is doing figure painting, the colors required will be different than if he is doing a landscape or still life. To avoid doing unnecessary work or wasting materials, I recommend that you place on your palette only those colors you need for your setup. For example, you may not need four different greens to paint a bowl of plums. One type of painting commonly created with an open palette is *alla prima* work, meaning work done "all at once." This type of painting values spontaneity and seeks to intuitively match spots of color and value while trusting that if all those spots are properly placed the image will be correct.

Gary Faigin, *Transparent and Solid,* 2000, oil on canvas, 24 x 36 inches

Faigin employed the opposition of prismatic hues to create this highly charged color landscape. He makes a color poster study to serve as a guide for every painting he does; he also premixes warm and cool color strings before painting each object.

The advantage of mixing paint with a brush and directly applying it on the canvas is that the color generated is uniquely tailored to the observations of the artist. Many unpredictable color combinations are created, and many colors are brought together as the artist intuitively mixes, making it impossible to determine how the artist arrived at a color. The energy spent wrestling with color generates a vitality and an interesting painting surface. The artist looks at the subject and simultaneously manipulates the hue, value, and chroma as he interprets what he sees. To more easily see the value relationships, some artists squint (as this limits the light hitting the retina and consequently minimizes the color). To more easily see the color, some artists leave their eyes open but refrain from focusing.

The two difficulties that accompany this color system are flip sides of the same coin. An artist can get muddy, dirty color if he does not keep his brushes clean. Alternately, if he does not mix his colors well enough, they can appear unsophisticated, as they will be too highly saturated. When an artist adopts an open palette he can lose perspective on his drawing and value because he is so focused on controlling his color. Using an open palette can cause an artist to create boneless, rainbow-colored people. Although awkward, this is sometimes a necessary intermediary stage for someone who is learning how to control this color system. Pressing through this challenge will allow an artist to master this palette.

Color Composition

Color is one part observed and one part created. Good design, in painting or drawing, is based on a principle found in nature: Use the simplest means to the greatest effect of balance and harmony. I once asked a mathematician how many color combinations one could generate from the most limited palette—black, white, and three earth tones. I speculated that the number would be large, a few hundred perhaps. I was surprised to learn that there are an infinite number of possible combinations. So within a predictable palette of a few colors, there is the possibility for enormous variety. Every new color added increases the range. However, the law of diminishing returns governs. There is a point at which unity can be lost and the painting becomes overwhelmed by too much variety. Daniel Parkhurst said, "Schemes of color or composition are not usually deliberately invented within the painter's brain. They are in most cases the result of some suggestion from a chance effect noticed and remembered or jotted down, and afterwards worked out. Nature is the great suggester. It is the artist's business to catch the suggestion and make it his own."

A friend who is a landscape gardener visited me. As he viewed my uninspired garden he noticed the five trees that I had planted in a row across the back fence. He noted, "You would never design a painting like that. It lacks a focal point by virtue of having too many principal elements." He was exactly right. The goal of the artist is essentially to create a symphonic harmony of all the elements in

Opposite: Mark Kang-O'Higgins, *Sacred to the Memory,* 2006, oil on canvas, 72 x 48 inches

This is a portrait of the artist's son standing on the grave of the artist's father. The top-heavy composition lends monumentality to the image. Generally Kang-O'Higgins's work is marked by a strong use of color, which he achieves with his open palette. The sobriety of the color reflects the sentiment conveyed by the art.

John Morra, *Mertz 1,* 2002, oil on canvas, 24 x 28 inches, private collection, courtesy of Hirschl & Adler Modern

Morra's image plays with our sense of scale, as discarded objects form a dramatic skyline to an imaginary cityscape of sorts. The overarching golden palette is predominantly warm but is accented by a few cool key notes, such as the blue on the left.

conjunction with one another. Too much unity appears monotonous and uninspired; too much variety is overstimulating and chaotic. The base note of good design—in line, tone, composition, and color alike—is to use one's means with restraint to create a visual hierarchy, creating order with just the right balance of unity and variety.

The first color principle, which was previously stated, cannot be overstressed: The creation of a hierarchy of color relationships is more important than trying to find the individual correct color notes. Contrary to the first instinct of many student artists, there is no one right color—only right relationships. The painting will look correct, even if it is not literally accurate, if the principle of keeping the relationships intact is respected. Many students have to experience this before they can completely grasp it. It often takes a long time for students to stop making their work about matching each color note and to begin to think in terms of pictorial composition.

In the chapter on value, we discussed the importance of creating a principal focal point in value. The artist can also deliberately guide the eye through the picture by using color notes in strategic ways. Color is emotional. It hits us at a subliminal level. Strategic use of color can illuminate and communicate the emotional tenor of a piece. The process of organizing color into a hierarchy

may be called a system of "color keying," in which the painting is orchestrated to emphasize one color note.

An example of this can be seen in some of Jean-Baptiste-Siméon Chardin's still-life paintings, where he deliberately guided the eye by limiting color. He intentionally painted a gray lemon and silver pears so that his red apple could take center stage without competition. Years later, his handling of color was so skillful that anyone who had not seen his earlier attempts, which drew our attention to the device, might not have realized how much they were being manipulated.

Some contemporary painters create focal points within an earth palette by saving a few cadmium notes for the key. Artists such as Bo Bartlett take this very seriously and have a very limited palette both in value and color, reserving intense color and strong value for where they need it most. In a piece I am currently working on, a painting of a wreath up against a wall, all the intensity of color is muted and the overall color is shifted slightly to the cool range so that the red flowers in the wreath are emphasized. Composition in color sets the principal lead and lets the rest become the supporting cast.

Sarah Lamb, *A Crab and a Bucket*, 2006, oil on canvas, 11 x 18 inches

Lamb elevated ordinary objects by raising the eye level in this image. The emotional impact of the work is heightened by having a very limited color scheme except for the blue and red notes on the claws.

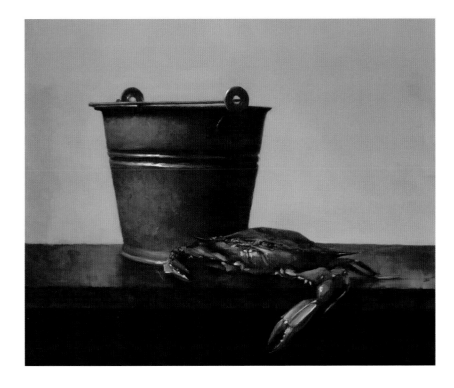

WARM-AND-COOL CAST PAINTING

Michael created this drawing to determine the overall proportion of the cast, its composition, and the shadow shapes. He developed it only to the point where he found the core shadow and lightly toned the shadow shapes.

Painting in color often relies on changes in value and temperature more than changes in hue for its success. By painting with a seriously limited palette we are forced to learn the pictorial language of warm and cool shifts, the balance between intensity and neutrality of color, and the relative relationships of value necessary to have a successful image. Making a two-color painting that seems accurate to life teaches us about the key factors for transcribing reality. The colors have to be exaggerated and must play against one another for the image to be read correctly. To the beginning artist it seems impossible that a white cast could be believably painted with intense color. The purpose of this exercise is not just to paint what you see but to use the full range of color available to produce a painting that represents life.

Gathering Your Materials

In preparation for creating your warm-and-cool cast painting, assemble the following materials:

- Oil paint*
- Brushes
- Canvas or panel
- Odorless mineral spirits
- Medium
- Paint rag
- Palette
- Palette knife
- Cast

Note: Michael used titanium white, ivory black, burnt sienna, and ultramarine blue for this exercise.

The value poster study gave Michael a chance to resolve issues of tonal composition. He tried various lighting situations and background tones to find the one that resolved the issues the best.

Michael created multiple color poster studies, each with a different scenario. This one was the most successful in terms of allowing his few colors to project as a chromatic palette.

Setting Up Your Painting

The setup procedure for this exercise is exactly the same as the setup in Lesson Two. Carefully consider the colors of the environment, such as the background and the ground plane. When setting up the light, check to see that it flows in a pleasing manner down the length of the cast, making sure the cast shadows are not too distracting. Carefully consider the reflected light of the cast. Ensuring that the setup is exactly the way you want to paint it minimizes the amount of adjusting you will have to do later in the painting.

Creating Your Warm-and-Cool Study

For this exercise, Michael decided to use the sight size technique because it allows for an easy comparison with

the actual cast. Before starting the painting, he also made poster studies to work out the composition, value, and color. However, you can select alternative working methods for the initial stages of this exercise, if you so choose.

Create a pencil or charcoal drawing of the cast. For this piece, Michael transferred the image to his canvas by placing tracing paper (or acetate) over his drawing and copying the image onto it. He then placed a sheet of transfer paper between this tracing and his canvas and outlined the image again with a pen, leaving an impression on his canvas. As this outline can be erased by turpentine, he made it permanent by using a thin permanent sepia pen. If you have time to let it dry, you could also use a fine brush with paint to secure the drawing.

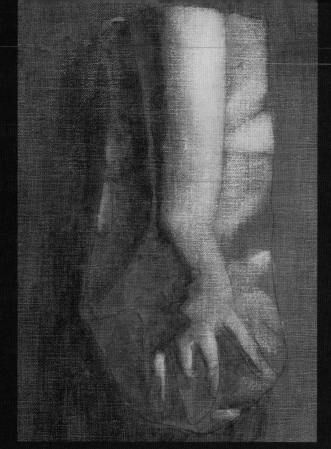

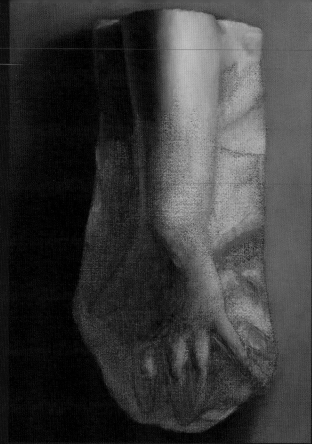

Michael could have effectively used any of a number of underpainting or direct painting methods. He chose a simple tonal wash, which established a unified base and provided a solid value anchor for his color.

Michael started with the background. He then gave careful attention to each individual area, turning the form from dark to light and focusing on the midtones.

Next, apply a wash of paint thinned with odorless mineral spirits as close to the value of the original as possible. Try to leave the painting transparent and lighter than it will need to be in the end. If you use a color wash underpainting rather than a tonal one, you will provide a guide for the overpainting in value as well as in color.

The next layer of paint should be more opaque. Starting with the background creates a context for the rest of the piece. Then establish your shadow shapes. It is often helpful to focus on finishing one small area of the painting at a time. Michael used a technique called tiling, in which a note of color is mixed and placed next to the core shadow, then another is mixed and placed next to it, and so on, getting lighter each time to bridge the shadow to the light area.

Finish your painting by turning form seamlessly while getting the correct value, hue, temperature, and chroma—all in a timely fashion. When you have finished the whole piece, make sure that the eye moves easily over the surface of the painting. If any areas do not work well, simply do an additional pass over the surface, starting from the shadow and working toward the light just as you did the first time.

Opposite: This limited-palette painting required Michael to think strategically. The most intense color notes (almost a straight burnt sienna) are the warm reflected lights.

Michael Hoppe, warm-and-cool copy after an unidentified cast of a hand, 2007, oil on canvas, 17 x 11 inches, courtesy of the Aristides Classical Atelier

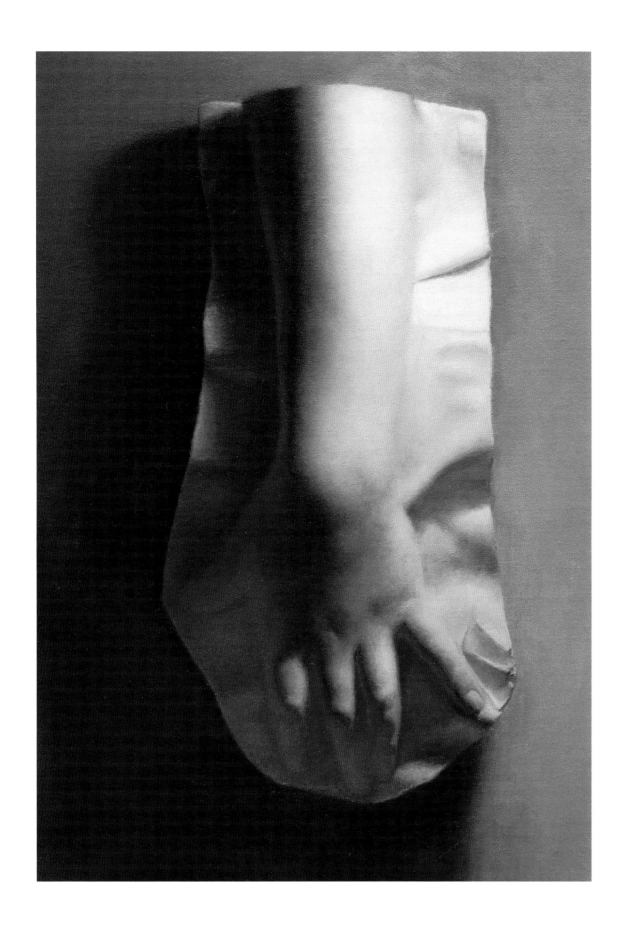

LESSON FIVE
COLOR MASTER
COPY PAINTING

David transferred the image to his canvas, inking over his light pencil transfer lines with sepia pen. This careful drawing ensured that he would have an accurate proportional guide through the entire work.

The goal of this lesson is to create a facsimile of a master-piece with the aim of getting a glimpse into the mind of its creator. Artists have always been inspired and challenged by the work of those who came before them. Through studying a great work of art the student is able to problem solve as well as use various methods of paint application and color that may have been closed to him beforehand.

It is not necessary to do an exact copy unless you are concerned with the finished aspects of the work. Sometimes focusing just on the abstract tones and colors and painting poster studies can be enough to help you understand composition, value, and color elements that contribute to the success of the masterpiece. Additionally, it affords an opportunity to internalize the palette that the master used for this particular work of art.

Gathering Your Materials

In preparation for creating your color master copy paint-ing, assemble the following materials:

· Oil paint*
· Brushes
· Canvas or panel
· Odorless mineral spirits
· Medium
· Paint rag
· Palette
· Palette knife

*Note: David used flake white, ivory black, Naples yellow light, Naples yellow, yellow ocher, raw sienna, cadmium red medium, alizarin crimson, transparent earth orange, king's blue, terre verte, and raw umber for this exercise.

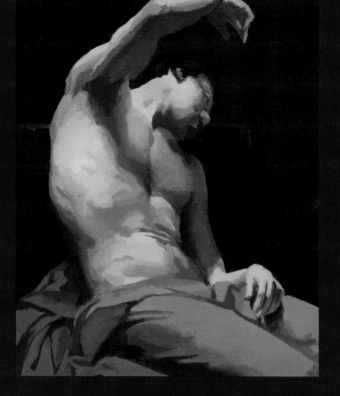

The value of a highly saturated color, such as the red drapery, is quite difficult to establish. A black mirror helped David to accurately see the underlying tone of the color during this value poster study.

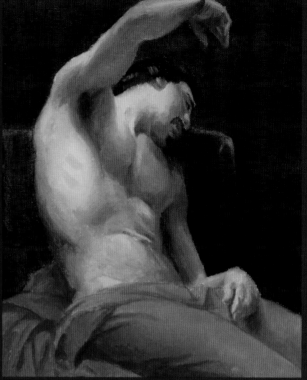

The colors found in figure paintings are evasive and delicate. David experimented with his palette while creating this color poster study before he embarked on his final painting.

Selecting Your Master Painting

Find a good reproduction of a work of art or go to a museum that allows copying. (Many of the best museums have a long history of this practice.) It is important to choose a work that you really admire, as you are more likely to have fun with the project and devote your best effort to it. David selected *Torso Study* by François-Léon Benouville. At the time that Benouville painted this image, the École des Beaux-Arts held annual competitions for its students in multiple categories. Benouville won the 1844 torso competition with this painting and went on to win the prestigious Prix de Rome in 1845. Since the original painting was in the archives of the École des Beaux-Arts, David had to rely on a high-quality 35mm slide of the painting. He had the image professionally printed onto glossy photographic paper in the same size of the intended final master copy painting (24 x 20 inches).

Setting Up Your Painting

If you are working from a reproduction, it is helpful to set up the painting and the picture next to one another and to work the same size as the reproduction. It is also important to have a good light source so you can see clearly. David set up the photograph and his canvas on adjacent easels and illuminated both with daylight-type incandescent bulbs (Sylvania Daylite) in an attempt to avoid chromatic bias.

Creating Your Master Copy Painting

David approached this master copy lesson as a painting study, not a drawing exercise. Therefore, he made a black-and-white xerographic copy of the original painting and used this image as a template to transfer a line drawing of the original painting to his stretched, primed canvas. He then used a sepia-colored waterproof India ink marking pen to ink in the drawing.

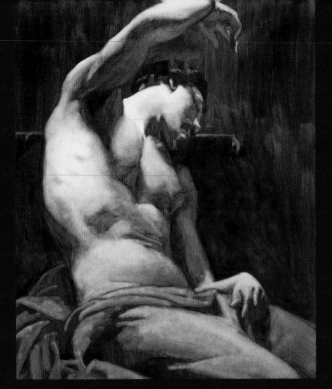

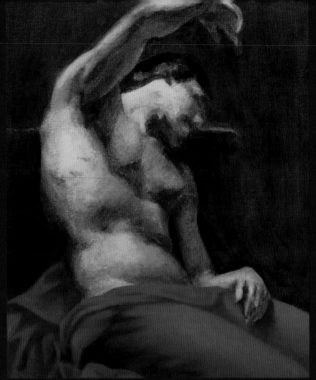

David employed a warm wipeout to give a unified tonality to the piece and provide a value guide for the subsequent layers of paint.

Since the wipeout covered the white of the canvas, it provided an accurate value map and articulated the distribution of lost and found edges.

After you transfer your drawing to the canvas, create your underpainting. David desired a fairly warm underpainting, so he mixed raw umber and transparent earth orange oil paint and applied this mixture (without medium or mineral spirits) evenly to the canvas. He then wiped out the lighter areas using a soft cloth and reemphasized the darker areas by applying more of the pigment to the canvas with a brush. To achieve the lightest lights, David moistened his cloth with mineral spirits and wiped back to the white canvas.

Once your underpainting has dried, build up your overpainting in layers, with an attempt to come as close as possible to the final painting in two or three layers of paint. Remember that each layer should be slightly "fatter" (have more oil) than the one before it.

One of David's primary discoveries during this master copy exercise was how Benouville approached the palette for his flesh tones. Virtually all of the areas of lighted skin were painted with predominantly yellow pigments, ranging from raw sienna in the darker halftones to Naples yellow and Naples yellow light mixed with flake white in the brightly lit areas. David achieved the cooler halftones by mixing raw umber in darker areas and a combination of raw umber and king's blue (basically cobalt blue and white) in lighter areas. The shadow areas were warm, with transparent earth orange (a transparent pigment similar to burnt sienna in hue) coming into play. The subtlety of the value transitions in Benouville's painting is superb.

Opposite: David executed the overpainting in stages, working on one area at a time and pushing it to a finish to match the original painting.

David Dwyer, copy after François-Léon Benouville's *Torso Study,* 2007, oil on canvas, 24 x 20 inches, courtesy of the Aristides Classical Atelier

Photo Credit: All images by Richard Nicol

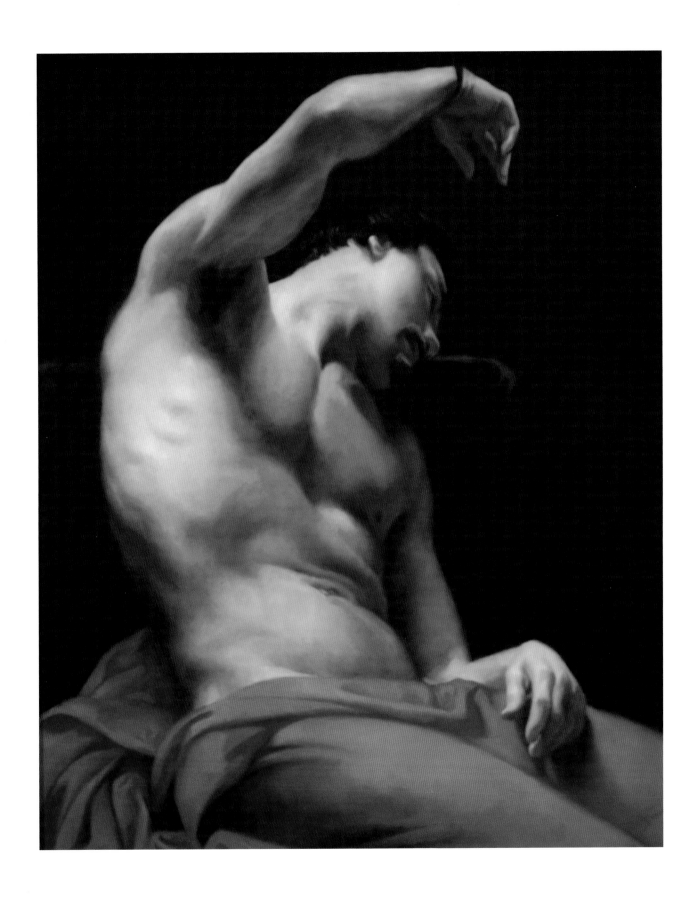

Timeless Practices

THE PAINTER'S PROCESS

Methods and Inspiration

"To be convinced with what persevering assiduity the most eminent Painters pursued their studies we need only reflect on their method of proceeding in their most celebrated works. When they conceived a subject, they first made a variety of sketches; after that a more correct drawing of every separate part..., they then painted the picture, and after all re-touched it from the life. The pictures, thus wrought with such pains, now appear like the effect of enchantment, and as if some mighty Genius had struck them off at a blow."

— SIR JOSHUA REYNOLDS (from *Discourses on Art*)

Spontaneity and originality are valued in our culture as indicators of authenticity, a key point of separation dividing true art from the broader popular culture. Often the contemporary art world finds virtue in the expression of an artist's first thoughts, which are seen to be the most genuine and culturally relevant. The concept of the artist developing a process or method of working may seem antithetical to current ideas about artistic genius; however, artists of the past would have disagreed. Historically, the same consideration, intelligence, and strategy that were expected in the design and construction of a piece of architecture were required in painting.

The great age of major figurative art commissions has waned, and many artists no longer create the sort of large-scale narrative works that have made up the greatest achievements in art history. However, any artist who aims to create work that will endure or hopes to match the excellence of the past masters could benefit from studying their working methods. Only when we have a well-trained group of artists waiting in the wings will there be any chance for another Renaissance. By studying the painter's process we become immersed in the mind of the artist. We catch a glimpse of the multifaceted approaches an artist took within one body of work. We see the continuum of his working methods, the wide range of expression produced by one individual. We also get a sense of the artist's goals, what he was trying to achieve, and how he solved problems.

Transforming a blank canvas into a work of art requires making a multitude of choices and solving an array of visual problems. Even abstract work requires the artist to make choices about color, composition, gesture, expression, scale, tone, and so on. When creating a figure painting, the artist must interpret the visual information he observes in the life model and make thousands of

Opposite: Eugène Carrière, *Intimacy* (also called *The Big Sister*), 1889, oil on canvas, Musée d'Orsay, Paris, France

Using essentially just one earth tone, Carrière created atmospheric and emotive works of art. His underpaintings, which other artists might have called an ébouche, became his primary mode of self-expression.

Photo Credit: Erich Lessing / Art Resource, New York, New York

Previous Spread: Andrew Wyeth, *Overflow* (detail), 1978, drybrush, 23 x 29 inches

Photo Credit: Image copyright © Pacific Sun Trading Company

Ernest Meissonier, *Study for The Barricade,*
1848, watercolor on paper, 10 1/4 x 8 1/4 inches,
Louvre, Paris, France

The deliberate use of red in a few key locations
accents the image and leads the eye into the
work. Meissonier blocked in the whole piece
to make sure that the figures work together
to form a powerful composition.

*Photo Credit: Erich Lessing / Art Resource,
New York, New York*

determinations, such as the size and shape of the canvas, the placement of the
figures, the lighting, coloration, tonal distribution, mood, and so on. The
human mind cannot simultaneously give complete attention to two ideas at
once, so it is necessary to isolate the component parts and give full attention
to each one. This method ensures that the artist starts his work with a map of
where he is going and how he intends to get there. Having this foundation
allows the artist to execute the finished painting without hesitation or exces-
sive reworking. This increase in initial planning actually enables the artist to
complete the process more quickly, finishing the painting with all the energy
and momentum possible.

Any problem is exponentially easier to solve in the planning and sketching
stages than once paint has been laid down. Historically, no commissioned
artist would dream of investing the time and expense required to create a
major piece of art without planning how to work within the limitations of the
format, subject, and scale of the piece. Sketches were submitted to the patron
for approval before an artist began painting. If the work was designed for
placement in a specific architectural setting, the artist would have to take into
consideration any restrictions created by the context. When the work contained
multifigure arrangements, only a few models at most would have been hired at
a time; however, because the composition was determined in advance, the
artist could work piecemeal with individual models while still attaining coherent
results. When doing work in fresco, a procedure that required the painting to
be divided into small, adjoining sections, with each section started and completed
during the course of a single day, not planning ahead was foolhardy. While oil
paint is more forgiving than fresco in many respects, repeated reworking of an
oil painting causes the work to lose its freshness.

Logic dictates that a work that is mulled over in advance can grow in thought-
fulness and complexity while simultaneously reducing the amount of materials
needed and the chances for failure. The necessity of organizing before painting
was forcefully brought home to me when I took my class to a small local
museum to see a collection of works from the Hermitage Museum. At first
glance I was uninspired, seeing only minor pieces from predominantly unknown
artists. I then passed into a gallery containing the work of a contemporary
artist. The work was technically excellent; some aspects were better rendered
and more accurate and colorful than the paintings in the Hermitage collection.
However, the overall effect was one of utters chaos. There was no hierarchy of
composition, value, or color. The artist re-created the hodgepodge and disarray
of imagery so often seen in modern life without the strength of vision to order
and control it. I withdrew to the second-rate collection from the Hermitage,
works of utter genius in comparison. This encounter made a visceral and lasting
impression on me of the importance of planning. It also revealed how simple
design considerations, used to advantage, are infinitely superior to great variety
with no superseding governing factors.

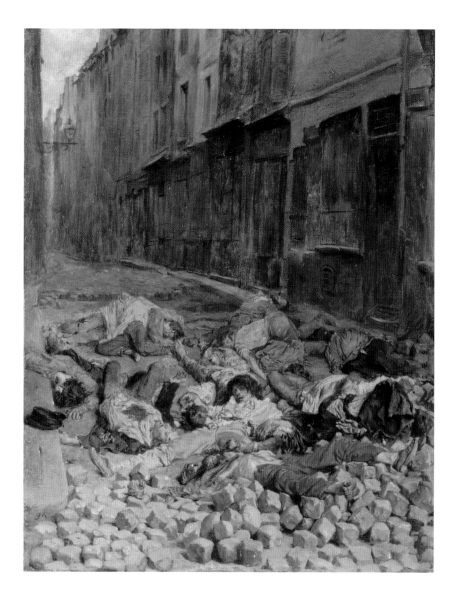

Ernest Meissonier, *The Barricade, rue de la Mortellerie, June 1848* (also called *Souvenir of the Civil War*), 1850–1851, oil on canvas, 11 3/8 x 8 5/8 inches, Louvre, Paris, France, courtesy of Art Renewal Center

The painting is so deftly handled that it appears to have been painted in a passionate fervor. The wash of the underpainting still shows through in places in the background and contrasts with the conscientiously observed small forms in the foreground. Meissonier, one of the most popular and successful artists of his time, is largely unknown today, due to many art historians' infatuation with the Impressionist movement.

While, at first glance, the sort of methodical working methods taught in historical and contemporary ateliers may seem constricting, a structured approach to beginning a work of art ultimately allows the artist to create confidently and efficiently. Just as architectural planning is integral to preventing all sorts of conceivable disasters in the construction of a building, preparatory work enables the artist to foresee and solve problems before beginning the painting, helping ensure that his efforts will produce successful results. The brilliant masterworks of the past, even if they appear to have been effortlessly done, became masterpieces because of the perfection of composition, value, color, execution, and sentiment that they contain. Behind the surface of every masterful painting is hidden the detailed construction of the painter's process. Some contemporary artists, such as Andrew Wyeth, treat every painting with such a high level of care and planning that it seems as if they expect each one to be a perfect gem of execution.

Above: Théodore Géricault, *Study for The Raft of the Medusa,* 1819, oil on canvas, private collection, courtesy of Art Renewal Center

Below Left: Théodore Géricault, *The Raft of the Medusa: The Sighting of the Argus,* 1819, pen with brown ink on paper, Musée des Beaux-Arts, Rouen, France

Photo Credit: Réunion des Musées Nationaux / Art Resource, New York, New York

Below Right: Théodore Géricault, *Oil Sketch for The Raft of the Medusa,* 1819, oil on canvas, 14 1/2 x 18 1/8 inches, courtesy of Art Renewal Center

Géricault did many different studies, only a few of which are shown here, to capture an event contemporary in his day, the sinking of the *Medusa.*

When the composition is thoughtfully predetermined, the abstract underpinning of the work is balanced and dynamic in its most fundamental terms. The artist is then free to concentrate on painting forms and objects without worrying if the foundation is off. Thumbnail sketches and compositional drawings are the most efficient way for an artist to explore his options. A well-done preparatory drawing of the subject eliminates the need to think about proportion, so the artist can instead concentrate on expression during the next stage of painting. A map of values helps an artist to fully realize the chiaroscuro, allowing him to focus on color shifts and possible solutions to color harmonies. In short, when the artist takes the time to devote his full attention to each aspect of the painting ahead of time, the final piece is as well unified and executed as possible.

The progressive steps within an atelier education mirror the idea that an artist learns best when he can study each part individually. The student studies drawing before painting so that he can learn how to create a block-in, execute correctly proportioned drawings, formulate a composition, evoke mood, turn form, and establish hierarchy within a work of art. All of these things are discussed in detail in the first book in this series, *The Classical Drawing Atelier.* In the nineteenth century, a painting student was as concerned with understanding the artistic process as with creating finished works of art. These preparatory stages require the artist to carefully consider every aspect of the painting process before he ever picks up a brush, so that by the time the artist begins a piece he is prepared to address most of the issues still likely to arise in the execution of the work.

This chapter breaks down the basic stages of creating a painting, giving an overview of the working method I teach in my atelier: Students begin with quick drawings, whose primary role is to determine the composition. Next is a careful drawing, in which students determine proportion. This is followed by painted sketches in value and color, respectively, which identify tone and hue distribution. The drawing is then transferred to the canvas. An underpainting locks in the composition and value. And the process ends with the final overpainting.

 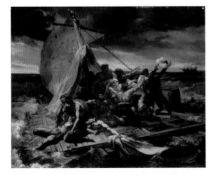

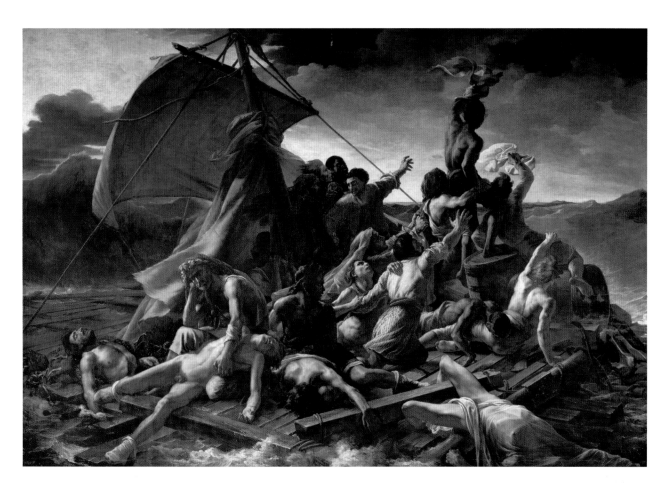

Compositional Studies

Drawn sketches, which may take the form of thumbnail sketches (named after their size) or *croquis*, are the genesis of almost any artistic endeavor. These sketches can be anything from a few lines dashed off with a bit of charcoal to a more developed pen-and-ink drawing. Drawings are the most direct and least expensive way for the artist to freely experiment with his ideas. They are a kind of shorthand, a way of capturing ideas quickly. These first thoughts are generally kept for the artist's eyes only and are rarely shown or exhibited. It is interesting to me that in spite of all my training, my notebook sketches have changed very little since I was a teenager. These sketches are often quite broad and concerned with the bigger composition. Sometimes it is necessary for an artist to do dozens of *croquis* before the idea comes together in the way he envisions. An artist will often draw many different variations on a theme to see which one resonates most closely with what he had in mind or which feels most successful.

Perfection in art is the settled feeling that there is nothing extraneous to the piece—that every line, tone, and color is perfectly orchestrated so that each part works for the benefit of the whole. Nothing can be removed without damaging the integrity of the painting. To achieve this kind of harmony, the artist must make careful decisions about the composition of his piece.

Théodore Géricault, *The Raft of the Medusa*, 1819, oil on canvas, 193 1/4 x 281 7/8 inches, Louvre, Paris, France, courtesy of Art Renewal Center

Géricault energetically portrayed the desperation of these people though the strong chiaroscuro and thrusting angles. Notice how the tiny boat on the horizon keeps our eye within the picture frame, moving us from the background to the foreground.

Top: Harvey Dinnerstein, *Compositional Study for Crossing Broadway*, 2004, charcoal, pastel, and acrylic on paper, 7 x 10 1/4 inches

Dinnerstein executed multiple drawing studies for this major work, only one of which is shown here. The difference in mood between the study and the final painting is palpable. The study simplifies the tones into a series of large, dynamic shapes that radiate outward.

Above: Harvey Dinnerstein, *Crossing Broadway*, 2004, oil on canvas, 44 x 66 inches, courtesy of Frey Norris Gallery

The finished painting differs dramatically from the sketch. It has an extended value range as well as more clarity to each part, turning the twilight into midday by showing an almost equal interchange of dark and light.

During this stage, the artist is creating theme and variation in both line and value. The subject of the painting can be distilled into simplified linear movements or angle directions that lead the viewer's eye through the work. The most simple of these are vertical, horizontal, and diagonal vectors, which create a strong statement if they are repeated throughout the artwork. For example, the repetition of vertical lines could be found in a forest scene, creating a sense of towering strength and stability while also forming an almost musical rhythm. This repetition helps convey the intentions of the artist through a hierarchy of directional line. Another linear element to consider is the curved gestural line, or arabesque, which draws the eye from one area of the painting to another, like the proverbial fairy tale of the hunter following the guiding ball of string through the wilderness. Enclosures, where arcs are used to encompass visual elements within simple circular shapes, are yet another unifying compositional tool. These can be as simple as relating the left side of a figure's ribcage to the right or as complicated as binding together a number of sweeping forms in a crowd of dancing figures. Enclosures can also take the form of other shapes in two and three dimensions.

When organizing a composition in value, the artist looks for an overall mood, such as a high key, low key, or middle key, as discussed in Chapter Three. Additionally, he prioritizes a principal value arrangement, both determining the areas of highest contrast and distilling the surrounding value into the biggest possible masses. This generates a beautiful and simple framework for the more detailed areas. When two artists are equally competent technically, the artist who is able to create a more brilliant composition will surpass the other every time.

Drawings

Compositional studies, like an architect's plans, allow the artist to begin to solve some of the nuts-and-bolts issues that will arise in the painting. However, no matter how much care is put into designing a house, when the building begins some ideas inevitably just do not work. Similarly, in the construction of a work of art, not every possibility can be expressed in reality. While the work is in the realm of the imagination it is limitless and full of endless possibilities, but as the artist transforms an idea from a theory to a reality a reconciliation process occurs. The first thoughts in the thumbnail drawings and other preliminary sketches meet reality in the form of more finished drawings, where the possible meets the actual.

Sometimes these more finished drawings are done from imagination and sometimes they are done from life. If a drawing is done from imagination, however, the artist will often complete more detailed studies from life at some point. It is impossible to outdo nature in terms of the complexity of information and nuance of the imagery that it provides. Therefore, even the best imaginative drawings need to be augmented with a study of the subtleties found in life.

Creating these more finished drawings allows an artist to emphasize and explore certain aspects that will help him more fully achieve his larger artistic goals. At this stage in the process, an artist may choose to draw parts of a composition—such as a single individual from a grouping of figures or characteristics of the drapery, feet, and hands—in great detail. Jean-Auguste-Dominique Ingres, for example, would do several such studies for a single portrait, at times drawing the sitter nude, studying an aspect of the gesture or a twist of the drapery, experimenting with the placement of the hands, and so forth. He would explore all of these details until he was content with the results; only then would he clothe the sitter and begin working on the drawing that would lead to the final painting. (Many artists also use mannequins to set up and study the intricacies of the clothing.)

When the drawing is finished, it is transferred to the canvas and used as a guide for the underpainting. Compositional drawings can be done the same size as the final painting or they can be enlarged as necessary. Artists have different methods for enlarging their drawings. For example, one method is to place a light grid of squares on top of the drawing and place the same number of squares on the blank canvas. Then the artist transfers the drawing to the canvas by simply transcribing and enlarging the image, one square at a time.

Above: Bo Bartlett, *Study for Habeas Corpus*, 2006, graphite on paper, 22 x 30 inches

Bartlett's study for *Habeas Corpus* captures the energy and gesture of the final painting while allowing the artist an opportunity to experiment with placement and composition.

Below: Bo Bartlett, *Habeas Corpus*, 2006, oil on linen, 82 x 138 inches

Bartlett carefully considers balance, distribution of value, and temperature in every painting he creates. Notice his deliberate manipulation of flat areas of shape, which contrast with volumetric turning form.

Painted Sketches

The next step in the painter's process is to create painted sketches or poster studies. These are quickly executed, smaller versions of the finished piece that can be used as a reference right up to the completion of a work of art. This stage of the process generally involves creating two paintings, with the first focusing on value and the second on color. However, an artist may choose to do only one or to do more. Sketch work eliminates smaller details in favor of broad strokes.

Painted sketches are distilled versions of the finished work, allowing an artist to see how few details are necessary to covey a general effect. They also enable the artist to see if the composition, value, and color of the small work can project well from a distance. If the artist does not like the way things are developing, he can do another sketch or modify the sketch on which he is working. The artist can experiment with his oil sketches to see how he likes the mood and tone of the work. If he is dissatisfied, it gives him a good indication that he will not be happy with a larger, finished version of the same thing.

Painting sketches was a standard practice in the painter's process. However, over time, the attributes of the sketches became admired in their own right, so much so that artists were able to exhibit and sell what earlier would have been considered only a preparatory work. Because such sketches are done quickly, they often show great energy and vitality, qualities that are sometimes lost as a work is brought to completion.

If one's final goal is to produce the type of painted *alla prima* sketch that is popular today, it may be unnecessary to use elaborate plans for its completion. However, size and complexity are not always the determining factors for the amount of preparatory work one does. Vermeer's paintings are sometimes tiny, yet they were created as thoughtfully as a mural. Some contemporary artists, such as Andrew Wyeth, do myriad sketches until the painting becomes a fixed entity, fully embodying his goals.

After the artist has had success with his painted sketches, he may do various studies observed from life. These studies are finished paintings of details that will be used as reference for the finished piece. They can be of anything— from hands and feet to a portion of a landscape to a portrait of an individual who will ultimately appear within a large group of figures. Historically, land- scapes were created in the studio; therefore, an artist would depend on the work that he did on location to create the effect of a naturally observed landscape. Studies of other things, such as various animals or architectural details, could also be completed from life and then brought into the studio as reference. These various studies in hand, the artist could essentially graft different sources and settings into his final painting.

From Top Left: Andrew Wyeth, *Study for Overflow,* **1978, pencil on paper, 18 x 23 ⁵/₈ inches; Andrew Wyeth,** *Study for Overflow,* **1976, pencil on paper, 18 ³/₄ x 24 inches; Andrew Wyeth,** *Study for Overflow,* **1978, pencil on paper, 18 ⁷/₈ x 24 ³/₄ inches; Andrew Wyeth,** *Study for Overflow,* **1978, watercolor on paper, 22 ⁷/₈ x 28 ⁷/₈ inches; Andrew Wyeth,** *Study for Overflow,* **1978, watercolor on paper, 22 ³/₄ x 28 ³/₄ inches; and Andrew Wyeth,** *Overflow,* **1978, drybrush, 23 x 29 inches**

Wyeth did approximately twenty drawings and watercolor sketches for the painting *Overflow.* **He executed these both from life and from memory until he had distilled the image into a perfect balance of artistic intent and faithfulness to life.**

Photo Credit: All images copyright © Pacific Sun Trading Company

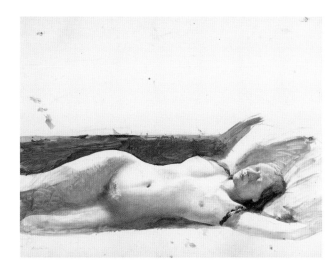

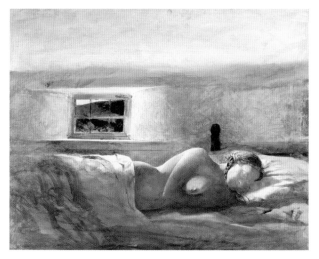

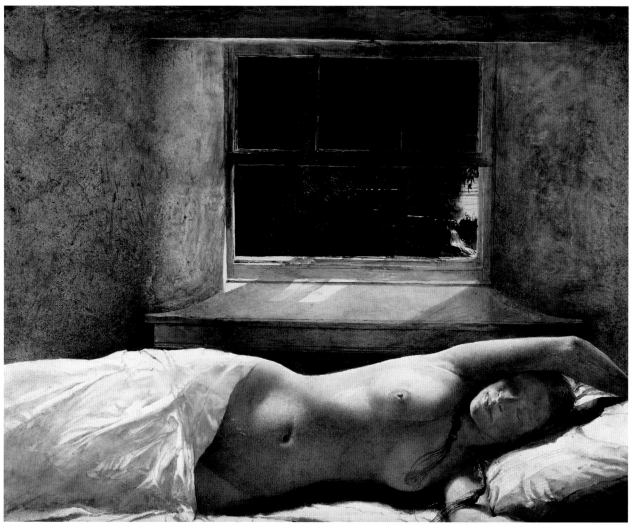

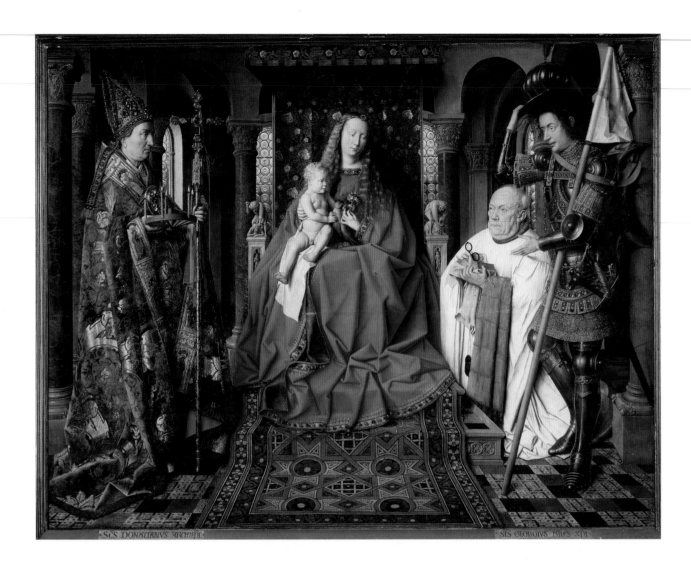

Underpaintings and Overpaintings

Once the artist has decided on a composition and has completed the various
preparatory works, he creates the underpainting, which can be the first layer
of paint to cover the canvas or panel. This first coat serves a few purposes.
This initial layer can simply provide a basic wash of tone, called an *imprimatura*,
so that the artist isn't painting directly on a white ground, as this way it is
easier to see the proper relationships of tones. This was also used as an isolating
layer to cut the absorbency of the traditional gesso and to secure the drawing.
This wash can be any color—everything from a neutral to a bright red or
green. Some artists, such as Steven Assael, generally paint on a highly colored
flat ground, as can be seen in Assael's untitled painting of heads on page 204.
Other artists, such as Jacob Collins, wash in a tone, modulating the lights and
darks and locking in the essential elements of the composition either in value
or color; this approach can be seen on page 213. This is an optimum time to
lock in the essential elements of the composition either in value or color.
When an underpainting is well executed it can provide a unified blueprint for

a finished work. This underpainting method attempts to go directly toward a finish product—except it should be lighter and more transparent than the later applications of paint.

Sometimes, an underpainting layer is designed to be visible in a finished work. For example, it may provide the shadow tone in dark areas. This change of surface—from transparent to opaque paint—can add a beautiful variety to the finished work. This approach was embraced by artists as diverse as Peter Paul Rubens and Jacques-Louis David. Other artists, however, such as Jean-Auguste-Dominique Ingres and John Singer Sargent, disliked transparent backgrounds and opted for putting white in their shadows to make them more opaque.

There are many different ways of creating an underpainting, with each one applicable to a particular outcome. For example, Rembrandt favored a warm, transparent brown *imprimatura* into which he built up opaque whites, giving full range to his halftones. By contrast, Joshua Reynolds used a very cold underpainting comprising blue, black, and white to establish strong light and shadows with limited halftones. Each system worked for the artist who used it. There are more ways of constructing a painting than we have space to record because each artist adapted a method for his own purpose. Additionally, artists varied their methods over the course of their careers, sometimes even from painting to painting. An underpainting is like a recipe that gets modified according to the taste of each cook. The text that follows mentions a few noteworthy practices. Understanding some of these approaches provides an entranceway into a subject that can be pursued independently by the reader; some recommended reading can be found in the bibliography.

The practice of painting in oils began during the early northern Renaissance. We do not know who the first practitioners were, but the first documented paintings are attributed to Hubert and Jan Van Eyck. (Prior to this, paintings were made using egg tempera, encaustic, and fresco.) The method credited to the Van Eyck brothers, called the Flemish method, starts with a wooden panel that is prepared with layers of gesso. On top of this panel the artist positions his highly detailed drawing and then seals it with a thin varnish that also helps cut the intense absorbency of the gesso panel. Then the artist lays down a bistre-colored underpainting, which establishes the shadows and modeling the halftones. The artist builds on top of this his halftones and lights with egg tempera, making sure that the shadows remain transparent. Next he brings each individual area of the painting to a finish with a layer of oil color. After all the elaborate preparatory work, the painting is finished essentially piece by piece as fully as possible, which keeps it looking fresh and varied between opacity in the lights and transparency in the shadows.

The type of work created using the Flemish method is detailed and highly resolved, characterized by color that is focused on a uniform local hue and a

Opposite: Jan Van Eyck, *Madonna Adored by Canonicus Van der Paele,* 1436, oil on panel, 48 x 61 7/8 inches, Groeninge Museum, Bruges, Belgium

Early oil paintings extended the working methods initially applied to egg tempera technique. An obsessively nuanced drawing forms the underpinnings of this image; the design was thoroughly considered and ensured that no part of the painting fell into obscurity. Next, a translucent layer of paint formed a barrier between the paint and the ground. A mid-toned local color was placed on the objects and then layers of glazes extended the range of the modeling.

Photo Credit: Erich Lessing / Art Resource, New York, New York

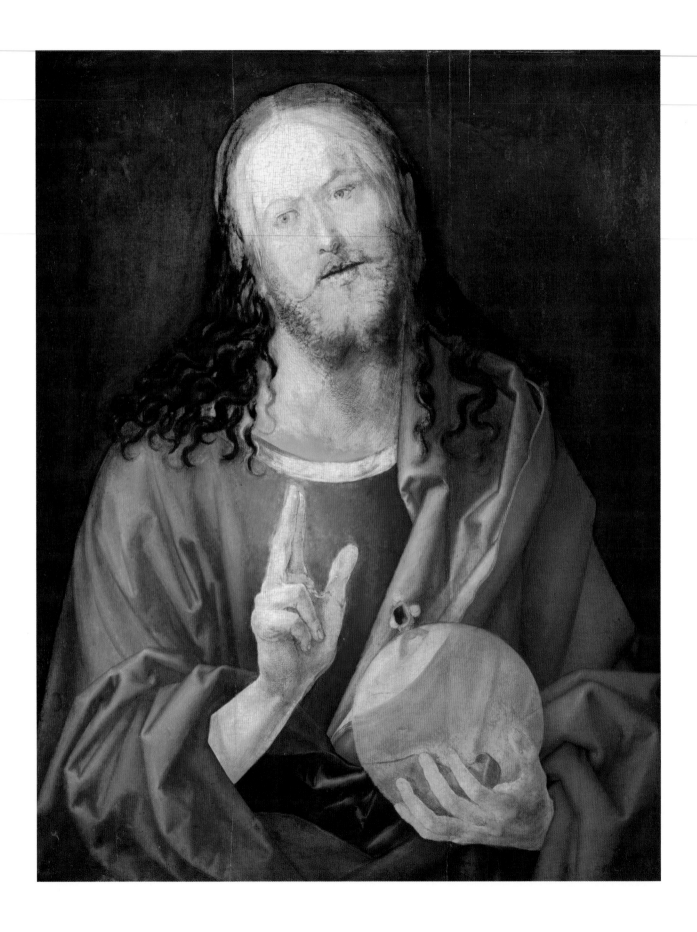

strongly delineated contour line. Historically, some artists who used this method, such as Albrecht Dürer, created a full underdrawing with beautiful ink hatching that followed the forms and then painted thin washes of color on top; Peter Paul Rubens became famous for his technique of dispensing with a detailed drawing and instead using the bistre layer of oil paint to build up opaque, cool halftones and lights; and still others did the whole first pass in egg tempera and then used an egg oil emulsion overpainting. I have done work in this method and know that the process of the panel preparation, the linear hatching, egg tempera underpainting, and subsequent layers of semi-opaque painting are very time consuming and suited for those who are quite detail oriented. However, the results definitely can be worth the effort, creating a brilliant, luminous painting in the right hands.

Glazing, which came directly out of the Flemish method, is a process of putting a transparent darker color over a lighter one. It is best used with colors that are inherently slightly transparent. The luminous white ground is made without oil, so it is bright white. The subsequent layers of paint applied during the glazing process allow the light to go through to the gesso primer and bounce back to the eye. The layers of paint on the white ground act like stained glass. When multiple glazes are used they create a clean, gemlike surface that reflects the light. This process enhances the luminosity and chroma of a color, making it appear even more intense. When glazing is employed, shadows are left translucent. Artists such as Peter Paul Rubens strongly recommended against adding white in the shadows, as this makes them more opaque and cooler. Because changes made late in the painting process can destroy the beauty of the work, this method in particular requires careful consideration on the part of the artist. Rubens used a variation of this technique in much of his work, which is known for its warm, light-filled shadows, cool halftones, and heavy, opaque lights.

It did not take long for word of the Flemish method of oil painting to travel, although some artists distrusted it well into the Renaissance. Venetian artists, such as Titian, were influenced by it, but they adapted the process in key ways. Consequently, the method that they devised, the Venetian method, bears their name. Although painting on linen goes back to ancient civilizations, the Venetian artists were the first to use it for oil painting. Wood supports are far more stable than canvas supports, as they do not flex and contract with changes in humidity. However, flexible supports such as linen are far more practical for travel because they are lightweight and easily rolled. Flexible supports also allow artists to fulfill large-scale commission work that is too big to be accomplished in wood (which would be too heavy and impractical). The artist does not paint directly on the canvas but coats the fabric with a ground, either in lead white paint or a gesso mixed with oil (which allows it to flex with environmental changes) in a process called priming, which is still necessary today.

Opposite: Albrecht Dürer, *Salvator Mundi*, oil on panel, 22 7/8 x 18 1/2 inches, Metropolitan Museum of Art, New York, New York

In the detail of the unfinished area of this painting you can clearly see Dürer's working method, a variation of the Flemish technique. A highly articulated ink drawing forms the substructure. Each hair was delineated within the curls of the beard. On top of this drawing, Dürer brought each section of the painting to a complete finish, piece by piece. When the surface of the painting had received equal treatment, the painting was done.

Photo Credit: Image copyright © The Metropolitan Museum of Art / Art Resource, New York, New York

A more finished rendering of his thumbnail sketches helped Titian more fully explore issues of form, anatomy, drapery, and environment. It is interesting to notice all of the changes he made between the drawing and the final work, especially the twisting of the head toward us, which perfectly completes the movement.

Opposite Bottom Left: Titian, *Study for Saint Sebastian*, 1520, ink on paper, private collection, courtesy of Art Renewal Center

Titian experimented with subtle changes in the gesture of his figure in an effort to convey maximum movement and energy.

Opposite Right: Titian, *Saint Sebastian*, 1520, oil on canvas, SS. Nazaro e Celso, Brescia, Italy.

Titian, one of the first artists to employ the Venetian technique, created large-scale canvases using an opaque underpainting (either in limited-color or in grisaille), which provided a guide for the composition and a plan for the value range. On top of this dry preliminary painting, he built up the finished piece by working broadly over the surface of the painting in layers. Titian was said to have applied as many as thirty layers of glaze along with scumbled areas of midtones and lights on some of his paintings.

Photo Credit: Scala / Art Resource, New York, New York

Differences in support aside, the Venetian technique differs from the Flemish one in a number of other ways. Artists who employ this method draw on a mid-toned ground and then overpaint this initial layer with either an opaque grisaille (meaning all grays), a monochromatic layer (meaning a one-color underpainting), or a "colored grisaille" or "dead painting" (meaning limited color that is lighter than the final, finishing coat). The use of grisaille work goes back to ancient days and is thought to be one of the first kinds of painting ever done. A dead palette painting can be done in browns, black, red, or a green such as terre verte. When dry, this solidly constructed underpainting lays the foundation upon which either additional glazes are applied to create the shadows or opaque, light paint (which is laid, or scrubbed, in) is applied to create the lights. Because oil paint becomes more yellow and transparent as it ages, the cooler and opaque underpainting sometimes can be seen through the subsequent layers of painting, supplying form and solidity to the layers above. When light colors are scumbled into the core shadow area it gives the impression of a range of cool tones and added atmosphere. When an artist uses the Venetian method, the color sketch provides a reference for how he can build up the subsequent color layers.

The Venetian method is far more flexible and painterly in its application than the Flemish technique. In fact, in the later work of Titian there is evidence that he used such things as his palette knife, fingers, and paint rags to manipulate the paint, creating everything from subtle glazes to impasto areas. In addition, the handling of the paint is often more energetic, and the composition can easily be changed as the work progresses. In contrast to the tightly rendered, highly detailed Flemish method, which brought each area to a finish individually and used a transparent ground, the Venetian method employs an opaque grisaille underpainting technique that offers a flexibility of scale and a range of vigorous paint handling that suited the results they desired.

Indirect painting methods such as the Flemish and the Venetian techniques have essentially been replaced by more direct painting practices, which suit contemporary subjects and a modern sensibility. However, many artists still use some kind of underpainting. The most familiar underpainting technique involves either a monochromatic or a color wash. A common practice, which originated in the nineteenth century and is still very much in use today, is to use a brown wash underpainting, which can be applied in a number of ways. It can be created as a wipeout, which involves spreading a thin saucelike substance over the surface of the painting, making a quick and unified underpainting. Then a smooth rag is used to quickly remove areas of the paint, exposing the light of the primer to simply portray lights and shadows in the work. Or light areas can be applied additively, with the artist scumbling in a light tone, creating the drawing and massing in the shadows on the canvas. These underpainting methods are useful for their speed and effectiveness, as they quickly create a harmonious painting surface. See the work of Eugène Carrière on pages 56 and 108 and Cecilia Beaux on page 196 for examples of this technique.

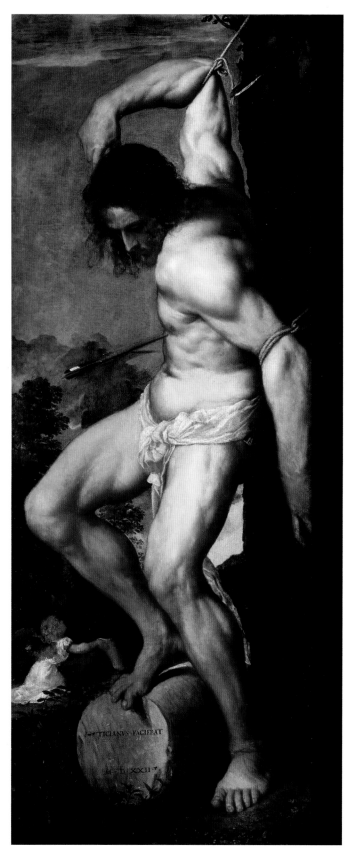

Ingres often painted variations of the same theme over and over again until he achieved his aim. Here he did a grisaille, which was a common historical method of underpainting. Notice how complete the piece feels and how much of the texture he was able to convey just through the use of grays.

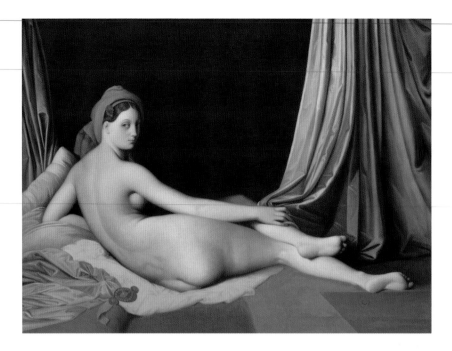

The most common color to use for these *ébouche* techniques is a warm brown, such as a bistre or earth umbers. (Indeed, sometimes this is referred to as the bistre method.) A brown wash was a common beginning for academic figure painters in the nineteenth century. They would then build upon that foundation by positioning light masses simply and broadly with accurate color. Next these artists premixed their halftones on the palette and applied the paint as though it were small tiles in a mosaic, working from dark to light to knit the shadows to the lights. This layer of paint creates the illusion of form. When the painting dried, they lightly scraped down the surface to get rid of the edges of paint and repaints it exactly the same way in the second coat, saving the brightest touches of paint until the end. See Jean-Auguste-Dominique Ingres life painting on page 135 and David Dwyer's mastercopy on page 105.

The systems discussed thus far are preferred by artists who like a tonalist approach. By contrast, colorists do not like to have the underpainting muting the effect of the colors that they place on top. Therefore, these artists wash thin layers of color that match what they observe in life over the top of a white ground. Essentially, they apply a thin, full-color version of the entire painting in a first pass. This gives a color and drawing guide to the subsequent layers of paint, which are then repainted, using opaque layers of paint, one small area at a time.

Anthony Ryder, whose work can be seen on page 15, starts his painting with a careful drawing, then applies oil color as thinly as watercolor over the white canvas. He carefully turns form, essentially starting on one side of the canvas and finishing when he gets to the other side, much as academic artist Jean-Léon Gérôme worked. After the first layer dries, he applies a final layer, working

just as he did before. The result has clarity of form combined with luminous color. Whether an artist chooses to pursue a tonalist approach, a colorist method, or something in between varies according to the teacher with whom they studied, personal purpose, and taste. However, these indirect methods share common elements such as the advantage of a predetermined composition, the beauty of the underlying tones, and variety in the surface.

Today, the most common method of working is the direct painting method called *alla prima*, which celebrates spontaneity and vitality. The artist paints straightforwardly from life focusing on fleeting effects of light and color. This virtuoso painting technique can be done with little or no preparatory work and conforms to many contemporary ideas about artistic genius. However, in the best examples of this technique, the apparent effortlessness belies a well-considered logic and method. The key to using this technique masterfully is to create perfect relationships between the large masses.

Rather than focusing on a subject or objects, the artist impartially observes the background, subject, light, and shadow. The head may become one with the background, the arm may blend with the fabric of the clothes, as the goal is a literal, unadorned faithfulness to observed reality apart from any mental constructs. It is a completely artistic way of seeing apart from any sense of tactile or utilitarian reality. To achieve this, the artist often squints (to properly assess the major masses of chiaroscuro and spots of color) and faithfully observes nature.

Jean-Auguste-Dominique Ingres, *The Great Odalisque*, 1814, oil on canvas, 35 7/8 x 63 3/4 inches, Louvre, Paris, France

Ralph Waldo Emerson once said that we ascribe beauty to that which is simple, which has no superfluous parts, which exactly answers its end, which stands related to all things, which is the mean of many extremes. The work of Ingres comes to mind when contemplating the perfect balance among parts.

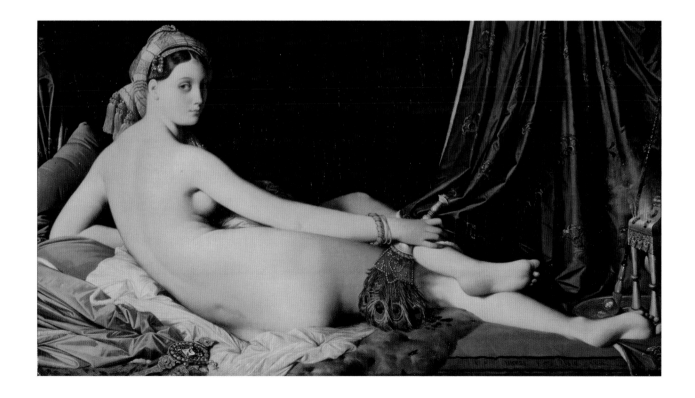

The artist who chooses this approach draws directly on the canvas with a brush and paint. Then, using as big a brush as is possible, he lays in large masses of the correct color and value. It is useful to start with a lay-in of the color and value of the shadow areas and background, as this creates a context for the light shapes and reduces the white of the canvas. The artist then works from large masses to small areas, achieving the correct drawing and color in one go. Generally, the artist tries to achieve a likeness from the large masses, essentially sculpting the forms until they feel right, not worrying about features or subject.

Alla prima artists do not keep transparent shadows, as is done in certain indirect methods, instead preferring to give the impression of vaporous shadows in fully loaded opaque passages. The color effects in the work are not contrasted by

John Singer Sargent, *Spanish Dance*, 1880–1881, oil on canvas, private collection, courtesy of Art Renewal Center

Sargent, who is known for advocating an economy of means and using the fewest strokes possible, painted quickly and often at sight size. In his studies from life he used a light gray canvas into which he would rub a broad tone that indicated the major masses. He would then start painting from the middle tones, sculpting the image with thick tiles of color, and would later move toward the more extremes of dark and light, leaving a few accents for last.

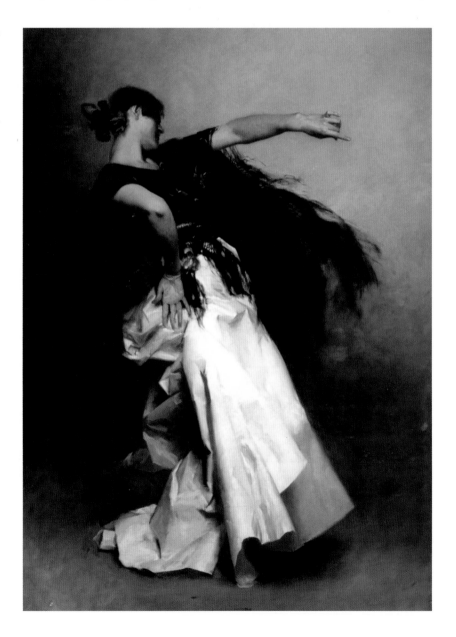

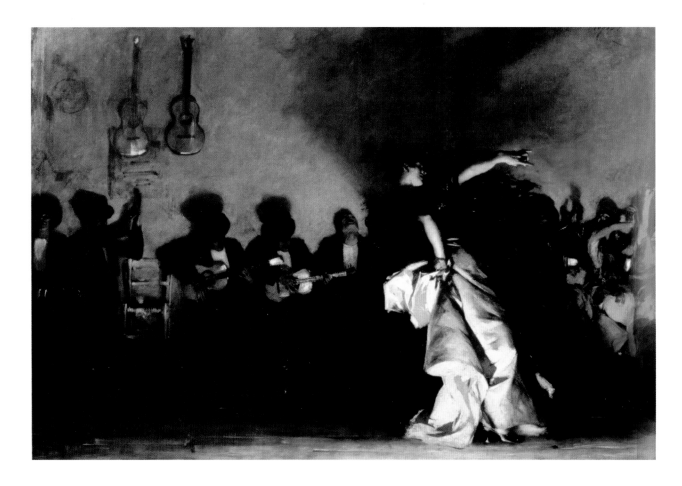

transparency and opacity but in carefully modulated edges and a range of color and temperature shifts. Often direct painting incorporates a highly chromatic palette and some impressionistic painting elements, such as broken color, which is the practice of placing touches of opposing color next to each other so that they can be mixed optically, and which gives the illusion of a varied, almost pulsating surface. This enlivens the surface and offers much added interest. Daniel Parkhurst wrote, "The Impressionist is imbued with the fact that all the light by means of which things are at all visible is luminous—that it vibrates. He does not think that living light can be represented by dead color. He strives to make his color live also."

The painter's process covers everything from creating spontaneous initial sketches to adding the finishing touches of subtle glazes. The range of possible working methods is as varied as is the range of personalities who have employed them. The romantic artist who loves the freedom found in the emotion of the moment is going to establish different processes than the analytical artist who is drawn to the clarity of fully resolved compositions and forms. Only one thing is certain: A full understanding of the variety of expression encompassed within the artist's craft will help put many educational styles in context and make almost any endeavor an educational one.

John Singer Sargent, *El Jeleo*, 1882, oil on canvas, 94 1/4 x 137 inches, Isabella Stewart Gardner Museum, Boston, Massachusetts, courtesy of Art Renewal Center

Sargent aimed to achieve perfect drawing, value, and color simultaneously with a single brushstroke rather than building up the painting in layers or even blending one note into another. If a layer of paint was not right, he preferred to scrape it off rather than rework the image to achieve accuracy. In this way he was able to capture fleeting effects found in observed nature and to achieve a remarkable vitality on the surface of the painting. In spite of the spontaneous appearance of his paintings, Sargent carefully thought through his compositions, as you can see by these images.

Notes on Archival Practices from a Painting Conservator

Jean-Baptiste-Siméon Chardin, *The Attributes of the Arts,* 1766, oil on canvas, 44 x 55 inches, Hermitage, St. Petersburg, Russia, courtesy of Art Renewal Center

Chardin's palette of colors can be seen in this still life. Notice the predominance of neutral earth tones along the top row, with the more prismatic primary colors below.

It is important to know as much as possible about your painting materials and the various ways of using them appropriately. The short-term benefit of this knowledge is an increased ability to achieve your expressive goals; the long-term benefit is a safer and more manageable aging process for the painting. The risks to your painting begin before you purchase its components, as the materials involved contain their own potential for deterioration. These physical and chemical properties are compounded by various environmental risks, from climates to elbows, that begin acting on the piece as soon as it passes from your care. You, as the maker, are the person best positioned to intervene in the long-term course of deterioration of your piece, and to allow it to communicate for many years.

The following text will acquaint you with the material principles that are at the foundation of a well-constructed painting. It is very general and not comprehensive, but is meant as a useful starting point.

Making a Well-Constructed Painting

The assembly of oil paintings as we know them today arrived at its current form roughly five hundred years ago. Oil paintings are laminated structures that are built on a rigid support such as a wooden panel or a semirigid support such as a linen or cotton fabric, stretched over a wooden frame. Oil paintings consist of a series of distinct layers, which include the support, primer, oil paint, and varnish. The proper formulation and application of these layers is critical to the stability of the painting.

PRIMER

The primer layer serves crucial functions. When stretched fabric supports such as linen or cotton duck are used, the primer stiffens the stretched fabric and isolates the vulnerable vegetable fibers of the fabric from the acid-bearing oil of the paint. When wooden supports are used, the primer isolates the oil paint layer from the acidic wood, and vice versa. The primer should be a stable layer that has a full bond with the

underlying support. This can be ensured by forcing the first layer of primer well into the fabric weave or wood grain and by sanding between the ensuing primer coats (generally, approximately three).

OIL PAINT

In its simplest form, oil paint is a collection of pigment (dry mineral particles) pinned in a matrix of long, vegetable-based oil molecules. During the initial paint-hardening phase, any thinners that have been used evaporate, leaving a physically bonded pigment/polymer structure. This layer never dries in the sense of losing moisture; however, in the early decades after completion, the polymers compress and eventually form chemical bonds to one another. This is broadly termed "crosslinking" of the polymers. The mature paint film can be very tough, durable, and ideally difficult to dissolve or damage. However, the paint layer remains semi-plastic and responsive to dimensional and planar changes in any support and will respond by warping and splitting. This can proceed for decades, depending on the thickness and makeup of the laminate and on the painting's environment. During these dimensional changes, the support, primer, and paint layers must remain bonded to avoid loss or disfiguration.

Eventually the paint layer will toughen to a point where it surpasses the flexibility demanded by a mobile fabric support, and a crack pattern may emerge. The craquelure is not necessarily an indicator of adhesion problems; however, the increased surface area caused by cracks can precipitate future lifting and planar distortion of all the layers. The crack pattern frequently corresponds to the morphology of the paint and the brush pattern, splitting along small but insistent tectonic stresses in the structure of the laminate, owing to varying paint hardness, drying time, and flexibility.

Whether an image is painted on a panel or on a stretched fabric, it is vital that each layer be more flexible than the one below it. This is achieved by increasing the oil-to-pigment ratio in the paint as you go. However, oil is paradoxical: While it is necessary for the paint's wide optical possibilities, oil also contains and continues to generate the acids that will discolor the paint layer unless there are enough reflective pigment particles present to mask the darkening and yellowing occurring in the oil matrix. This means that you should use only as much oil as is needed to fully bond the pigment in each layer and gradually increase the oil-to-pigment ratio in sequential coats.

No additional oil, or medium, should be used in the first paint layer, which for both optical and structural reasons should be an opaque, substantial paint coat. This includes the dark passages, which generally look and last best if provided with enough opaque pigment, in addition to transparent dark pigments, to create some opacity and color reflection.

Subsequent layers may incorporate slightly more oil or other medium. If the paint layers begin to look matte or powdery, oil is likely being absorbed into the primer and paint layers beneath. In this case, oil or medium should be added slightly more liberally to the next coats to fill this more porous layer. The following coats incorporate increasing amounts of oil or medium, in very slight increments. The final surfaces of reliably bonded oil layers have a velvety to moderately glossy appearing surface. Oiling out is not necessary except when poorly bonded layers have occurred. If oiling out is practiced, this should be done with minimal oil.

The amount of oil used in glazes must be very limited. There is more pigment in glazes, and far less oil, than is commonly

believed. The transparency used in successful glaze effects is a result of wide pigment dispersal, not a transparent film of medium. Glazes are not runny, and on the palette they should not appear or feel much thinner than straight paint. With a very small amount of glaze paint on the brush tip, work this mixture firmly into the base layer. A glaze that is fluid enough to be pushed into place with a sable or synthetic brush probably contains too much medium—a hog's-bristle brush or clean, lint-free cloth works well. It is best not to use numerous layers of glaze; the representational effects of volume and form should generally have been achieved in the base layer, with glazes reserved for color and value enhancement.

VARNISH

Both the material history of varnish and its aesthetic intent have changed during the last three hundred years. In some historical phases the varnish had an intended long-term aesthetic role; the artist knew that the varnish would yellow as it aged and used this quality to mellow the painting toward a desirable fusion of graphic elements, eventually creating a "gallery glow." Generally speaking, varnishes of the past entailed more viscous recipes and heavier applications than we commonly use today.

At present, a varnish is commonly meant to saturate the surface and thus the colors, particularly the darks, which tend to lighten in perceived value as thinners evaporate and paint layers mature. A varnish's dried structure is normally largely crystalline or non-crosslinking polymers and will ideally remain soluble in weak solvents. While the traditional sap-based varnishes, such as dammar or mastic, are not inherently objectionable from the preservation standpoint, they will gradually yellow and become increasingly resistant to solvents over the years. Some contemporary

synthetic varnishes have been developed with the longer term in mind; they remain readily soluble in weak solvents, which makes them easier to manipulate or remove without affecting the paint surface.

Time spent making and applying varnishes from raw materials will pay off. Varnish can be tricky to manage, either spraying or brushing, but varnishing is important for the appearance and protection of the surface. Varnish, regardless of type, should ideally not be applied until at least a year after the painting is finished. This will help ensure the division of the paint layer and the varnish layer, which will facilitate safe removal of the varnish should it be necessary in the future.

Selecting Your Materials

The simpler the paint system, the better its longevity will be. In most cases, the optical effects achieved by Rubens, Rembrandt, Titian, Vermeer, and other masters are the effect of simple materials carefully applied. Contemporary chemical analyses of these successful paint layers generally reveal that these artists used simply processed drying oils, such as linseed and walnut, without many additives, cooking, or chemical processing beyond partial oxidation via sun-thickening or partial polymerization of linseed oil by cooking it in the absence of oxygen to form stand oil.

In some phases of Western painting history, artists have followed a romantic interest in supposed secrets of the masters. This has led to risky medium ingredients, such as coal tar, amber, and excessive sap-based resin, and structurally compromising oil processing. This periodic absorption with material distractions has resulted in paint films that are both structurally and optically flawed.

Simplicity of materials is the key to becoming a stronger painter and creating permanent results. Taking the time to prepare your materials in the old way is not a quaint conceit. These methods are based on the longest-lasting pieces, many of which have lasted for hundreds of years, some without any intervention by conservators or restorers.

SUPPORTS

Supports come in many forms, including wood panels, fabric glued to a wooden panel, or fabric affixed to a wooden stretcher. In terms of wood-based supports, it is possible to use good-quality plywood, as its cross-grained laminate will not develop splits or warps. Indeed, it will behave better than many single-piece solid wood pieces currently available. Masonite and other hardboards can be acceptable if thoroughly primed and properly supported according to size.

Paintings on stretched fabric must be able to take a lot of pressure from the brush, particularly if glazes are being used. Therefore, the wood stock of the stretchers should be as sturdy as possible, and the bevel should be 1/8-inch high, at a minimum. The high bevel allows the fabric to withstand strong brush pressure without impressing onto the inner edge of the stretcher or its cross pieces, which causes plane distortions and texture variations that will affect the painting in the future. Two fabrics are acceptable as stretched fabric supports: cotton duck and linen. Linen is woven from flax and contains longer and stronger fibers than cotton; as such it tends to be more durable.

PRIMER

The support you are using will determine what kind of primer is required. There are basically three categories of primer: traditional gesso, oil primer, and acrylic artist's primer.

Traditional gesso is used to prepare wooden panels. If fabric is being used, it is glued onto the panel with rabbit-skin glue. The subsequent primer layers comprise "gesso"—a plaster of calcium carbonate—based filler, pigment, and gelatin (such as rabbit-skin glue). This gesso is applied in successive layers, each of which can be polished to a range of finishes with abrasives. The surface will possibly be absorbent; to cut the absorbency the surface can be sealed with a very thin layer of rabbit-skin glue, traditional shellac, or sap-based varnish. If fabric isn't being used, the gesso is applied in a similar manner directly onto the panel.

Oil primer (which is composed of lead carbonate and linseed oil) is the primer traditionally used on stretched fabric. This primer has as its base a pigment-heavy, low-oil paint that dries to be more flexible, and less responsive to humidity, than traditional gesso. This type of primer is not chemically or structurally different from the following paint layers. To protect the fabric from acidic oils in this priming system, thin rabbit-skin glue is applied to the raw fabric, after it is stretched but before it is primed. This sizing layer must saturate all fibers, front and back, without forming a heavy film, which would prohibit a strong bond between primer and fabric. The use of white lead poses significant health and environmental risks, and it may be preferable to buy pre-primed canvases to avoid them. Pre-primed canvases are usually made of cotton or linen and are created with different weaves, ranging from coarse (which gives a textural appearance to the finished piece) to fine (which lends a smooth finish and is sometimes referred to as portrait quality). When purchasing canvases, it is best to buy the densest weave possible, regardless of your selected thread thickness.

Acrylic artist's primer (which is usually marketed as "artist's acrylic gesso") is presently the simplest and most common priming system for stretched fabric. Acrylic priming does not release acid and therefore does not require a preliminary sizing. In fact, most acrylic polymers are incompatible with animal protein films; thus, when using this priming system, the fabric should not be sized.

OIL PAINTS

It is best to use professional-grade paints rather than student-grade ones. However, with an absence of fillers and stabilizers in good-quality tube paints, the pigment tends to settle, leaving a reservoir of oil in the tube. Excess oil should be withdrawn from each session's paint by squeezing it onto a paper towel or blotter and allowing the oil to leach out. This practice diminishes the oil count to begin with and allows more options for your oil-dependent optical strategies in subsequent layers.

Each manufacturer creates unique versions of a color. For example, every burnt sienna will be different, so look carefully to find the one you want. Some colors—such as lakes, alizarin crimson, and Van Dyck brown—are considered fugitive. However, manufactures will sometimes make an alternate permanent version. Each label on a tube of paint should have a lightfastness rating that says how well the color remains consistent upon exposure to light.

Grinding paints by hand remains viable and permits complete control of the ingredients. Hand-ground paints may contain more oil per volume, as manual power does not match a paint mill for efficient oil dispersal. Excess oil can be managed in the same way, by removing it from the paint before application.

OILS AND MEDIUMS

The words *oil* and *medium* are interchangeable in the sense that each adds polymers and optical properties to the paint. Many medium recipes or products add other materials, such as dammar varnish, Venice turpentine, and driers. In any case, painting mediums and glaze recipes should not be complicated. The simpler the mix, the better. Ideally, they should contain only a single type of oil. Alkyd resin is based on linseed oil and is a sound medium. Stand oil and sun-thickened linseed oil are both viscous and will add significant body to your paint even in small amounts. The main working difference is that sun-thickened oil hardens quickly, whereas stand oil stays workable longer.

Thinner is not technically part of the medium. Thinner should be used only to lubricate the paint as needed. Too much thinner disperses the polymers too broadly to effectively bond the pigment and forms weak, porous coats.

When possible, you should make your own mediums and carefully control the recipe to avoid excessive additions of other resins such as dammar and Venice turpentine (which, confusingly, does not evaporate like turpentine but rather contains oleoresinous, binding particles). Purchase only those store-bought materials whose manufacturers provide satisfactory technical data about recipes and components.

BRUSHES

Although brushes are not part of the finished oil painting, they are instrumental in its creation and therefore should be understood. In short, there are three different *types* of brushes (hog's hair, sable, and synthetic) and three different *shapes* of brushes (filberts, rounds, and flats). Each serves a different purpose. You should purchase a range of sizes.

Hog's-hair brushes are stiff, white, and economical. They are good for pushing stiff paint into position. Surfaces made with hog's-hair brushes tend to be textural.

Sable brushes are strong, supple, and expensive. They are good for flawlessly blending colors and smoothly coating layers. Using sable brushes can lead to working with oil mixtures that are too runny for optical and structural stability.

Synthetic brushes are soft, economical, and short-lived. They are good for creating smooth surfaces. Synthetic brushes hold far less paint than other hair types and "fuzz out" quickly, eliminating the option of creating crisp edges. Synthetic/sable blends achieve the benefits of neither; it is more economical to buy one or the other.

Filberts are the most versatile of the various shapes and can be used for many different brushstrokes and paint types.

Rounds are good for glazes and undercoats. Small rounds and "riggers" (named for precise nautical painting) are useful for the placement of underdrawing lines and fine details. Among fine-point hairs, sable rounds offer a desirable combination of control, versatility, and paint quantity. One benefit of using fine brushes of all types, particularly with a high-quality hair, is their ability to manage both fine and broad optical effects simultaneously.

Flats are used for establishing planar effects in the base coat. They are good for laying down a lot of paint quickly; however, they are not designed for glazing.

..

PETER MALARKEY *works privately as a painting conservator, painter, and instructor in Seattle, Washington. He studied atelier methods with Charles Cecil and Daniel Graves in Florence, Italy, from 1984 to 1987.*

PAINTING FROM LIFE

The Muse

"The artist goes first. Before him lies a dark, trackless, formless, chaotic field, which he probes with the antennae of his techniques and ideas, seeking by his action to transform it into pure presence."

— KROME BARRATT (from *Logic and Design*)

Whether in the context of secular, religious, mythological, or historical artwork, the figure was the principal subject throughout Western art prior to the twentieth century. Even the most miserable person is a remarkable physical, spiritual, intellectual, and emotional being and presents both the greatest challenge and the possibility for the greatest attainment for the artist. The centrality of the figure is perhaps best demonstrated in Leonardo da Vinci's *Vitruvian Man* (pictured on the following page). Kenneth Clark wrote about the Vitruvian man, saying "It is impossible to exaggerate what this simple-looking proposition meant to the men of the Renaissance. To them it was far more than a convenient rule: It was the foundation of a whole philosophy. Taken together with the musical scale of Pythagoras, it seemed to offer exactly that link between sensation and order, between organic and geometric basis of beauty, which was (and perhaps is) the philosopher's stone of aesthetics."

This meticulously proportioned figure was crafted to embody the complex anatomical formulas of the Roman architect Vitruvius, who matched the geometric patterns in the body to an overarching cosmic order that can be applied to measurements throughout the physical universe. This Vitruvian man, shown on the following page, is the reconciliation of the square, representing the finite elements of the Earth, and the circle, representing the infinite nature of God. Underlying this philosophy was the belief that human beings were different from the rest of nature, designed in the image of God and containing both divine and earthly aspects. This heroic vision of humanity, which views man as the crowning glory of creation, was born of Renaissance humanism and the biblical worldview and was the central pin that secured the figure's role as the chief subject in art.

Opposite: Jacob Collins, *Carolina*, 2006, oil on canvas, 22 x 20 inches, courtesy of Hirschl & Adler Modern

When representing the figure, Collins does a careful drawing from life and then transfers the image to the canvas. He then does a raw umber *imprimatura*, into which he either wipes out or builds up the lights and shadows. Into this underpainting he turns form from the core shadow area, tiling nuanced form and descriptive halftones and bringing each area to a finish.

Following Page: Eugène Delacroix, *Seated Nude, Mademoiselle Rose (Model for the Guerin Studio)*, 1820, oil on canvas, 31$^7/_8$ x 25$^1/_2$ inches, Louvre, Paris, France

Delacroix trained academically, along with fellow student Théodore Géricault, before becoming the foremost artist of the Romantic movement. His interest in movement and color separated him from his Neoclassical contemporaries, such as Jean-Auguste-Dominique Ingres, who were much more interested in form and line.

Photo Credit: Réunion des Musées Nationaux / Art Resource, New York, New York

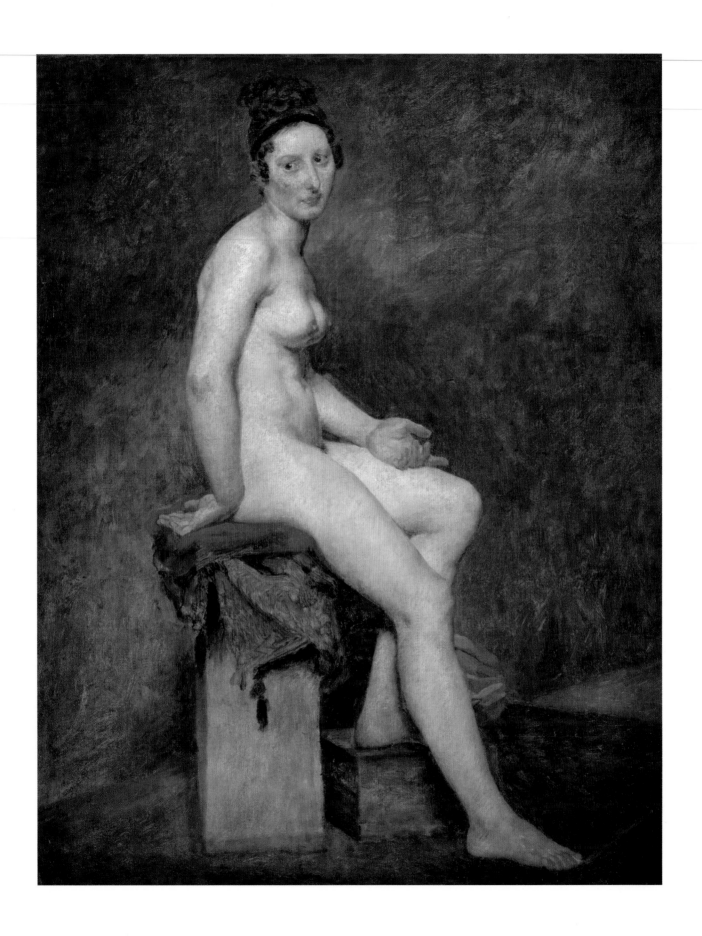

Above: Leonardo da Vinci, *Vitruvian Man*, 1492, pen and ink on paper, 13 1/2 x 9 5/8 inches, Accademia, Venice, Italy

Da Vinci thought of the artist as a natural philosopher and said that through art we may be said to be grandsons to God. A fitting image for such a belief, here da Vinci reconciles the earthbound man, contained within a square, with the circle, a symbol of an immortal God.

Photo Credit: Cameraphoto Arte, Venice, Italy / Art Resource, New York, New York

Left: Jean-Auguste-Dominique Ingres, *Male Torso*, 1800, oil on canvas, École des Beaux-Arts, Paris, France, courtesy of Art Renewal Center

This image is a synthesis of observed reality and the rules of art. Ingres simplified his lights and shadows into clear unified shapes that run down the length of the figure, bringing visual emphasis to the core shadow area.

While the figure was considered the noblest of subjects, it is also the most difficult one to do well. The primary goal of pre-twentieth-century art academies and studios was to produce technically brilliant artists who were capable of fulfilling complex commissions, which almost universally included the human form. Consequently, figure painting became the most essential component of an artist's training.

The sole focus of all of the exercises discussed in the previous chapters is to stack the cards in a student's favor, so when he enters the "life room," where he will begin to work from the figure model, he will have a good chance of success. Rendering a subject that is not only technically accurate but also emotive and compelling is extremely challenging. Thus, the principal objective during the early stages of atelier training is to arm the student with the visual lexicon and

Above: Jacques-Louis David, *Nude Study of Hector*, 1778, oil on canvas, Musée Fabre, Montpellier, France, courtesy of Art Renewal Center

David studied for fifteen years before finishing his education with the Prix de Rome. During the course of his studies he did many paintings such as this to help him master the figure.

Opposite: Juliette Aristides, *Rachel*, 2002, oil on panel, 21 x 13 inches

This painting, created from the life model over a period of weeks, shows a strongly abstracted series of light and dark shapes. The stability of the centered vertical figure is offset by a series of diagonals that add visual tension.

the relationship with the instructor he will need to be successful in endeavoring to render these more complex exercises from life as well as to build up the stamina he will need to complete the prolonged study necessary for mastery.

Historically, this progression of study guided students through a course that began with copying engravings and casts of the figure before moving on to drawing from life. Cennini wrote in the fifteenth century that the artist should take pains and pleasure in constantly copying the best things done by the hands of great masters. He encouraged them, saying "And as you go on from day to day, it will be against nature if you do not get some grasp of his style and spirit." The assumption was that if a student could not draw a stationary white object, then what hope did he have of rendering a lumpy, hairy, constantly shifting model? Achieving a certain level of mastery during the early stages of atelier training did not guarantee ultimate success, however. A student could do beautiful master copies and drawings from casts and still be a complete novice when working from life. Even the student who had learned how to handle the materials well often continued to struggle with the practical aspects of painting, such as proportion and gesture, when confronted with having to interpret life rather than copying someone else's artistic creation. To successfully advance to working from the figure, students were required to develop a solid

working method supported by tools and tricks to help them solve every visual dilemma they would encounter. So important was this foundation that placement in the life drawing room was determined by how well the student could copy masterworks, with the best views of the model being awarded to the most adept students.

The immense effort that artists who were enrolled in ateliers of the past invested in executing master copies and drawing the cast before they ever attempted the figure helped them determine which lines, angle directions, and shapes were most essential for capturing the likeness of the model. While the figure hints at great order and beauty, it rarely exhibits it, for it is hidden within a vast labyrinth of visual information. Even if it were desirable to do so, it is not possible to copy all the visual complexity one sees. The aim of art is not to render every detail in life as precisely and realistically as possible; rather, it is to

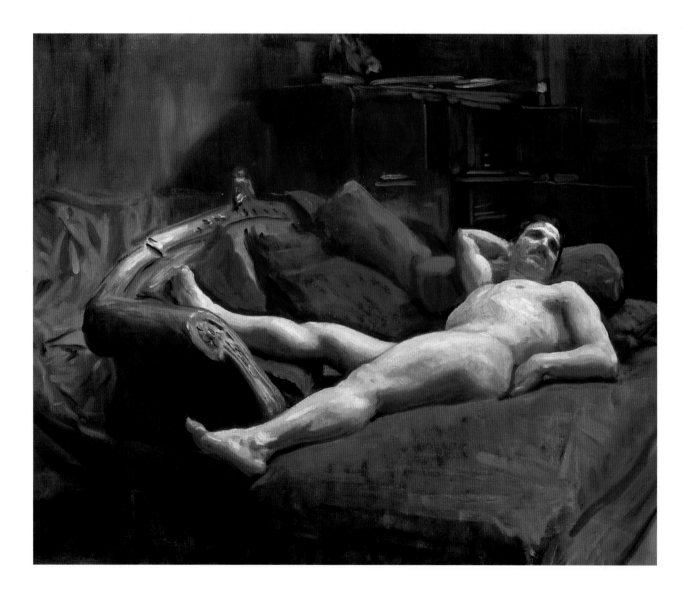

Left: Richard Lack, *Study for Andromeda,* 1968, oil on panel, 20 x 13 inches, collection of Stephen and Patricia Gjertson

Lack experimented with elements of the Flemish painting technique, combining a warm transparent underpainting on which he built cooler, more opaque areas of light.

Opposite: John Singer Sargent, *Male Model Resting,* circa 1895, oil on canvas, 22 x 28 inches, courtesy of A.J. Kollar Fine Paintings

R. A. M. Stevenson, a fellow student with John Singer Sargent, wrote that Sargent followed Carolus Durand's teaching closely without seeking to be original. This gave Sargent such a command of his technique that within a few years he was able to achieve whatever goal he set for himself.

sift through nature in order to express the particular vision of the artist. For this reason, the figure, in order to be a beautiful monument to the human form, must be distilled or interpreted by the artist. Kenneth Clark wrote, "Almost every artist or writer on art who has thought seriously about the nude has concluded that it must have some basis of construction that can be stated in terms of measurement. Although the artist cannot construct a beautiful nude by mathematical rules, he cannot ignore them. They must be lodged somewhere at the back of his mind or in the movements of his figures."

Right: William Bouguereau, *Sketch of a Young Woman,* oil on canvas, 18 x 15 inches, collection of Fred and Sherry Ross, courtesy of Art Renewal Center

This sketch reveals the hand of the artist and gives us a glimpse of Bouguereau's working methods. We can see a pale gray ground as well as a light warm *imprimatura* into which he worked a wash drawing and built up the beautiful modeling in the lights.

Opposite: Albert Herter, *Young Woman with Dogwood,* 1891, oil on canvas, 27 x 22 inches, courtesy of A.J. Kollar Fine Paintings

The Japanese woodblock prints in the background indicate some of Herter's inspiration. He created a gestural enclosure—from the woman's face through the arc of her arm to the dogwood flowers and back again by way of the distant arm of the chair.

Learning how to distill life in this way—learning to see and design as an artist, to transcribe life—is an essential part of the student's education. Not many people realize that the great figurative paintings of the past are often highly designed constructions, containing as much fiction as truth. Just as a tiny redwood seed contains the potential to become a magnificent tree, the frail human life has the potential, sometimes deeply buried, for greatness. The paintings of the past masters were monuments to the human condition. These artists saw an element of greatness in common individuals, just like the people we see every day coming home on the bus or walking through the mall, and transformed them into both demons and angels.

A rigorous artistic education provides a mental template for the student artist to work from when drawing or painting from life. Training enables one to see the commanding structure of the torso hidden inside the sagging old man.

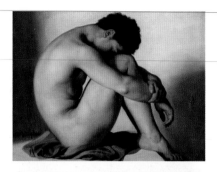

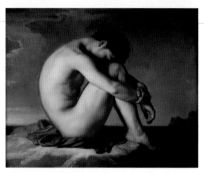

Top: Hippolyte Flandrin, *Study of a Nude Young Man Sitting,* circa 1836, oil on canvas, 23¼ x 28⅜ inches, Louvre, Paris, France

Photo Credit: Réunion des Musées Nationaux / Art Resource, New York, New York

Above: Hippolyte Flandrin, *Young Man Sitting by the Seashore,* 1836, oil on canvas, 45¼ x 38½ inches, Louvre, Paris, France, courtesy of Art Renewal Center

Flandrin executed the figure painting for the color study from the life model in his studio. Notice how the figure remained virtually unchanged, as Flandrin added an imaginative landscape for the final painting.

Yet, the atelier student is also required to depict the literal visual information in an accurate way. A figure painting is a composite image of many hours of painting from the model, an imperfect being who is continuously shifting and moving in small ways. This complex information is compounded by the extreme difficulty of transcribing subtleties, such as the translucency of skin hit by light, which demands that figurative training include everything from the nuts and bolts of craft to in-depth study of proportion, gesture, composition, value, and color. These challenges require the artist to master a method of both drawing and painting that will grant him the structure he needs to succeed.

These challenges have not lessened over the last several centuries. The figure remains at the center of a traditional studio program and continues to represent the highest attainment of the figurative artist, in part precisely *because* of its complexity. However, unlike the art students of the past, today's atelier students generally begin their studies later in life and have limited time and resources to devote to their education. While it is certainly ideal to gain command of the master copy and cast before working from the figure, modern time restrictions make this nearly impossible. Most ateliers, including my own, choose to train students by having them work in the life room right away, simultaneously studying the master copy and the cast.

Today's atelier students face an additional challenge: We are at a disadvantage by having the whole history of art at our fingertips. Having so much conflicting information is frequently confusing and paralyzing for the student. Students are often tempted to scatter their efforts, attempting to master every method and style as they try to proceed in their training. Ultimately, this approach is a recipe for mediocrity, and those who aim to be the masters of everything often end up as the masters of none.

Limits can actually generate freedom. The boundaries of the highly structured progression of learning in atelier training provide a framework within which the artist can safely explore. The musician is limited by an eight-note scale; however, those few notes contain all the possibilities for variation needed to give birth to everything from classical music to speed metal. Likewise, the basic underlying principles in every great artwork are the same and can be orchestrated to suit each individual and era. Studying these unifying foundational principles provides a student artist with an anchor that will prevent him from being blown about by each passing art trend.

Eugène Carrière compellingly said, "An individual's personality consists precisely in what he adds to what he has received. What can he add when he ignores the essentials of what already exists and of what men have already accomplished? The masters' studios in the great periods of art didn't prevent men of genius from finding the elements they required for their development in the knowledge of the practical aspects of their craft—the most original artists

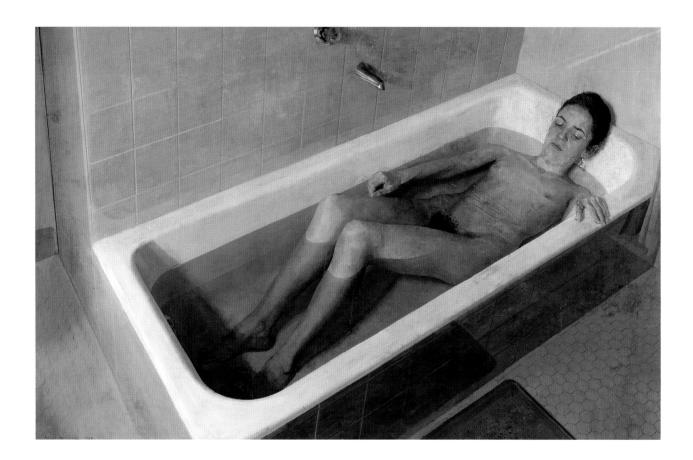

began in the most servile imitation of the men with whom they were working. How can directionless young people left to themselves help but spend the most beautiful and fruitful years of their lives in incoherence?"

It is natural to fear that one's individuality may be lost through rigorous training. However, think of this process as akin to extracting gold from a rock. Many impurities must be sifted away before the gold is transformed into a luminous precious metal. The rock is crushed and repeatedly subjected to extreme heat; the gold only rises up from the fires of the furnace. You cannot extract the valuable metal without risking everything to get it. If all is lost in the process, perhaps there was not enough there to begin with. The aspiration of a student must be to learn "to see" while mastering the techniques of art. The more technically adept we become, the greater our capacity to express our vision will be. This kind of mastery allows art to become a pure vehicle for the artist's voice.

While brilliant technicians, in any field, do not go unnoticed, technique alone does not guarantee an enduring achievement. Art is often derailed by technical failings, such as not having a focal point or being poorly designed. However, it is possible for an artist to achieve technical mastery and for his work to still feel limited. Andrew Wyeth has said, "I think one's art goes as far and as deep as one's love goes." An artwork can be limited by the sensibility and the ambition

Antonio López García, *Woman in the Bath*, 1968, oil on panel, 42 1/8 x 65 3/8 inches

López García creates intimacy through his choice of eye level and close quarters. He paints the figure with objectivity, rendering both the woman and the background with equal precision.

Photo Credit: Image copyright © 2006 Artists Rights Society (ARS), New York / VEGAP, Madrid

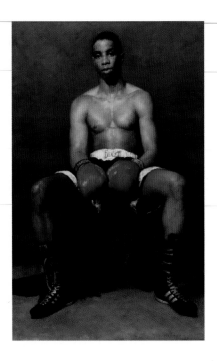

Patricia Watwood, *The Boxer*, 1999, oil on canvas, 36 x 24 inches

The strength of the boxer is mirrored in his pyramidal pose. Our eye is drawn through the piece—from his laces to his gloves, from his chest to his face.

of the artist. The eyes of the artist make something beautiful. Although some subjects lend themselves to artistic representation better than others by being inherently aesthetically pleasing, ultimately it is the sympathy of the artist that transforms them.

There is a lake near my house. At sunset, occasionally the light rakes over the surface of the land and water in such a way that the sky appears dark while the Earth glows a golden orange. Absolutely everything standing in the path of this light gets transformed by it. It is difficult to talk about the experience without somehow cheapening it, but the effect is transfixing, heart-poundingly beautiful. The eyes and hands of the artist can make anything that compels them that beautiful. Think of Jean-Baptiste-Siméon Chardin's peaches, Henri Fantin-Latour's flowers, Rembrandt's side of beef, or Francisco de Zurbarán's monks.

It would be difficult to separate artists such as Johannes Vermeer or Caravaggio from their brilliant handling of paint. For each artist, the different regional painting methods he was taught ended up being interpreted by his unique personality, allowing his work to be distinguished from the work by anyone else trained in that way. The content found in Vermeer's works was quite common in his times. (The image on page VI, opposite the contents page, is a particularly notable example.) Therefore, simply in terms of content, his works look just like all other paintings from the Netherlands in the seventeenth century. However, the other artists of the time simply did not have such fluid brilliance of execution, composition, and sensitivity. It is not his choice of subjects that differentiates him but his vision of those objects. The greatest painters manage to speak in spite of their subject matter, not because of it. Artists like Vermeer saw something and managed to convey it in a way that other artists could not, even though they were looking at essentially the same material.

Joseph Conrad's book *Lord Jim* is one of my favorites, yet I am completely indifferent to the subject of the life of a seaman. Vermeer likewise managed to make his paintings both universal enough that they speak to us today and also more deeply observed than we generally manage in real life. He was able to catch the nuanced light and details that make us feel as if we can breathe the air in his rooms. He makes us care.

The essential elements of painting are best understood when they are disassembled. The various facets remain constant from artist to artist, but their application and priority are shuffled and emphasized based on the individual's sensibility and temperament. A tonalist, such as Pietro Annigoni, would place drawing as the most important aspect of painting, while a colorist, such as Henry Hensche, may believe that exploration of hue and chroma is the key to the success of a piece.

Four main elements contribute to the success of a figure painting: accurate drawing, interesting and balanced composition, convincing value, and believable

color (each one of which is discussed in more depth elsewhere in this book). Within these categories are numerous subfactors. For instance, drawing includes issues related to anatomy, proportion, gesture, likeness, shadow, and form. Composition includes considerations such as the size and shape of the rectangle, the overarching linear design, the hierarchy of value and color, and the distribution of sharp and soft edges. Value includes numerous factors, such as the direction and shape of the lights and darks, mood, pattern, and form. Color includes issues such as temperature, intensity, key, harmony, and hue. Some artists consider these considerations intuitively as they attack their

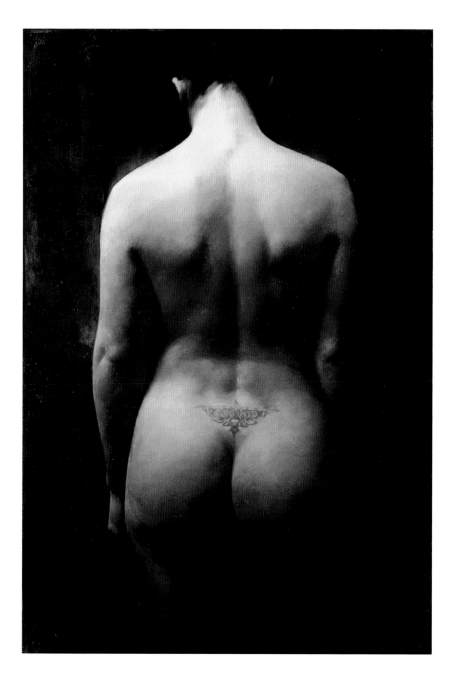

Michael Grimaldi, *Verso*, 2001, oil on canvas, 37 x 25 1/2 inches, private collection

By showing the model's back, rather than her face, Grimaldi draws our attention to her as a universal archetype instead of celebrating the specific life of the model.

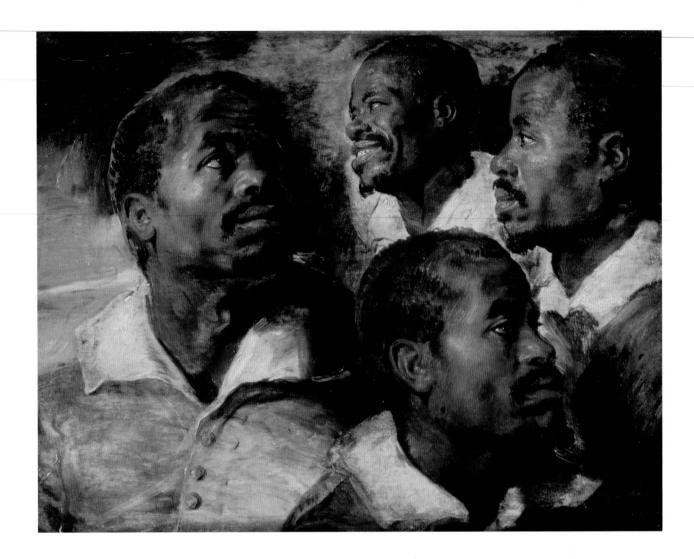

canvas with a brush, achieving their artistic goals as they make every decision at once *alla prima*. Others prefer to break down this process so that they can give every aspect of the painting process equal consideration. (However, even a classicist does his studies intuitively and in one sitting.)

Reality in art has more to do with a consistency and unity of vision than with truth. Establishing a series of relationships that feel accurate within the universe the artist has created in his picture is a goal of primary importance to the figure painter regardless of his style. If the artist can get one area to work well, he will be able to key the rest of the painting from that one achievement. For example, if an artist painted a head successfully with warm shadows, cool halftones, and a warm local tone, he must maintain consistency through the rest of the piece. The work must be "of a kind" to be harmonious. Focusing on the fact that the painting must be believable, not actual, helps prevent artists from spinning their wheels trying to account for every fluctuation and shifting truth.

Another stumbling block for beginners is the evasive truth of skin coloration. There is a false belief that skin has a right color that will work perfectly, as if it can be squeezed out of a tube. There is no such thing as "skin color" like that you find on a Barbie doll. Any color can be found in skin as long as the context is correct; the artist must paint what he sees rather than what he expects to find. Compare Dan Thomson's self-portrait on page 91 with Max Klinger's *The Blue Hour* on page 86. Both paintings have color that is not naturally associated with skin, yet the figures are completely plausible within their respective contexts. Remember that objects have no actual intrinsic color; they simply reflect the hue of the light source. The key is to squint and match value along with applying the relative color relationships. This is one of the principal lessons of the first color exercise (the warm-and-cool study). Every student I have worked with has been amazed by the color combinations found on the figure that emerge in this lesson. The artist must be faithful and humble before nature but be bold enough to make mistakes and seek relative color relationships for success.

There is nothing magical about the process; there is simply a direct correlation between practice and skill. Not any kind of practice, but concentrated focus on the foundational principles of art—zeroing in on your weakest areas and trying consistently to achieve your personal best. That said, there are many methods for improving skills. Doing quick paintings has advantages, as the process can encourage an artist to go directly for bold color changes and large distributions of light and shadow. Alternately, bringing a work to a careful finish can teach an artist what he needs to bring to the picture initially to expedite the full journey and how to fully realize his vision. I recommend practicing both ways on a regular basis.

A standard way of beginning a painting is to sketch either in paint or charcoal the basic proportions of your figure and then mass in the shapes of the shadow and the background (in color or in monochrome). The examples shown in this chapter—from Jacques-Louis David to Jacob Collins—all pay special attention to accuracy in the broadest masses of value and to color in the light and shadow. John Singer Sargent once said, "If you spend a week on the head and have not put in the features, you will be on the right track." Cover the canvas as expeditiously as possible; squint down and unify the lights and darks while carefully modulating the edges. (Until the ground of the canvas is covered it is difficult to judge the accuracy of the piece.) Find the strongest cool and warm color notes, as these provide a basis of comparison for believable color relationships. Once the large masses are blocked in, pay full attention to turning form and placing the accents while avoiding undermining the integrity of the largest masses.

Beginning artists are often tempted to rush through the awkward stages and try to attain a facility not yet earned. Authenticity comes only through time.

Opposite: Peter Paul Rubens, *Four Studies of a Head,* **oil on canvas, Musée d'Art Ancient, Musées Royaux des Beaux-Arts, Brussels, Belgium**

The spontaneity and liveliness of these beautiful head studies show Rubens's virtuosity as a painter. It is no wonder he became the inspiration of so many Romantic artists, including Eugène Delacroix and Théodore Géricault.

Photo Credit: Giraudon / Art Resource, New York, New York

Jeremy Lipking, *Reclining Figure*, 2004, oil on canvas, 46 x 54 inches, courtesy of Arcadia Gallery

The red triangle makes this figure come alive, giving the appearance that the painting is very colorful. In actuality, if you cover the saturated color note, the image is surprisingly tonal.

Quick attempts to feign an accomplishment by relying on style only rob the student of a chance to really learn. Artists are sometimes enticed and pressured to peak early, but in doing this they run the risk of fading fast. As Joshua Reynolds said so eloquently, "The impetuosity of youth is disgusted at the slow approaches of a regular siege and desires to take the citadel by storm. They wish to find some shorter path to excellence, and hope to obtain the reward of eminence by other means than those which the indispensable rules of art have prescribed. They must, therefore, be told again and again that labor is the only price of solid fame, and that, whatever their force of genius may be, there is no easy method of becoming a good painter."

It is far better in the long run to experience the awkwardness and wrestling of a sincere heart, which later can become the fuel for artwork of real depth and substance.

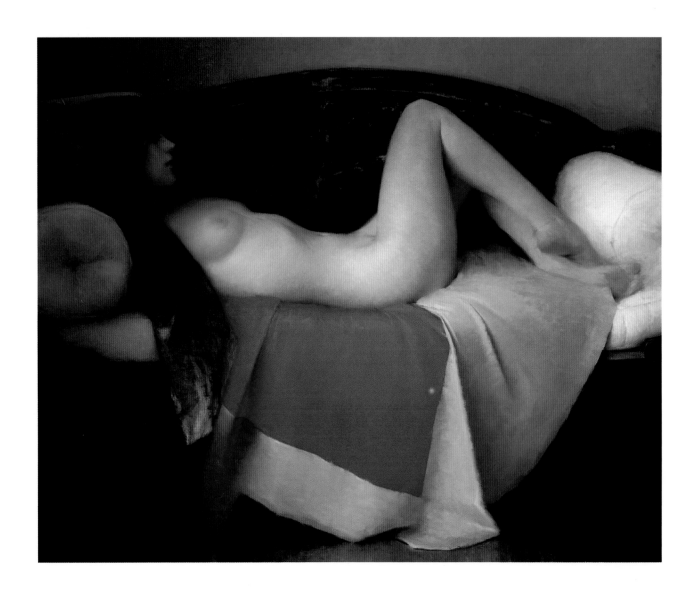

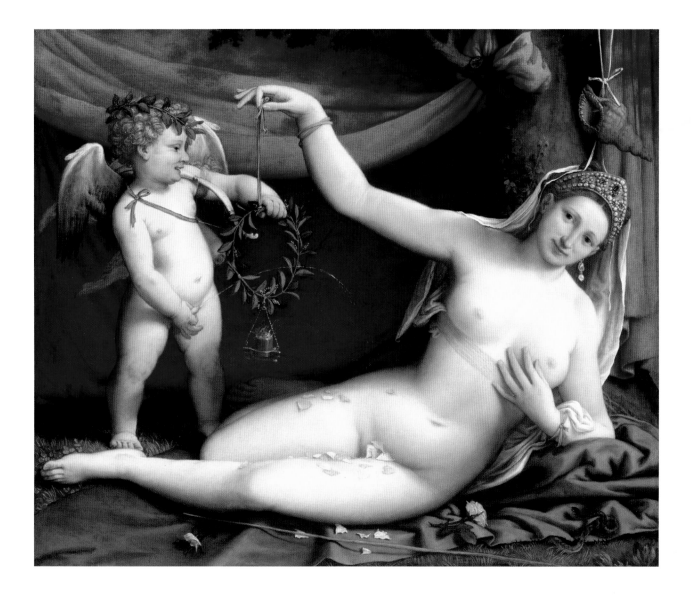

Regardless of the details of a student's curriculum, the ultimate objective of an art education is to ensure that the student does not have to reinvent the wheel. Rather, students are given the tools they need to fulfill their vision and are encouraged by the community in which they are immersed to produce excellent work. Working from life provides the most complex and noble of subjects. A student who is well versed in the practice of life drawing can easily work on less challenging subjects with success. By getting a strong education, the budding artist is given a noble lineage that is essentially a blessing and a charge to go and do likewise. The new artist will have the same skills and tools that produced some of the greatest cultural achievements humanity has yet attained.

Lorenzo Lotto, *Venus and Cupid*, circa 1523–1526, oil on canvas, 36 3/8 x 43 7/8 inches, Metropolitan Museum of Art, New York, New York, purchase, Mrs. Charles Wrightsman gift, in honor of Marietta Tree

This playful and highly symbolic image, with Venus representing love and Cupid suggesting fertility, brings together many aspects of the figure in art.

Photo Credit: Image copyright © The Metropolitan Museum of Art / Art Resource, New York, New York

COLOR STILL-LIFE PAINTING

Tonality and composition have a dramatic effect on a still-life painting's impact, mood, and subject. Susan did a series of quick sketches to help her solidify her ideas.

The aim of this exercise is to learn to arrange a still-life composition and establish a reliable working procedure for creating an original painting. Additionally, still life offers an accessible way to practice color mixing. The colors in still life are often less subtle than those found on the human body, so painting still lifes offers a forum for learning to match the wide color spectrum found in life. The one demonstrated here is essentially a study of color harmonies. Set up a composition that is to your liking—perhaps one that experiments with different subjects, highly saturated colors, and alternate depths of space.

Gathering Your Materials

In preparation for creating your color still-life painting, assemble the following materials:

- Oil paint*
- Brushes
- Canvas or panel
- Odorless mineral spirits
- Medium
- Paint rag
- Palette
- Palette knife

Note: Susan used titanium white, ivory black, raw umber, cadmium yellow, cadmium red, and ultramarine blue for this exercise. Susan chose such a drastically reduced palette because she prefers to mix a full spectrum of colors from these few primary hues; however, by the time she was finished premixing, her palette held dozens of colors. If you are not premixing your paints, a more balanced palette, such as one of those mentioned in Chapter Four, will probably be more manageable.

Setting Up Your Painting

Anything from an old pair of boots to a grand floral display can be the subject of a compelling painting. When setting up your objects, consider carefully the composition, value, and color, as those elements will be the key indicators of the work's success. A few guidelines—such as making sure you have a focal point and keeping your values and shapes simple and clear—will go a long way toward creating a solid composition.

For this demonstration, Susan chose to paint a simple, creased linen cloth, which held personal meaning for her. She set up her still-life composition by attaching a rope in a corner of her studio and hanging the cloth on the rope.

Susan used this value poster study to solve a number of pictorial problems, such as the composition and the distribution of values. Notice how she subtly pushed the primary focal point by having the darkest and lightest areas coincide on the upper left-hand corner of the drapery.

Susan did a few color poster studies to determine the most effective use of color before she continued to the larger piece. These quick sketches are often referenced and compared with the final painting to assess how successfully the artist's initial vision was realized.

Susan utilized natural light from a north-facing skylight, which provided ambient light, and a smaller amount of direct light from an east-facing window, which provided focused light on the left of her cloth. Susan's setup is unusual, as it shows neither a ground plane nor a background on which to place cast shadows, to anchor the objects in space.

Creating Your Still-Life Painting

First, determine the composition of your still life by creating a number of thumbnail sketches. The small size will enable you to work up different ideas easily and execute them quickly. Susan did several small sketches with a graphite pencil. She used a stump (a piece of rolled-up paper) to flatten the shapes and push the graphite into the paper for the darkest darks. However, you can do your thumbnail drawings in charcoal, pen, or whatever else you are familiar with.

Next, create a value poster study to explore the shapes and value changes in your still life. This exploration can be accomplished in various ways. Susan chose to do a wipeout painting, as it helped her visualize the halftones and determine the value shifts. A wipeout can be executed

in any color; Susan chose raw umber. She squeezed the paint directly from the tube onto the palette and mixed it with a small amount of odorless mineral spirits to make it more malleable. She then placed the mixture uniformly on the surface with a brush. Using a rag, she removed the light areas to create the difference between shadow and light shapes.

Now do your color poster study. Susan executed hers in a small format by slightly squinting her eyes and laying on simple tiles of paint. She was striving to create the distilled visual impression of the pattern of the composition along with the feeling of luminosity and natural color. This process also gave her the opportunity to see what color combinations would work for the final painting and to determine if she had an appropriate series of colors on her palette. The colors Susan selected in the end were somewhat unconventional, as they were fairly intense. However, she did not use these hues unadulterated. Rather, she mixed neutral tones and strings of color of varying intensity until she had a complete palette of colors.

For the final painting, Susan did a careful drawing, which she transferred to the canvas. She next did a raw

Susan transferred her drawing onto the canvas, providing a proportional and compositional guide for the final piece.

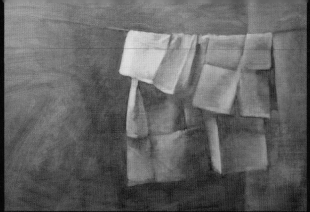

Susan employed a wipeout underpainting to capture the essence of her value poster study. The composition and value distribution was locked in with this coat of paint, which allowed Susan to finish the work by solely focusing on color changes.

umber wipeout underpainting to establish the big value patterns and provide an anchor for the next layer. Then, in color, Susan painted the background and shadow shapes to create a context for the form-revealing halftones and from which the light shapes could emerge. She started with the background to establish the darkest darks and worked up in value from there, knowing that her lightest light was going to be the upper-left corner of the cloth. Susan found it challenging to apply her paint thickly enough to create the illusion of mass. Many beginning painters run into problems by not using enough paint, as they intuitively feel that if they creep up on accuracy it will be easier to attain. However, the opposite is usually true; a tentative stroke almost always looks erroneous.

Next, Susan painted in lights, starting from warm shadows to cool halftones and back to warm light areas. The cloth had a lot of "flat" areas, but they still required that she shift from cool to warm and create subtle value changes to make the panels read as though they were folded. One of the biggest lessons Susan learned while doing this particular project was just how light something could be and still be in shadow.

Susan's experience painting a white cloth helped her to discern many colors, when at first there appeared to be none, and helped her eyes acclimate to seeing tiny shifts in value, temperature, and color. It took her a while to see any color at all in the white. Additionally, she learned that adding white does not necessarily make something appear brighter. Colors such as cadmium yellow or orange often appear brighter than white, even though they are actually darker in value. To account for this phenomenon, Susan created her lightest light with straight white and a hint of cadmium yellow.

Opposite: In this work consistency was more instrumental than accuracy in generating the appearance of truth. The colors in the white cloth were so delicate that they could be interpreted many different ways. Therefore, Susan needed to faithfully adhere to the color scheme that she had chosen to bring the work to conclusion.

Susan Bari Price, *Surrender,* 2006, oil on canvas, 17 x 23 inches, courtesy of the Aristides Classical Atelier

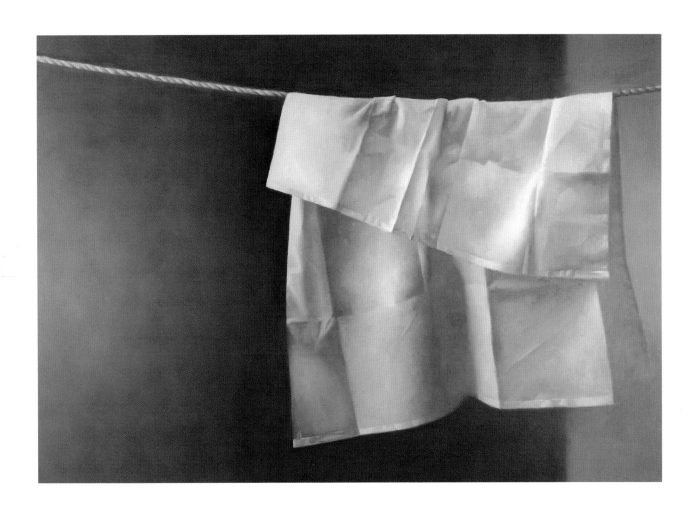

COLOR FIGURE PAINTING

When doing her thumbnail sketches, Susan was contemplating whether she wanted to make the figure an open form and merge the shadows into the background or a closed form with either a complete contour or a small area of lost edges around the halftones.

The goal of this lesson is to learn to work directly from the life model. Painting the figure is one of the most intense challenges an artist can face. A few of the complexities include the figure's nuanced color, the small margin of error for proportion and form, and the necessity that it feel not only correct, but alive. Comprehending the layers of color found in the human body can be mind-bending. The more closely you look at them, the more they seem to change. It takes systematic practice over an extended period of time to become comfortable with painting in color from life.

Gathering Your Materials

In preparation for creating your color figure painting, assemble the following materials:

- Oil paint*
- Brushes
- Canvas or panel
- Odorless mineral spirits
- Medium
- Paint rag
- Palette
- Palette knife

*Note: Susan used titanium white, ivory black, raw umber, burnt umber, Naples yellow, yellow ocher, cadmium red, English red, cobalt blue, and ultramarine blue for this exercise.

Setting Up Your Painting

When lighting the model, it is useful to understand classic, form-revealing lighting, even if you do not choose to use it. Additionally, it is important to consider your background. Do you want it to be darker, lighter, or the same as parts of your figure? Look at the shadow side of the model. Does it dissolve into the background or does the reflected light create a continuous contour around the figure? There are no right answers. However, some lighting and backdrop configurations will suit your purposes better than others.

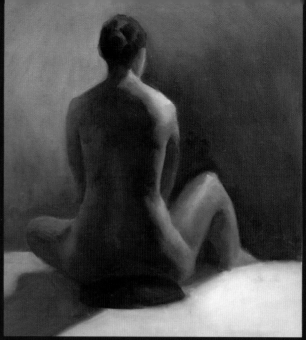

Having a correct drawing of the model is critical for the believability and beauty of the final work. For this image, Susan chose to draw directly on the canvas and then carefully and lightly ink over her lines before she started painting.

In this value poster study, Susan created a wave of value that undulates (reading from left to right along the shoulder line) from a light background to a dim shadow, to the luminous form of the skin, and again to the dark of the background.

In the example shown here, the main light source was a spotlight positioned above the model at about a 45-degree angle. This was supplemented by natural light from a north-facing skylight, which generated the reflected lights. This unusual lighting configuration—a dominant light from the right and subordinate light from the left—allowed the majority of the figure to remain in shadow.

Creating Your Figure Painting

Begin by creating a series of thumbnail sketches to determine the overall composition and value distribution. Once you've selected the sketch that captures your idea, create a value poster study in oil paint and in a slightly bigger format than your sketches, such as 8 x 10 inches. This process will allow you to push your composition one step further. Specifically, you will be able to determine the areas of brightest contrast, play with edgework, decide what is happening around the figure in the way of props, and even create an outdoor scene.

Next, create a color poster study. When making a painting, an artist is often not concerned with what color exists in life but what color works pictorially. For example, the model in this painting was sitting on a green and red drapery. However, when Susan was working on her color poster study she realized that these hues were jarring, so she decided to make some adjustments.

Once you are satisfied with the pictorial elements, push the process closer to resolution by doing a drawing—either directly on your canvas or on a separate piece of paper (which you will then transfer to the canvas). In this case, Susan did a charcoal sketch directly on the canvas and then inked over it extremely lightly with a fine permanent pen.

Next, create the underpainting. Susan covered the whole surface with a layer of raw umber mixed with a little mineral spirits and then wiped out the lights. You could do a

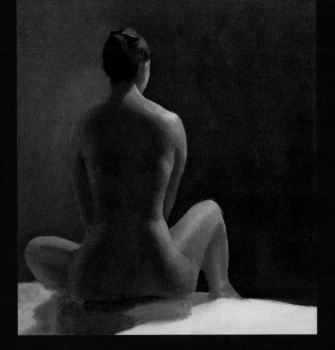

This color poster study answered Susan's questions about what color choices would work best for the background and ground plane as well as the range of colors that would work for the skin.

Susan could have progressed in many different ways at this point. She chose to do a wipeout for the underpainting of her final piece because she wanted the finished work to be predominantly tonal and knew this approach would easily integrate with her overpainting.

full-color wash, an opaquely painted grisaille, an *alla prima* layer, or any of a number of other underpainting methods.

Now, begin the overpainting. Paint the background and shadow shapes first to create a context for the lights. Work from darks to lights because it is easier to see, and consequently to paint, the halftones when they come out of the shadow and are anchored to the core shadow.

Susan started with the background to establish the darkest darks and worked up in value from there, knowing that her lightest light was going to be on the right shoulder. She roughed in the value and hue shifts in the lights but kept the darks relatively flat. Next, she painted the whole piece more specifically, shifting from warm shadows to cool halftones and then to warm lights and cooler highlights. Susan focused on each area of the figure and worked on it until it was close to finished. When the

entire piece was covered, she refined the weakest areas until the entire piece read as a harmonious whole.

Susan's biggest lesson from this exercise was understanding the relationship between warm and cool colors. She was surprised by how blue she could go on the cool side without it looking unnatural when balanced with the warmth of the shadow and the warm lights on the opposite side of the body. She also learned how a gradation of tone could create distance on the ground plane, between the edges closest to and farthest from the viewer.

Opposite: The finished painting alternates between largely unmodulated areas, such as the shadows on the figure, and areas with carefully executed turning form, such the lights and reflected lights on the figure.

Susan Bari Price, *Yvonne*, 2007, oil on canvas, courtesy of the Aristides Classical Atelier

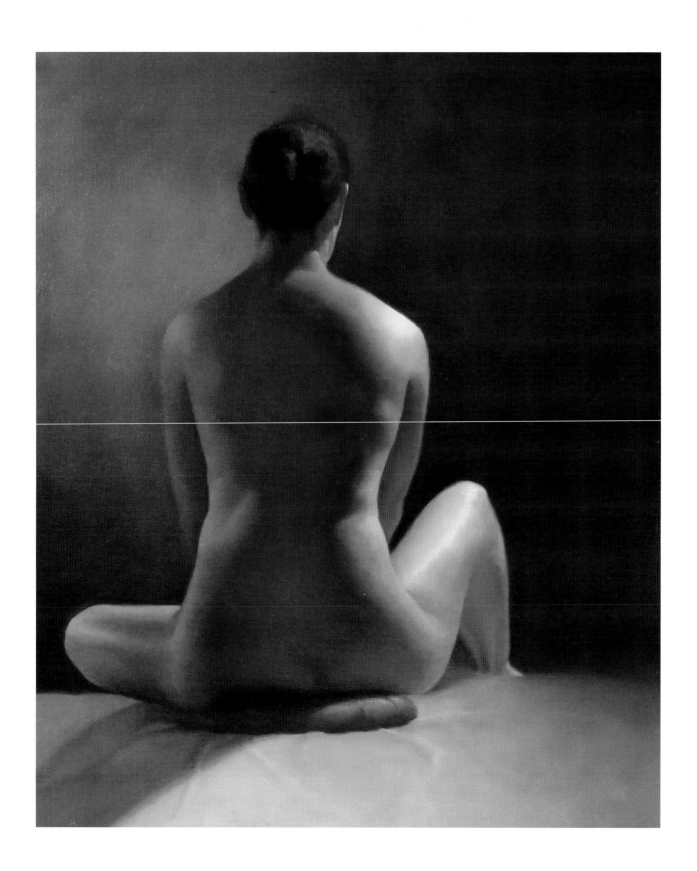

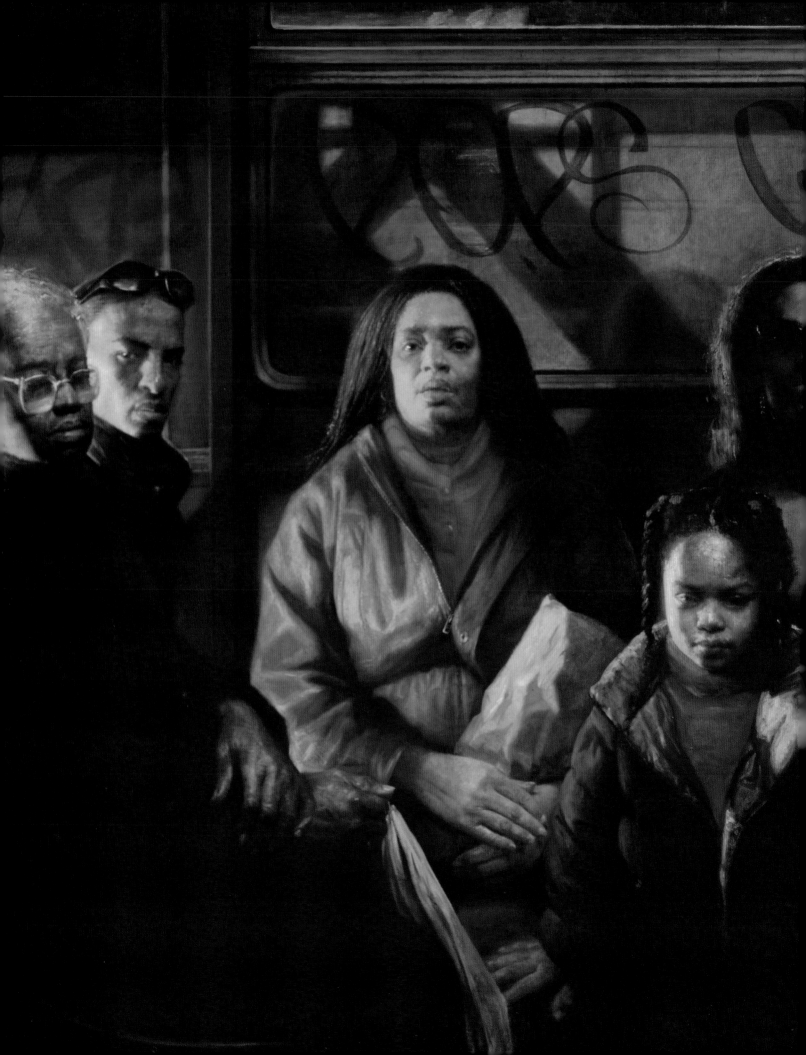

Masterworks

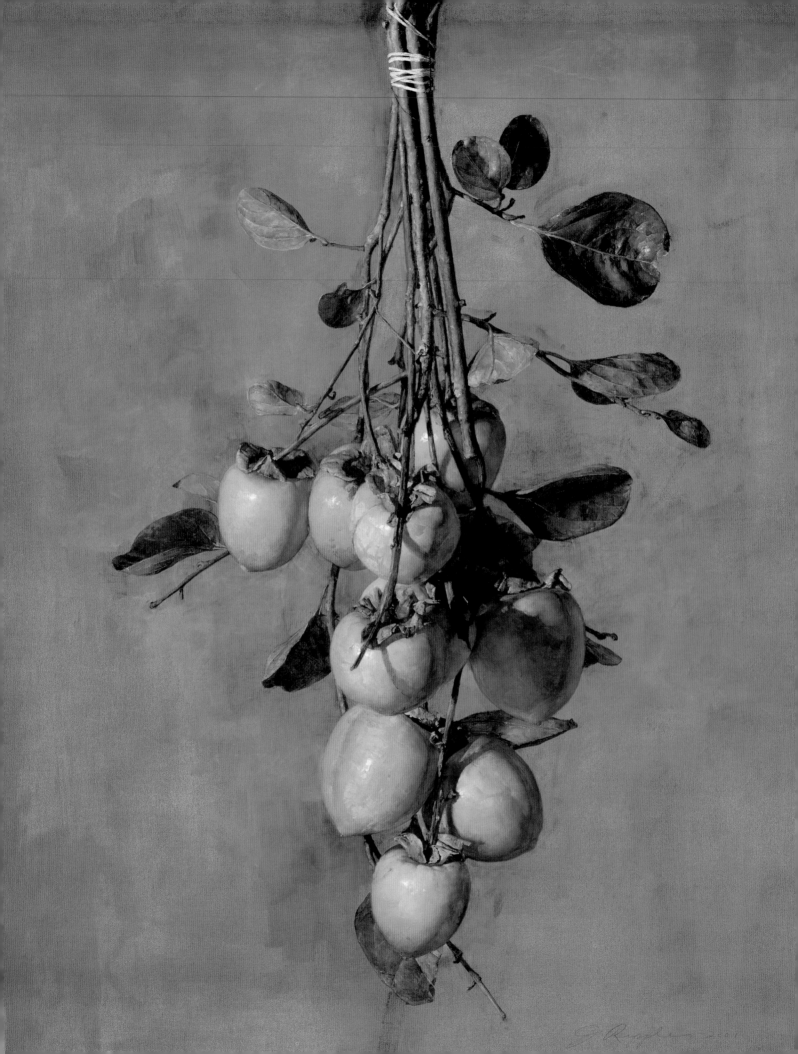

STILL-LIFE PAINTING

Nature Tamed

"In one sense nothing is commonplace, for everything exists visibly by means of light and color, and light and color are the most fundamental beauties." — **DANIEL PARKHURST** (from *The Painter in Oil*)

Since its inception, the still life, or *nature morte* (dead nature), has encompassed a wide range of subjects and an even wider range of intended purposes. Historically, the goals of this art form have ranged from literal representation to narrative work intended to convey a story or message. The still-life painting has sometimes been thematic, with symbolic meaning that would have been evident to the viewers of the time. For example, a still-life form called *vanitas* (vanities painting) showed the fleeting nature of worldly endeavors and the frailty of humanity with such things as globes representing travel, books portraying knowledge, skulls or decaying fruit indicating the inevitability of mortality, and extinguished candles representing the passing of a life. At other times, the still life was intended to document the wealth of a patron, with rare foods, flowers, and the like. Another common form of the still life was trompe l'oeil (meaning "trick the eye"), which seeks to create such a convincing illusion that the viewer is led to believe that the painted objects are real. Yet another form was the allegorical still life, which used different objects to represent people and situations with the goal of relating a moral or a story.

Today still life most commonly takes the form of a celebration of the predominantly inanimate world we engage with daily. These objects may bring us joy or frustration; either way, they are essential to our lives. My days are bordered by these displays, which include deliberately placed teapots in my kitchen window, family photographs taped to the wall (as shown in the painting on the following page), and stacks of books and papers thrown in a happenstance manner on my desk. In art, these vignettes of life are distilled into images with the power to engage with modern life and speak to a new generation.

Opposite: Jeffrey Ripple, *Persimmon Branches*, 2001, oil on canvas, 26 x 19 1/2 inches, courtesy of Hackett Freedman Gallery

The objects in this closed-form painting are in complete relief against the background. Ripple achieved a heightened realism by juxtaposing the sumptuously modeled forms with flat areas of color.

Previous Spread: Steven Assael, *D* (detail), 1998, oil on canvas, 62 1/2 x 98 1/2 inches, courtesy of Forum Gallery

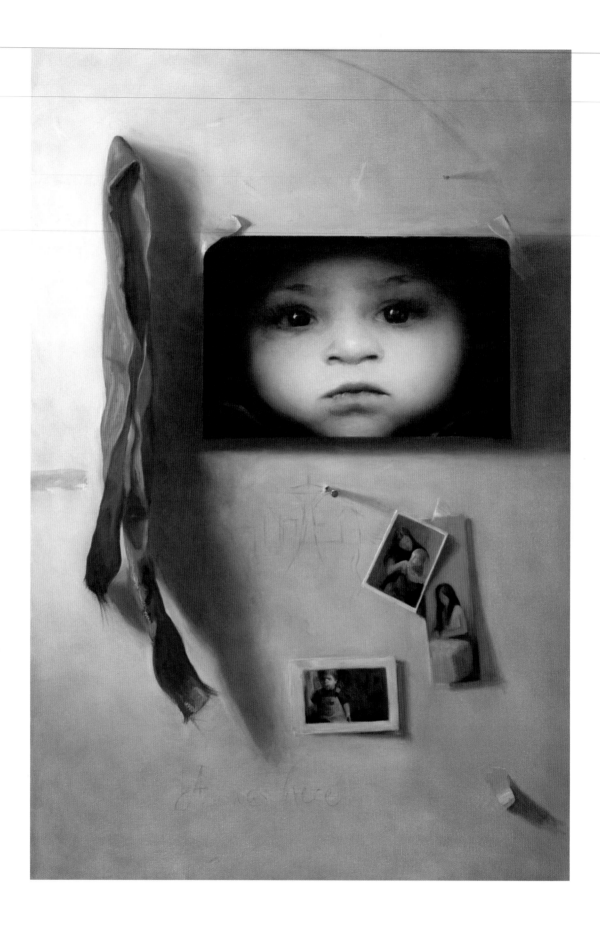

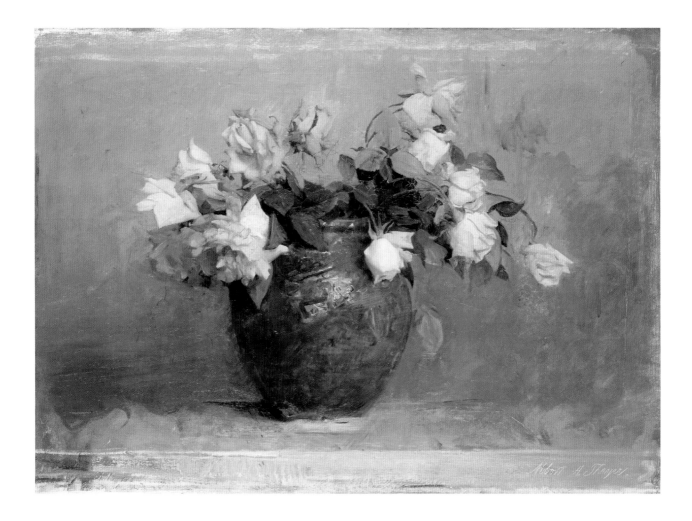

The still life has not always been an admired or respected subject in art. Rather, its role has shifted over the years. Although artists since antiquity often included still-life objects within their paintings, works featuring the still life as the primary subject did not emerge as a serious art form until the seventeenth century Dutch reformation. Church patronage of artists was waning, since Protestants had banned religious subject matter in art, so artists began to be primarily supported by an emerging middle class, which had an interest in collecting portrait, genre, and still-life work. During this time the still life reflected the belief that God manifests himself in all of nature and that even the humblest natural object can reveal something of the Divine. In the eighteenth century, the aristocracy used still life to glorify the excesses of the time; the Rococo style embraced the concept of decoration for its own sake and encouraged trompe l'oeil work. However, the austere art academies, which by the mid-nineteenth century were prevalent throughout Europe, had little interest in still life. The hierarchy of subject matter established by the academies dictated that historical, religious, and mythological painting were the most serious art forms, followed by portraiture and landscape, with still life ranking last. Underlying this belief was the thought that God had chosen the human form

Above: Abott Handerson Thayer, *Roses*, circa 1896, oil on canvas, 22 3/8 x 31 3/8 inches, Smithsonian American Art Museum, Washington, D.C.

The delicacy of the ephemeral rose petals is in stark contrast with the heaviness of the earthenware pot. The blue accent forms the color key. Thayer vigorously painted this image; we can see straight to the underpainting in many places.

Photo Credit: Smithsonian American Art Museum, Washington, D.C. / Art Resource, New York, New York

Opposite: Juliette Aristides, *Biography*, 2007, oil on canvas, 36 x 26 inches

The shallow depth of field and naturalistic shadows define this as a classic trompe l'oeil work executed in a contemporary manner. The painting contains many elements that relate to my personal life in Seattle.

Geoff Laurence, *Survivors*, 2000, oil on canvas, 18 x 16 inches

Laurence is a dynamic artist whose deceptively peaceful composition of somewhat mundane objects underscores highly personal imagery. As an adult, he discovered family secrets that shaped his destiny. In this image Laurence combines strong technique with a powerful message.

to reflect his image and the rest of nature was therefore secondary in importance. Later in the nineteenth century tastes began to shift again and artists became increasingly interested in portraying contemporary life, so the still life rose correspondingly in importance, a status that continues to our day.

The still life has a unique ability to capture life in a particular time or frame of mind. We can tell as much about a person by inspecting his home as from meeting him directly, sometimes more. The contents of a home can communicate clues about its owner—through the choice of books stacked by the bed, food in the refrigerator, or pictures on the wall. Likewise, we get a glimpse into the mind of an artist through the subject matter and treatment he chooses in a particular work. Still-life painting gives us the opportunity to visit the artist's room, so to speak, stare at his things, and peek into his mind. The artist is not just a passive observer; he uses his objects to tell a story, share his personality and worldview.

The still life provides an emotionally neutral platform upon which the artist can use composition, value, color, and other elements of art to create what often amounts to a self-portrait of sorts. When viewing the still life we are given an opportunity to experience the beauty the artist sees in everyday objects. Great sensibility combined with consummate skill transform the ordinary and help people see life more clearly. Common objects are reinterpreted in the artist's hand; suddenly items we use, ignore, or toss aside every day are vehicles for self-expression that speak to us about life, permanence, and the love of simple things. This is why I often find an expertly done still life to be far more emotive than many paintings of grander subjects.

Just as a single word carries more weight among the sparse language of a poem than it would in the onslaught of verbiage in a lengthier narrative, the objects in a still life often bear more burden of meaning and expression than they might if they were included in a multifigure piece with a complex background. The compositional choices the artist makes can change the entire vantage point of the piece—both literally and figuratively. Something as simple as adjusting the eye level or repositioning the objects within a piece can change its entire mood and meaning. For example, the configuration of the foreground, middle ground, and background can convey a feeling of either closed or expansive space. The way the objects are placed and anchored in space can feel either natural or iconic, each choice resulting in a different message.

So too with value. A slight adjustment in the position of the light source can make the difference between the creation of a soothing or a disturbing painting. Strong light with a warm tone conveys an entirely different mood than cool, diffused north light. The artist can develop the tonal character of the piece using chiaroscuro to either reveal or obscure the forms. Each object can be independently rendered, celebrating the contour or edges; or whole objects can dissolve into the background.

Color determines the character of the piece. It can be used decoratively or descriptively, bunched up in a particular area to draw focus or distributed to create pattern and movement. Whether the color is symbolic, literal, or decorative affects the feeling of a work of art. Choice of palette and distribution of color are just two of the different configurations, however; in fact, the variables that can be used to create a painting are limitless. Because of this freedom the still-life genre continues to capture the imagination of many artists and patrons.

In the following pages we will examine the ways both historical and contemporary artists used major and minor principles of art to construct their unique works. We will become detectives trying to uncover the factors that contribute to success of the work. Examining composition, value, color, and many other elements in the work of others can aid our understanding of painting and help hone our own vision. In the text that accompanies the work, I generally analyze one main element of each piece; however, feel free to apply any principle you feel is pertinent in your own analysis.

John Morra, *Mertz 2*, 2002, oil on canvas, courtesy of Hirschl & Adler Modern

Morra creates small color sketches for every painting he does during what he calls his "gathering of ideas phase." Depending on the piece, he then either does a careful drawing and enlarges it or he masses in a raw umber wash-in directly on the final canvas, forming a gestural sweep that initially appears chaotic but that coalesces into an accurate drawing.

Jean-Baptiste-Siméon Chardin

(French, 1699–1779)

Opposite: Jean-Baptiste-Siméon Chardin, *Still Life with Grapes and Pomegranates*, 1763, oil on canvas, 18 1/2 x 22 3/8 inches, Louvre, Paris, France, courtesy of Art Renewal Center

Chardin was considered to be an old master within his lifetime due to his ability to adhere to the rules of art yet achieve an exceptional naturalism in his work.

Chardin, who is best known for his still-life paintings, studied under Pierre-Jacques Cazes and then Noël Coypel before being admitted to the Académie Royale de Peinture et de Sculpture in 1728, when he was nearly thirty years old. Chardin was more interested in the restrained Dutch still lifes of the seventeenth century and the chiaroscuro found in Italian Baroque works than in the Rococo style that was popular in his day.

Chardin primed his canvas with a red-orange color that he covered with a light gray-brown ground, producing an optical gray upon which he painted. He used a palette that would be the equivalent of lead white, Naples yellow, vermilion, ocher, burnt umber, ultramarine blue, and Prussian blue, among others. He mixed his colors on the palette rather than on the painting, layering his brush-strokes so that the work allowed for atmospheric optical mixing. Chardin was a perfectionist who worked slowly, on one painting at a time and always from life. Standing back often, repainting areas to be sure the piece worked well from a distance, Chardin took care to ensure that the shadows were unified through tone and color. He cared more about the feeling of the piece than its technique.

The work pictured here, *Still Life with Grapes and Pomegranates,* shows some of the elements that made Chardin famous. Philosopher and critic Dennis Diderot said, "Close up the work seems like a set of colors roughly applied. Nothing is more difficult than to combine this attention, these details, with what is called the broad manner." The eye fluidly moves from the foreground to the background, from one object to another, from objects to atmosphere. The color is not equally distributed but is deliberately placed to guide the eye in a triangle through the picture—from the pomegranates on the left to the pattern on the jug in the middle to the apples on the right. The overall tone of the picture is cool, allowing his minority color notes, the reds, to read as primary. Notice how soft Chardin keeps his edges and how often they fade completely into surrounding areas, such as with the back wineglass, background, and the shadow on the pear. Chardin's simple and direct approach to his subject matter influenced many diverse groups of artists after him.

Henri Fantin-Latour
(French, 1836–1904)

Above: Henri Fantin-Latour, *Bowl of Peaches,* 1869, oil on canvas, courtesy of Art Renewal Center

Fantin-Latour's naturalism is deceptive. From a distance it often appears that he has painted every detail, but when the viewer goes up close the work dissolves into splotches of broadly painted shapes.

Opposite: Henri Fantin-Latour, *Narcissus and Tulips,* 1862, oil on canvas, 18 1/8 x 15 1/8 inches, Musée d'Orsay, Paris, France, courtesy of Art Renewal Center

To create a sense of monumentality Fantin-Latour used orthographic perspective, where the viewer looks at the arrangement at eye level and does not see the top of the table or the ellipses of the vase.

Photo Credit: Image copyright © Photo RMN / Gérard Blot

Henri Fantin-Latour grew up in Paris and studied for four years with Lecoq de Boisbaudran. De Boisbaudran, a major proponent of memory drawing, encouraged such practices as master copying, with the unusual caveat that the painter studies the masterpieces at the museum but returns to paint it in the studio without references. Fantin-Latour then briefly studied at the École des Beaux-Arts with Thomas Couture and afterward in Gustave Courbet's studio. Fantin-Latour was famed as being one of the most avid copyists. For twelve years he regularly worked in the Louvre, studying the work of past masters, especially artists such as Titian, Peter Paul Rubens, and Frans Hals. In 1879 Fantin-Latour was awarded the Légion d'honneur medal.

Fantin-Latour was friends with James Abbott McNeill Whistler, who brought him to England, where he began to paint the floral works for which he is now primarily known. Despite featuring organic forms, which create a casual feeling, *Narcissus and Tulips* is carefully designed. Fantin-Latour created a formally balanced composition by placing his vase and dominant flower in the center of the canvas, but he incorporated diagonals to add a sense of movement and dynamism. A series of triangles form the structure behind the flower clusters. Fantin-Latour carefully balanced a number of compositional elements (such as alternating between curves and angles and juxtaposing unbroken blocks of tone in the background with details in the flowers in the foreground), making this a harmonious and interesting arrangement.

The more intimate *Bowl of Peaches* is one of my favorites among his works. The arrangement is a wonderful example of theme and variation, as the unity of the brown *imprimatura* forms the base note, allowing colors and values to break free and merge back again. Notice how the underpainting makes up not only the background color, as seen above the white jug, but also the tabletop; the violet haze on the right-hand side and the dark accents on the left are the only elements that serve to disrupt this unity. The principle of using simultaneous contrast, or having fewer elements give the illusion of more, is a recurring theme in enduring works of art.

William Nicholson

(English, 1872–1949)

Above: William Nicholson, *Stocks and Silver*, 1918, oil on canvas laid on board, 13 1/2 x 10 7/8 inches, courtesy of Paul Kasmin Gallery

Nicholson designed woodblock illustrations early in his career, which gave him a practiced mastery of manipulating value pattern.

Photo Credit: Image copyright © Elizabeth Banks

Opposite: William Nicholson, *The Silver Casket*, 1919, oil on canvas, 16 x 13 inches, courtesy of Paul Kasmin Gallery

Nicholson could elegantly simplify complex works into large tonal areas, lending a breadth and monumentality to small-format still-life paintings.

Photo Credit: Image copyright © Elizabeth Banks

William Nicholson worked as a painter, printmaker, and book illustrator, although he is perhaps best known for the revolutionary poster designs that he created with his brother-in-law James Pryde at the beginning of his career. Nicholson got his training in Paris at the Académie Julien. He painted a variety of subjects, including portraits, landscapes, and military scenes. In 1936 he was knighted in honor of his contributions to portrait painting. (One of his works is in the collection of the Queen of England.) In spite of Nicholson's multi-faceted abilities, his still-life paintings have long been considered the strongest of his fine art works. Nicholson did not begin to paint the still life seriously until 1907, when he was 35.

Nicholson's small masterpieces combine an elegant simplification of value relationships with a painterly aesthetic. Perhaps due to his background in print-making, Nicholson shows enormous restraint in his use of tone, judiciously placing large blocks of value pattern into strong compositions. In *Stocks and Silver*, as in many of his best still-life paintings, it is possible to simplify all the shifts in tonality into three or four abstract value shapes. Notice Nicholson's economy of means as he abstracts the space; the light wall of the background becomes the ground plane. If you cover up the knives (which delineate the right edge of the tabletop) and the highlights, the image is revealed to be surprising flat. If you squint, the shadow of the pitcher and the pitcher itself merge into a dark circular form.

The painting *The Silver Casket* highlights Nicholson's deliberate use of color notations. He offset a limited palette with a few sparks of intense chroma. A key color note and a few details are all that anchor this image to realism, as the artist strikes a brilliant balance of abstract and representational components. In these two pieces, Nicholson combines a breadth of vision found in the large compositional elements with the small, idiosyncratic forms of intensely observed reality, a hallmark of much great work seen through the ages.

Walter Murch

(American, 1907–1967)

Walter Murch attended Ontario College of Art until he moved to New York in 1927 to study at the Art Students League. Later he met Arshile Gorky, who became a good friend and mentor. Gorky is credited with helping Murch become recognized as a fine artist. Murch worked as an assistant stained-glass designer, then as a commercial muralist, until his fine art reputation was established. Now he is recognized as one of the leading still-life artists of his generation. Murch's paintings are in the collections of the Metropolitan Museum of Art, Museum of Modern Art, and Whitney Museum of American Art in New York City, among other prestigious places.

Throughout his career, Murch often chose the lowly or forgotten object, such as fragments of a clock mechanism, a manifold, or a light bulb, which he frequently combined with more conventional still-life objects, such as oranges, apples, or eggs. In *Radio,* as in much of his work, a painterly atmosphere and dramatic light emphasize the monumentality of cast-off articles and lend a mystical aura to the painting. Murch was fascinated by the patina imparted by the passage of time, such as in a discarded machine. Fading, scratches, and stains are made expressive in his pictures through his handling of paint. In this painting, he has added atmosphere to the stark mechanical object by softening the edges of all the forms. In spite of the right angles of the base of the radio there is not a hard edge to be found. The eye moves easily through the image. The strong shift from light to dark in the background and the reverse shift of value in the object itself create an interesting tonal balance.

Antonio López García

(Spanish, born 1936)

Antonio López García was born in Tomelloso, Spain, and was taught as a child by his uncle, the renowned painter Antonio Lopes Torres. His talent was recognized very early, and by age thirteen he enrolled at the Fine Arts School in Madrid. A great admirer of the art of the past, López García then continued his studies on his own at the Prado and received scholarships to study in Italy. He gained a great appreciation for Spanish realism and is influenced particularly by Diego Velázquez.

López García's paintings create a faithful pictorial testimony of the world around him, including commonplace domestic interiors and exteriors, isolated individuals, desolate vistas and garden scenes, and everyday objects such as the skinned rabbit shown here. In this image López García has combined simple, abstract shapes that offset the intensely observed smaller forms. By raising the viewer's eye level, he has created a sense of intimate space.

Precise, intense, enigmatic works like this painting encourage the viewer to reexamine the presence of ordinary objects. López García's process is famously slow; some paintings take the better part of fifteen years to complete. For example, his cityscapes (such as the one shown on page 78) are painted en plein air over several years and are meticulously re-created at specific hours, days, seasons, and under very precise lighting conditions. If buildings are torn down and replaced with other structures, López García adjusts his painting, removing and adding as needed. He is obsessive and uncompromising in his search for visual truth. He also prefers large-scale formats, where representation comes close to ordinary perception. Other works are marked by forced close-up angles that enhance the intensity of the image. López García is an artist's artist, cited by many contemporary realists as their favorite living painter. His modern aes- thetic and love of painterly verisimilitude ensure he will leave an enduring legacy.

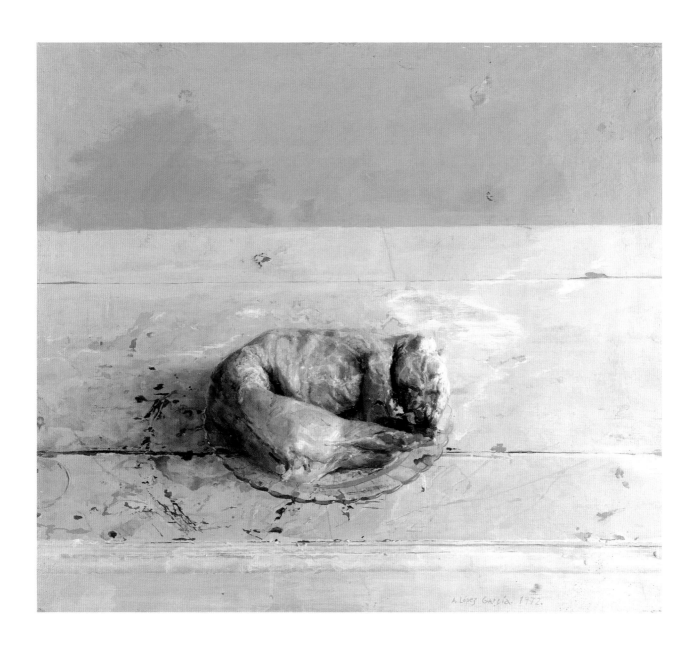

Norman Lundin

(American, born 1938)

Above: Norman Lundin, *Night: Room by the Sea,* 2006, oil on canvas, 22 x 32 inches, courtesy Francine Seders Gallery

Lundin's interest in subtle shifts in tonality and temperatures reflects his artistic influences and his environment; the gentle grays in his paintings are often found in the overcast skies of Seattle, where he lives.

Opposite: Norman Lundin, *Studio in Half-Light #2,* 2006, oil on canvas, 36 x 84 inches, courtesy of Francine Seders Gallery

Lundin is interested in tone and temperature shift. His working method involves creating a warm-and-cool underpainting using white, burnt sienna (or raw umber), and ultramarine blue. This first layer solves the initial compositional, value, and temperature decisions and forms the foundation for his final pass, which he creates using a limited palette.

Lundin did his undergraduate work at the School of the Art Institute of Chicago and completed his graduate studies at the University of Cincinnati. Early in his career Lundin was awarded a Fulbright scholarship to study the work of Edvard Munch in Norway, where he was also exposed to the work of other Scandinavian artists, in particular Wilhem Hammershoi. The effect of light in the sparse compositions in the paintings by these artists had a major influence on Lundin.

Although Lundin has worked figuratively in the past, his recent work focuses on landscape and contemplative interiors that evoke emotions of melancholy and longing. He paints the open spaces toward which he is drawn; the objects in his work are there only to better define the space around them. Compositions of simple objects, such as cans, bottles, and tools on a table in a sunlit room indicate the presence of man.

Night: Room by the Sea is composed almost entirely of repeated vertical and horizontal lines, which convey strength and stability. The placid horizon line mirrors the window ledge, while the window sill is visible through the water glass. Lundin's careful placement of the empty glass hints at human presence, while his judiciously selected color and the limited tonal range convey a somber, quiet mood.

Lundin initially does a warm and cool underpainting, using white, burnt sienna (or raw umber), and ultramarine blue. This first layer solves the initial compositional, temperature, and value decisions, allowing him to overpaint with a limited palette. *Studio in Half-Light #2* exhibits Lundin's deliberate use of color and temperature. It employs the primary colors—red, blue, and yellow— which are found on the objects on the ledge; these are set against an atmosphere of carefully shifting neutrals. The painting is a harmonious symphony of color, with the highly saturated blue notes acting as the keynote. Lundin's deliberately controlled palette and orchestration of space make his work serene and meditative, a perfect reflection of the artist himself.

Daniel Sprick

(American, born 1953)

Above: Daniel Sprick, *Corner Window,* 2001, oil on panel, 24 x 36 inches

Sprick's restrained use of red as an accent color in the label of the can enlivens the surface of the painting and creates visual hierarchy. Here the viewer looks into Sprick's studio and backyard.

Opposite: Daniel Sprick, *Milk Pitcher,* 2003, oil on panel, 24 x 24 inches

For his major works Sprick creates separate studies and preliminary drawings before slowly working on his panels, applying layer upon layer of paint. The process frequently takes two months for a single painting.

Daniel Sprick studied at the Ramon Froman School of Art, the National Academy of Design, Mesa College, and the University of Northern Colorado. He is indebted to earlier masters—especially the Northern Renaissance painters Vermeer, Robert Campin, Roger van der Weyden, Hugo van der Goes, and Jan and Hubert Van Eyck—whom he admires for their ability to create a believable look at invisible realms and supernatural happenings.

Sprick works under natural north light, which allows for a beautiful, cool, and constant light throughout the day. His subject matter is often common household objects and everyday refuse such as eggshells, orange peels, milk cartons, Chinese food containers, and withered flowers; he transforms these into objects of metaphysical beauty. For Sprick, painting is entwined with the process of contemplation; looking inward sparks his imagination. For all his devotion to the realist tradition in painting, Daniel Sprick's views are entirely contemporary and surprisingly abstract.

Milk Pitcher is a precisely balanced composition. If you drew a diagonal line from the upper-left to the lower-right corner, you would see that all the objects are clustered in the left triangle, with a large area of white space and just a few dark elements on the right-hand edge to offset them. Sprick also strikes a delicate balance with his use of color. The predominantly cool temperature of the image is accented by several intense color notes. Even though the red rose against the green cloth on the left side provides a stronger color contrast, the peach steals the show by virtue of its near-central placement, simple form, strong value contrast, and big color jump.

In *Corner Window* the magical sits alongside the mundane. The cool, muted colors of the twilight world outside recede in space, an impression created by soft edges and a narrow value range. By comparison, a bright lights shines on his interior objects, exposing their forms and possible meanings. The sinister quality of the axe and red drips along the soup can contrast with the purity and enchantment of the levitating roses.

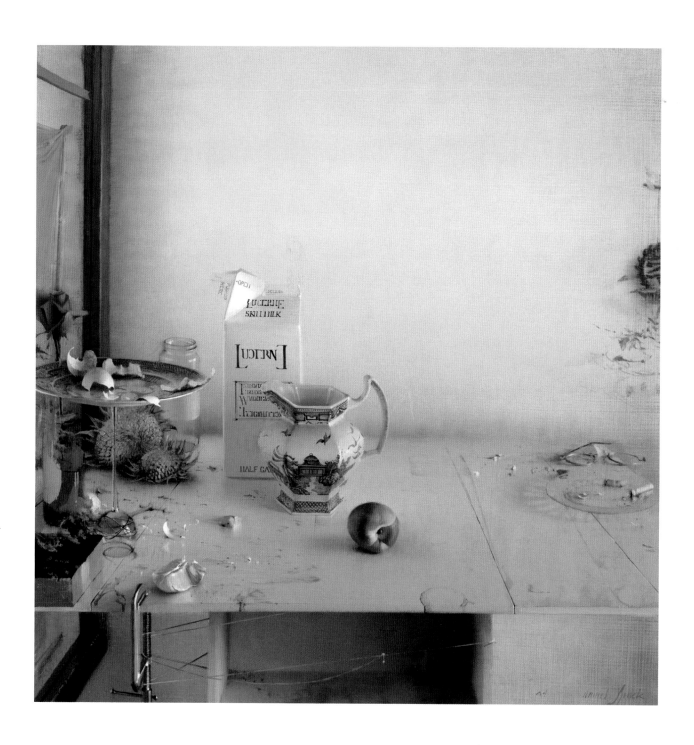

Scott Fraser

(American, born 1957)

Above: Scott Fraser, *Three Pieces*, 2003, oil on panel, 17 1/2 x 14 inches

The narrow depth of field, myriad details, and accurate placing of the shadows all make this piece convincingly trick the eye.

Opposite: Scott Fraser, *Thin Fragile Line*, 1992, oil on panel, 16 x 20 inches

Fraser starts his underpaintings with a thin, transparent wash of high-key colors. For his overpaintings, he premixes warm and cool color bands on his palette so that he can apply just the right color quickly, using the largest brush possible. He aims to get things right in the first heavy coat of paint and follows with details, using a smaller brush to manipulate the surface and achieve volume.

Scott Fraser studied at the Kansas City Art Institute, the University of Colorado, and the Atelierhaus at Worpswede, Germany. He spent a period of time in Germany, where he was influenced by the northern European artists and learned the techniques of past masters, such as glazing. Fraser's work incorporates some thematic elements popular from the golden age of still life, including *vanitas* symbolism. Whatever inspiration he draws from the past is firmly applied in the present. Fraser portrays traditional still-life objects in an unconventional manner and intermingles these items with such things as paper plates and Styrofoam cups.

Much of the imagery in Fraser's work is inspired by his surroundings and family. Paper planes, little shoes, and goldfish crackers can all be found in his work. He painted *Thin Fragile Line* after finding out that his wife, Bronwyn, had a brain tumor the size of a marble. In this painting Fraser's mastery of warm and cool is evident as he forgoes strong color for subtle shifts in temperature. To get an idea of the complexity and frequency in temperature shifts that create such a dynamic surface, count the changes from the left-hand side of the cardboard box to the deck of cards on the right. This continual undulation gives an effect of natural light. *Three Pieces* is a contemporary trompe l'oeil work. Fraser has created a formal, balanced composition, where the two sides are essentially mirror images of one another. The focal point is a dark note, whereas in *Thin Fragile Line* the primary element is a light note.

The artist describes his working process as very simple and direct. He prefers to work from life and under north light because the light is cool and casts a warm luminous shadow. Little medium is used, and the underpainting starts with a thin transparent wash of high key colors. Warm and cool color strings are premixed on the palette so that just the right color can be applied quickly using the largest brush possible. At times whole areas will be scraped off, passages changed, and thin veils of glaze or opaque color will be applied as needed. However, the aim is to get things right in the first heavy oil coat to maximize freshness and luminosity. Details follow with smaller brushes to manipulate the paint surface and achieve volume. To direct the viewer's eye in subtle ways, particular attention is placed where edges fall away in contrast to other areas of tight focus.

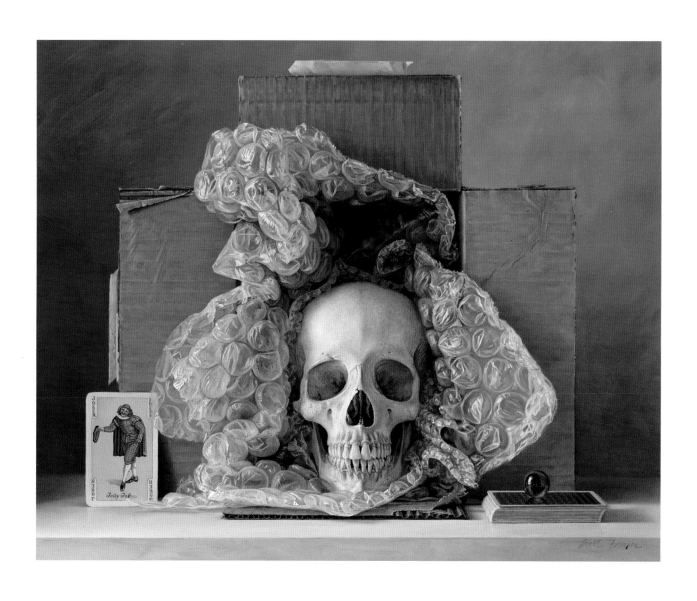

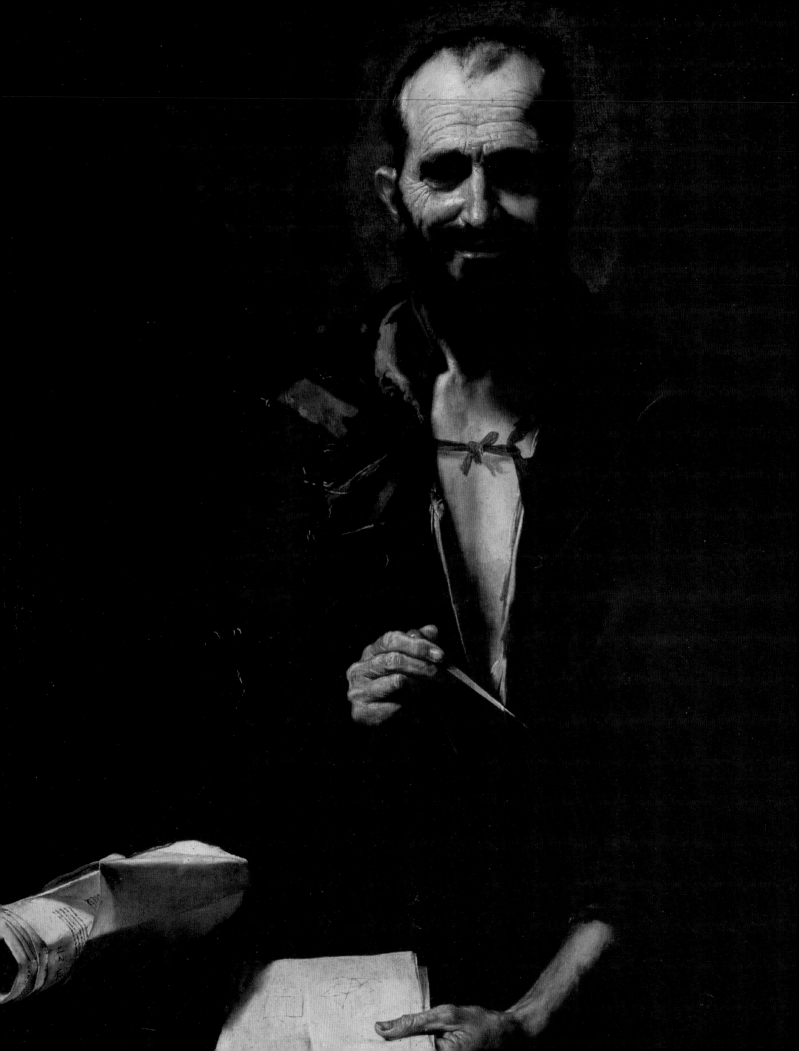

PORTRAIT PAINTING

An Intimate Likeness

"The sight of beauty never creates these raptures in those who do not understand her. She is so simple, she only speaks to the initiated. If you look superficially, you have only a common image; look longer and deeper, the image becomes sublime." — THOMAS COUTURE (from *Conversations on Art Methods*)

Portrait painting has many functions—from the funereal portraits of ancient Egypt and painted effigies of mighty Roman emperors to the society paintings of today. At its most fundamental level, portraiture is a celebration of a single human life, but as a genre, it has waxed and waned in popularity over the centuries. A first-century Italian writer noted that portraiture was "out at the moment." However, more than 1,500 years later, in the Renaissance, it had fully flowered into a genre greatly admired for its ability to celebrate the individual.

Today, we have several thousand years of portraiture behind us. With the technological advancements of photographic media, many say that portrait painters have nothing new to offer. However, no matter how thoroughly artists have documented the past, the present remains virtually unexplored. We live in a time like none ever before experienced by humanity. We have unique fears and accomplishments and are surrounded by a pervasive, existential uncertainty that calls for the vision of great artists.

Usually, when we gaze at another person, we see only one aspect—his or her physical presence. In a fundamental way, we as human beings experience much of life as solitary entities. Inside each of us is the composite of our experiences, beliefs, and inherited temperament; trapped within our skulls exists a fantastic world of dreams and nightmares. Regardless of how many friends we have or how close we are to a spouse or parent, these people are excluded from our innermost thoughts, motivations, experiences, and emotions. We can infer the inner world of others, but we only truly know our own. Our personal internal commentaries are transmitted to others through art, which is able to convey our wordless thoughts. Likewise, looking at great art gives us a chance to experience another's innermost thoughts, to see through their eyes.

Opposite: Jusepe de Ribera, *Archimedes*, 1630, oil on canvas, $49^{1/8}$ x $31^{7/8}$ inches, Prado, Madrid, Spain, courtesy of Art Renewal Center

Archimedes was a famous Greek mathematician and inventor who was portrayed by Ribera as a jovial philosopher.

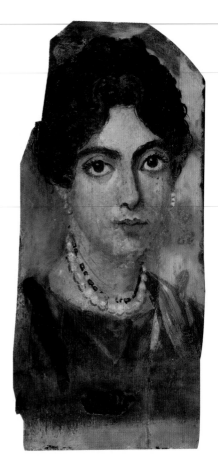

Above: Artist Unknown, *Mummy Portrait of a Young Woman with a Double Pearl Necklace from Fayum,* **circa c.e. 160, encaustic on wood. Ägyptisches Museum, Staatliche Museen zu Berlin, Berlin, Germany**

While this image captures the likeness of a woman who died almost two thousand years ago, it also displays a sophistication and aesthetic that are remarkably contemporary.

Photo: Ingrid Geske-Heiden

Photo Credit: Bildarchiv Preußischer Kulturbesitz / Art Resource, New York, New York

Opposite: Odd Nerdrum, *Self-Portrait in Profile,* **1998, oil on canvas, 33 x 30 inches, courtesy of Forum Gallery**

Most self-portraits directly confront the viewer; here we see the artist in profile. The impasto lights pull the side of his face close to the viewer, while his features dissolve into the background.

Within the kind of narrative found in portraiture, we can recognize that we are not alone. Today, more than ever, the world needs powerful portraiture. The level to which various forms of media permeate our lives ensures that we are confronted with an endless stream of faces, many belonging to people we will never know. Great portraiture rebels against our society's tendency to stereotype, categorize, and objectify those around us. By celebrating a single personality, portraiture provides a humanizing influence in an age of detachment.

Great works of portraiture can also provide an authentic encounter with another person, revealing him in his humanity apart from any job he does or any social role he performs. When I catch a glimpse of the real person, my preconceptions are demolished, along with the barriers created by such things as time, race, age, sex, and nationality. I encounter not just an idea, theme, or symbol, but a person, documentation of someone who walked the Earth as a distinct human life. As author Norbert Schneider said, almost no other genre of painting is capable of transmitting such an intimate sense of a lived presence over so great a distance of time. Good portraiture invites us into a relationship with the painting; great portraiture leaves us little choice but to enter into the experience and life of the sitter. Portraiture, at its best, allows us to step outside the limitations of mortal language for a moment to join minds with another individual. At its core, portraiture is about relationships—the relationships among the artist, the patron, the sitter, and the viewer, all of whose internal, wordless narratives have the opportunity to cross paths at the juncture of the painting.

Art based on nature needs no interpreter; it speaks directly to us. The intelligence, hope, love, desire, and fear of the artist stir our emotions and connect with us as viewers. We look at the outward form and see signs of the inward stirrings of a spirit. The more accomplished the artist, the more the means used to create the painting fade into a transparent vehicle for self-expression. When I look at the portrait of Lucas Van Uffel by Anthony Van Dyck on page 193, I am looking at a composite image. Van Uffel has been transformed into a classic Van Dyck painting, while still being recognizably himself. This work of art is not only technically brilliant but has been created with empathy.

Not surprisingly, self-portraits are often the most sensitively done portraits. These are not commissioned works; they are created purely for their own sake, and that authenticity shows in the work. For this reason, artist self-portraits are my favorite branch of this genre.

Portraiture manifests itself in diverse ways, yet in the broadest sense, there are two primary branches of portraiture—the institutional and the personal. The institutional portrait is concerned not only with capturing a likeness of a private individual but with establishing and portraying him to the public in a way that secures his status and enhances, even idealizes, his image. The history

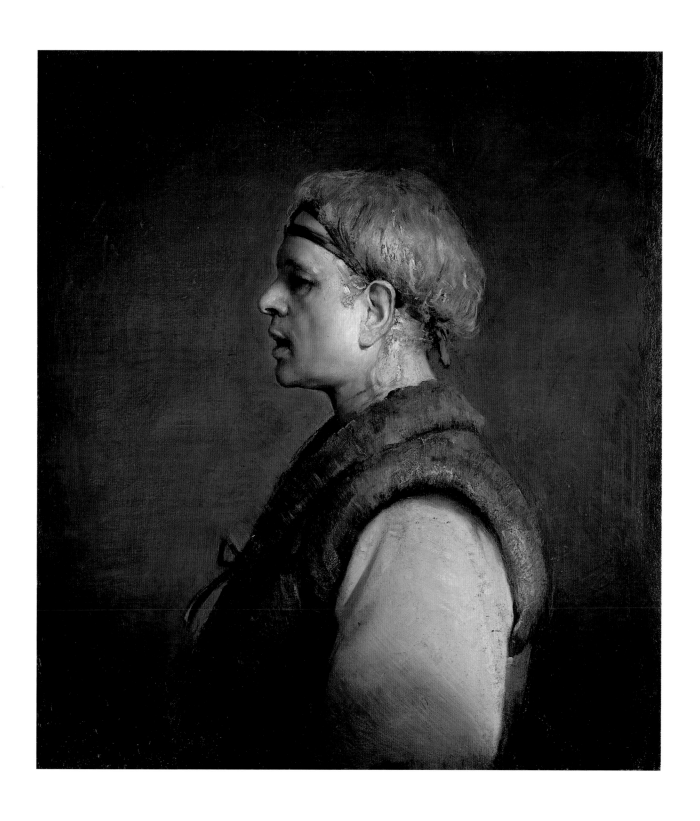

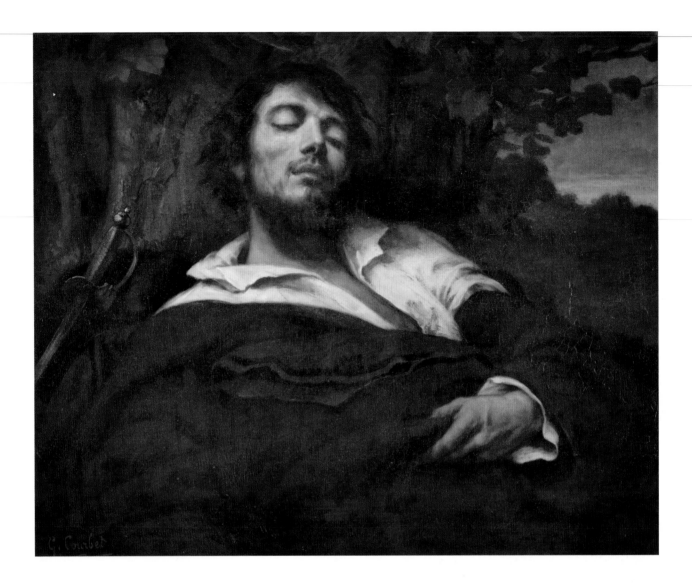

Gustave Courbet, *Wounded Man*, 1844–1845,
oil on canvas, 32 x 38 3/8 inches, Musée d'Orsay,
Paris, France, courtesy of Art Renewal Center

Courbet considered himself to be a revolu-
tionary set against the artistic establishment
of his day. He painted himself many times
through his career, including this image, which
he finished when he was twenty-six.

of official portraiture can be seen in the representations of leaders from the
Egyptian pharaohs to the presidents of our own country. However, other types
of public individuals also invested in portraiture, including philosophers,
scholars, clergy, merchants, and guild members. These official portraits show
the sitter/patron as worldly, educated, pious, wealthy, and discerning. The
institutional portrait artist is part myth maker, as he transforms a private
individual into a public persona that exudes power, competence, and strength
among myriad other ideal attributes.

In one such circumstance, Peter Paul Rubens was hired to decorate the Palais
du Luxembourg with monumental canvases cataloging the life of Marie de
Médicis. By all accounts, Marie was not a good-natured person; she had a
complicated yet mundane life and a miserable marriage. Rubens had to find a
way to flatter his patron while fulfilling the stipulation that his commission
represent the facts of her life. Rubens brilliantly solved the conundrum by

using Greek mythology to surround the life of this queen. He painted Marie surrounded by the Pantheon of Greek gods: the Fates weave the unborn queen's destiny; her education is led by Apollo, Athena, and the three Graces; Marie is welcomed to France by Neptune himself; her coronation is attended by ethereal beings throwing petals. Rubens created a piece of fiction that established Marie's rise to power as one of divine destiny; she was portrayed as larger than life, inhabiting a world of gods rather than men and inspiring awe and reverence in all who viewed the canvases. I wish Rubens worked for me; he could document my morning commute to my studio in a chariot driven by Hermes and accompanied by the personification of inspiration in the form of an Olympic high diver.

Another, more subtle example that typifies official portraiture was made by the American artist Gilbert Stuart. When Stuart painted a picture of George Washington, he presented the world with an influential statesman and president. However, Washington had no teeth. (He used uncomfortable dentures only for special occasions.) And his face had warts and pox marks. Stuart realized that to portray him "warts and all" was antithetical to the purpose of the commission, so by carefully selecting his facts, Stuart created a painting that looked like Washington without being a photographically accurate account. The painting was an idealized version of the president, a combination of the individual George Washington intermingled with his role as a national hero. The institutional portrait offers a personal face for public institutions. The sundry CEOs, university presidents, and government officials of today are the subjects of the institution portraits of our era. These portraits are no longer created with the aim to communicate the gumption of a potentate, yet they continue to maintain a respectful distance from the specifics of the sitter's personal life.

Portraits concerned not only with capturing the likeness of an individual but also with promoting status fall into the category of society portraiture. For example, the beautiful society paintings of John Singer Sargent captured the ideals of his era by turning each of his subjects into a figment of his own imagination. He made each of his sitters into a perfect archetype of the time— a well-dressed, gracious, intelligent, and jeweled Madonna living the nineteenth-century high-society life.

On the opposite end of the spectrum from the official and society portraits are the ones that are concerned with the unique attributes of an individual, whether public or private. For instance, Sargent's painting of Robert Louis Stevenson is a quirky portrayal of the author twisting his beard and pacing across his living room, while his wife, Fanny, sits under a ream of fabric and stares off to the side of the picture. Some of the most extreme of these individual portraits include those in which artists, fascinated by irregularity of proportion and deformity, focus on the malformations of individual sitters. Leonardo da Vinci's grotesque heads fall into this category. Likewise Jusepe de Ribera painted a

Top: Koo Schadler, *Profile of Girl with Pearl Buttons*, 2003, egg tempera on panel, 7 x 5 1/2 inches, private collection

Schadler is a contemporary artist reviving an ancient technique. Her tiny paintings are meticulously executed, yet convey warmth and personality.

Above: Robert Bauer, *Jeff*, oil on panel, 2004, 7 5/8 x 5 3/4 inches, courtesy of Forum Gallery

Bauer's highly detailed works appear to capture every hair of his sitter, which is all the more remarkable considering the tiny size of his images. This painting conveys a sense of intimacy, as it draws the viewer into its small world.

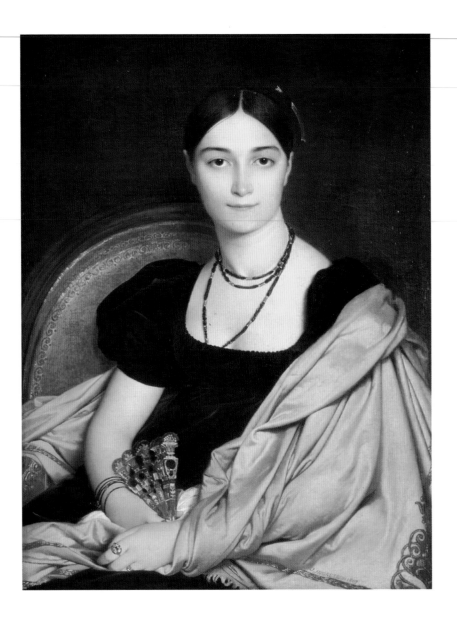

Jean-Auguste-Dominique Ingres, *Portrait of Mme. Devaucay,* 1807, oil on canvas, 30 x 23 ¼ inches, Musée Condé, Chantilly, France, courtesy of Art Renewal

Ingres favored a smooth, highly finished technique. Reflecting his deep love of classic, ideal beauty, his painting gives a nod toward Raphael's Madonnas.

boy grinning as he used a cane to help him stand on a deformed clubbed foot, striking a beautiful balance by portraying him with dignity without hiding his malformation. Painter Diego Velázquez catalogued Spanish court life, painting both dwarfs and royalty, raising up the lowly, making accessible the lofty, and revealing to us the humanity of each individual. His paintings of the pale face of King Phillip IV were recorded with the empathy of a friend.

In contemporary times, artists such as Lucian Freud push anomalies to the extreme, painting the faces of his sitters with sagging skin and asymmetrical features that border on the deformed. He seems to rejoice in the worn out, mottled colors of his subjects, who seem steps away from the grave. His painting of Queen Elizabeth is the opposite of idealization; he pushed the image to

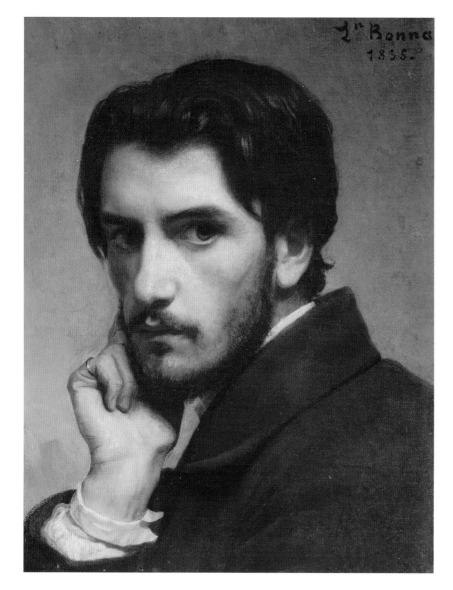

Léon Bonnat, *Self-Portrait*, 1855, oil on panel, 18 1/8 x 14 1/2 inches, Musée d'Orsay, Paris, France

Here a twenty-two-year-old Bonnat stares confidently at the viewer. His three-quarters angle self-portrait with a mountainous landscape gives a nod to the Italian High Renaissance.

Photo Credit: Réunion des Musées Nationaux / Art Resource, New York, New York

intentionally exaggerate the ugly, ordinary, and earthbound elements of his sitter. Freud has used the countenance of the queen as an expression of his worldview.

In the following pages we will analyze the works of portrait artists, past and present, with the aim of better understanding their language and working methods. There is almost no subject harder to draw or paint than the human form, especially the face. Familiarity with the face and our dependency on it for communication and survival make it difficult to see it dispassionately. By studying the systems of master artists we can identify what tools they used to aid them in accomplishing their task. We will look at their choices of composition, value, and color to appreciate their achievements and be able to apply what is useful in their systems to our own art.

Frans Hals

(Dutch, 1581–1666)

Above: Frans Hals, *The Gypsy Woman,* 1628–1630, oil on panel, 22 7/8 x 20 1/2 inches, Louvre, Paris, France, courtesy Art Renewal Center

Portrait painting flourished in a period of Dutch history when religious art was banned. The portraits of Frans Hals reflect the rising optimism of people in early seventeenth-century Netherlands.

Opposite: Frans Hals, *Clown with a Lute,* circa 1623, oil on canvas, 27 1/2 x 24 3/8 inches, Louvre, Paris, France, courtesy of Art Renewal

Hals's portraits of performers are often considered to capture the essence of a type of person rather than to portray an exact likeness of a specific individual.

Frans Hals was one of the old masters from the Golden Age of Dutch painting and is best known for his lively portraiture. Not much is known for certain about his early life until age twenty-nine, when he became a member of the Guild of St. Luke in Haarlem (where he lived the greater part of his life). Italian painter Caravaggio influenced him, not in his use of chiaroscuro but rather in the types of figures he portrayed. Hals painted a variety of interesting people, such as gypsies, topers, musicians, and other street types. His *Clown with a Lute* and *Gypsy Woman* are both characteristic of the early portraits for which he became famous.

Hals's portraiture style was revolutionary in both its content and its technique. His humble subjects are usually shown in a jovial mood. Prior to this, portraiture had always been a serious affair. Even when the subject was smiling, such as in Leonardo da Vinci's *Mona Lisa,* the expression was very slight. Smiling figures had connotations of idiocy or lunacy. However, Hals managed to convey an atmosphere of merriment and liveliness with his subjects. His loose brushwork and painterly style added to the feeling of his sitters' vibrancy.

The painterly, oil sketch quality of Hals's work influenced many nineteenth-century artists, such as Edouard Manet, who were seeking a greater freedom than was taught with the academic methods popular at that time. Hals's paintings appear to be done *alla prima,* but analysis has shown that they were created instead with successive layers of paint, as were most of the works done in his day. Unlike his contemporaries, however, Hals allowed the surface to show his hand, by applying a loose underpainting on top of a quick chalk drawing possibly directly done on a midtone gray or pink ground.

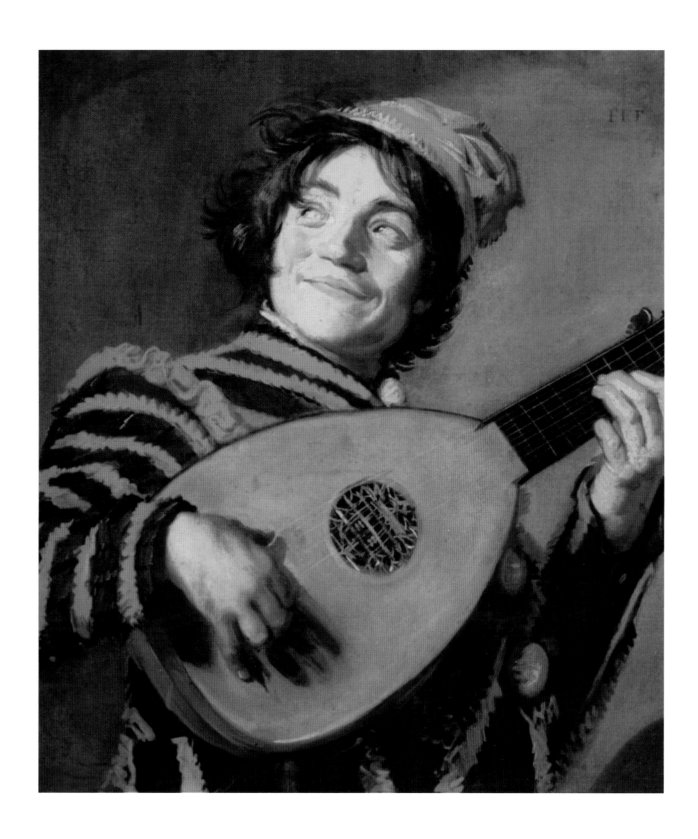

Anthony Van Dyck

(Flemish, 1599–1641)

Above: Anthony Van Dyck, *Family Portrait,* **1618–1620, oil on canvas, 44 5/8 x 36 3/4 inches, Hermitage, St. Petersburg, Russia, courtesy of Art Renewal Center**

This touching image is a good example of what made Van Dyck such a highly sought after portrait artist. He was adept at capturing elegant surroundings while conveying the strength and intelligence of his patrons.

Opposite: Anthony Van Dyck, *Lucas Van Uffel,* **circa 1621–1627, oil on canvas, 49 x 39 5/8 inches, Metropolitan Museum of Art, New York, New York**

This image captures Van Uffel, a wealthy Flemish merchant and shipowner, at his desk as though we have just interrupted him. We look up at this three-quarter portrait, which conveys movement and elegance.

Photo Credit: Image copyright © The Metropolitan Museum of Art/ Art Resource, New York, New York

Anthony Van Dyck was a Flemish Baroque painter of extraordinary talent who was best known for his portraiture. Van Dyck began his art training in the studio of painter Hendrick Van Balen in Antwerp at the age of ten. He was already a full guild member with his own workshop when he studied under the great master Peter Paul Rubens. Although Van Dyck was already an accomplished painter, he learned much from Rubens and his style did change somewhat. After his studies with Rubens, Van Dyck traveled to Italy, where he remained for six years, studying firsthand the work of the Italian masters, especially Titian, Jacopo Robusti Tintoretto, and Paolo Veronese. He moved to England in 1632, became the court painter for the royal family, and was knighted by King Charles I. He remained there for the rest of his life.

Although Van Dyck's paintings appear effortlessly done, he believed that indirect painting methods executed over a period of time were preferable to those done in one sitting. Van Dyck wrote, "The tempera painters whose manner of applying the tempera technique was reflected in the way they handled techniques in oil, were the best. Nowadays painters have discovered that they do not have to follow the rules of tempera painting so closely, and therefore have strayed from the basic rules of art; that is why they have fallen into various confusions, and they have lost their sense of direction." Instead Van Dyck proposed the following sequence: sketching, underpainting (dead coloring), painting, shadowing, heightening, and final touching.

In the two portraits shown here, *Family Portrait* and *Lucas Van Uffel,* we can see some of the elements of style that made Van Dyck so successful. Both his individual and group portraits are elegant and flattering to the sitter. He often paints three-quarter length with the intelligent glance of his sitters looking slightly down on us. He masterfully combines broad, powerful compositions with careful brushstrokes and extreme detail. Rubens's influence can be seen in Van Dyck's use of more expressive brushwork in his backgrounds and clothing.

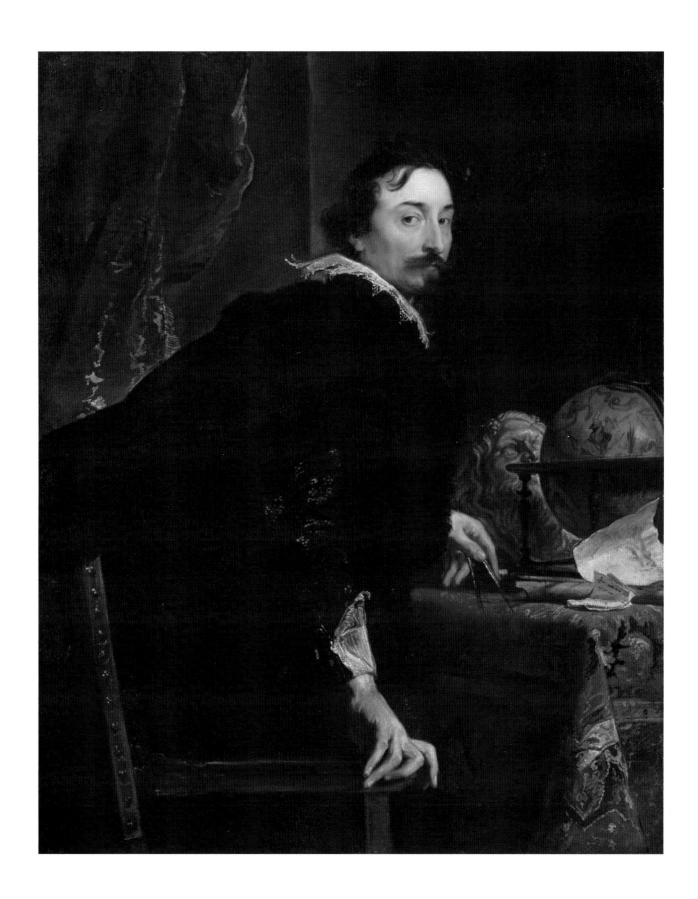

Rembrandt van Rijn

(Dutch, 1606–1669)

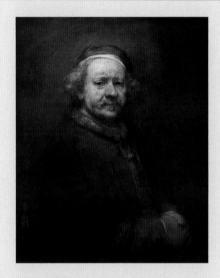

Above: Rembrandt van Rijn, *Self-Portrait*, 1669, oil on canvas, 33 ³/₄ x 27 ³/₄ inches, National Gallery, London, England, courtesy of Art Renewal Center

Rembrandt's true mastery is shown well in this haunting self-portrait. He captured a subtle expression that conveys a realm of emotion as subtle as thought itself.

Opposite: Rembrandt van Rijn, *Herman Doomer,* 1640, oil on panel, 29 ⁵/₈ x 21 ³/₄ inches, Metropolitan Museum of Art, New York, New York

Herman Doomer was a well-known furniture maker who worked in ebony; Rembrandt also painted Doomer's wife, Baertje Martens.

Photo Credit: Image copyright © the Metropolitan Museum of Art / Art Resource, New York, New York

Rembrandt was perhaps the most influential and prolific painter to ever come out of the Netherlands. He was a master draftsman, printmaker, and painter, leaving behind more than a thousand drawings and hundreds of paintings. As a young man, Rembrandt apprenticed with the artist Jacob van Swanenburgh. Three years later he studied briefly with history painter Pieter Lastman before opening a studio in his hometown of Leiden with fellow Dutch painter Jan Lievens. Within a few years of opening his studio, Rembrandt started teaching his craft to others.

While Rembrandt painted every type of subject matter over the course of his illustrious career, he is perhaps most famous for his biblical narratives and portraits. Rembrandt completed forty portraits during the years of 1632 and 1633 alone. *Herman Doomer* shows Rembrandt's signature style, which is marked by large abstract shapes of value combined with intensely observed turning forms and brilliant technical execution. The strong diagonals of the shoulders create a dynamic pyramid, drawing our attention to the dominant eye. Bold brush-strokes, especially in the costume, add to its individuality. The restrained palette and the atmospheric treatment of light create a warm, intimate atmosphere. The regular rhythm of light against dark, and dark against light, creates a repeating value pattern punctuated by the bright white of the collar. However, no formal analysis can fully explain the life that Rembrandt breathed into this portrait. Doomer seems on the verge of speaking to us; his somber, compassionate features are animated with a general sympathy instilled by the hands of this artistic giant.

In addition to his portraits of others, Rembrandt produced approximately seventy-five drawings, paintings, and etchings of his own visage, more than any of the other past masters. A master copy of a self-portrait completed when he was only twenty-six is shown on page 7. The self-portrait shown here was done in the last year of his life. Rembrandt's later style was more expressive than his earlier style. His later style used looser and wider brushstrokes. Here the artist portrays himself looking poignant and world-weary. Typical of his later work, it is a highly personal expression, sacrificing finished forms and details for breadth of execution and greater emotion.

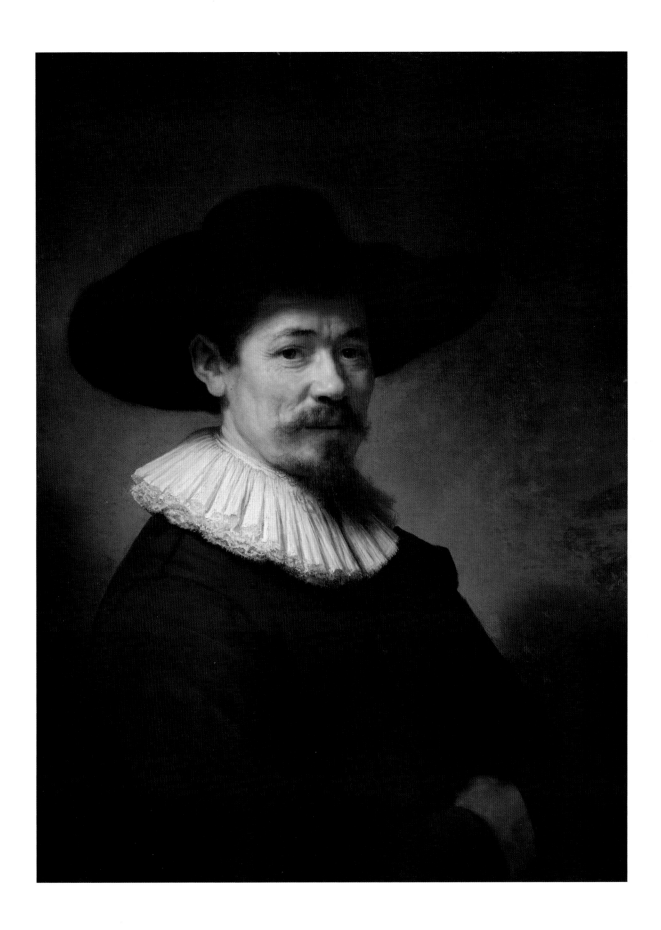

Cecelia Beaux

(American, 1855–1942)

Above: Cecilia Beaux, *Self-Portrait*, circa 1880–1885, oil on canvas, National Portrait Gallery, Smithsonian Institution, Washington, D.C.

For many of her early works Beaux used the *ébouche* technique for the underpainting.

Photo Credit: National Portrait Gallery, Smithsonian Institution, Washington, D.C. / Art Resource, New York, New York

Opposite: Cecelia Beaux, *Henry Sturgis Drinker* (also called *Man with the Cat*), 1898, oil on canvas, 48 x 34 ⁵/₈ inches, Smithsonian American Art Museum, Washington, D.C., courtesy of Art Renewal Center

Beaux was greatly influenced by the work she saw in Europe, both by old masters and contemporary Impressionists. Her fluid handling of paint and mastery of technique seamlessly merge these two influences.

Cecelia Beaux was born in Philadelphia and studied at the Pennsylvania Academy of the Fine Arts, where she later returned to teach. In 1888, at the age of 33, she made the first of several trips to Europe to study, like many of her peers, even though she was already considered one of the best portrait painters in Philadelphia. She studied at the Académie Julien under the many artists who critiqued there, including William Bouguereau. Beaux painted portraits of many prominent figures, including Henry James and Theodore Roosevelt. In 1933 she received the Chi Omega fraternity's gold medal from Eleanor Roosevelt, for being "the American woman who had made the greatest contribution to the culture of the world."

In the self-portrait on the left, we can see some of Beaux's early working methods. It features a warm, scrubbed-in underpainting into which she started massing in the general shapes of the lights. Beaux's body of work can be generally divided into two groups: those that are focused on value (such as this tonal painting) and those that are heavily influenced by Impressionism (such as the painting on the right).

The sitter for *Henry Sturgis Drinker (Man with the Cat)* was Beaux's brother-in-law, a railroad executive and the president of Lehigh University in Pennsylvania. The work is loosely painted with broad brushstrokes and strong impressionistic color. Beaux achieves a sense of agitation through the vibrating color and casual environment, creating a feeling that the subject only sat down for a moment and was caught by the artist almost by chance. Notice the continual shifts between warm and cool found throughout the painting. Because the dark notes in the hair and tie draw your eyes to the face, it becomes the natural focal point in spite of the color throughout the rest of the piece. Also notice the luminosity created by atmospheric use of ambient light.

William McGregor Paxton

(American, 1869–1941)

William Paxton attended the Cowles Art School to study with Dennis Bunker on scholarship before making a pilgrimage to Paris to study at the Académie Julien with Jules-Joseph Lefevre. Later he entered the École des Beaux-Arts to study with Jean-Léon Gérôme. Gérôme taught for more than forty years; his atelier was popular with Americans, and such prominent artists as Julian Alden Weir, Thomas Eakins, and Abbot Thayer studied with him. Gérôme was a serious, generous teacher who advocated solid drawing skills and the academic method of training artists. Paxton's strong training in drawing was not abandoned when he started experimenting with Impressionist color. Rather, he combined the subtle draftsmanship of his academic training with naturalistic Impressionist coloring as he sought to portray the contemporary life of upperclass Bostonians. Paxton himself became an influential teacher and forms a link in the lineage of many contemporary ateliers.

The Pink Ruff captures the mood of many of Paxton's works, which predominantly feature women who are portrayed as intelligent, compelling, reserved, and with a hint of sensual languor. It is a carefully composed picture. Strong angles of light create a dynamic triangle—with the division of light from the neck through the face demarcating a strong vertical line, followed by the dark line of the hat, hair, and feather leading down and to the right, and the division between the pink ruff and the shoulder closing the triangular form. These strong angles create a powerful structure that offsets and supports all the folds of fabric and the soft fanning of the hat and feathers. They also create a directional thrust that leads you to the dominant eye. The combination of the soft forms of the face interwoven with the strong chiaroscuro has created a masterpiece of American art.

Edwin Dickinson

(American, 1891–1978)

Dickinson's childhood was marked by tragedy, with the death of his mother and suicide of his brother before he was twelve. In 1910, he enrolled at the Pratt Institute; the following year he studied with William Merritt Chase and Robert Henri at the Art Students League of New York; he later went to Provincetown and studied with Charles Hawthorne. He was in the navy for several years during World War I, after which he spent almost a year in Paris engaged in life drawing and independent study. He visited Spain and was greatly influenced by Diego Velázquez, Francisco de Zurbarán, and El Greco. Dickinson's amazing draftsmanship and his poetic handling of pictorial space, which blends traditional figuration with surrealistic imagery in many of his works, won him critical acclaim and respect at a time when abstract, rather than academic, painting was at the forefront of American art.

Dickinson's working methods reflect the traditional approaches of the Munich School and the painterly Spanish tradition he learned from William Merritt Chase and Charles Hawthorne. His work is marked by rich, sober tones of color mixed on the palette and followed by a certain amount of blending directly on canvas or board. Remarkably, he often improvised, using brushes, palette knife, and sometimes fingers, to establish the precise tonal relationships that are a hallmark of his painting. Simple compositions, unexpected color harmonies, and atmospheric renderings prompt the viewer to reflect on fundamental questions of vision and representation.

This self-portrait is an example of an open form painting in which the contour of the forms dissolves into the atmosphere of the environment in the picture. Dickinson abstracted the shapes of the light and dark, with his head emerging from a sideways trapezoid of darkness, perhaps reiterating the geometric shapes on the board behind him. The edges of his jacket evaporate into the white board behind him. The shapes of the beard and hair likewise withdraw into the dark of the background. Against these vast areas of melding forms he has found certain sharp edges (such as the lapels of his coat), which guide the eye around the picture.

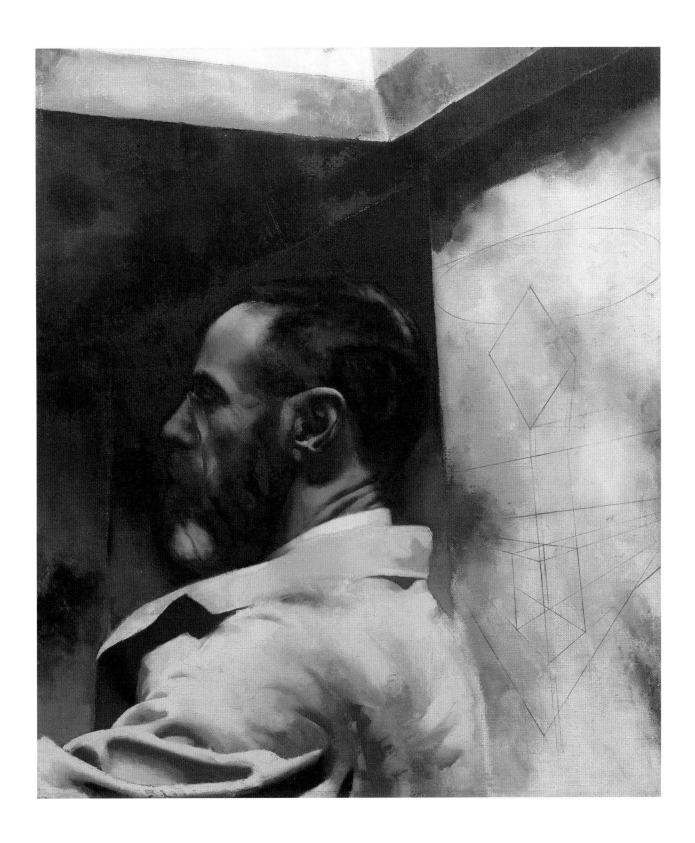

Pietro Annigoni
(Italian, 1910–1988)

Above: Pietro Annigoni, *Self-Portrait*, egg tempera and oil on canvas, 31 1/2 x 23 5/8 inches, Uffizi, Florence, Italy

Annigoni viewed Impressionism as an end to the great lineage of painting that began with Giotto. He preferred to emphasize the aspects of painting that are based on drawing and form.

Photo Credit: Scala / Art Resource, New York, New York

Opposite: Pietro Annigoni, *Self-Portrait*, 1946, egg tempera and oil on canvas, 17 5/8 x 13 7/8 inches, Gherardesca, Florence, Italy

Annigoni left a legacy as an artist and a teacher; his enthusiasm for life and his respect for the craft of painting made him the last "old master."

Photo Credit: Scala / Art Resource, New York, New York

Pietro Annigoni, influential artist and teacher, was drawn to the principles of the Renaissance during the heyday of avant-garde art. When he was seventeen he entered the Accademia di Belle Arti in Florence, where he studied with master etcher Celestino Celestini. There Annigoni was befriended and inspired by literature professor and painter Renzo Simi and sculptor Mario Parri, and did many master copies from Michelangelo, Leonardo da Vinci, and Raphael. Although Annigoni produced a wide variety of work, including still-life, religious, and allegorical paintings, he became famous for his portraiture. The most eminent figures of the twentieth century, including Queen Elizabeth II, John F. Kennedy, and Pope John XXIII, sat for him, and *Time* magazine used his work on its cover seven times.

Annigoni, with the heart of a poet and the mind of a philosopher, was keenly aware that his painting was out of step with the art of his times. He wrote compellingly about many aspects of art and although he was not a religious man he lamented the utilitarian state to which humanity had sunk. He wrote, "Truly, contemporary society is at once the slave and victim of the boundless liberty it has drawn upon itself. As far as Art is concerned, the image comes to mind of a great raft drifting in a sea, without a landing place and without a course."

The self-portraits shown here are among my favorites of his works; the first was done when he was thirty-six, the second when he was fifty. In both images he has painted himself with closed form, meaning the figure is distinct and separated from the background by a delineated contour line. He has kept the lights and shadows polarized. In the earlier work, simple shapes form large areas of color, such as the flat blue background, which heighten the impact of minutely observed details, such as the folds of the ear and the stubble of the beard. In the later portrait, clarity of form and love of detail continue to be present. Annigoni could easily be paralleled with Hans Holbein in the sense that the luxurious clothes contrast with the nuanced features of the face. Annigoni used his strong knowledge of drawing, art history, and design to retain in his work the breadth of vision so often undermined by pushing a work to such a complete resolution.

Steven Assael

(American, born 1957)

Above: Steven Assael, *Untitled*, 2000, oil on panel, 12 x 16 inches

An obsessive worker, Assael varies his approach depending on the painting. For his major works he does careful drawings and much direct observation from life, as with this image.

Opposite: Steven Assael, *D*, 1998, oil on canvas, 62 1/2 x 98 1/2 inches, courtesy of Forum Gallery

Assael always carries a sketchbook, which he uses to record ideas and visual experiences. He uses these records as the reference for many of his paintings, including this one.

Steven Assael attended classes at the Art Students League of New York while he was still in high school, studying with such instructors as Robert Beverly Hale and David Leffel. He also studied at the Pratt Institute for four years. Assael's work is inspired by the narrative figure painting tradition advanced by Rembrandt, Velázquez, and Goya. His conscientious focus on visual truth combined with his compassionate sensibility for the human condition transform his figures into towering works of art, placing him among the ranks of the world's greatest figurative artists.

This painting, *D*, is not of a literal occurrence but a syntheses of ideas, experiences, and people set against the backdrop of the New York City subway. It was inspired by the memory of riding in the older subway cars, with its dusty brown tone juxtaposed against the dramatic light that flickered on and off from outside sources in an abrupt, almost abrasive manner. In this image, Assael plays with light. A raking golden light comes from the left-hand side and dances across the figures at an oblique angle, resulting in the unusual situation of providing rim, side, and back lighting. This is offset by a cooler and more muted secondary light source, which is placed more traditionally, coming in from the upper right. The core shadow on the four central figures touches against a strong beam of light, instead of a more typical ambient reflected light. Notice how the chiaroscuro creates large lost areas of form (for instance, in the lower half of the painting), binding all the riders together, with the found edges directing our eyes to their faces, enhancing their individuality. Perhaps this image is a commentary of life itself—the sense of being motionless while being hurled to a destination along with whomever life throws into your path.

I had an opportunity to see Assael paint and sat for this untitled portrait during a trip he made to Seattle. Assael works quickly, placing large masses of color directly on the canvas, without locating any of the specific forms that other artists would consider essential. As the work progresses he brings the forms to completion, as can be seen in the different stages of the three heads.

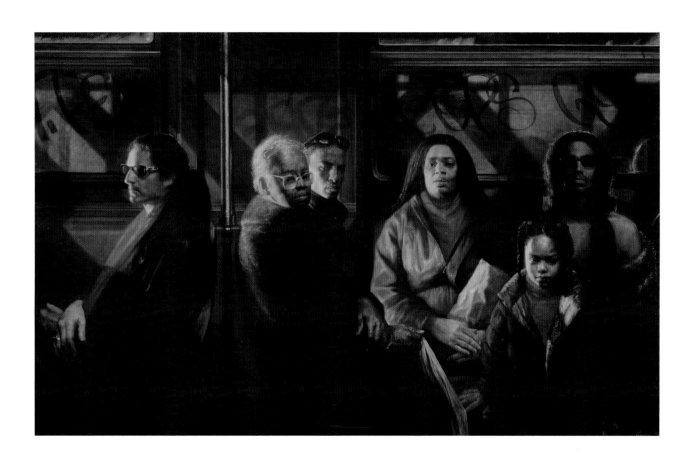

Yuqi Wang

(Chinese, born 1958)

Above: Yuqi Wang, *Untitled*, 2005, oil on canvas, 20 x 16 inches

This meditating woman creates a graceful arch, which is framed between the mahl stick on the left and the model's arm on the right.

Opposite: Yuqi Wang, *From Red Hook*, 2002–2005, oil on canvas, 30 x 30 inches

Wang holds his mahl stick defensively as a weapon of choice to record and convey his opinions to the world.

Yuqi Wang was trained at the Tianjin Academy of Fine Arts and obtained his postgraduate degree in painting at the Central Academy of Fine Arts in Beijing. In the mid-1990s he moved to New York and still resides there. His art hangs in public collections in China and is in the collection of the Japanese royal family. Influenced by artists such as Dante Gabriel Rossetti and Edward Coley Burne-Jones, Wang works in the tradition of the Pre-Raphaelites, creating paintings that are as sensitive as they are powerful. Wang finds the classic styles to be timeless, with a warmth and honesty not offered anymore with modern movements.

Wang's technical mastery, combined with his love of beauty, is clearly seen in these two works. In his untitled work he plays with space, creating a trompe l'oeil element. Wang's maulstick leans against the finished painting of a model, casting a convincing shadow. The model herself is made up of simple shapes of light and dark that hold together, undivided by the smaller areas of superbly rendered form. The small table in the foreground adds an additional sense of depth.

Double portraits have long been part of the artist's repertoire; this painting of the artist and his wife form part of that great tradition. The difficulty inherent in having more than one person's portrait on a single canvas is that they compete for attention, becoming rivals for the focal point. Artists in the past handled this many ways, including having only one of the sitters maintain eye contact with the viewer or placing one of the figures in a more dominant role. Here Wang creates tension by weighting both of his figures equally, allowing both to maintain eye contact with the viewer, and positioning both within the same foreground space. Perhaps this is a deliberate comment about the mutual respect and interdependence of these two figures, who seem somewhat separate from their urban surroundings. The random telephone poles and apartments invade the artist's life much as they do the picture plane of his image, as the artist with a Renaissance sensibility struggles to find his place in contemporary life.

FIGURE PAINTING

The Body Divine

"Men may have mean and meager faces; but man, in the ideal, is so noble and so sparkling, such a grand and glowing creature, that over any ignominious blemish in him all his fellows should run to throw their costliest robes." — HERMAN MELVILLE (from *Moby-Dick*)

The figure is the most powerful subject in art. Whether in literature, theater, or film, the figure dominates in its ability to convey layers of meaning pertinent to the human condition. The humble figure can simultaneously represent an individual and humanity as a whole, giving form to our wordless thoughts, binding us together in the solidarity of an experience shared in a universal language. Because human beings have not only an external physical component but also an internal emotional and spiritual life, the figure is able to communicate the deep truths about the human experience. If we agree with Tolstoy that the function of art is to communicate, nothing can so directly convey or mirror our existence.

The history of figurative art spans the eons, beginning roughly 30,000 years ago with paintings of hunters on the walls of a cave in France and continuing through such manifestations as ancient Egyptian sculptures, sixth-century Byzantine mosaics, nineteenth-century Japanese woodblock prints, and twentieth-century French Cubist paintings. Each culture creates art in its own image, a reflection of its own worldview. However, the best work is universal enough to also become timeless, conveying an artist's message many years after its creation. Because it is universal, the figure is frequently used to express the beliefs of both the artist and the culture as a whole. This versatility is why a seventeenth-century Dutch portrait, a nineteenth-century neoclassical figure painting, and a twentieth-century Impressionist work can each be completely unique despite being nearly identical in subject matter (the human form).

In the past, historical, religious, and mythological subjects represented a major part, if not the entire scope, of the figurative artist's repertoire. This is because every society throughout history has nurtured its past, encouraged its spirituality,

Opposite: William Bouguereau, *The Youth of Bacchus,* 1884, oil on canvas, 240 1/8 x 130 1/4 inches, private collection, courtesy of Art Renewal Center

Like Sandro Botticelli, Bouguereau loved the elegant contour of the closed form figure. Here he separated his nudes from their environment by a continuous outline. Notice the unity of the shapes and his use of local rather than Impressionist color.

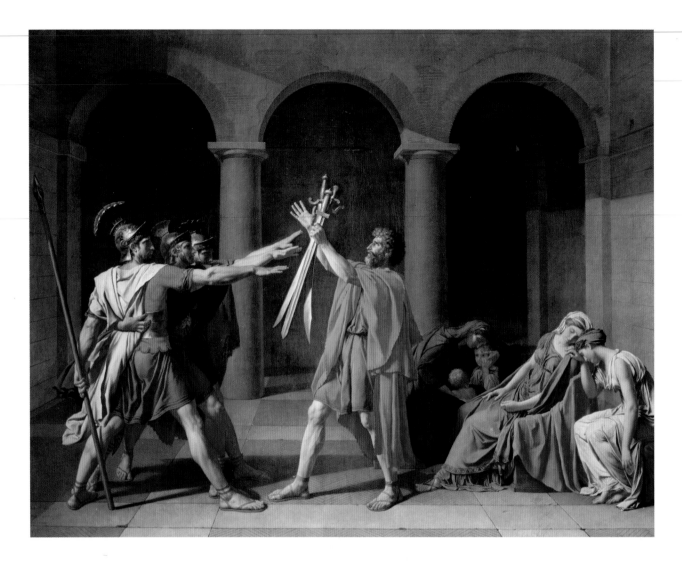

Jacques-Louis David, *Oath of the Horatii*, 1789, oil on canvas, 130 x 167 3/8 inches, Louvre, Paris, France, courtesy of Art Renewal Center

David used this painting to represent the hopes of the French people that the monarchy would soon end and would be replaced by a republic similar to the republic of pre-Imperial ancient Rome. This painting marked a turning point in the art of his day.

and recorded its legends. Civilizations were decorated and made legendary, powerful royalty extended their reach and immortalized their rule, and people were educated, indoctrinated, warned, and uplifted through the symbolic and literal use of the figure in art. The figure, in all forms of art, has been the principal means by which cultures have passed on these formative tales.

Here are a few notable examples: When Jacques-Louis David wanted a worthy subject to convey a new aesthetic, countering the lighthearted Rococo style popular in his time, he took a page from the history of ancient Rome. In *Oath of the Horatii,* the virtues of self-sacrifice, austerity, and morality were personified in the powerful charge by the father and the show of strength by his sons. This painting resonated with David's viewers as a call to action and courage. The biblical narratives of creation were commissioned to educate and inspire in the Sistine Chapel. *The Creation of Man* by Michelangelo is arguably one of the most famous images in the world and depicts the birth of humanity. Michelangelo elegantly portrayed the moment of awakening by showing God

sweeping down to touch Adam's outstretched hand. A mythological subject can be seen in Bernini's magnificent sculpture *Apollo and Daphne.* Daphne is shown turning into a laurel tree to escape the unwanted and relentless advances of Apollo. It can portray chastity's triumph over lust—on the base of the sculpture was later inscribed: "Those who love to pursue fleeting forms of pleasure, in the end find only leaves and bitter berries in their hands."

The genres of history, religious, and mythological painting are less relevant for today's figurative artist who has moved away from narrative work. However, one genre that has been prevalent throughout history may still interest the contemporary mind—symbolism. Symbolic, or allegorical, art is a work of fiction used to portray a truth. It is a mode of representation that allows the artist to transform paintings of commonplace images into stories with nuanced, powerful layers of meaning. These are concrete symbols that convey abstract truths and interpret everything from man's search for his destiny to what happens when we die. Universal themes such as love and loss, heroism and cowardice, hope and doubt, and good and evil have all paraded on the stage of the great artworks of the past. In painting, the omnipresent figure has served as the most versatile and pervasive allegorical subject, traveling myriad symbolic landscapes to portray the human circumstance—always changing and ever the same.

Martha Erlebacher, *Air: Childhood,* 2004, oil on canvas, 64 x 64 inches

This image is from Erlebacher's *The Cycle of Life* series, which represents youth to old age. Here, the outward-looking innocence of childhood is mirrored in the freedom and naturalism of the doves.

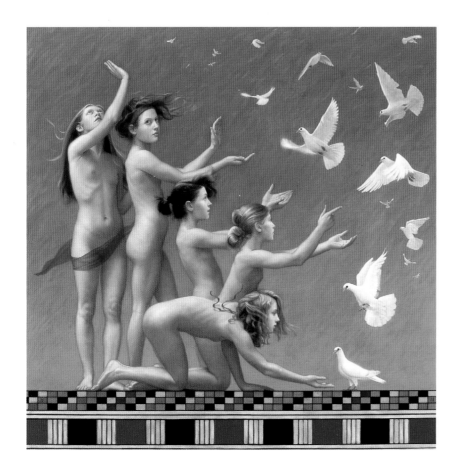

Right: Juliette Aristides, *Back to Back*, 2004, oil on panel, 29 1/2 x 25 1/2 inches

The two figures are united by a repeating diagonal that runs along the back of the neck of the figure on the left and along the arm of the figure on the right.

Opposite: Jacob Collins, *Vincent*, 1998, oil on canvas, 24 x 20 inches, private collection, courtesy of the John Pence Gallery

The transparency of the background exposes the warmth of the *imprimatura*. Notice the unity of the shadows compared with the beautiful extended description of the turning form up into the highlights.

Some artists adamantly reject the idea that their works use symbolism to convey complex meaning. Author J. R. R. Tolkien renounced the idea that *The Lord of the Rings* was allegorical, believing that good art functions as life itself, allowing readers to read layers of meaning of their own choosing. Tolkien memorably said, "I much prefer history, true or feigned, with its varied applicability to the thought and experience of readers. I think that many confuse 'applicability' with 'allegory'; but the one resides in the freedom of the reader, and the other in the purposed domination of the author." However, to one prone to seeing allegory, *The Lord of the Rings* can be interpreted as a veiled rendition of life during World War II, which Tolkien lived through, or more broadly as an expression of his Catholicism as the cosmic struggle between good and evil. Other artists fully and openly embrace allegory. In C. S. Lewis's *Chronicles of Narnia* series, for example, the lion Aslan represents God, and the stories are meant to portray a life of faith and the act of redemption. Whether a work purports to be intentionally allegorical or simply tells a story, all good work that uses human (or humanized) figures will resonate with people's experience and thus become opportunities to see our story writ large.

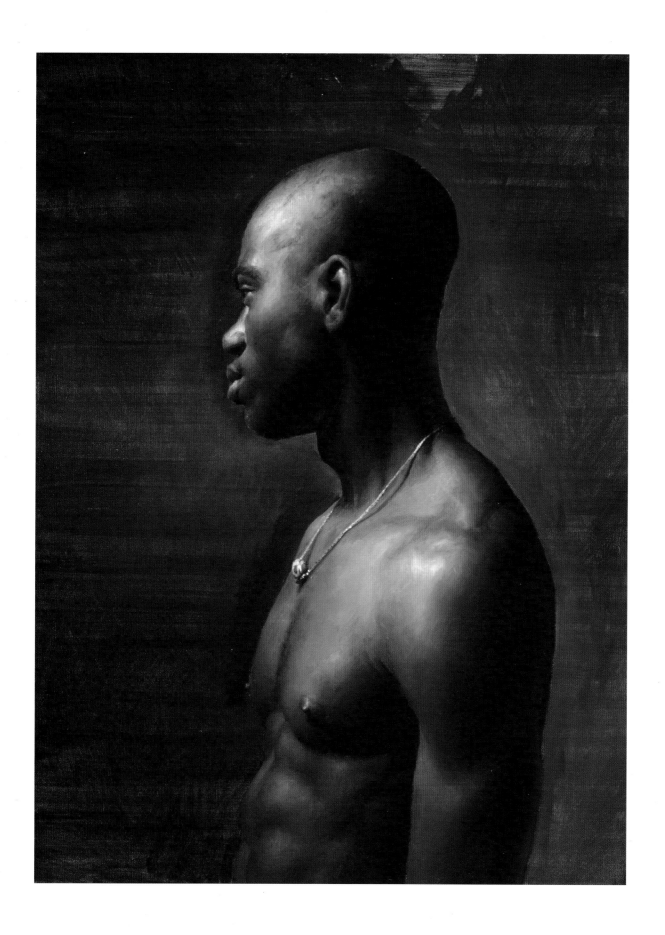

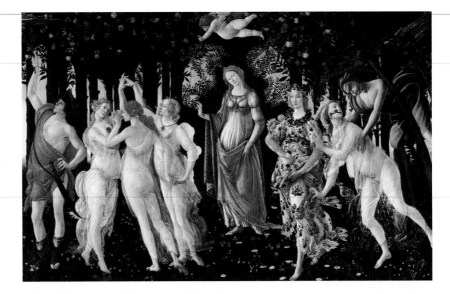

Right: Sandro Botticelli, *Allegory of Spring*, 1477–1478, oil on panel, 80 5/8 x 124 inches, Uffizi, Florence, Italy, courtesy of Art Renewal Center

Botticelli, rediscovered and made famous by the Pre-Raphaelites, used Greek mythology to portray themes relevant to the human condition.

Opposite: Gustave Courbet, *The Source* (also called *Bather at the Source*), 1868, oil on canvas, 50 3/8 x 38 1/8 inches, Musée d'Orsay, Paris, France

Courbet coined the term "Realism" and used it to describe his own work, which he desired to base entirely on nature rather than relying on artistic convention.

Photo Credit: Scala / Art Resource, New York, New York

Below: Gabrielle Bakker, *Drama*, 1999, 24 x 21 inches, oil on panel

Bakker employs her fascination with classical mythology to convey her love of ideal beauty and simplified form. The Roman goddess of the hunt, Diana, is shown here with her bow. Bakker does most of her work from studies and her imagination.

Many different allegorical subjects have incorporated the figure. In the Renaissance the four seasons sometimes took to forms of mythological figures. Sandro Botticelli's *Allegory of Spring* is a famous example. The five senses—sight, hearing, taste, smell, and touch—have likewise often been represented by women involved in activities that conjure up associations with the particular sense, such as looking at paintings (sight) or being in a room of musical instruments (hearing). An example is Jan Breugel's *Allegories of the Five Senses*. Similarly, vices and virtues feature prominently in allegory. Pride, for instance, has been shown as an overly confident rider falling from his horse, while humility, a woman with downward-gazing eyes, steps on a crown with her bare foot; wrath angrily attacks a monk with his dagger, while innocence washes her hands in a vessel of pure water. Many other subjects, including fortune, opportunity, and destiny to name just a few, can all be represented allegorically, with the figure being paired with symbolism that is meant to provide a framework, moral guidance, and warning to aid our journey through life.

Nothing is more uplifting than looking at a brilliant figure painting; likewise, nothing is as uninspiring as encountering one done poorly. In the following pages we will examine some of the many monuments of figure painting produced by historical and contemporary master artists. As we have done with the preceding two chapters, we will examine the formal qualities of each piece, heightening our awareness of how they relate to the principles outlined in this book. Although we are doing a technical analysis, each painting also has emotional content to explore. Because these issues are more speculative, I have left them for you to discover on your own, at your leisure. In other words, rather than delve into meaning, we will focus on the way that meaning is achieved. Gleaning insights into the genius of each work can both increase your pleasure when looking at other great works of art as well as enhance your ability to infuse portions of that greatness into your own work.

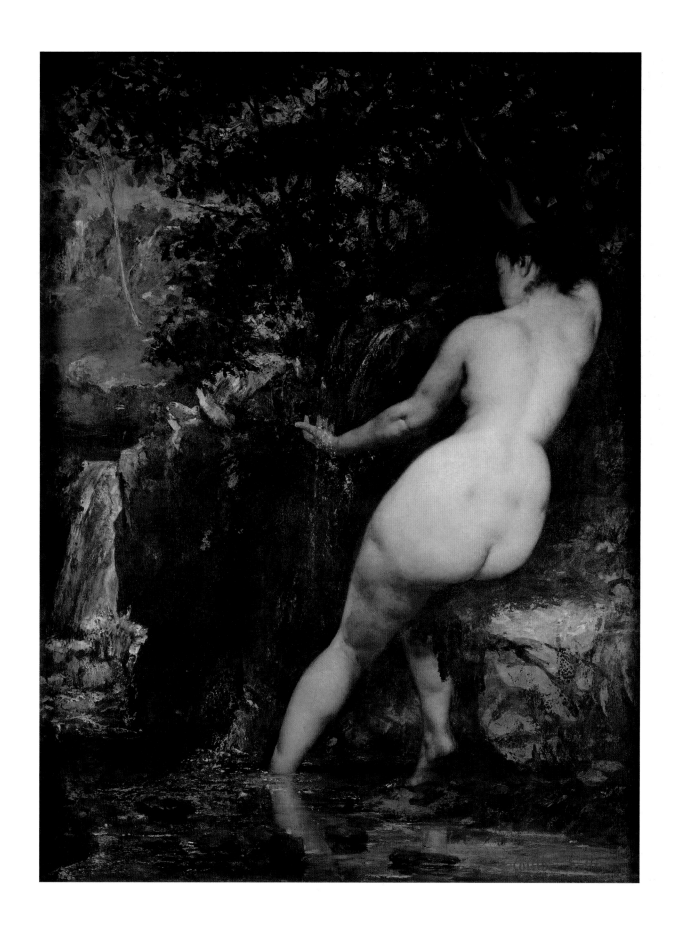

Titian (Tiziano Vecellio)

(Italian, circa 1488–1576)

Above: Titian, *Flora*, circa 1520, oil on canvas, 31 3/8 x 25 inches, Uffizi, Florence, Italy

This era featured a turning point in art; for the first time color and light were used as unifying elements. This image was based at least partially on direct observation of nature.

Photo Credit: Alinari / Art Resource, New York, New York

Opposite: Titian, *Entombment of Christ*, circa 1520, oil on canvas, 58 1/4 x 83 1/2 inches, Louvre, Paris, France

To fully appreciate Titian's innovation, compare this image with Raphel's *The Deposition* on page 32, from which this painting is derived. Titian embraced atmosphere rather than clarity of form and a continuous contour, and nuanced shifts of hue rather than symbolic color.

Photo Credit: Erich Lessing / Art Resource, New York, New York

Titian is undisputedly one of the greatest masters of the late Italian Renaissance. He studied under three other masters, Gentile and Giovanni Bellini and Giorgione, and built on the skills he learned from them to become the most influential painter to come out of the Venetian School. One of Titian's most significant contributions was his style of brushwork. He broke from the Flemish tradition of meticulously painting every minute detail, instead using bold strokes and dots of color to create illusions that captured reality on a grand scale. His techniques revolutionized painting in the sixteenth century, and Titian became the official painter of the Venetian Republic in 1516.

His *Entombment of Christ* is a relatively early work. In this composition Titian placed his figures in an isosceles triangle with mathematical precision. The two diagonals that define the left and right edges of the triangle emanate from the lower corners of the rectangle and intersect at the halfway point at the top of the canvas. The central figure is locked firmly into the vertical centerline. The curving shapes of the backs of standing figures and the central figures lock the entire grouping into a dynamic and unified dome. This emphasizes Titian's use of harmonious proportions and draws the eye of the viewer into the action taking place.

Titian executed his early paintings in the style of his teachers, but as he matured he embraced a naturalism that had been previously unknown in art. In *Flora*, he combined gracefulness and freedom—both in her gesture and in the technique with which he painted her. Titian's liberty of execution and emphasis on art's emotive qualities influenced artists as diverse as Diego Velázquez, Peter Paul Rubens, and Anthony Van Dyck.

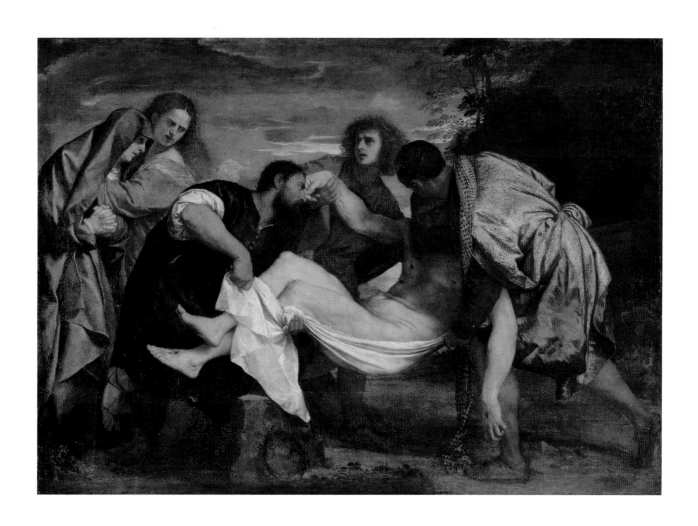

Caravaggio
(Michelangelo Merisi)
(Italian, 1573–1610)

Above: Caravaggio, *Saint John the Baptist*, 1597–1598, oil on canvas, 52 x 38 ⅛ inches, Capitoline Picture Gallery, Capitoline Museums, Rome, Italy

Caravaggio created a playful and almost shockingly sensual figure to represent Saint John the Baptist in this early painting.

Photo Credit: Scala / Art Resource, New York, New York

Opposite: Caravaggio, *Christ at the Column*, circa 1607, oil on canvas, 52 ⅞ x 69 inches, Musée des Beaux-Arts, Rouen, France, courtesy of Art Renewal Center

This image features dramatic chiaroscuro, typical of Caravaggio's later religious paintings; the light source signified a holy and divine light while the other figures are cast in the shadow of the unredeemed.

Caravaggio is known almost as well for his turbulent personal life as for his revolutionary and influential Baroque style of painting. He began his successful career in Rome; however, he frequently found himself in trouble for his untoward behavior. In 1606, he was forced to flee the city after stabbing a man to death. He continued painting, moving frequently to areas in the south of Italy as well as to neighboring islands. In 1610, he returned to Rome after Pope Paul V pardoned him, but he was arrested in a case of mistaken identity. He became ill while in jail after two days; his conditioned worsened and he died a few days later.

Caravaggio diverged from the approaches taken by artists during the Renaissance, breaking new ground with his naturalistic representation of the human figure. He pushed his use of chiaroscuro further than any artist had before him, creating intense drama by using stage lighting, often against a black or flat background, setting his figures set into high, but not atmospheric, relief. His use of value was later called *tenebrism*, which was a bunching up of a few lights in a highly dramatic way.

Christ at the Column is typical of the style for which Caravaggio became famous. Much of the image is in darkness, while a bright light seems to emanate from Christ. Caravaggio keeps his shadows simple and flat while modeling all small forms found in the turning halftones, keeping the viewer's eyes firmly locked into the halftone and light areas of the form. The composition is simplified and almost no background is used, which helps the viewer better contemplate the figures and events. Caravaggio used street ruffians as models for his figures. This flew in the face of the Renaissance ideal of beauty but lent a sense of authenticity of an observed reality to the work. Similarly, *Saint John the Baptist* is less noteworthy for its religious sentiment than for its animated gesture. Caravaggio created a serpentine pose for the figure by the spiraling planes of his body; the saint looks toward us while his torso turns away and his lower body slightly tips back toward us again. The vigorous gesture, lighthearted expression, and strongly punctuated lights and darks create a dynamic image that keeps our eyes continuously moving.

Jusepe de Ribera

(Spanish, 1591–1652)

Above: Jusepe de Ribera, *Saint Jerome and the Angel of Judgement*, 1626, oil on canvas, 103 ¹/₈ x 64¹/₂ inches, Museo Nazionale di Capodimonte, Naples, Italy

Saint Jerome is identified by the cardinal's red cloak and the Bible he is translating.

Photo Credit: Scala / Art Resource, New York, New York

Opposite: Jusepe de Ribera, *Drunken Silenus*, 1628, oil on canvas, 72⁷/₈ x 90¹/₈ inches, Museo Nazionale di Capodimonte, Naples, Italy

Unlike regal Bacchus, who is also known for his love of wine, Silenus is often loathed and used as an allegory for gluttony.

Photo Credit: Scala / Art Resource, New York, New York

The records of Ribera's life mirror his painting. Some elements, such as his artistic training, remain obscured by shadow, while other parts, such as his purchase of house locks, are minutely recorded. Ribera was a Spanish painter who moved to Rome, where he studied the buildings, sculptures, and frescos of antiquity, and where he also received the nickname "Lo Spagnoletto," or Little Spaniard. Later he moved to Naples (which was then under Spanish rule), supposedly to escape his creditors; where he finished out his career, becoming one of the top painters of the seventeenth century.

Ribera closely observed nature, taking Caravaggio's *tenebrism* techniques a step further. He became well known for portraying figures in an extremely naturalistic style, focusing on details unique to a living (rather than an imaginary or idealized) individual. *Drunken Silenus* was one of Ribera's first signed and dated works and is characteristic of his early style. In this painting, his nuanced observations from life combine with dramatic compositions to form a psychologically compelling image. The principal figure, Silenus, follows the diagonal of the rectangle. The canvas divides in half vertically directly where the hands of the wine bearer meet the cup and arm of the central figure. The diagonal created by connecting the vertical halfway mark to the lower right-hand corner defines Silenus's gazing direction and locks in the central angle of the cupbearer. Ribera consistently intertwines his figures with the geometry of the rectangle, making him a rewarding artist to study in the art of composition.

Saint Jerome and the Angel of Judgement is a subject Ribera painted multiple times in his career. An energetic composition based on multiple diagonals, the image is full of emotion and life and replete with symbolic and narrative elements. The skull on the book warns of the vanity of life; aspects of the saint's aesthetic lifestyle are revealed in his frail body and rocky habitation. A lion, whom Saint Jerome purportedly befriended by removing a thorn from his paw, peeks in on the left side of the canvas. The angel interrupts Saint Jerome's work of translating the Hebrew scriptures into Latin.

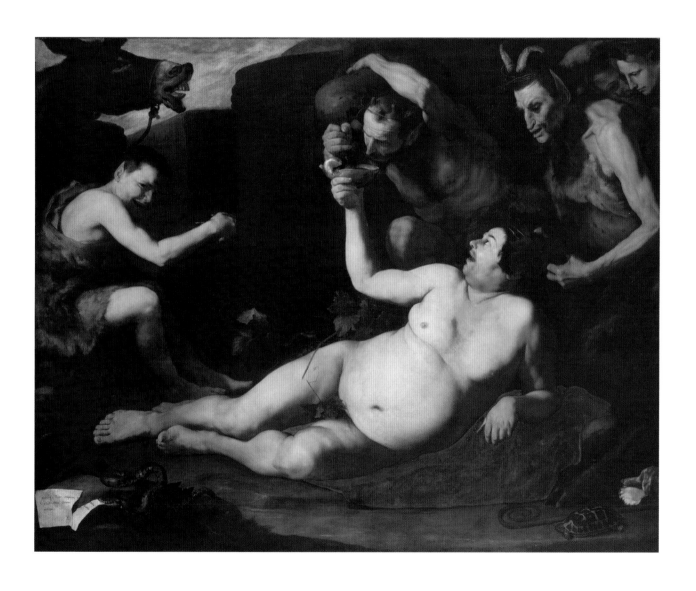

Jean-François Millet

(French, 1814–1875)

Above: Jean-François Millet, *The Angelus*, 1857, oil on canvas, 21⁷/₈ x 26 inches, Musée d'Orsay, Paris, France

This image became the most reproduced and influential of Millet's paintings. The farming community, with its deep roots in the land and self-sufficiency, seemed to offer a noble alternative to contemporary life.

Photo Credit: Erich Lessing / Art Resource, New York, New York

Opposite: Jean-François Millet, *The Gleaners*, 1885, oil on canvas, 33 x 43 ³/₄ inches, Musée d'Orsay, Paris, France, courtesy of Art Renewal Center

The elevation of Millet's stature corresponded with the rise in interest during the late nineteenth century in traditional rural life. The writings of Leo Tolstoy helped fuel this movement, which sought to find a cure for societal ills through the simplicity of peasant life.

Millet grew up in a poor farming family on the coast of Normandy. Despite his humble origins, he was educated in art and literature and decided to move to Paris in 1835 to further his studies in art. He was educated for five years at the École des Beaux-Arts, training in the studio of Paul Delaroche. After being rejected for the Prix de Rome he left the atelier and studied independently, supporting himself by selling copies of Rococo paintings until he permanently settled in the Barbizon area of France. Millet was renowned in his lifetime and was one of the first major painters to focus on peasants. Peasant life had been depicted since the Renaissance, but these images portrayed a comedic or rowdy bunch of characters or an overly romanticized view of their lifestyle. Millet's images, by comparison, were relatively straightforward depictions of country life.

The Gleaners, which was exhibited in the Salon of 1857, broke new ground, depicting the lowest type of peasants, those who gathered the scraps of hay after the harvest has taken place. The women are hunched over, their lives so connected with the earth that none of their heads are placed above the horizon. However, they are shown in a warm, glowing light and are set apart from the neutral background by their outfits, which are muted primary colors. The proportions and placement of the figures in this well-thought-through composition lend a sobriety, quiet grace, and dignity to his subject.

The Angelus was commissioned by a friend of William Morris Hunt, who was a disciple of Millet. The painting features two figures, who are silhouetted by the fading light at the close of the day. The sincerity of their faith is reflected in the solemnity of the painting. This work contains many parallel elements: The arc of the figures echoes in the clouds, the hoe mirrors the angle of the woman, the wheelbarrow repeats the horizon of the earth and the shadows on the ground.

William Bouguereau

(French, 1825–1905)

Above: William Bouguereau, *The First Mourning*, 1888, oil on canvas, 79 7/8 x 99 1/8 inches, Museo Nacional de Bellas Artes, Buenos Aires, Argentina, courtesy of Art Renewal Center

This painting was created after the death of the artist's son. Bouguereau used the theme of the death of Abel, configured as a Pietà, as a vehicle through which to convey his great loss.

Opposite: William Bouguereau, *Pietà*, 1876, oil on canvas, 90 1/2 x 58 1/4 inches, private collection, courtesy of Art Renewal Center

This formal composition elevated the loss of a grieving mother into an iconic religious image. The halos offer a glimpse of hope, suggesting the resurrection yet to come.

William Bouguereau, academician and painter of legendary ability, was a student of François-Edouard Picot at the École des Beaux-Arts in Paris, winning the Prix de Rome in 1850. Bouguereau was a methodical and prolific painter, producing more than 700 works during his lifetime. He became famous for his exquisite technical command, the beauty of his subjects, and the sophistication of his compositions. He was considered the greatest, and certainly the most popular, artist of his day. He trained many students, and it is noteworthy that he was the first artist to open the French academies to women.

Bouguereau's working procedure followed the common practices of the day. He began each painting with quick drawings and oil sketches. He next carefully finished drawings from life for all figures as well as additional studies for surrounding elements. He transferred his drawing to a canvas with a light gray ground, inked over the drawing, and then sealed it with a varnish (as did early Flemish artists), so as not to lose his hard work in subsequent paint layers. He would then block-in the underpainting in color, allow it to dry, and scrape it down before applying the final coat of paint.

This *Pietà* shows a stoic Mary shrouded in darkness, her clothes dissolving into blackness around her as she stares unflinchingly at the viewer. The darkest part of the picture projects the lightest part of the picture, with the milky skin of the dead body pushing forward toward the picture plane. The arch of mourning angels is made into a complete circle by the arm and thighs of the body of Jesus, framing the central faces. This painting is an essay in contrast; the two-dimensional shapes of the halos and black background set against the three-dimensional modeling of form; the restrained, expressionless Mary juxtaposed with the overt grief of the angels.

The First Mourning presents an exquisitely accurate and nuanced contour line, a thread that runs through all of Bouguereau's work. This line is balanced by areas that feature softly turning forms and delicate coloring. As in most of his work, the modeling is kept in check by the contour; notice how your eye goes to the contour rather than the light forms on the chest and arm of Abel.

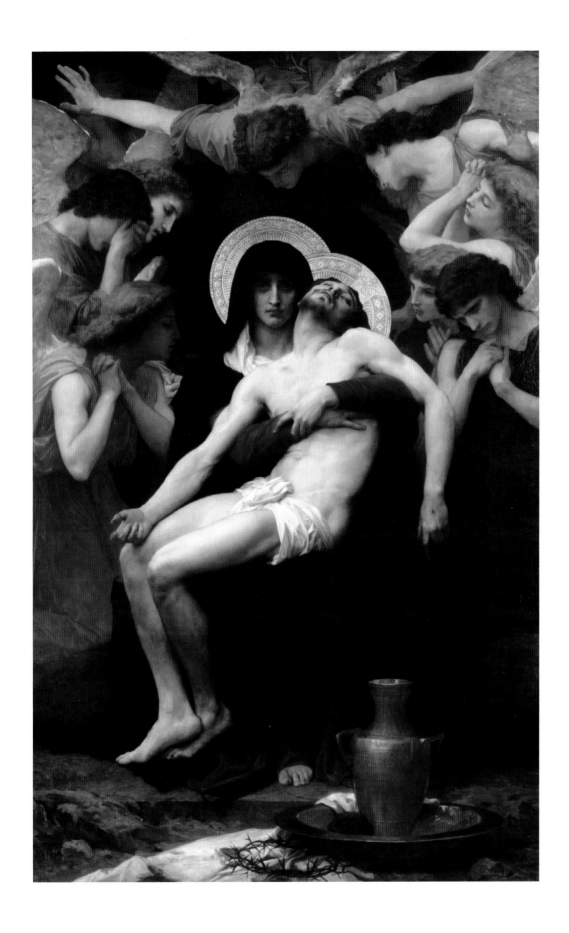

Léon Bonnat

(French, 1833–1922)

Above: Léon Bonnat, *The Crucifixion,* 1874, oil on canvas, Musée du Petit Palais, Paris, France

This painting, commissioned for a courthouse, was controversial in its day because it showed Christ's suffering. Normally images of this nature were designed to bring comfort, not fear.

Photo Credit: Réunion des Musées Nationaux / Art Resource, New York, New York

Opposite: Léon Bonnat, *Job,* 1880, oil on canvas, 63 3/8 x 50 3/4 inches, Musée Bonnat, Bayonne, France

Bonnat was influenced by artists such as Jusepe de Ribera. His use of tenebrism, a heightened sense of realism, and tortured figures are all reminiscent of the Spanish masters.

Photo Credit: Réunion des Musées Nationaux / Art Resource, New York, New York

Léon Bonnat was a successful portrait painter and teacher who used his money to create an impressive personal collection of old master paintings and drawings, which is now held in the Musée Bonnat in Bayonne, France, where the artist was born. Bonnat was raised in nearby Spain and was strongly influenced by Spanish painters such as Diego Velázquez and Jusepe de Ribera, particularly in his use of extreme naturalism and varied and expressive brushwork. Bonnat had an extensive academic training, both in Madrid and in Paris, which he capped off by three years of copying High Renaissance masterworks in Rome. In addition to painting and collecting art, Bonnat taught many aspiring artists, including Edwin Blashfield, Henri de Toulouse-Lautrec, and Georges Braque.

Bonnat thought that all of the great movements in art sprang directly from observed nature. One of his portrait clients said that he attended eighty sittings for Bonnat to capture his likeness. This faithfulness to nature is evident in *Job* and *The Crucifixion.* Both images are carefully observed and capture the excruciating sets of circumstances these religious figures endured. At first glance, these images can appear so realistic that one can easily miss the artfulness of their construction and overlook the simplicity of the forms.

In *Job,* the light planes in the head and beard form a right-angled mask of highly schematic shapes. The lights and shadows of the figure are greatly simplified and set in relief against the energetic brushstrokes of the background. The light falls equally from the top of the head to the tip of the toes. This could easily make the painting appear flat, yet the strength of the large shapes is broken up by beautiful, nuanced areas of turning form, such as are found in the veins and folds of flesh, forming a striking balance of breadth and specificity.

The Crucifixion reveals Bonnat's deep love for observed form and dramatic chiaroscuro. A few of his students bribed a guard to see Bonnat's studio set up when he was starting this painting. They opened the door and discovered that he had a cadaver nailed to a cross, which he was using as reference for this work. Fidelity to nature, breadth of vision in value, lively paint handling, and subordination of details to the general effect are all key characteristics of Bonnat's work.

Abott Handerson Thayer

(American, 1849–1921)

Above: Abott Handerson Thayer, *Angel*, 1887, oil on canvas, 36 ¼ x 28 ⅛ inches, Smithsonian American Art Museum, courtesy of Art Renewal Center

Thayer posed his twelve-year old daughter as an angel for this image. Her dark hair is the principal value accent, drawing our eyes firmly to her sincere and unaffected gaze.

Opposite: Abott Handerson Thayer, *The Virgin Enthroned*, 1891, oil on canvas, 72 ⅝ x 52 ½ inches, Smithsonian American Art Museum, Washington, D.C.

This composition has the formal symmetry of a Raphael Madonna. This is balanced by Thayer's passionate brushwork and fluid drapery.

Photo Credit: Smithsonian American Art Museum, Washington, D.C. / Art Resource, New York, New York

Abbott Handerson Thayer was a student at the National Academy of Design in New York and the École des Beaux-Arts in Paris, where he studied with Henri Lehmann and Jean-Léon Gérôme. After Thayer returned from Paris in 1879, he began painting ethereal women and children and writing about natural history. Thayer was an amateur naturalist, a passionate bird lover, and the father of military camouflage. His professional training in design, value, and color, combined with his precise observation of nature, gave him excellent command of combining figures in imagined spaces.

Thayer's children, Gerald, Mary, and Gladys, posed for *The Virgin Enthroned*. The calm mood exuded by the portrait stands in stark contrast to their personal life; Thayer's wife was sick and died within this same year. During those months, Thayer immersed himself in his painting. After the death of his wife, Thayer was left the single father of three children. He later remarried and had an eccentric lifestyle, living and teaching in the country in an artists' colony owned by a direct descendant of the colonial portraitist John Singleton Copley.

The Virgin Enthroned harkens back to a Raphael Madonna, with its simplification of the light shapes into masses as well as its strong formal composition. There is very little modeling of volumes; instead, the painting relies on a posterization of the big shapes. Thayer painted quite thinly and broadly; parts of the ground of the canvas are still visible in such places as the little girl's hair on the right. Notice the treatment of her leg, which is simplified into a two-dimensional shape, and the vigorous brushstrokes in his treatment of the clothing. The expressiveness of the paint handling is offset by the perfectly balanced ceremonial composition and the strict hierarchy of value. Because the values of the shapes are so simply organized, the detail on the Virgin's face draws our attention. The figure on the left is a clear secondary form and the figure on the right a tertiary element.

In *Angel*, Thayer employed a loose treatment of the forms of the wings and arms toward the edge of the canvas to help focus the viewer's attention to the face of the girl. This is a good example of a high-key painting, in which the focal point is a dark element set up against a light ground.

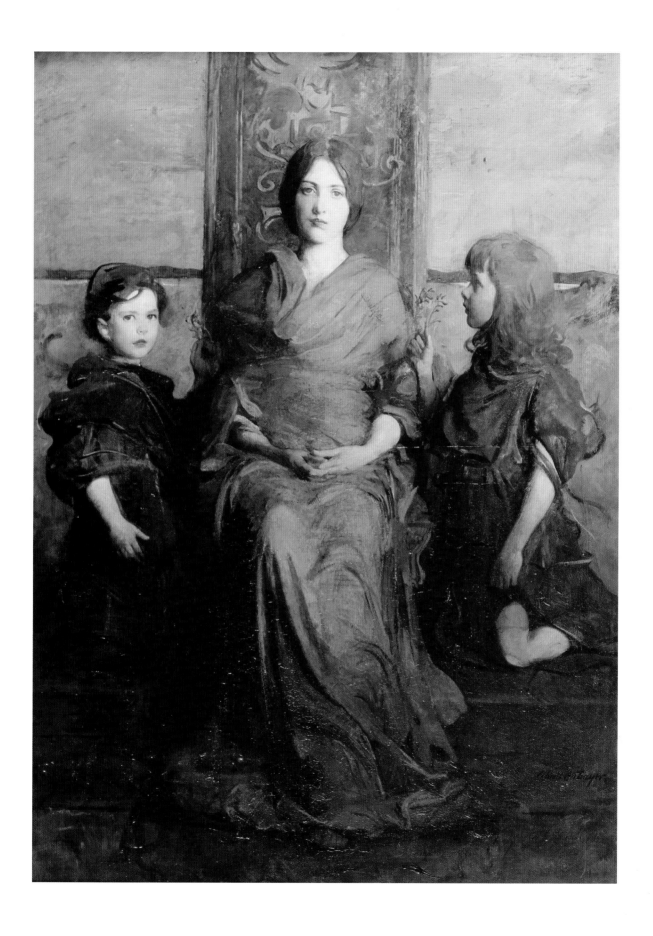

Andrew Wyeth

(American, born 1917)

Andrew Wyeth is a quintessentially American painter who has created some of the most recognizable and beloved paintings in our culture. His paintings are a rich tapestry, reflecting the land on which he has lived most of his life, his family, and his neighbors. His father, N. C. Wyeth, was a larger-than-life figure, one of the most accomplished illustrators of his time, and a role model of how to integrate art and life. N.C. was taught by the brilliant illustrator Howard Pyle, who emphasized painting from one's personal experience and the necessity to create a uniquely American art form. This legacy of great artists continues with Andrew's son Jamie, whose painting of his father can be seen on page 68.

Andrew Wyeth started serious art training in his father's studio as a teenager, working from the plaster cast, model, still life, and landscape. His education was focused intently on drawing, memory training, and the importance of complete identification with his subject. The deep belief that people can only paint what they know so intimately and thoroughly that they could reproduce the object from imagination forms an undercurrent of Wyeth's work.

Wyeth's working procedure is integral to the paintings themselves. His preliminary work includes myriad variations of an idea in pencil, watercolor, and ink—first done from memory and then, as the idea moves further along, from life. Wyeth constantly distills his ideas, determining what is critical to the work's success and what is superfluous to the work's character.

This painting, titled *Barracoon,* is emblematic of what makes Wyeth's work so striking. It has a simple and commanding series of abstract shapes that are perfectly placed. He combines this broad compositional underpinning with continual shifts of warm and cool, light and dark, with careful modulations of light and color observed from life. In this painting Wyeth continually repeated the long horizontal—in the ceiling, the bed, and the contours and spine of the figure—which gives the feeling of complete rest or resignation. The gentle sweeping arch of the figure against the sheets and the continual juxtaposition of value and hue make this a meditative work. Wyeth's subjects feel etched in memory as much as on the canvas itself.

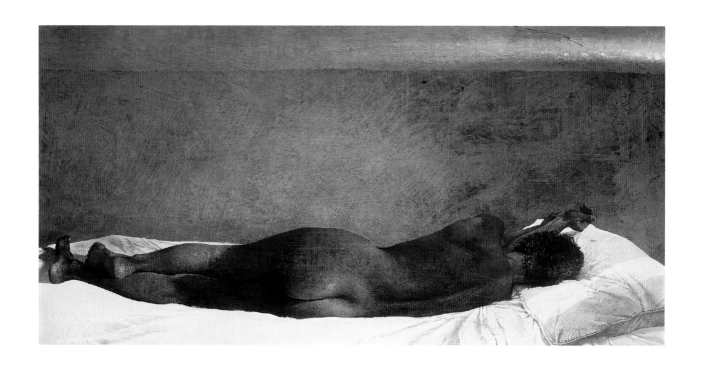

Nelson Shanks

(American, born 1937)

Above: Nelson Shanks, *Pigtails,* 2004, oil on canvas, 20 x 28 inches, collection of Mr. and Mrs. Larry Hall

Shanks makes his paintings by direct observation of life. Here he creates a portrait of sorts by finding all the idiosyncrasies of form on this woman's back. The slight gesture and color convey the optimism of youth.

Opposite: Nelson Shanks, *Flora,* 1994, oil on canvas, 34 3/8 x 18 1/4 inches, collection of Meg Goodman

Shanks uses direct working methods to achieve correct drawing, value, and color within each brushstroke. He masses in his painting with no preparatory drawing and works directly with a full palette on a light gray ground, building his forms from general to specific.

Nelson Shanks studied at the Kansas City Art Institute, at the National Academy of Design, and at the Art Students League of New York with Edwin Dickinson, among others. In Italy he followed in the footsteps of Pietro Annigoni, studying at the Accademia di Belle Arti in Florence and then with Annigoni himself. He has traveled and studied extensively throughout Europe. Privately he studied with John Koch and Henry Hensche. Shanks is acclaimed as a portrait painter, and his sitters have included Pope John Paul II; Diana, Princess of Wales; Ronald Reagan; and Bill Clinton.

Nelson Shanks is a contemporary master who uses direct painting methods to portray his unique insights into the world. Shanks focuses on capturing the drawing, composition, and value considerations all at once in shapes of color on a lightly toned gray canvas. Years of training, study of masterworks, and continual practice have trained his eye and hand so well that he thinks in color. He paints, working the whole composition as long as he can, until the whole image—from the carefully modeled form to the nuanced edges—is resolved to an equal degree of finish. Shanks considers color paramount and looks for continual shifts in hue, temperature, and chroma to express changes in the surface of the form. His palette consists of intense, pure hues, which he mixes in degrees of neutrality according to his purposes.

In these two paintings—*Pigtails* and *Flora*—Shank's technical command of paint and his love of color are clearly visible. In both paintings he has combined intense color with the full range of chiaroscuro. *Flora* is intertwined with the background through large areas of shadow; her form melds into the darkness behind her, while the light shapes gradually emerge, revealed by a warm light. By contrast, *Pigtails* is an example of closed form, as the figure stands out in its entirety against the background. The composition undulates from a dark corner on the left to the light of the figure, the dark of her shadow side to the light of the background on the right.

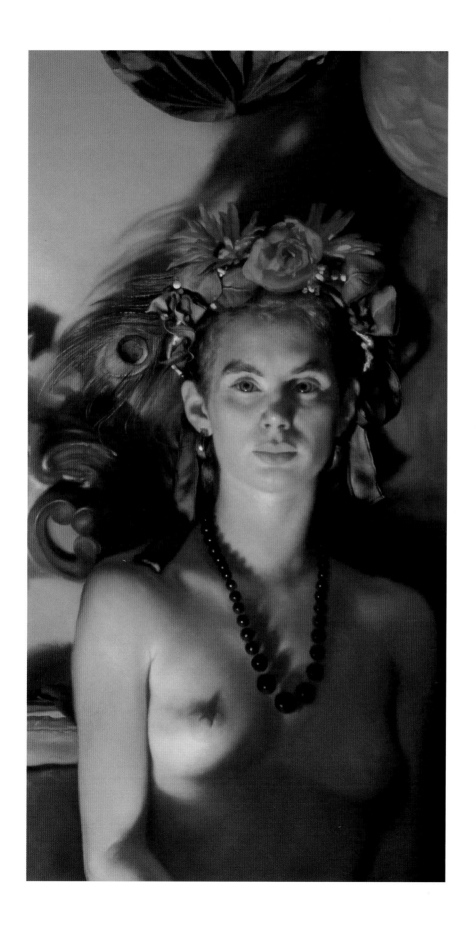

Odd Nerdrum

(Norwegian, born 1944)

Opposite: Odd Nerdrum, *Drifting*, 2006, oil on canvas, 80 ⅛ x 111 ⅞ inches, courtesy of Forum Gallery

Legendary for his energy, diligent working habits, and meticulous technique, Nerdrum produces a few monumental paintings each year. Nerdrum is a dynamic painter, achieving his varied paint surfaces by scraping, sanding, glazing, painting, and repainting the work until it achieves his desired end.

Odd Nerdrum's career as an artist has been as controversial as it has been brilliant. He works in an age of nonrepresentational art, yet many of his paintings have a strong sense of chiaroscuro and the feel of a Rembrandt. He attended the Oslo Academy of Art for two years but afterward was largely self-taught by studying works of the old masters in museums and consulting conservation experts on choice of grounds, oils, and varnishes. Nerdrum is principally known for his monumental figure works. His mythic subject matter and brilliant execution have made him one of the greatest painters of our time.

The ambiguous space and lighting in *Drifting* are very different from his earlier work, an example of which can be seen on page 20. This image is interesting on many levels— from the psychologically compelling aspect of it subject matter to the elliptical nature of the composition.

The figures in *Drifting* are suspended together in darkness yet are essentially alone, almost in a devolved fetal state. Nerdrum's use of chiaroscuro is dramatic, and he contrasts large areas of effectively blank space with beautifully realized volumetric form. Nerdrum allows much of the work to dissolve into obscurity, as open form meshes the figures into the environment. The origins of the light sources for this painting are difficult to determine—one of them seems to emanate from between the two figures. The low-key value that permeates the image is the perfect vehicle to convey feelings of mystery and melancholy. The cool spectral light that hits the woman's torso and the man's feet contrasts with the warm spotlight directed at their pelvises, projecting and recessing their bodies in space. The power of Nerdrum's vision allows us to look past technique and experience the emotional impact of his image.

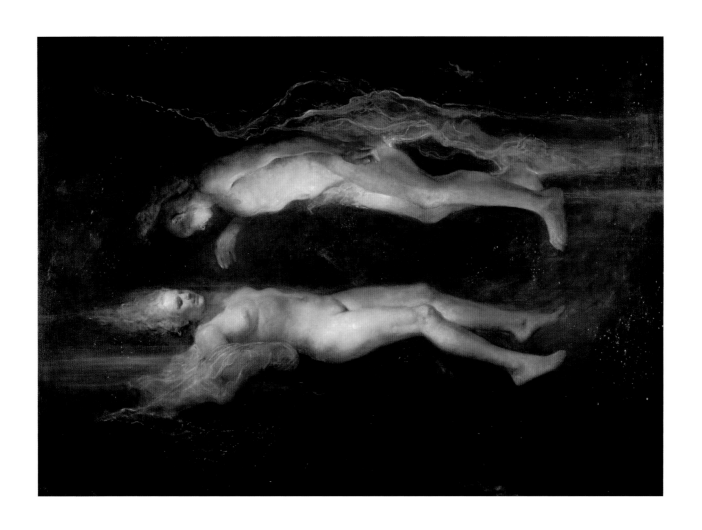

Bo Bartlett

(American, born 1955)

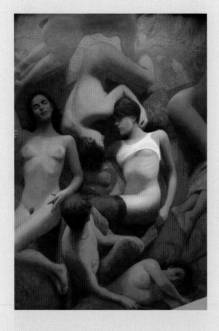

Above: Bo Bartlett, *Samsara*, 2006, oil on linen, 81 x 56 inches

Bartlett essentially paints in grisaille for the initial layers of his work, using a limited palette of warm and cool colors and saving his principal color notes for subsequent paint layers.

Opposite: Bo Bartlett, *Civil War*, 1994, oil on linen, 134 x 204 inches

The technical emphasis of this painting is on composition, balanced tonality, and subtle temperature shifts.

During his formative years Bo Bartlett studied with a number of significant painters, including Ben Long IV, Aaron Shikler, and Harvey Dinnerstein. In 1975 he moved to Philadelphia so he could attend the University of the Arts and the Pennsylvania Academy of the Fine Arts, the bastion of American realist painting, where he studied under Ben Kamihira, Morris Blackburn, and Sidney Goodman. He also apprenticed under Nelson Shanks. In the tradition of Thomas Eakins, Bartlett studied anatomy at the Philadelphia College of Osteopathic Medicine and Thomas Jefferson University. In 1986, he obtained a certificate in filmmaking from New York University.

Bartlett looks at America's heart—its land and its people—and describes the beauty he finds in everyday life. His paintings celebrate the underlying epic nature of the commonplace and the personal significance of the extraordinary. He pushes the boundaries of the realist tradition with his multilayered imagery. Life, death, passage, memory, and confrontation coexist easily in his world.

The two paintings shown here display his love of tonality and his thoughtful, diverse compositions. *Civil War* presents an iconic American subject underlined with subtle, open-ended questions. The central characters form a pietà of sorts. The juxtaposition of light and dark shapes rivets our attention on the theme and the primary focal point. The formal composition is balanced between the strong anchor in the center, the stake and the tree across the middle horizontal line, and the strong diagonal that connects the front left-hand figure to the figures in the upper right. In *Samsara*, the composition is less formal, featuring a strong arabesque. The serpentine lines of the figures keep our eye continually moving through this painting. The light shape of the tank top prevents uniformity and creates visual hierarchy.

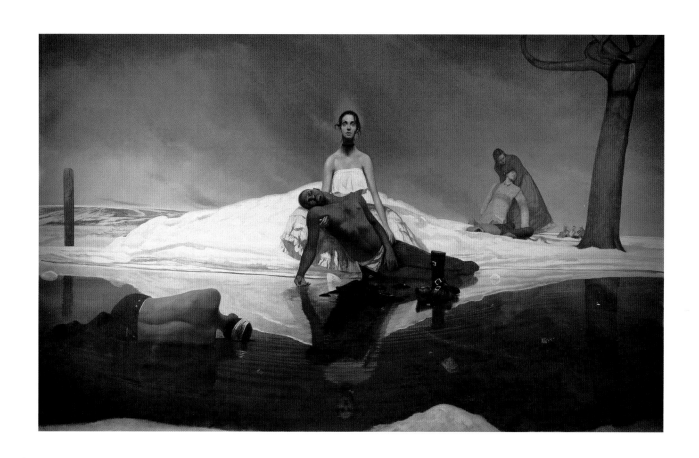

APPENDIX

Here are a few palettes used by some of the contemporary artists featured in this book. Each palette is different, yet each gives outstanding results. Artists often change their palettes over the course of their careers or augment them depending on the subject they are painting, particularly when they are working on still-life paintings or landscapes. These colors are not listed in the order that the artists place them on the palette.

Steven Assael
titanium white
brilliant yellow light
Naples yellow light
cadmium yellow light
cadmium orange
cadmium red light
yellow ocher
transparent golden ocher
burnt sienna
brown pink
burnt umber
transparent oxide red
alizarin crimson
ultramarine blue
Prussian blue
cadmium green light
viridian green
ivory black

Bo Bartlett
flake white
titanium white
yellow ocher
raw sienna
cadmium yellow
cadmium orange
cadmium red
burnt sienna
raw umber
alizarin crimson permanent
cobalt violet
cobalt blue
tiger's eye
cadmium green

Jacob Collins
flake white
Naples yellow
yellow ocher

flesh ocher
transparent earth orange
raw sienna
burnt sienna
burnt umber
raw umber
alizarin crimson permanent
ivory black

Michael Grimaldi
titanium white
Naples yellow
cadmium yellow
raw sienna
cadmium red
alizarin crimson
ultramarine violet
ultramarine blue
cobalt blue
cerulean blue
viridian
cadmium green
raw umber
burnt umber
Van Dyke brown
Paynes gray
neutral gray light
neutral gray middle

John Morra
titanium white
flake white
yellow ocher
raw sienna
Indian yellow
cadmium orange
transparent orange
raw umber
burnt umber
transparent red oxide

Venetian red
cadmium red deep
permanent alizarin crimson
quinacridone violet
Utrecht green
viridian
cobalt turquoise
ultramarine blue
cerulean blue
ivory black

Dan Thomson
titanium white
flake white
Indian yellow
yellow ocher pale
Mars orange
burnt sienna
raw umber
raw sienna
cadmium yellow light
cadmium yellow deep
cadmium yellow extra deep
cadmium orange
cadmium red light
Naphthol red
Perylene red
permanent alizarin crimson
Venetian red
permanent magenta
Mars violet deep
permanent rose
dioxazine purple
cerulean blue hue
phthalo turquoise
cadmium green pale
permanent green light
French ultramarine

BIBLIOGRAPHY

Abendschein, Albert. *The Secret of the Old Masters.* New York: D. Appleton and Company, 1916.

Aristides, Juliette. *Classical Drawing Atelier: A Contemporary Guide to Traditional Studio Practice.* New York: Watson-Guptill Publications, 2006.

Arnheim, Rudolf. *Art and Visual Perception: A Psychology of the Creative Eye.* Berkeley: University of California Press, 1974.

Barratt, Krome. *Logic and Design: In Art, Science & Mathematics.* New York: Design Press, 1989.

Birren, Faber. *The History of Color Painting.* New York: Van Nostrand Reinhold Company, 1965.

Boime, Albert. *The Academy and French Painting in the Nineteenth Century.* London: Phaidon Publishers, 1971.

Bouleau, Charles. *The Painter's Secret Geometry: A Study of Composition in Art.* New York: Hacker Art Books, 1980.

Cennini, Cennino d'Andrea. *The Craftsman's Handbook.* Translated by Daniel V. Thompson, Jr. New York: Dover Publications, 1960.

Couture, Thomas. *Conversations on Art Methods.* Translated by S.E. Stewart. New York: G.P. Putnam's Sons, 1897.

Doczi, György. *The Power of Limits: Proportional Harmonies in Nature, Art, and Architecture.* Boston: Shambhala Publications, 1981.

Doerner, Max. *The Materials of the Artist and Their Use in Painting, with Notes on the Techniques of the Old Masters.* New York: Harcourt, Brace, 1949.

Dow, Arthur W. *Composition: A Series of Exercises in Art Structure for the Use of Students and Teachers.* Garden City, NY: Doubleday, Page & Company, 1913.

Eastlake, Sir Charles Lock. *Methods and Materials of Painting of the Great Schools and Masters.* New York: Dover Publications, 2001.

Finlay, Victoria. *Color: A Natural History of the Palette.* New York: Random House, 2002.

Ghyka, Matila. *The Geometry of Art and Life.* New York: Dover Publications, 1977.

Gombrich, E.H. *Art and Illusion: A Study in the Psychology of Pictorial Representation.* Princeton, NJ: Princeton University Press, 1956.

Hambidge, Jay. *The Elements of Dynamic Symmetry.* New York: Dover Publications, 1967.

Küppers, Harald. *Color: Origin, Systems, Uses.* London: Van Nostrand Reinhold Company, 1973.

Lack, Richard. *On the Training of Painters, with Notes on the Atelier Program.* Minneapolis, MN: The American Society of Classical Realism, 1971.

Lawlor, Robert. *Sacred Geometry: Philosophy and Practice.* London: Thames and Hudson, 1989.

Parkhurst, Daniel Burleigh. *The Painter in Oil: A Complete Treatise on the Principles and Technique Necessary to the Painting of Pictures in Oil Colors.* Boston: Lee and Shepard, 1898.

Pearce, Cyril. *Composition: An Analysis of the Principles of Pictorial Design for the Use of Students, Art Schools, Etc.* London: B.T. Batsford Publishers, 1927.

Poore, Henry Rankin. *Pictorial Composition: An Introduction.* New York: Dover Publications, 1976.

Solomon, Solomon J. *The Practice of Oil Painting and of Drawing as Associated with It.* London: Seeley, Service, and Company, 1930.

Speed, Harold. *Oil Painting Techniques and Materials.* New York: Dover Publications, 1987.

Vitruvius. *The Ten Books on Architecture.* Translated by Morris Hicky Morgan. New York: Dover Publications, 1960.

INDEX

Alla prima method, 93, 116, 125–127, 146
Allegorical art, 211–214
Analogous colors, 81
Annigoni, Pietro, 144, 202–203, 232
Archival practices, 128–131
Art:
 ancient Greek, 21, 23–25, 35, 60
 communication through, 57, 96
 impressionistic, 92, 127, 196
 limitation and compensation of, 54–57
 perception in life, 54, 68
 reality in, 146
 religious, 33, 133, 163, 190, 202, 209–211, 218, 224, 226
 Renaissance, 24–26, 36, 41 *See also* Renaissance
 and technical failings, 143
 as visual music, 32
Artists:
 classical, 19, 24, 41
 as craftsmen, 3
 representational versus abstract, 170
 sensibility/ambition of, 143–144
Assael, Steven, 69, 118, 161, 204–205
Atelier training, 1–4, 9, 142, 143
Ateliers:
 contemporary, 3, 13, 111, 198
 curriculum in, 5–13

Bartlett, Bo, 97, 115, 236–237
Beaux, Cecelia, 196–197
Bonnat, Léon, 189, 226–227
Bouguereau, William, 19, 140, 196, 208–209, 224–225
Brown wash, 122–124
Brushes, 131

Caravaggio (Michelangelo Merisi), 38–39, 57, 69, 144, 190, 218–219, 220
Cast painting, 6, 9
 monochromatic, 48–51
 warm-and-cool, 98–101
Chardin, Jean-Baptiste-Siméon, 88–89, 97, 128, 144, 166–167
Chiaroscuro, 6, 53
Chroma, 81
Chromatic black, 80
Closed palette, 92–93
Color, 75–105
 articulation of, 75
 attributes of, 81–82
 basics of, 79–81
 color theory, 78–79
 color wheel, 77
 composition, 65–66, 95–97
 context for understanding, creating, 75
 making the palette work, 77–78
 mixing, 77, 82–85
 relationships, hierarchy of, 96
 strategic use of, 96–97
 systems, 85–95
 using emotionally/symbolically, 76
Color figure painting, 154–157
Color keying, 97
Color master copy painting, 12, 102–105

Color painting, 11–14
Color still-life painting, 150–153
Color strings, 92–93
Complementary colors, 80–81
Composition, 19–51
 and master paintings, 19
 overall themes/goals for, 42
 value in, 63–64
Compositional studies, 113–114
Contrast, simultaneous, 91, 169
Core shadow, 68, 69, 98, 100, 122, 133, 135, 156
Curriculum, 5–13, 149
 color painting, 11–14
 drawing, 5
 foundational principles of art, 5
 monochromatic painting, 5–10
 structure of, 6
 warm-and-cool studies, 10–11
 work in the life room, 13–14

Dark:
 as bedrock of artistic production, 54
 omnipresence of, 53–54
Design systems, 20–21
 rectangle, armature of, 26–33
 root rectangles, 34–43
Dickinson, Edwin, 200–201
Drawings, 5
 and composition, 112–114
 creating the illusion of the third dimension, 6, 66
 grounding in reality, 114

Ébouche, 97, 124
Eyes:
 leading, 50
 of the rectangle, 36

Fantin-Latour, Henri, 85, 144, 168–169
Figure painting, 6, 154–157, 209–237
 atelier training culminating with, 13–14
 symbolism, 211–214
Flemish method, 119–122
Fraser, Scott, 180–181

García, Antonio López, 1, 79, 143, 174–175
Glazing, 121
Grisaille, 6, 9, 79, 122, 124

Halftones, 68, 70, 71, 73, 119, 124
Hals, Frans, 168, 190–191
Harmonic proportions, 21–23
Hue, 81–82

Imprimatura, 118–119

Life room, work in, 13–14
Light:
 distribution of, 53–54
 omnipresence of, 53–54
Limited palette, 10–11
Lundin, Norman, 176–177

Master copying, 6–9, 12, 44–47, 102–105, 138

Material selection, 130–131
Measuring:
 relational, 49
 sight size, 48, 49, 99, 126
Millet, Jean-François, 222–223
Mixing color, 77, 82–85
Monochromatic cast painting, 9, 48–51
Monochromatic master copy painting, 6–9, 44–47
Monochromatic painting, 5–10
Murch, Walter, 172–173

Nerdrum, Odd, 21, 184–185, 234–235
Nicholson, William, 61–63, 170–171

Oil paint, 129, 131
Oils and mediums, 131
Opacity, 65
Open palette, 93–95
Overpaintings, 112, 118–127

Painter's process, 109–131
Paintings:
 beginning, 147–148
 cast, 6, 9, 48–51, 98–101
 essential elements of, understanding, 144–145
 figure, 6, 154–155, 209–237
 master copy, 8–9, 12, 44–47, 102–105
 portraits, 183–207
 quick, advantage of, 147
 self-portraits, 88–89, 91, 147, 164, 184, 194, 200, 202
 still-life, 6, 9, 12–13, 72–73, 150–153, 161–181
Palette systems, 92–95
Paxton, William McGregor, 198–199
Portrait painting, 183–207
 functions of, 183, 184
 institutional portraiture, 184–187
 personal portraiture, 184–187
 society portraiture, 187
 unique individual portraiture, 187–189
Poster studies:
 black-and-white, 7–8
 color, 13
Primer, 128–129, 131
Priming, 121–122
Pythagoras, 21–23

Rectangle, armature of, 26–33
Rembrandt (van Rijn), 7, 66, 119, 130, 194–195
Renaissance:
 artists, 25–26, 36, 41
 copying during, 24–25
 fascination with classical world, 24
 harmonic ratios used in, 24
 heroic vision of humanity and, 133
 and portrait painting, 183
 root rectangles in, 36
 seasons as mythological figures in, 214
Ribera, Jusepe de, 32, 183, 187–188, 220–221
Root rectangles, 34–43

Self-portraits, 88–89, 91, 147, 164, 184, 194, 200, 202
Shanks, Nelson, 232–233
Sight size, 48, 49, 99, 126
Sketches, 110, 112–113
 painted, 116–117
Skin coloration, 147
Split complement, 81
Sprick, Daniel, 42, 53, 178–179
Still-life painting, 6, 9, 12–13, 72–73, 150–153, 161–181
 and emotion, 164
 goals of art form, 161
 history of, 163–164
 transcribing life, learning how to, 140
Studio practices, 1–15
Supports, 130
Symbolic art, 211–214

Temperature:
 color, 81
 study of, 11
Tenebrism, 118
Tension, 21, 75, 136, 206
Thayer, Abott Handerson, 163, 198, 228–229
Tiling, 100
Titian (Tiziano Vecellio), 26, 29, 30, 36, 40–41, 88, 121–123, 130, 169, 192, 216–217
Tonal painting, 10–11
Transparency, 65

Underpainting, 6, 13, 46, 73, 100, 104, 109, 111–112, 118–127, 122, 156
Unity, 8, 41, 66, 69, 169, 209
 overuse of, 96
 within variety, 92, 96
 visual, 66, 146

Value, 52–73
 color, 81
 in composition, 63–64
 and focal point, 64–65
 mood and tone, 60–63
 qualities of, 57–69
 range, experimenting with, 71
 in two dimensions, 70
 value pattern, strength of, 57–60
 volume, illusion of, 66–69
Value-based still-life painting, 72–73
Van Dyck, Anthony, 19, 90, 184, 192–193, 216
Vanitas (vanities painting), 161
Varnish, 129–130
Venetian method, 121–122
Volume, illusion, 66–69

Wang, Yugi, 206–207
Warm-and-cool cast painting, 98–101
Warm-and-cool studies, 10–11
Wipeout, 122
Wyeth, Andrew, 106–107, 111, 116, 143, 230–231